ALL THOUGHTS ARE EQUAL

Cary Wolfe, Series Editor

(*continued on page 377*)

ALL THOUGHTS ARE EQUAL

Laruelle and Nonhuman Philosophy

JOHN Ó MAOILEARCA

posthumanities **34**

University of Minnesota Press
Minneapolis · London

Elements of chapter 4 appeared in "Animal Spirits: Philosomorphism and the Background Revolts of Cinema," *Angelaki: Journal of the Theoretical Humanities* 18, no. 1 (2013): 11–29; "The Animal Line: On the Possibility of a 'Laruellean' Non-Human Philosophy," *Angelaki: Journal of the Theoretical Humanities* 19, no. 2 (2014): 113–29; and "The Tragedy of the Object: Democracy of Vision and the Terrorism of Things in Bazin's Cinematic Realism," *Angelaki: Journal of the Theoretical Humanities* 17, no. 4 (2013): 39–59. Elements of chapter 2 appeared in "1 + 1 = 1: The Non-Consistency of Non-Philosophical Practice (Photo: Quantum: Fractal)," in *Laruelle and Non-Philosophy,* edited by John Ó Maoilearca and Anthony Paul Smith, 143–68 (Edinburgh: Edinburgh University Press, 2012).

Published by the University of Minnesota Press
111 Third Avenue South, Suite 290
Minneapolis, MN 55401-2520
http://www.upress.umn.edu

Library of Congress Cataloging-in-Publication Data

Ó Maoilearca, John.
 All thoughts are equal : Laruelle and nonhuman philosophy /
 John Ó Maoilearca.
 (Posthumanities; v 34)
 Includes bibliographical references and index.
 ISBN 978-0-8166-9734-2 (hc)
 ISBN 978-0-8166-9735-9 (pb)
 1. Laruelle, François. 2. Philosophy, French—21st century. 3. Animals
 (Philosophy) 4. Philosophical anthropology. I. Title.
B2433.L374O33 2015
194—dc23 2014043037

Printed on acid-free paper

The University of Minnesota is an equal-opportunity educator and employer.

Reason is the operating knife that cuts appearances into defined and workable rations. This Greek vision of the relation between appearance and reason is not "originally" Greek, but "specifically" human. The first tool produced by man at the very instant of becoming man was the stone knife. Human reason produces knives because it works like a knife, and it works like a knife because it produces knives

VILÉM FLUSSER, *Vampyroteuthis Infernalis*

Xenophanes ... memorably said ... that if horses or oxen or lions had hands, they would draw the figures of the gods as similar to horses, oxen or lions. ... Our problem with "anthropomorphism" relates to the projection of humanity into divinity, not animality.

EDUARDO VIVEIROS DE CASTRO, *Cosmologies*

CONTENTS

INTRODUCTION

FIVE POSTURAL MUTATIONS OF LARUELLE AND THE NONHUMAN

A non-philosophy postulates that there will always be philosophy, not because philosophy has not died or has survived, but because what is essential for it is that it is—by definition of its own posture or by internal postulation

FRANÇOIS LARUELLE, *Principles of Non-Philosophy*

QUESTION: What's the difference between a philosopher and a de-railed train?
ANSWER: The train will eventually stop.

THE AUTHORITY AND VICTIMIZATION OF PHILOSOPHY

We begin with a quotation and a joke, as is the fashion. It is doubtless that philosophers have been a perennial and easy target for ridicule—since Aristophanes's *The Clouds* at least—some of it well deserved, some of it less so. Philosophy itself, however, is more than a halfhearted jest; as François Laruelle warns, "philosophy is too serious an affair to be left to the philosophers alone."[1] In what follows in these pages, philosophical thought will be presented as a relentless, unstoppable force (which is why Laruelle himself is under no illusion that his work could ever counter this force completely—philosophy is here to stay). Despite what appears to many as philosophy's benign, abstracted appearance, the stance adopted here takes it to be the supreme form of thought control, or, to be perfectly clear, a device for controlling what counts as thought. Its objective is to capture everything under its own authority—*its* definitions of reality, knowledge, and, most particularly, thinking itself—an aristocratism of thinking. Its very form is transcendence, specifically, its *own* transcendence over every rival thought, regardless of content (whether the philosophy in question is deemed "metaphysical," "critical," or even "radical" is unimportant). What

1

matters most to it is simply *"that it is"*—that such authority of thought, or philosophy, exists. So, whatever else it might be, philosophy is also a question of extreme importance for Laruelle.

Of course, this rather melodramatic and (some might say) hugely overgeneralized picture of philosophy may seem counterintuitive. And this will be especially so to those philosophers who characterize their discipline in epistemic terms, be it of analysis, argument, clarification, questioning, or wonder. Philosophy is neither aristocratic nor democratic for them, for such moralizing terms are inapplicable to its questions of knowledge. Others would go even further in opposing the Laruellean view, only now *precisely* by placing philosophy in a highly moral position, as both a benchmark and a safeguard of intellectual freedom and human flourishing. Agnes Heller, for instance, argues that "every philosophy is—in its structure—democratic." In her book *Radical Philosophy*, she paints an altogether different picture of the discipline:

> It was said that the challenge of philosophy, "Come, let us think together, let us seek the truth together," is addressed to everyone, for philosophy assumes that all people are equally rational beings. It was said that philosophy appeals to the understanding and not to the belief of reasonable people. It was said that philosophy recognizes no *other* authority than human reason.[2]

"Human reason" is the sole authority for philosophy, the one that allows it to address "all people" equally. So why should Laruelle think of philosophy in such draconian terms, when so many think of it as a force for good or, at worst, no more than a moral irrelevance (being ethically neutral)? *The reason is because philosophy's democracy is, he claims, an illusion.* Indeed, Heller herself, while declaring that (left-wing) radical thought is "always *democratic*," also admits that such philosophies also have a "painfully *aristocratic* aspect: they ascribe to every person abilities and values of which the majority of men and women are either ignorant or unconscious."[3] Yet what for Heller is an unfortunate but still incidental feature of even radical thought for Laruelle exposes philosophy's authoritarian core.

Despite appearances to the contrary, philosophy remains our dominant form of knowledge, according to Laruelle. Or rather, it is the very

form of domination within knowledge. Adopting many shapes and poses (empiricism, rationalism, idealism, materialism, scientism, even anti-philosophy), its fundamental pose is as a form of exemplary thinking. It is *the* model for all foundational thinking, even when those foundations are differential or antifoundational. As Laruelle puts it, "philosophy is not 'first' for nothing; it is that which declares itself first and possessor."[4] Even in our contemporary scientistic era, in *epistemic relations,*

> philosophy holds the dominant place, science the dominated place. In positivism or scientism, the hierarchy is reversed or inverted; but it is still philosophy that dominates in anti-philosophy. The superior or dominant place is in effect always occupied by philosophy.[5]

Scientism is a philosophy too (albeit a self-hating one). Alternatively, those philosophies that posit a more open, liberal thought of "embodiment," or of the "unsaid," or of the "unthought," the "subaltern," "thought of the outside," "pure difference," and so on, *in as much as they remain philosophical positions,* also maintain a covert dominance: "every philosophical critique (of philosophy) is *first critique* and, as a result, can only be founded upon a non-being or an Other which it *supposes given.*"[6] The "givenness" that supports both totalizing critique (scientism) and antitotalitarian thought is ultimately that of philosophy itself—its entitlement to judge the value (ontological, epistemic, ethical, or aesthetic) of all things. This is its own givenness, "that it is." Philosophy generates "an authoritarian image" or "authoritarian mechanism" that it calls "reality" or the "World."[7]

By contrast, non-philosophy aspires to bring democracy *into* thought, because what it says is that philosophy—the discipline that posits itself exclusively as the power to think at the highest level—does *not* have a monopoly on thinking. In non-philosophy, all thoughts are equalized. However, this equivalence or conceptual democracy is not *political* in the philosophical and representational sense of the term (with all its attendant troubles). It is not a *theoretical* democracy—which would leave what counts as "theory" alone—but the "democracy of theory itself." Such a nonrepresentational democracy aims to resolve the traditional hierarchies of philosophy "with experience, art, ethics, technology, mysticism, science, etc.," by mutating just what thought

and theory might be—by "universalizing thought beyond philosophy."[8]

Coming from the Latin, *aequalis,* "equality," not only means "the state of being equal" but also "even" or "level." According to Laruelle, philosophically driven arguments can only go so far before becoming lexically circular (referring us back to the start) or ostensive. With an abstraction such as "equality," moreover, the inadequacies of the more seemingly exact lexical strategy are even more instructive. To say that "equality *means x*" (or "*y*" or "*z*") necessitates a willful blindness toward its own semantic circularity, to wit: "equality *equals x*" (or "*y*" or "*z*"). Of course, the question of equality—its nature, origins, and current impediments—is a pressing one among those forms of philosophy focused on political programs: does it reside in some kind of sovereign power like sensibility or self-awareness (as Peter Singer argues), or in the lack of any such power, in vulnerability (as Jacques Derrida claims)? Or is it based on a quantity opposed to any quality, be it sensibility, vulnerability, or anything else (Alain Badiou's view)? Doubtless, these particular philosophers should not be numbered among strict political egalitarians on a par with, say, G. A. Cohen or Amartya Sen. Rather, it is because they attempt to give a *philosophical* argument for egalitarian thought (that is supposedly noncircular) that, as we will see, they are apt material for non-philosophical study—that is, one that "levels" or equalizes all arguments.

One purpose of this study is to explain Laruelle's strange image of philosophy—only without either the authority, or the terms of reference, found in *philosophers'* explanations of philosophy. As such, it strives to see how "thought" might appear when we look at it with non-philosophical eyes, once it is "defetishized," as Laruelle puts it.[9] It also serves to defetishize the much-vaunted "human reason" of philosophical power. Instead, the question of both what is human and what is reason will be given a nonstandard rendering, one that goes beyond historicism (Foucault, MacIntyre, Feyerabend) toward something nonhuman. Indeed, the theme of the nonhuman, in particular the animal, must remain prominent in this study given that a striking implication of Laruelle's nonstandard approach to both man and philosophy is that what would be most unthinkable for philosophers, an animal philosophy, becomes thinkable for non-philosophers.

In some of what we will hear, it will seem at first that Laruelle victimizes

philosophy too much, what with his accusations of circularity, narcissism, and intolerance. This is especially the case when he appears to personalize philosophy through the proper names of Immanuel Kant, Jacques Derrida, Gilles Deleuze, Alain Badiou, and various others. Indeed, hearing such a long charge sheet can have a reverse effect on some readers and encourage a stubborn defense of the accused. However, though such a reflex is understandable, we should be careful not to take things so personally. What is "on trial," so to speak, is a kind of thought, a structure or position in thinking. Indeed, we would encourage a type of literalization of this notion of "position." "Philosophy" is the position thought adopts when it becomes authoritarian, irrespective of its source in extraphilosophical domains (like science, art, or history). When these fields enter into a purported dominance—real or ideal—on account of their *self-nomination* as supreme thought, then they become "philosophical." As Laruelle writes in *Anti-Badiou,* "we blame the 'philosopher' for nothing. Badiou, insofar as he strives to succeed Derrida and Deleuze, on the contrary, we blame him right down to his philosopher-sufficient essence—the essence, and not at all the way in which he puts it to work."[10] This "essence" is in fact a kind of behavior, an activity—of positioning—rather than a *specific* body of knowledge, or history, or method (such as Alain Badiou's—for that is only one version of it). The history of philosophy is always retrospectively constructed, of course, with either some new names being written in (as some old ones are written out) or certain permanent names, like Plato or Hegel, being constantly reinterpreted. But "no name," Laruelle claims,

> however big it is, not even Plato or Hegel, sums up Philosophy or can substitute itself for it. No proper human name of history can substitute itself for the name of "Philosophy," a quality-performative name.[11]

The proper names of "Deleuze," "Derrida," and "Kant" are not used here as those of once-living persons, but for the many ruses by which thought can appoint itself the arbiter of all thought (even when it appears at its most benign and open-minded). Consequently, the authority and power of the philosopher—seen particularly in the *posturing* of the public "intellectual"—is not that of an actual person such as Slavoj Žižek, Jürgen Habermas, or Badiou but something in the essence of philosophy itself.

The apparent power of the intellectual is that of thought when it raises itself to the level of a total, complete, or all-powerful position (even if only ideally). Individuals do not have this power: it is rather that philosophical thought is the power of being *in* a certain position. As Katerina Kolozova describes,

> adherence to a determinate theoretical horizon provides one with the comfort and safety of philosophical certainty. It is a twofaced certainty established by the hybridization of the transcendental (or thought) and the real: the comfortable sense of unshakability *in* one's philosophical knowledge and the safe sense of "knowing the reality."[12]

Knowing or representing X ("philosophically") is the power of being *in* a position over X, transcending X, even if one must use mathematics, or physics, or poetry to enter into this position.

Understood in this fashion, philosophy is also the authoritarian structure of a kind of thinking that can operate in numerous domains, whether or not *we* call them "philosophy." Such a self-promoting thought—that is, one that promotes itself as *the* model of thought—is not tethered to certain names or historical disciplines: as Laruelle has said in a recent interview, "*every discipline very soon arrives at its own sufficiency, in the sense that it tends to auto-finalise itself, raise itself to the level of a total, complete or all-powerful thought*").[13] Philosophy is a vector, "an affair of movements and becomings, of lines and vectors, of reversals and displacements."[14] It is a "phase-state" in thought rather than any universally acknowledged "content," one that gives itself sovereign power of thought over all others, whether they be philosophers or non-philosophers, and even whether they be human or nonhuman.

So what is unusual, and undoubtedly counterintuitive, about non-philosophy is the consistency with which it materializes all thought, including its own, within a radically *immanent* approach: it renders transcendence as immanence, as "position." This immanentist stance thereby sees philosophical thinking as both a performance *and* a physical tendency or spatial *activity* (which will be described as the power of "distancing" or "withdrawal"). It is this core to philosophy, as the most persistent performance or position of power, that is under interrogation

here. Non-philosophy, then, attempts to reorient (rather than oppose) philosophy understood as a material tendency, vector, or orientation.

In this introductory chapter, we look at Laruelle's general non-philosophical approach (his attitude toward philosophical representation, performative consistency, material thought, decision, "posture," and science), his unusual treatment of the human (anthropomorphism and extended definitions of thought), and the methodology adopted for this study (non-philosophy's artistic source material, the use of cinema to inform our approach, the horror of the nonhuman, and an outline of the argument's structure). Lengthy though it is, covering this material now will save us some time later.

ALL THOUGHTS ARE EQUAL, BUT SOME THOUGHTS APPEAR MORE EQUAL THAN OTHERS: FROM POSITION TO REPRESENTATION

François Laruelle (b. 1937) is Professor Emeritus in Philosophy at the University of Nanterre, Paris, the inventor of "non-standard philosophy" (or just "non-philosophy"), and the author of more than twenty-five books on this topic. His project, as he sees it, is the attempt to envision philosophy as a material and to study it from a genuinely nonpartisan point of view. The ideas of philosophy are no longer positions to be argued with, critiqued, accepted, or promoted but raw material to be utilized: it is not a question any more of how we should study philosophy "philosophically" but rather one of "what should we make *of Philosophy* itself?"[15] As he also writes, "*there is a body of philosophy, a philosophical materiality, a conceptual and lived material, and one can treat philosophy as a part of physical nature.*"[16] In pursuing this task, then, we must first avoid the circular method of "treating philosophy philosophically" and instead propose a "means of causing thought to function otherwise than philosophically."[17] This is neither to reject philosophy nor to surpass it in any recognizably philosophical terms: such an approach "only claims to succeed the faith and authority of philosophy, never to deny its reality, nor to refuse it at least a 'relative' autonomy."[18] Non-philosophy negates "*only that part of it that can be negated—its sufficiency.*"[19] Instead, Laruelle wishes to utilize philosophy and will do so employing models from both the sciences, like biology and physics, as well as the arts, such as photography and music.

Taking this view of philosophy and thought also brings about an expansion of the definitions of both *indefinitely* (which, as we will see, is ultimately to refuse to define either). Laruelle aims to deauthorize philosophy, to democratize it: "as soon as I give a definition it is a failure. We have to refuse the temptation or appearance of definition."[20] However, this gesture goes beyond merely relativizing thought within a pluralism that is actually indifferent to philosophy ("all opinions are valid") or anarchizing knowledge as part of a methodology where "anything goes." Rather, the "flat" thought Laruelle strives for is democratic because it is materialized in *different* ways, some of them "scientific" (quantum physics, biology, geometry), some of them aesthetic (photography, performance art, music). *Standard* philosophy—the positioning of authority over thought—does not have a monopoly on what counts as thought or even "philosophy." What might look like relativism, then, is always expansion, an inclusivity of thought. Moreover, non-standard philosophy also refuses any fixed definition of the Real or the Human. Whether this inclusivity might also extend to the nonhuman, to a thought and philosophy that is not the right of *Homo sapiens* alone, is, therefore, a further question for this work.

One thing we must be clear about from the start is that non-philosophy is *not* an antiphilosophy. Laruelle is not heralding another "end of philosophy" nor the kind of internal critique of philosophy common in much post-Kantian European thought. His use of the term *non-philosophy* is neither a dialectical negation nor even something contrary to philosophy: "while non-philosophy has overtones of anti-philosophy, it cannot recognize itself in current anti-philosophy, whose origins are predominantly philosophical."[21] As we will see later, the "death" of philosophy is more often than not only a botched suicide attempt, a cry for help (or demand for attention) rather than a genuine thirst for annihilation: "*there is indeed a suicide of philosophy, but it has lasted as long as philosophy's own history.*"[22] Rather, modeling the name "non-philosophy" on an analogy with "non-Euclidean geometry," Laruelle proposes a broadened, pluralistic science of thought and philosophy as well as a major reworking of philosophical concepts. Crucially, the *non-* in *non-Euclidean* is not a negative: non-Euclidean geometries do not negate the principles of Euclid's *Elements* but affirm them within a broader or amplified paradigm that allows other, apparently opposed geometries to coexist,

while also explaining where and in what respects they are still relevant.

Similarly, non-philosophy attempts a transformation that locates philosophy as one instance in a larger set of theoretical forms.[23] It is a *positive* act: "the 'non' is therefore not an all-powerful negation. It has a status or function only at a level that is no longer dialectical, no longer at the level of signifier and sense, but that of usage; it is a 'non' that affects the usage of terms, a lived that transforms them."[24] Non-philosophy is a conception of philosophy (and all forms of thought) that allows us to see them as equivalent according to a broader explanatory paradigm.[25] It enlarges the set of things that can count as thoughtful, a set that includes existing philosophy but also a host of what are often presently deemed (by standard philosophy) to be non-philosophical (art, technology, natural science). In addition, Laruelle integrates present examples of philosophy with instances of what *those same philosophies* regard as their "opposites" within philosophy. In this democracy of thinking, all thought is equalized when regarded as raw material for non-philosophy, that is, as part of the Real, or "One" (as it is also called), rather than as "representations" of it.

We now need to introduce the connection between non-philosophy and *representation* in some detail. Each method of philosophical thought ("philosophical" being understood once again as a phase-state of thought), because it *occupies* itself with representing the whole exclusively, misses its target in part—it is partial (just *one* method).[26] Yet this is not to say that each and every philosophy misses it entirely, that they all *misrepresent*. Laruelle is *not* saying that method "X" is "wrong" and that it can be improved upon or replaced with a truer method "Y." The Real is indifferent to every attempt at representing it. This is because every thought, *when regarded as* a physical body, is already a part of it (and a part cannot be the whole, even through the magic of "representation," which always fails to capture its quarry complete). Separated from each of their claims to exclusive truth, philosophical positions becomes a question of precisely that, *positions* in space, a question of physics and the material coexistence of different thoughts.

Alternatively, what makes the arguments of the philosophers *circular* is due to their representational form. Philosophical reasoning is tautological, privileging one piece of empirical evidence by raising its status to the transcendent or representational (creating what Michel Foucault called

"empirico-transcendental" doublets). Philosophical practice "mixes" the Real with a predecided representational schema—be it substance and accident, actual and virtual, being and nothingness, phenomenal and noumenal, and so on—that attempts to transcend the Real (through these philosophical concepts). The resulting worldview, however, is entirely relative to this decisive starting point. Hence, we have what Laruelle describes as all the "great circles" of philosophy: "'Unity of experience' (Kant), '*Lebenswelt*' (Husserl), 'Being-in-the-world' and 'Care' (Heidegger), 'General Perception' of 'Flesh' (Merleau-Ponty), etc."[27] And as we saw, each philosophy's transcendent form leaves no room for alternative positions. As a consequence of their attempts to exhaust all explanatory space, each philosophy—be it phenomenology, deconstruction, Platonism, or any other—cannot explain its rivals' existence as anything other than illusion or error (or *misrepresentation*). Nor can it justify the grounds of such illusions or errors without again presupposing what a "proper" representation and a "proper" ground might be. Even pluralism—ostensibly affirming all other views (or at worst being indifferent to them)—still *occupies a position* and must thereby elbow out both nonpluralist and other kinds of pluralist positions to make room for itself.

In all of this, Laruelle may appear rather unoriginal. For some, his ideas will sound like a version of Kant's critical philosophy: metaphysics cannot *represent* the "thing in itself," for its "truths" are the result of the "manifold" *after* it has been reconfigured through the mind's structure of knowing. The (human) mind refracts rather than reflects reality. Indeed, long before even Kant, Francis Bacon had already written in his *Novum Organum* that human understanding is like "a false mirror, which receiving rays irregularly, distorts and discolours the nature of things by mingling its own nature with it."[28] In fact, Laruelle would be the first to admit that the "intraphilosophical critique of the mirror and reflection is almost universal," being also found in Fichte, Husserl, Wittgenstein, Heidegger, and Lévinas.[29] His own work, however, concerns *the reality of the reflection* within a philosophy of immanence as well as an extension of the critique of (human) metaphysics to *all thought of the Real*. It is not just metaphysics that is asked to forgo its supposed power to represent reality but any philosophy that would hope to represent things in their essence, that believes that it can capture reality through its own putative powers

(of questioning, wonder, deduction, induction, intuition, will to power, affective encounter, sympathy, selfless attention, pluralist affirmation, and so on). Kant's critique needs to be generalized from one of metaphysics to one of philosophy as such. As a result, Laruelle's accusations concern *all* self-styled philosophical thought, metaphysical *and* nonmetaphysical. Ironically, Kantian transcendental deduction must be included in this lineup too in as much as it also believes that reality can be thought, even if only through *inference*, as this is defined and understood according to its own method.

In short, at no time is a *representationalist* critique being offered by Laruelle, that is, one that judges philosophies according to epistemic values—*his is not an attempt to improve upon other philosophies' "failed" pictures of the Real*:

> non-philosophy does not draw its motivation from philosophy's failure but from the positive necessity of explaining it, of elaborating the reasons of this inability within the Real itself or the Ego that forces every thought to its foreclosure, philosophy on the other hand ignores this foreclosure and claims or wants to know the Real.[30]

The function of a non-philosophy is to integrate (rather than reduce, replace, or eliminate) philosophical views back into the Real by surveying them together in a democratic, immanent, revision where no one view is superior to or transcends the other. At the same time, such a real integration shows their *physical* limits: the fact that they are seen to share a space (that their one theory is never as total as it hopes to be) indicates that they cannot occupy the entirety of that space alone ("what the Real really is"). Yet philosophical views are not dismissed thereby as failed representations. Rather, they and their "limits" (irreducible remainders, *aporias*, even circularities—all the usual tools of "critique") are made Real, they are physicalized as parts of the Real. (What such an affirmation entails for a *non-philosophical* pluralism like this, *in its own position*—such that it does not enter into a new form of authority—remains to be seen.)

Taken individually, each philosophy is as arbitrary and circular as the other: though some will be more complex, such complexity only serves to occlude their ultimately tautological grounding. This is

especially true of those philosophies of philosophy that offer definitions of "proper" thought. The fact is that the various forms of thinking privileged by different philosophies is always done by *fiat* (stemming from a "position"). The history of philosophy is a litany of different baptisms: thinking descriptively, poetically, mathematically, affectively, embodiedly, analogically, syllogistically, fuzzily, paraconsistently; thinking through a method of questions, of problems, of dialogue, of dialectic, of genealogy, of historicism, of deconstruction, and so on. Taken on their own, though, each of these exemplary cases restricts the idea of thinking in a presumptive manner, either by positing what could count as thinking per se or by positing what counts as "good," "proper," or "true" thinking. Even Badiou's apparent egalitarianism toward art, science, politics, and love, as forms of thinking, masks a demand—says Laruelle—that "philosophy define their essence and itself be their excellent form and their ultimate type, whether the thought of thought, or what totalizes or simply gathers thought, picks it up as a last resort, etc."[31] In other words, philosophy always remains King: it "auto-presents itself as titleholder of thought."[32]

Non-philosophy, on the contrary, is "the manner of thinking that does not know *a priori* what it is to think or to think the One."[33] And in practice, this means that it is "essential," as Laruelle constantly reiterates, "to remodel 'thought' or the cogitative in terms of the autonomy of the Real"; or again, "what is necessary is to change the paradigm of thinking" (and what counts as thinking).[34] And this change of paradigm, which he also calls a "mutation," must be continually reperformed (in case it should fall into one position). The work of non-philosophy, therefore, is an ongoing experiment in what results from seeing philosophical thought in a non-philosophical way—thought as just one other (real) thing rather than thought as *the* (irreal) representation *of* "All" things. This is what Laruelle dubs a thinking "according to" or "alongside" the Real.[35]

PERFORMATIVE INCONSISTENCY

To examine better the means by which non-philosophy tries to avoid becoming another "position," we must return to the question of what makes Laruelle's non-philosophy different, only now in terms of its *activity*. What it attempts, he says, is "*not a new philosophical paradigm*" but the

"*transformation of philosophy.*"[36] Laruelle is adamant that non-philosophy is a new "practice of philosophy" rather than a "philosophical taking of sides and thus inside philosophy."[37] Various commentators agree on this point, Rocco Gangle describing his work as a "radically new form of thought," Robin Mackay calling it a "new mode of thought."[38] A weak interpretation of such ascriptions might take them to imply merely a peculiar variation upon philosophical method (most often owing to novel subject matter), whereas, in fact, Laruelle seeks a radical mutation in methodology and content *at the same time.* He seeks an "experience of thought" that is even "non-Greek" in terms of its philosophical trajectory (which, for Laruelle, means that it must avoid *logical identity* at all cost).[39] Whereas standard philosophical approaches take their conception of what proper philosophy is and then apply it to all and sundry objects—which Laruelle calls the "*Principle of Sufficient Philosophy*"—non-philosophy is a "style of thought" that mutates with its object.[40] Hence, non-philosophy is neither "theoretical nor practical nor aesthetic, etc., in the sense whereby philosophy defines separated regions of experience."[41] It is all of these at once.

So, despite its own sometimes abstract and abstracted appearance, non-philosophy is intended to be a practical theory too. Indeed, it is forwarded as a performative thought that does things (to philosophy and to "Theory" generally), albeit through words in Laruelle's own practice. Laruelle even goes so far as to say that "*non-philosophy is a practice, it is enacted* [*en acte*], *almost criminally performative* [*performative au crime près*], this is the only way of demonstrating it."[42] This practice involves taking the concepts of philosophy and attempting to extract all transcendence from them (in a manner and with what success we have yet to ascertain), to review them as parts of the Real and no longer as representations.

Of course, non-philosophy is hardly unique in placing practice at the heart of its method, nor in endorsing a democratic pluralism as regards the definition of thought—many "philosophies of difference" cherish such ideas too.[43] Yet Laruelle is not being naïve: he knows that such values (openness, practice, tolerance) are universally commended. What is different is Laruelle's constant acknowledgment of the difficulty of practicing them, of practicing tolerance and even of practicing practice. This concern with *consistency* in actually doing what one says and saying what one does, is crucial to the difference between philosophy and non-philosophy—it is

its essential, *performative* element: "But we know through the philosophers themselves, in an undoubtedly still limited manner, that they do not say what they are doing, and do not do what they are saying."[44]

Even the most open philosophies (of difference) still aspire to seize reality exclusively. Deleuze, for example, believes that thought should think of itself as immanent to the Real, rather than as a representation that transcends it. So far, so non-philosophical. Yet Deleuze would perform this explanation *in the name of his philosophy*: the image of thought he has in mind is as depicted in his explanation, with all its architectonics of the Real readily defined and hierarchized (virtual versus actual, Bodies without Organs versus the organism, war machines, rhizomes, etc.). Even though Deleuze embraces multiplicity and a variety of kinds of thought in what he says (artistic and scientific as well as philosophical), all the same, *what enables him to say this* is his own highest thought, or "creation of concepts": it is *this* that belongs to Deleuzian philosophy alone. *He* explains the Real; not Boulez, nor Artaud, nor Bacon (they provide the material for the philosopher). For *this* is Deleuze's performative, though it is one that does *not* do what it says.

The same even goes for Deleuze and philosophy as such. Coauthoring a book on philosophy (with Félix Guattari) is a performative act:

> Let's suppose that there exists a book called "What is philosophy?" and that it claims to answer this question by virtue of its own existence or manifestation. Thus it is impossible to talk about it: because this book is at the center of philosophy and philosophy is at the center of this book; because *philosophia sive natura* and one does not converse with God.[45]

Because he remains a philosopher, Deleuze cannot *enact* the egalitarian demands of radical immanence that he espouses. This is not a matter of unwitting self-deception or bad faith, nor conscious duplicity. It is part and parcel of the nature of philosophical thought as "auto-positional" or self-positing. For Laruelle, there is no explaining what the Real "really is," because every thought, *be it Deleuzian or not, be it philosophical or not,* is as good or as bad an explanation as any other—for they are all (nonsummative) material parts.

What follows from an axiom of radical immanence, if acted upon, is

that non-philosophy *does do what it is saying*. Or at least it *says that it does* (such consistent practice is easier said than done). And, indeed, who is to judge whether it has been successful? Undoubtedly, a number of problems emerge when it comes to evaluating such immanent performativity. For a start, it may be that Laruelle is deluding himself as to his own consistency and actually falling into performative contradiction whenever he refers to his own thought as an "identity of saying and doing" (simply because he is *describing* what he is doing *elsewhere* instead of doing it *here*).[46] Second, on one level it is just trivially true that *any* utterance is a kind of action. What is less obvious is when an utterance's "form" and "content" are one and the same (if such a duality can be applied to Laruelle). What is most in need of argument, however, is the notion that *this* saying, here and now, both expresses and embodies what it says consistently in all contexts. If, that is, "this" is what Laruelle means by consistency (the nature of this "this" will be examined in the final chapter, as well as the threat of trivial "explosion," whereby all things become performative).

We could attempt to make things easier for ourselves—and avoid the dangers of triviality, self-delusion, or contradiction—by invoking a "use"–"mention" distinction here. On this view, it might be that when Laruelle says that (to paraphrase) "philosophy does not do what it says and non-philosophy does do what it says," this utterance is itself to be taken as a "mention" rather than a "use" of its terms. As such, it would fall within philosophical purview and avoid the various abysses of self-reference (because the referring statement only *mentions* itself). To mention "animal" in saying "'animal' is not animal" avoids the pitfalls of using "animal" in saying "animal is not animal." Of course, this fix would come at the cost of subverting non-philosophy's entire enterprise by "renormalizing" it. The salvage would also be on the basis of a distinction that is itself contestable (both between philosophy and non-philosophy *and* among philosophers). Laruelle sees *usage* as such a large part of the non-standard approach that even "mentioning" (his own thought) is itself *a kind of usage,* called "cloning." The duality of use–mention rests on philosophical assumptions that non-philosophy cannot share (especially concerning representation and the nature of self-reference or "meta" talk). So, while it is possible to save non-philosophy from certain aporia in this manner, the price is too high (the operation may be a success, but we lose the patient). We

need another approach if we are going to give non-philosophy a better run for its money.

The performative dimension of thought is one more notion that is not unique to Laruelle, of course. As Jaako Hintikka once showed, even Descartes's "*Cogito, ergo sum*" can be understand as a performative act rather than an inference.[47] Performative contradictions too—"this sentence is not true," "I am asleep," "everything is a lie"—have been the source of the many paradoxes that have kept philosophers distracted for centuries and a major point of entry into the performative aspects of philosophical thought. The lack of fit between the content and the performance of an utterance—*saying* "I am asleep" does not lie well with *being* asleep (unless, of course, one happens to talk in one's sleep)—can generate numerous ideas on the nature of thought and language. The misfit (inconsistency) between the speech as *act*, the doing, and what is *said* is also important with respect to the performance of philosophies *as a whole*, however, and not just in its particular "speech acts." In Emmanuel Lévinas's work, for example, the ethical message found in his book *Totality and Infinity*—concerning the inability of any being in the world to totalize or objectivize our infinite ethical responsibility toward the Other—appears to be contradicted by the very writing of *Totality and Infinity*, which is all too adept at conveying its message *objectively*, that is, through beings in the world. Hence, spurred on in part by Jacques Derrida's criticisms, the sequel to that text, *Otherwise Than Being or beyond Essence*, played a far more complex game with language, between content and performance (or "the said" and "the saying"), to scupper any false impression that this book has some *ontological* (worldly) thing that it wanted to say. In a similar vein, Derrida himself is famed for supposedly having stopped *arguing* for his quasi-concept of *différance* in the 1960s in favor of actually performing it in the 1970s (in books like *Glas*) to be consistent with his message regarding the futility of self-present arguments (logocentrism).

Note, however, the emphasis for both of these figures on using performance to *avoid* contradiction, to assure *consistency*. One might even say that neither Derrida nor Lévinas abandoned (logocentric) argument in toto because, to salvage the *coherence of their positions*, they adopted a higher-order meta-argument (*through* the performative). The performative was a means to an end, even though that end concerned such

seemingly extraphilosophical notions as alterity and *différance*. (We will see this philosophical urgency to save coherence again in chapter 2, despite it being done to protect a paraconsistent position.) The performative was never the end in itself for these philosophers. Regardless of its best efforts, for Laruelle there is a constitutive disingenuity in (any one) philosophy given its ongoing desire to explain reality from *its* position. Even when a philosophy is seemingly aware of its own performativity and the impossibility of transcending it, it still attempts to sidestep the implications of such radical immanence. *Its* act, there, is always the *exception* to the case:

> The philosopher, legislating for reason, the life of the mind [*vie de la pensée*] or social life, makes an exception even of the fact that he does not do what he says or does not say what he does, but, speaking the law, he makes an exception and enjoys the privilege of speaking about it and imposing it with his authority. I speak the truth, says the liar; I speak democracy, says the anti-democrat: this is the paradox of the philosopher as thinker of the Whole who is never short of expedients for presenting the paradox as if it were acceptable.[48]

For there is the rub: if *inconsistency* is the content of one's thought, of one's argument, and philosophy is auto-position par excellence (the coherence of a self-identical argument), then one must continually invent new ways of arguing that no longer appear either as philosophical or even as coherent. There must be auto-mutation or self-destruction built in. By pushing this idea to its practicable limit, Laruelle produces the strange vision of a non-philosophical "philosophy." Hence, his approach must be seen as performative *all the time*. In fact, this is its primary constraint:

> In non-philosophy, thought in act is not distinct, in its essence at least, from its effects or its speech because, if it is relatively free regarding its cause, this is its cause as imprinted with a radical performativity, unlike philosophy which only reaches this under the form of a circle, or more or less a circle, or in another case some sort of unconscious which destroys it. Non-philosophy is constrained—materials aside—to do what it says and say what it does.[49]

This "constraint," according to Laruelle, is "transcendental" in nature, a "to-do-in-saying, to-say-in-doing . . . the only instance whose usage speaks itself through this identity without fault." However, notwithstanding the mutation that Laruelle will also render to the concept of the "transcendental" itself (which we will chart in chapter 1), the concept of the performative will mutate in his hands too, taking it away from its linguistic and active origins ("speech acts") and attaching it to the Real as a form of "passive performativity."[50] All of these ideas will need to be addressed again later.

MATERIAL THINKING

This emphasis on philosophy and thought as material is part and parcel of non-philosophy's formal innovation—it approaches thought, "rigorously," "consistently," as material, as a thing, immanent to the Real. Crucially, though, non-philosophy operates without any commitments to a *philosophical materialism* that would only infect its practice with various ideas *about* matter—definitions of what is truly matter, hierarchies of what true matter explains, causes, determines, and so on. Instead, using models directly from physics, biology, or art, Laruelle performs "a quasi-physics of philosophy"—the "quasi-" denoting a nonpositivist, nonreductive approach that takes the model of thought from one domain (like non-Euclidean geometry, as we saw) to shed light on another. Laruelle's choice of models appears somewhat arbitrary and is indeed contingent on his own biography. What counts in their usage is not any supposedly true picture of "what there is" offered by one or the other but the style of thinking that each practices. This is not a project in "naturalizing philosophy" out of existence: Laruelle is far from being a "post-Quinean" who would replace "folk-philosophy" with the discourses of (one or other) "hard science."[51] Philosophy's thoughts are retained in all their molar specificity but are shorn of their ambition (to explain everything) to become bodily parts: there is a "body or a thickness of philosophy" that needs to be acknowledged.[52]

As a consequence, the "materiality" of philosophy is not to be understood according to standard materialist approaches, the techno-scientisms of computationalism, biologism, or physicalism, for example. What Laruelle

says of photography in *The Concept of Non-Photography* is no less true of philosophy qua matter for non-philosophy. His approach, he writes, is

> a materiality without materialist *thesis* since every thesis is already given in it, in its turn, as "flat," just like any other singularity whatsoever. Far from giving back perception, history or actuality, etc., in a weakened form, photography gives for the first time a *field of infinite materialities* which the photographer is immediately "plugged into." This field remains beyond the grasp of any external (philosophical, semiological, analytic, artistic, etc.) technology.[53]

It is a "field of infinite materialities"—not one or other domains (neuroscience *or* physics *or* mathematics) *to* which everything can be reduced, and *through* which philosophy can thereafter explain everything by proxy of it becoming *the* philosophy "of neuroscience," "of physics," "of mathematics," or of whatever else. Philosophical materialism remains especially hubristic and hypocritical in this regard: though it claims to *follow* a scientific reduction of the Real practiced vicariously through the physicists or mathematicians who offer "theories of everything," what counts is *its lead* in appointing the favored science (physics today, mathematics tomorrow) for wholly philosophical reasons of its own making. It is the King-maker who is truly the King (like the so-called masochist who has all the power). Once again, philosophy does not do what it says.

Significantly, philosophy must leave the origins of its godlike powers of representation a mystery, or palm it onto a theory of "reference," of statements and their relations (which has a plethora of its own idiosyncratic mysteries). As Laruelle puts it in *Principe de minorité*,

> what renders a statement "material"—or rather "real"—and not merely materialist, can be demonstrated neither in terms of its objects, nor its meaning or signification, nor by its *materiality* as statement, that differential materiality or relatively indivisible and *continuous* distance *relating* it to other statements. As far as a statement is concerned, at least insofar as it is grasped in its essence, to be "materialist" is never a question of the manner in which it relates to other statements, but consists rather in its refusing to enter into a relation, a becoming or mediating tendency,

refusing to allow itself to be inscribed within the strategy of a reciproc-
ity, the economy of a community, into the trade between "positions,"
"forces," or "powers."[54]

Philosophy (materialist or otherwise) orchestrates an entire network of
statements (about science and philosophy), conferring legitimacy on some,
illegitimacy on others. But its own power to confer high and low grades
must remain outside of the network as a transcendent. By contrast, Laru-
elle's postulate or "posture" (as we will explain later) could be described as
an non-relational, *auto-affective* hypothesis, that is, a conjecture that all
thought, *including itself,* is material. *Think this,* it says: thought is a thing,
the Real *is* "the *thing* (of) thought, its 'in-itself.'"[55] If we take *this* thought
seriously (i.e., as consistently as possible), it follows that it too is a material
thing (though *not* because it might be composed from neurons, atoms,
or sets). The thought implicates itself—hence the "auto"—but it sidesteps
a possible response from philosophy that this consistency is grounded
upon metalevel reflection, so proving that non-philosophy is actually
only "more philosophy." It avoids this trap because its explicitly posits
itself as performative rather than representational—it is not saying how
things really stand. As such, non-philosophy is *not* some form of higher-
order reflection, representation (of philosophy), or metaphilosophy.[56]
Non-philosophy as a practice never appeals to the "meta-," understood
as a transcendent form behind material practice. And that is also why
non-philosophy is always a *use* of philosophy.[57]

That said, non-philosophy *can* look very similar to philosophy on
account of an apparent "ventriloquism" of approach that utilizes the
discourse of philosophy in its own speech acts. It does indeed appear to
some as simply "more philosophy," be it in the adopted shape of Kantian,
Derridean, Deleuzian, or even Badiouian thought. This impression, ac-
cording to Laruelle, is itself the product of philosophical narcissism,
though, for philosophy cannot see anything other than itself in other
forms of thought. Hence, all of the non-philosophical strategies to *resist*
being taken as one more account of the Real (its avowed performativity
and materiality) *will themselves* be taken up by philosophy as only another
set of representations, and so as simply another philosophy (and, indeed, a
not very original one at that). Laruelle's posture, however, remains one that

endeavors to see all thought—*including its own*—as part of the Real rather than a picture of it. The posture alone is new, following the hypothesis, "what happens if thought is not a representation but a thing," with radical *self*-consistency. But, of course, nothing of logical necessity follows from this: one does not *have* to see non-philosophy as performative (nobody *has* to do anything of necessity). *This* description of Laruelle, too, is only an invitation or suggestion to adopt a similar posture.

THE STRUCTURE OF DECISION AND POSTURAL MUTATION

Philosophy, by contrast, is all about necessity: "In History—the World and 'the facts'—one finds a type of decision that is called necessary and more than necessary: it is called 'unavoidable' and christens itself 'philosophy.'"[58] Perhaps the most implausible aspect of Laruelle's approach to philosophical thought is also the most controversial trait of his depiction of philosophy, namely, this notion of "decision."[59] Though he admits that the term "Philosophy" *(la philosophie)* is a "highly ambiguous expression, as often multiple as it is one," and even that its history "bears witness to several ways of philosophizing," Laruelle still retains "the structure of Decision" as the one "invariant" of every philosophy.[60] Decision is philosophy's lowest common denominator, so to speak. Each and every philosophy involves a decision—specifically, *to explain or represent the Real in one exclusive way—its own.* Such a "sweeping statement," as Laruelle scholar Anthony Paul Smith recognizes, begs the question as to its universal applicability. Surely Laruelle homogenizes philosophy too much? Nonetheless, Smith defends this idea of decision on a number of grounds:

> It seems plausible since Laruelle has traced it within European philosophy's most radical philosophers (Spinoza, Hegel, Marx, Nietzsche, Heidegger, Derrida, Deleuze, Michel Henry, and Badiou, among others). Others who have taken up the task of non-philosophy have also located this structure in the thought of phenomenologists such as Husserl, Levinas, and Marion; in the philosophically influenced sociology of Pierre Bourdieu; in the antiphilosophies of Blanchot and Lacan; and stretching from the ancient philosophy of Plato to contemporary standard approaches to epistemology and aesthetics.[61]

Still, despite these corroborative remarks, one can imagine how most will only see this as a set of assertions rather than as evidence. Indeed, the continued resistance from many others to the structure of decision may well be due to the associated connotations of it apparently being an *intellectual* act: decision here would seem individualistic, voluntary, and conscious. Yet confirmation of the presence of such features in all philosophical thought is rare, to say the least. Additionally, a methodological individualism like this, if such be the case in non-philosophy, would itself be a very large presupposition on Laruelle's part. It could easily be countered by philosophies positing alternative sources for their position: radical encounter with the outside, fundamental existential choice, revelation, wonder, common sense, prayer, a gift... Moreover, from the perspective of the newcomer to non-philosophy, Laruelle's approach would then appear to be just one more position in a "game of positions," slugging it out with the other philosophies (and on a terrain of *their* making to boot). So much for a significantly new *kind* of thought.

Now, of course, there is more to decision than this depiction, something indeed more physical and even (as we will argue) "animal" that thereby retains a radicality otherwise lost when it is understood too intellectually and too anthropocentrically. For a start, decision does not itself *have* a metaphysical essence (as free, say, or conscious), for *it is precisely* the invariant position that "hallucinates" such essences in the Real. In the most basic terms, to "decide" is simply to cut oneself off from the Real, to make a cut—*decaedere* (*de-* "off" + *caedere* "cut"). To cut off, to de-cide. At second glance, then, there is in fact something quite spatial, even behavioral, about this game of positions. And, *qua* position, to decide also has something to do with "withdrawal." As Laruelle put it in an interview: "to philosophise on X is to withdraw from X; to take an essential distance from the term for which we will posit other terms."[62] Philosophy, understood as decisionistic *in this manner,* then, is a withdrawal, a distancing, a cutoff. It is this "distance" that allows it its sense of authority—to capture, to transcend, to represent things "objectively," "essentially," "fundamentally" (or with greatest intelligence, wisdom, logic, clarity, etc.). Regardless of whether the language incorporates any actual imagery of separation (detachment, spacing, horizontality, distanciation, spatialization, deterritorialization, or even logical space, the space of

reasons, etc.), when thought enters the phase-state of philosophy, it enters the position of distance and withdrawal.

This distance is also the "sufficiency of philosophy," which is entirely in philosophy's own "mind," or rather in its "auto-position." This sense of entitlement is a delusion because philosophy, like any other thought, is *necessarily insufficient*, a mere part. Philosophy is, however, the part that has wandered furthest and even takes its errancy as the power to see the Real with absolute clarity. What it sees is a hallucination, though: "I call *hallucinating*... every thought or vision which believes to see the real when it only sees the all; which believes to see the One when it sees Being. It is a hallucinating of the type: I think, therefore I am."[63] The hallucination itself, however, is a product of this "Distance," which, *because everything is immanent to the Real,* should also be understood as a product of the Real. Distance is a type of auto-exile from the Real by the Real that generates the duality of a philosophy *and* the Real: "the One or the Real is the cause and the object of the illusion," a "hallucination" that bases itself on a "unitary projection of the One and which, from the start, falls outside of that as the World itself."[64]

These initial remarks on distance, withdrawal, and position (which we will extend in chapter 3) also let us glimpse a further possibility: that of a *conversion* of withdrawal. Here is why. Laruelle's message for philosophy is, prima facie, simple: not everything is "philosophisable."[65] As soon as we gloss this message a little further, however, things become more nuanced: not everything is thinkable by *standard* philosophy. Or, even further, what counts as philosophy must mutate for some things to be philosophizable at all. If philosophy is to acknowledge the specific form of thinking indigenous to film, for instance, then it must mutate into "film-philosophy," that is, a new kind of audiovisual philosophy. Otherwise, cinematic thinking will be misunderstood as a covert form of extant, written philosophy (hidden somewhere within the textual components of some film dialogue and plot). The mutation of philosophy reflects a change in emphasis from the Real (of film) fitting the needs of philosophy to philosophy fitting the Real. We no longer have the concept of an "unconditioned" thought (philosophy) that limits phenomena (its "objects") but rather "the unconditional phenomenal itself determining and limiting thought." Or, again, whereas the philosopher wants to "fold the real onto his thought,"

non-philosophy "constrains us to do the opposite: fold our thought onto the real by modifying the concept in accordance with it."[66] So, where philosophy thinks of itself as self-sufficient, sui generis, immaterial, and transcendent, non-philosophy sees it as a dependent, material, immanent exile of the Real. *And this difference in emphasis can be translated into a change or conversion of direction.* According to Laruelle, its withdrawn position requires redirection: thought that *was* directed from philosophy to the Real, *when newly viewed non-philosophically,* inverts itself to being directed from the Real to philosophy. And it really is a change in direction or orientation: as Laruelle puts it himself, "my problem is that of the re-orientation of thought."[67] We might even say that the mutation reorients thought-*as-an-orientation.* However, in its claim to be a "radical inversion" of philosophy's relationship with the Real, non-philosophy aspires to more than merely *reversing* the relationship between the two, for that would leave the door open to an eventual counterreversal. Non-philosophy aims to *invert* the relationship fundamentally, with no subsequent volte-face.[68]

This reorientation or radical inversion is also the mutation that expands thought, and precisely because the mutation is ultimately determined by the Real rather than by a decision (philosophy). This is a "postural mutation," a change of vector or directionality that issues from the One, or, to be exact, from a "vision-in-One" and a democracy *in* thought (as we will explain further).[69] The philosophical decision, then, can be seen as either a determining, intellectual (disembodied) position or, through reorientation, as a bodily "posture" determined by the Real. As *Anti-Badiou* relates, the Real, or One, "is that of a posture, and is given as a lived-without-life or is felt through and through in the image where, however, it is never projected, as in a first image that would precede it."[70] This still fairly subtle idea deserves an extended quotation from Laruelle's *Philosophy and Non-Philosophy*:

> The One is a postural rather than decisional and positional identity. Here one must distinguish between the postural and the positional. The postural designates a holding not of self, but *in* self, the *how* this holding (is) held insofar as it has essentially never reposed except in itself. Posture is more subjective, corporeal and undivided than position; more internal, spontaneous and naive than will and decision. Posture is too immanent and

completed, it indivisibly involves the individual's entire being too much to reinstate a decision or make it equal to a "position," which is always relative to another position, always alienable and revocable, always to be taken up and taken back up. Hence one can describe the mode of thinking that "corresponds" with the One as nothing-but-One, as a postural and subjective experience of thought from the outset freed from the constraints of the World, from the codes of philosophy, from the norms of transcendent exteriority, from the rules of speculative figuration or the speculative imagination. In other words, it is necessary to distinguish the *figurative,* but also the *figural, relational* and *positional,* from the *postural,* but as the necessary kernel of reality that precedes them absolutely and instead constrains them to be distinguished from it as mediated by unreality.[71]

Rather than "will and decision" being understood through methodological individualism, "posture," for Laruelle, connotes something "more subjective, corporeal and undivided"—terms that are close approximates to immanence, as he understands it. He also puts it as follows in *En tant qu'un*: "postural 'mutations' [are] more profound still than changes of philosophy or of 'positions.'"[72] Just as position is not the same as posture, so mutation must be seen as more than simply change.

These key concepts of "posture," "position," and "mutation" will be analyzed fully in chapters 3 and 4, respectively. The first of these will need our special attention. There have only been a few discussions of posture within recent philosophical literature. John Schumacher's *Human Posture: The Nature of Inquiry* is a pertinent example, given that it describes how *"posture is the way a thing makes a place in the world,"* or how "to be in the world *is* to have a posture."[73] His study, which is primarily phenomenological, concentrates on the human, however, and especially the human face; though even here his description of the face as an orientation—a *facing*—is not without connection with Laruelle's more abstract concepts of withdrawal and distance:

> A human face, early or modern, introduces a kind of loosening from the world, making possible the reference of that face's orientation in the world to that face itself. . . . A modern human face is not only loosened from the world, but also, so it is said, broken apart from the world.[74]

Alternatively, Annette Baier's *Postures of the Mind*—despite its rather empiricist approach to "Mind and Morals"—actually comes closer to the abstracted, nonpsychological nature of Laruelle's enquiry. Taking her cue from a line in John Locke's *Essay,* she writes that

> Locke, realizing that at least some words did not name simple or complex ideas which themselves named atomic or molecular things, added a brief chapter on "particles" to Book Three of the *Essay Concerning Human Understanding,* and gave these little non-names such as *but* the job of indicating not ideas but "the actions of the mind relating to those ideas," and "the several postures of the mind in discoursing." . . . The following essays in the philosophy of mind and in ethics do try to direct attention away from the overcultivated field of single beliefs, intentions, and intentional actions to the individual abilities, social powers, continuing policies and purposes, virtues and vices they exhibit. A distrust of supposedly discrete events and entities, of Lockean nameables, is one pervasive theme. . . . I have tried to look at streams of developing and decaying beliefs and intentions, at changes of mind as well as decisions and realizations, and at assessment not just of single actions but of lives and of character, at moral style of life.[75]

Her nonintentionalist approach to beliefs—their formation, reformation, and decay—does not go much further into the concept of posture than this, but her one example of a Lockean posture of the mind, the nonname of "but," is salient, for as Locke writes, "All animals have sense, but a dog is an animal." Baier describes herself as a contrarian, *and so a philosopher,* which would point to the importance of "but" within philosophical postures, postures that Laruelle would more readily call "positions." To understand this "but" (and all its avatars in contradiction, *agonistics,* the dialectic, negation, polemic, etc.) in terms of behavior and even animality (nonhuman postures) will be one tack in our attempt to comprehend decision as positional (withdrawal, distance, separation). "But" we are not trying to form a genealogy, foundation, or truth of posture on Laruelle's behalf here. It is the *mutation* (or nonfoundation) of posture, its ongoing performativity, that distinguishes it from philosophical position. Keeping this in mind will help us to understand the meaning of "decision"

all the more, taking it further way from transcendent representation and closer to an immanent, physical, behavioral, and even nonhuman rendering.

We will also see how non-philosophy takes the decisional structure of philosophies and, using both art and science, clones or reperforms it such that, instead of a thought representing the Real in being cut off from it, we have a thought that performs the Real as a postural part of it. Inch by inch, we will see Laruelle's account of philosophy and decision shift from a seemingly personalized and judgmental "critique" closer to an impersonal descriptive science. To get us started, then, we need to know a little more about what Laruelle means by "science."

HYPOTHESES OF REAL SCIENCE

The first thing to understand about non-philosophy's self-image as a "science" (Laruelle often uses this title as an alternative name) is how *unscientistic* it is. It works through "axioms," "hypotheses," and "thought experiments," but they are not employed as a means, however indirect, to verify a thought. Rather, they are used to generate an experiment—and so *experience—in thinking*. Scientific verification, as one more authority, does not interest Laruelle: beyond any "truth" that has been "verified, validated," there is an "axiomatic form" of "the true" that allows "the transformation of the discourse of representation."[76] It is this axiomatic form (which can also be rendered as "posture") that really counts:

> even as a simple hypothesis, it [non-philosophy] must—this is our second demand—contribute to transforming the reality of philosophy and science, rather than just having knowledge of it. In effect, the hypothesis of non-philosophy can neither be empirically justified nor invalidated through comparison to experience; it must at least also transform experience.[77]

Hence, any appearance of scientism in Laruelle's work (as might be gleaned from its continual references to both general science and biology, geometry, and physics) is based on a false inference that being scientific, for him, is a form of authorization, of proof, of enlightenment. Yet Laruelle

never makes claims that even come close to biologism, mathematicism, or physicalism. All knowledges are equal, or "flat," vis-à-vis their discoveries:

> If philosophy has not been able to explore the nature and extent of flat thoughts, let us change our general hypothesis and horizon: science, a new science perhaps, shall be the guiding thread ... on condition that we globally re-evaluate and reveal the "thinking" at work in science.[78]

Indeed, rather than enlightenment, Laruelle is more interested in our experience of the *unproven*, the foreclosure of all thought, equally, before the Real. His is a "black universe," where everything is equally dark, and equalized by the dark.[79] All the same, Laruelle is not a proponent of an anti- or counter-Enlightenment either. This equality of color is actually scientific, but scientific in neither a heliocentric (Kantian) *nor* Ptolemaic orientation. There is no absolute sun, no center in science:

> If there is a real task of thought, it is instead in what is no longer completely a reversal and definitely not a Copernican reversal. To put science at the centre—and philosophy at the periphery? Not quite, for when science is really "at the centre," there is no longer centre or periphery. Nothing, not even philosophy, turns around it.[80]

Science decenters—it is an *activity* rather than a body of knowledge, a posture that continually unearths the foundations of authoritarian knowledge. Rather than one more variant of the Copernican revolution, Laruelle's project, he writes, is "to introduce into philosophy a *Lobachevskian and Riemannian mutation.*" This is a non-Euclidean extension of thought beyond the classical, Greek experience of *identity,* as well as the Jewish countermovement of *difference,* which is really only a reversal rather than a genuine inversion.[81] Such mutations are in fact the hallmark of *both* "the sciences and the arts—above all painting and music"—in the twentieth century, and yet they have bypassed philosophy for all this period, which has remained mostly stuck in the sterile to-and-fro of the Greco-Judiac dyad (identity and difference): "this is why non-philosophy will discover in these scientific and artistic mutations if not its *raison d'être,* then at least its strongest encouragement."[82] Science *and* art, as experimental, mutational thoughts, can redeem philosophy from its stagnant authoritarianism:

How do we equalize philosophy and science, philosophy and art, philosophy and ethics outside of every hierarchy and its last avatar (anarchist and nihilist leveling)? ... This is to universalize them within the common layer of an a priori of a new style, rendering regional knowings more universal than they spontaneously are, or rendering them co-extensive with philosophy; and rendering philosophy more empirical than it now is.[83]

Indeed, this study, using a cinematic model of thought, is one attempt at such a mutation, a "regional knowledge" made "co-extensive with philosophy" while also "rendering philosophy more empirical."

That said, such experimentalism must not be subsumed within a philosophical paradigm of *epistemology* either: these hypotheses are *posed as* Real. We might say that axioms and hypotheses are real "postures," poses of the Real, but not according to any philosophical "position" of realism. As Laruelle admits in a recent interview:

> I look for the Real without being a realist, for materiality without being a materialist, the physical nature of generic man without naturalism. All of these philosophical positions want to obliterate the Real through reality; materiality through materialism; physical nature by naturalism.[84]

In contrast to the inveterate idealism of philosophy (which refracts the Real through its own ideas, be they metaphysical, critical, or even materialist), non-philosophy attempts to be "ultra-realist," though without any relation to philosophical realism. "Realism" remains a *position*—one more definition of the Real.[85] The language of non-philosophy—the "transcendental," "a priori," "thought," even the "Real"—is harvested from philosophical definitions, of course, but it is then reoriented *as* Real materials rather than ideas *about* the Real. The Real itself is left undefined, indifferent, nonrelational—though these negatives here are not dialectical (and so reversible) on account of a positive identity that allows each philosophical position an equal standing. Here real identity and multiplicity are no longer mutually exclusive. The "One" is not a numeral.[86] Moreover, the "foreclosure" of the Real to philosophical capture and definition does not mean it is ineffable but that it is multiply, equally, sayable. As Anthony Paul Smith and Nicola Rubczak phrase it: "the Real cannot be captured by philosophy, but instead authorizes the equivalency of all philosophies,

all knowings, as relative before the Real. Or, in other words, the Real is not ineffable, but infinitely effable."[87]

One of the myriad ways through which the Real appears to be "known," however, does have a special status for Laruelle—the way through what he often simply calls "Man" or "man-in-person": "Man," Laruelle writes, "is precisely the Real foreclosed to philosophy"; or "I say that Man is the Real, that we are the Real."[88] However, this Man is not an object of knowledge, at least not of the sort acquired through a philosophical position. As we will see, it is a Real identity.

ANTHROPOMORPHISM AND EXTENDED THINKING

Despite all of its protestations to the contrary, to many readers non-philosophy still seems idealist, and hence philosophical, in virtue of this nomination of the Real as "Man" or "human" (Laruelle uses each term interchangeably with the other). As Ray Brassier writes, the "privi-leging of the nomenclature 'man' to designate the real cannot but re-phenomenologize and re-substantialize its radical in-consistency."[89] Ian James echoes Brassier's point and also questions Laruelle's apparent con-tradiction in humanizing the Real while also declaring not to define it.[90] So what exactly is Laruelle doing with such a humanization? Smith and Rubczak, conversely, offer a positive interpretation of the issue:

> what we find here is not typical philosophical humanism, represented in everyday culture as a privileging of some claimed universal human being that is in reality taken as a hetero-normative, white, healthy male. But instead the question of the human is open in non-philosophy, even as the human or what he comes to call Human-in-person is also the name of the Real. It is not the Real that is impersonal, but rather the Real is foreclosed to philosophy, represented not in some anti-humanist hatred or indifference towards human beings, but in the maxim that, "Philosophy was made for man, not man for philosophy."[91]

Indeed, this apparent anthropomorphism of the Real actually lies at the heart of non-philosophical research (and therefore this study). It is not only central on account of its endeavor to reorient thought—from going

from philosophy to the Real to going from the Real to philosophy—but also on account of the maxim that Smith and Rubczak refer to earlier, which actually accompanies this shift. We should note that, while individual philosophies are not *epistemically* judged by Laruelle (they are rendered positional and equal), philosophy *as a structure of decision* is *ethically* judged on account of its deleterious effects on the human. Hence, the non-philosophical maxim is that philosophy should be made for the human rather than (as is the case in standard philosophical thought) that the human be made for philosophy: "we must change hypothesis and even paradigm: break up the mixtures, found philosophy on man rather than the inverse."[92] Man has been described, defined, categorized, quantified, and normalized by philosophy since its beginning, and it is the task of non-philosophy to invert this mediation of the human through philosophy.

This double reidentification of both the human and the Real over philosophy carries with it this new identity of the Real with the human. But with that we also have two opposed "subspecies" of anthropomorphism: alongside the idealizations of man through philosophy (the human modeled on philosophical anthropology—what we will call "philosomorphism" in chapter 4), there is the Laruellean inversion that realizes man through non-philosophy. This realization (or de-idealization) does not *define* man, however, but simply subtracts two and a half millennia of philosophical mediation (exploitation, harassment, racism, sexism, inequalities of all kinds) from the image of the human. Doing so, as we will see, leads to peculiar results, not least that what man is, is rendered wholly indefinite. Man also becomes, in a specifically Laruellean sense, nonhuman and utopian.

Here, then, anthropomorphism—the transformation of animals and inanimate objects into an image of the human—is reframed by this new, more radical form that equates the human and the Real. This rearticulation is not without connection with traditional analyses of anthropomorphism, though, as we can see in what Lorraine Daston and Gregg Mitman say here:

> "anthropomorphism" is the word used to describe the belief that animals are essentially like humans, and it is usually applied as a term of reproach, both intellectual and moral. Originally, the word referred to the attribution of human form to gods, forbidden by several religions as blasphemous.

Something of the religious taboo still clings to secular, modern instances of anthropomorphism, even if it is animals rather than divinities that are being humanized.[93]

What religion forbids the "heresy" of non-philosophy performs. In this secular, *affirmative* anthropomorphism, however, identifying the human with the Real allows the human image to be multiplied as a consequence (without any definition, nor synthesis of definitions). *Anthropos* is altered too, morphed, not on account of philosophical difference (Deleuzian becoming, Derridean deconstruction, Lévinasian alterity), but because, as Real, man is indifferent to any one image. "We" do not *know* what the human is because we *are* already human *before* philosophy. Answering, or not answering, the question of who "we" are, then, is itself a problem for non-philosophy. As Rocco Gangle asks, "are these two terms *human* and *philosophy* co-penetrating and reciprocally determined or are they definitively separate?"[94] Laruelle thinks of this question as follows, here using the more abstract nomination "individual":

Individuals are not philosophisable nor liable to an All-political treatment; they are no longer subjects; they have no predicate and are thus politically indefinable and undecidable. We "define" them indirectly through axioms which decide for individuals since political philosophy is incapable of doing so. With respect to philosophy, emancipation begins with a thought free of every predicate; with those individuals who are nothing other than real, and not formal, axioms. These are subjects-without-predicates, individuals without qualities or properties, which we call "Men-in-person."[95]

These subjects-without-predicates might put us in mind of Sartrean humanism: the subject as a predicateless nothing, a *poursoi* with no essence, only existence. Yet even attaching nothing to the individual is already too philosophical for Laruelle: any definite decision always bears potentially catastrophic consequences for humans.

The question of the human, then, is central to Laruelle's new style of thought and vital to its reorientation, its new posture. The non-philosophical human, as we will argue throughout this work, is some-

thing nonanthropological, perhaps even nonhuman. Equating the Real with Man is itself a gesture in this direction, an anthropomorphic posture that leaves both the Real and the human indefinite. And so we intend to demonstrate that such humanization is, in fact, a radical anthropomorphism, that is, a reorientation of *both* what the human and the Real entail, along with what counts as human thought and human philosophy, each of these receiving a nonstandard treatment. And with that, therefore, just as the *non-* of *non-philosophy* is not a negation but a broadening of our vision of philosophy, so a Laruellean nonhuman-ism is not a negation of "man" (posthumanism, antihumanism) but an expansive mutation—an alter-humanism or pluri-humanism that reverses the narrowing action of philosophy that always limits the human according to a single model.

One component of this posture of expansive "indefinition" and mutation involves reconfiguring what we mean by *Homo sapiens* as the thinking, "wise" animal. Doubtless *philosophia,* the love of wisdom, would be happy to aid us in this and all other matters involving the classification of "Man," which is presumably one reason why Laruelle describes the "philosopher," sarcastically, of course, as "the human par excellence in speaking, knowing, acting."[96] The contrast, by implication, is with the imperfect, unwise animal, that is, with the non-philosophical individual (at least as seen from the philosophical vantage point). This is precisely why Laruelle does not ask for philosophy's help. Quite the contrary: dephilosophizing the human is what is needed most.

This duality of apparent wisdom and ignorance affords us a new, starker formulation of Laruelle's project—"how to elaborate an outside-philosophy thought?"[97] At one still recognizably human and even philosophical level, the elaboration of such an "outsider thought," or *philosophie brute,* requires a kind of unlearning:

> the Real is an *unlearned knowledge,* rather than a "learned ignorance." Unlearned means that it is neither an expert knowledge nor a taught knowledge. It is non-taught knowledge, it gives its unilateral identity to a subject.[98]

Admittedly, the commendation of *any* form of ignorance (even as a Keatsian "negative capability" or a stupidity) can strike some as churlish

and even duplicitous.[99] Certainly Laruelle finds Deleuze's own theory of stupidity (in *Difference and Repetition*) a rather disingenuous move. Despite its being offered in place of the standard image of error in representationalist philosophy,

> we find here once again, under the mitigated form of an unlimited becoming, the distinction between man and philosopher, their hierarchy in spite of all: the philosopher who constructs the system and the idiot whom he talks about and who doubtless stumbles through the windings of the system do not adequately coincide. Once again the philosopher does not really want idiocy, he limits it.[100]

Merely playing the idiot will not suffice: if there is anything like a "transcendental idiot" who is not merely a philosopher's stooge, then he, she, or it will exist in a much more postural, bodily manner. Indeed, at another level, non-philosophical "unlearning" involves something more radical again, the idea (to be explored further) that

> thought is not the intrinsic property of humans that must serve to define their essence, an essence that would then indeed be "local"; it is a universal milieu. If we tend now to emphasise animality, bringing it within the sphere of culture, then why not emphasise the most elevated humanity, so as to bring it into the universe; and, through a paradoxical example, why not reexamine its links with animality, of which it will then be a matter of knowing whether it, also, is universal?[101]

With respect to the human and this animality, Laruelle goes so far as to say that "thought is not necessary—and perhaps even foreign—to the Ego itself which can be *given* without thought."[102] That is why non-philosophy is also nonhuman.

A FILM OF PHILOSOPHY: *THE FIVE OBSTRUCTIONS*

To introduce non-philosophy in the spirit of consistency, we have made it our goal to think about it *non-philosophically*. If we are going to have any chance of success in this, we will have to acknowledge two things: first, the

importance of extraphilosophical materials as models for non-philosophy's modes of thought—what Laruelle describes as "techniques of creation that would be pictorial, poetic, musical, architectural, informational, etc."— even though we know that what counts as "extraphilosophical" is itself as mutable as philosophy, being determined differently within each "game of positions"; second, the constant threat of reducing non-philosophy to a set of tenets understood through extant forms of philosophical explanation.[103] Indeed, in respect to this last item, Rocco Gangle has pointed out that introducing non-philosophy is particularly challenging given that there is "a distinctive 'pedagogical' or 'initiatory' problem built into the very fabric of non-philosophy."[104] Likewise, Taylor Adkins openly admits that any "proper" introduction to Laruelle "*is an illusion.*"[105] The slow reception of Laruelle's work thus far has, no doubt, some connection to this problem of "initiation," that is, the difficulty of explaining its highly unorthodox approach. As Andrew Reszitnyk also bemoans:

> Laruelle and his commentators—myself included—often encounter great difficulty when writing about non-philosophy. The injunction to gener-ate self-conscious fictions, as opposed to treatises that pretend to some privileged view of reality, demands that we alter not only *what* we write, but also and especially *how* we write.... However, it must be acknowledged that the results of this attempt are decidedly mixed. Laruelle often writes as though he comes from another world, replete with its own foreign and radically abstract standards of truth, clarity, and beauty.[106]

In fact, in an interview for a volume on art and non-philosophy, Laruelle reflects on the "failure" of his work, partly in terms of both its style and its lack of examples and citations. He explains this absence as follows: "I don't talk about the great metaphysical poets like Donne, Hölderlin, and Mallarmé, who have been the consistent prey of philosophical com-mentaries; my project is different. I'm not that kind of commentator and perhaps that's why I've failed."[107] The mention of failure is connected to this lack of citations, as he then continues to explain:

> Just as I cite very few other philosophers (except as floating markers in my dream) and never cite myself at all, I do not cite applied work,

much preferring a certain type of paraphrase that is a destruction of commentary.... Rightly or wrongly, and I admit that it may be wrongly, if it is necessary to cite an aesthetician, I try to do so in such a way that I use just a strictly circumscribed piece or moment in my work. What I write is a sample, not an example, of what I do when I think. To think is to make, no?[108]

Thinking is making: it is not "of" the Real—its ideal representation—but a material part or sample *from* it. We think "according to" or "alongside" the Real. And if making is a thinking, it is of its *own kind* (rather than an illustration of one philosophical kind).

Such questions of art and failure bring us back to the issue of how one should introduce Laruelle when performative consistency—doing what one says and saying what one does—is so important. How do we assess Laruelle faithfully, that is, without "representing" him? Our response, modeled on Laruelle's own methods, will involve art. In point of fact, when speaking about his more "experimental texts" in another interview, Laruelle recounted his ongoing project to "treat philosophy as a material, and thus also as a materiality—without preoccupying oneself with the aims of philosophy, of its dignity, of its quasi-theological ends, of philosophical virtues, wisdom etc." And he then adds: "what interests me is philosophy as the material for an art, at the limit, an art."[109] Yet, what is true of his "experimental texts" (that aim for art) is also true of all Laruelle's works inasmuch as they partake in this experiment: to demonstrate a new "behavior," "stance," or "posture" as regards what philosophy is—both as a material and how it can be reviewed using art practices, such as photography (as outlined in his *The Concept of Non-Photography* and *Photo-Fiction*) or music.[110] So, in *Anti-Badiou*, for instance, non-philosophy's "initial project" was, he says, to "*serialize the standard tonality of the philosophical scale*— to treat all of its pitches equally, as parameters or variables, so as to make heard a music other than the classical."[111] Elsewhere, he describes such an approach as being "a question of imagining in this way a 'non-informatics' or a 'non-poetry,' etc. and thus of capitalizing on the maximum effects of the type: poetry-fiction, logic-fiction, religion-fiction, etc."[112]

A reorientation of philosophy through art-material, then, can be seen in Laruelle's call for a "non-standard aesthetics," which is described as

"an 'installation' made up of multiple thought materials which are made at the edge of art and philosophy."[113] In this connection, he also writes that he would

> like to use philosophy as a material (as one would use space or color, as a materiality) for an art that would be of a piece with conceptual thought without making a new aesthetic or a new philosophy. The ambition of creating a new genre is the deepest consistent core of all my undertakings.[114]

And so, pausing at this point of convergence between non-philosophy and art, we are emboldened to take an extraphilosophical, indirect or *tangential* approach. This will use a visual art form (cinema) to perform a *non-philosophical* introduction. If what Laruelle says is true, namely, that "the model of art and of its liberty of material is something that encouraged me in non-philosophy," then such an approach may work well for us too.[115]

Indeed, in my previous work, *Philosophy and the Moving Image: Refractions of Reality* (a study of different philosophies of cinema), I began to adopt the non-philosophical posture by showing how to understand theories of film as material parts of the Real of film (i.e., as immanent to it).[116] Each theory, qua part, was related to film mereologically rather than in epistemic terms of right (absolutism) or wrong (traditional relativism). In other words, I argued that if one materializes theory itself, then there is no point in looking for one transcendent discourse that will somehow have a privileged access to film (such as cognitive neuroscience, Lacanian psychoanalysis, or Deleuzian ontology). Each discourse is both selective and circular (as regards the properties of film that make it an "art"). Materializing theory in this fashion shows each theory to be only a part and, by that, democratically opens up each part to every other part within the Real of film.

Nonetheless, the exegetical form of that text still, perhaps, resembled the *written* Laruellean form too closely such that it might have been taken as an application of his "theory" in a transcendent manner. To develop a non-philosophical approach directly from the structure of film itself, albeit still of necessity communicated in textual form, would be another step toward a more autonomous film-philosophy that moves even further away

from resembling (standard) philosophy. And so I have decided, with both some justification and some arbitrariness, to utilize one particular film structure, that of Lars von Trier's *De fem bensptend* (*The Five Obstructions*, 2003).[117] This will be an attempt at making a "Film of Philosophy" rather than a "Philosophy of Film."[118] *The Five Obstructions* will be neither an application nor an illustration of (Laruelle's) non-philosophy but *its own non-philosophy*, though one that also operates here as a non-philosophical "introduction," that which "leads to the inside" *(intro-ducere)* of Laruelle. So, *The Five Obstructions*, when it does intervene in each chapter, will come in a series a *tangents* alone, rather than a *direct* address (where "this" equals "that"). Its various appearances will "touch" on matters concerning Laruelle (philosophy, logic, behavior, animality, and performance), of course, but also on its own matter, the film itself, *for itself* (the documentary gaze, editing, acting, animation, and performativity). Here is where we hope the film becomes a posture that thinks *alongside* the other discussions *in the same way* that it and Laruelle's work both think alongside the Real.[119]

The two most salient aspects (for our purposes) of *The Five Obstructions* are, first, its peculiar composition and, second, that it is a collaborative work. *The Five Obstructions* is made up of five remakes of an original work by another filmmaker—Jørgen Leth. Leth (born, like Laruelle, in 1937) is a mentor of von Trier, yet it is he who is under von Trier's command in this picture, having to remake sequences from his own first film (a 1967 short) five times, each with an obstruction or "creative constraint." The constraints are as follows: (1) that it be remade with no shot longer than twelve frames, (2) that it be remade in the most miserable place on earth, (3) that it be remade with *no* constraint (a form of metaobstruction), (4) that it be remade as a cartoon (*the* definition of a nonfilm for both von Trier and Leth), and finally, (5) that von Trier makes the fifth remake, though it must be both credited to and narrated by Leth. Mette Hjort gives us the background to this strange game being played between the two:

> The idea of undertaking a collaborative project was first discussed by von Trier and Leth during the celebratory launch of a new Zentropa subsidiary devoted to nonfiction filmmaking, Zentropa Real. As is the case with many of von Trier's initiatives, the establishing of Zentropa Real in 2000 was marked by manifesto-like statements, in this case not only by von

Trier himself, but also by Leth, Børge Høst, and Toger Seidenfaden. Von Trier's pronouncements introduce a concept of "defocus," the point being to learn how to set aside "simple patterns," "solutions chosen in advance," and routine "techniques" in order somehow to reach and rediscover life that has not, as the director puts it, been "drain[ed of] life."[120]

The Five Obstructions, consequently, is a work whose very form explores a number of issues, but especially those concerning aesthetic creativity and generative constraint. Indeed, many of the obstacles that von Trier puts in front of Leth are designed to thwart "the latter's artistic habits and routines," such as his penchant for the long take.[121] No wonder, then, that Hector Rodriguez has described the film as a "model for creativity as ludic action" and a "work of thinking as problematising."[122]

In our study, we will introduce Laruelle *tangentially* via this same constrained approach, multiplying images of non-philosophy according to a fivefold cinematic structure. Non-philosophy will thus be *forced* through five different entryways—beginning, ironically, with the most perspicuous one, philosophy (chapter 1), before continuing through paraconsistent logic (chapter 2), behaviorism (chapter 3), animality (chapter 4), and performance (chapter 5). The arrangement of these five chapters is to some extent arbitrary, stemming from the structure of a film with passing resemblances to Laruelle's work (as will be seen).[123] A more "direct" motive for our choice of *this* film is that von Trier's obstructions can also be taken as five forms of non-philosophical thought in its own right, tackling questions of (1) *philosophy* understood as the dystopian "worst place" that exploits the Human, (2) *paraconsistent logic* that equalizes all shots into a democratic frame rate (a kind of visual serialism) while also leveling truth and fiction in a Meinongian "jungle" or *"chôra,"* (3) a radical (non-philosophical) *behaviorism* seen in the basic remake without constraint that tries to *clone* or mime an original through gesture and posture alone, (4) the cartoon or animation that *animalizes* the optical real, and (5) the misattributed commentary whereby the author plays the subject in an act of *performative consistency.*

Last, *The Five Obstructions* also suggested itself on account of the subject matter of Leth's original 1967 short film, titled *Det perfekte menneske* (The perfect human). That Leth and his protégé von Trier—both

oftentimes working in various forms of the realist tradition (documentary and Dogme 95 film)—should use this short film, which studies, with much humor, the behavior of the supposedly "perfect human," raised many questions too tantalizing to resist asking. Krista Geneviève Lynes describes the film thus:

> Although the film has been described as having the cool aesthetic of Richard Avedon, it also insinuates other histories: the stark discipline of Eadweard Muybridge or Etienne-Jules Marey, and Alphonse Bertillon's physiological dissections. In it, Claus Nissen—dressed in a tuxedo—and Maiken Algren—in a white dress with radiant silver knee-high boots—perform daily activities in a white spaceless room: shaving, eating, jumping, sleeping, making love, falling, getting dressed and dancing.[124]

In *The Perfect Human,* various human behaviors are observed, often in close-up, dissected from the whole. They are sometimes ordinary and sometimes surreal actions, but all are viewed with the same supposedly transcendent camera's eye, accompanied by the narrator's detached voice:

> Yes, there he is! Who is he? What can he do? What does he want? Why does he move like that? How does he move like that? Look at him. Look at him now. And now, and now. Look at him all the time.
> How does she lie down? Like that.
> We're going to see what the perfect human looks like and what it can do.

Yet, as Caroline Bainbridge points out, "the 'obstructions' imposed by von Trier have as their focus an attempt to undo Leth's pursuit of 'masterful' observations of human nature and to dismantle his approach to filmmaking systematically in the hope of breaking him down."[125] He wishes, von Trier says, to reduce the objective "distance" that Leth (like many documentary makers) places between himself, his camera, and his subject. Nonetheless, despite all of these rules and constraints, it only *seems* that von Trier is in command.[126] As Bainbridge continues: "while, on the surface, von Trier appears to be in control, issuing the obstructions and formulating the challenges, Leth resists his adversary's attempt to re-shape his working methods and ultimately comes off more successfully at the

end of the film."[127] Who is in control, who is the authority in this game of "originals" and remakes, is very much the question that animates the whole documentary.

Indeed, as Lynes observes, von Trier's realist tendencies, from his Dogme 95 period onward, have always eschewed the director's usual "aesthetic" interventions in favor of a search for some kind of *non*-artistic truth (almost in the style of performance artist Allan Kaprow). In support of this, she cites the final proclamation that follows Dogme 95's famous "vow of chastity"—made by von Trier and Thomas Vinterberg:

> I am no longer an artist. I swear to refrain from creating a "work." . . . My supreme goal is to force the truth out of my characters and settings. I swear to do so by all the means available and at the cost of any good taste and any aesthetic considerations. Thus, I make my vow of chastity.[128]

The parallel between this nonartistic, noncinematic filmmaking and Laruelle's non-philosophical aspirations is obvious (perhaps too much so). Von Trier has been described as the "great democratiser of cinema in the digital age," and likewise, we will try to show that cinema in various forms—not just that of the art house—can act on the margins of perception to create a democratizing perception (André Bazin's neorealist notion of the objective, yet *democratic,* perception of the camera lens will aid us in this task later).[129]

It is ironic, then, that von Trier regards *The Perfect Human* as a pinnacle of *artistic* achievement (he says he has viewed it at least twenty times). Indeed, such a position might give both the film and its human subject matter a Platonic perfection and thereby render it classically philosophical (in Laruellean terms). And yet *The Perfect Human* itself clearly subverts both its own form and content with its overt pseudoscientific style, while von Trier subsequently subverts Leth's film (or so it seems) through these multiple clones. In light of this, there may equally be an anti-Platonism at work here. Significantly, Leth's allegedly detached eye, that of the nonparticipatory and "modest" observer, is thwarted in various ways by von Trier. As Lynes asserts, "*The Five Obstructions* perverts this modesty: the ventriloquising relay of modest witnessing involves not only

speaking for but also penetrating the body of the other, a puppet act."[130]

If we, then, in our turn are explicitly trying to ventriloquize Laruelle—through the materials of philosophy, logic, behaviorism, animality, and performance studies—then the added constraint of forcing the structure of one film onto this parallelism acts both to help and to hinder us even more. Yet it is not added gratuitously *in order to* make some kind of "romantic" gesture of failure; on the contrary, it is an attempt to allow a further perversion such that, *all the same,* the parts can *still* "refer" or "correspond" to each other. As promised, this will not be on account of some crude one-to-one correlation, with one side "illustrating" or "applying" the other (specific ideas and specific scenes, images, elements of dialogue, etc.). Nor can it even be in virtue of some isomorphism in structure (which is there, to be sure, because I have both discovered *and* invented it). If the parts do somehow work in parallel, we should refrain from seeing this as the "cleverness" of the author–artist at work (the human philosopher). Instead, and to adopt another pose, the suggestion is that *anything* viewed with sufficient care (the *act, practice,* or *performance* of a vision-in-One) can be thoughtful, can correspond to another part of the One, when each is seen as equally Real. This is because thought itself is not representation (true, false, or relative) but a form of democratic, material participation. Obstructions and constraints should be thought of here as positive rather than as negative or contradictory. We have no intention to romanticize failure.[131]

THE HORROR *OF* THE NONHUMAN

Some philosophers may not like such an interdisciplinary approach. For some, it is quite horrifying to see philosophical concepts ooze, flow, and mutate out of all recognizable shape. Yet, if philosophy begins in *thaumazein* (wonder), as Plato's *Theaetetus* and Aristotle's *Metaphysics* say it does, is it surprising, then, that *thaumazein* can also mean "horror" *(deinon)*? So what of this wonder, and horror? Perhaps (for some) it is the horror that philosophy *itself,* that is, *the* model of thought (allegedly), may not be singular at all but multiple. It is the horror of finding thought among those who have either always been previously regarded as *unthinking* or, if they can think, only do so *monstrously.* Indeed, according to David

Bollert, *deinon* can refer to both a "wonder with respect to a human being and to that which is monstrous in humanity."[132]

One of those monstrosities, we will argue, is cinema, understood as a monstrous, "animal" thought within the "human." Cinema thinks, monstrously. Indeed, as Eric Dufour has shown, cinema began in horror when, in 1895, an inanimate background image came alive and plunged into the foreground *(L'Arrivée d'un train en gare de La Ciotat)*.[133] In what follows, we will pursue this horror of animation even further, seeing a monstrous thought and even a possible animal philosophy at work in film. Again, be it taken as art, entertainment, or both, that cinema might think for itself and in its own audiovisual structure (taken here as shot length, foreground and background structure, recording format, animation, and performance) will be anathema for many philosophers. For these, film can only think by proxy of the human artists who make it, be they philosophers *manqué* or no. It is truly nauseating for them to see philosophy slip away from its textual, human hands into the paws of something inhuman, especially when cinema is understood as an animal mode of perception.

However, if we use a cinematic structure to introduce Laruelle, it is not *in order* to summon up only the allied horror of a certain nonhuman animation and animality within "us" (after all, for some, the response may equally be of wonder and even joy). Rather, this resort to film is ultimately only so that we might "give up deciding on philosophy philosophically," as Laruelle says.[134] To have any chance of avoiding the circularity of philosophical explanation, we must take the various tautological definitions of Philosophy, the Human, and the Real *and use them as materials.* And we attempt this by treating their thought paraconsistently, behaviorally, animalistically, and performatively, in accordance with what Laruelle describes as *"heterophilosophical treatments of philosophy."*[135] Admittedly, some of what follows may well appear as simply more philosophy (and so not very radical). However, if one looks at this usage *as a practice that performs its theory*—doing what we say and saying what we do—then it promises something quite different: a nonhuman posture for human thought. For *this* is what makes non-philosophy different: it is not another sales pitch for one more philosophical position but the suggestion of a posture that has consequences—through a materiality of thought—for "human" and "animal" alike.

However, in none of this should we be tempted to see Laruelle as an *antihuman* thinker. Indeed, non-philosophy can add much to debates concerning humanism and antihumanism, partially because its approach is uncategorizable for both camps. And here is another point of contact inasmuch as the more recent paradigms of "posthumanism" and "transhumanism" have pushed the field beyond the shibboleths of post-Althusserian antihumanism. Now the question is no longer simply whether one is for or against humanism (and what it putatively stands for) but whether we have ever known what it means to be human, or, further still, whether we have ever been human. Using the resources of hard science, theoretical speculation, and artistic invention, what the word *human* means has been interrogated from every angle. Recent art, technofantasy (both dystopian and utopian), performance work (Stelarc, Orlan, Franko B.), and various artistic experiments have exploded any one definition of the human, pluralizing and/or dissolving its scope. In the field of theory, work by Cary Wolfe, Neil Badmington, Steve Fuller, Rosi Braidotti, Patricia MacCormack, and many others has refracted the image of *anthropos* through philosophy, biopolitics, bioscience, technology, futurism, and, crucially, animal studies.[136] Aside from the "deconstruction" of the human subject as a sociopolitical myth, the "becoming-molecular" of Deleuze and Guattari, or the "bare life" of Agamben's "anthropological machines," the extension of the human in thought and technology (robotics, informatics, and art), also continues apace.

At the most obvious level, Laruelle brings something "metatheoretical" to this discourse. To see why, let us take the problem of circularity as an example. Philosophy is plagued by circles, the broadest one probably being the antinomy of ontological primacy versus epistemological primacy (being vs. knowing): "to (really) know, one must already know *reality*; but to know reality, one must already really *know*." Variations of such antinomies, dilemmas, and even trilemmas abound: Heidegger argues for ontology over logic; Dummet argues for logic over metaphysics; Lévinas "argues" for ethics over both, and so on. And each demonstrates his case perfectly well, so long as one adheres to *his* idea of what a good demonstration does, or does not, look like (can it use examples, or logic, or poetry?). Each of them, in other words, forms a circle. Laruelle's non-philosophical response to these aporias is *not* to step into their demonstration, be it on one side or the other, but to sidestep it altogether through a materializing posture.

This is what he calls, in *Principles of Non-Philosophy,* "the principle of a *real solution* to antinomies."[137] Aporias are realized rather than surrendered to nihilistically or explained away synthetically:

> Theoretically using an antinomy, explaining it in an immanent manner, is to require an identity-without-synthesis, a transcendental identity of a "unilateral duality," capable of explaining it. . . . The true "solution" to philosophical antinomies, under whatever form they present themselves, does not consist in interiorizing them or imploding them, but in making them into a *problem* regarding which we discover a hypothesis that is at once a priori and experimental and designed to explain and critique them in an immanent manner.[138]

With this realizing method to hand, then, we arrive at another basic antinomy, and circularity, for philosophy: that of man and animal. The approach we will adopt takes the various philosophies of the human and the nonhuman as real objects, irrespective of whether they are speciesist, chauvinistic. They are examined to see how they work, how they remain always *too* "philosophical" (with circular arguments as to what thought is, what the human is, what the environment is, what the animal or plant is, and so on). This approach does not aim to displace any of these ideas with new, superior philosophies (of human and nonhuman) but to change *our relevant optical field* (with cinema to aid us). We will attempt to see these philosophies as Real in virtue of their material equality rather than their "representational" superiority (i.e., the claim by any one of them to account for things correctly). The Real of man or of animal is never defined but revisioned (through the materiality of these philosophies) in such a way that allows us to think anew (monstrously or mutationally) "*about*" what it is to have supposedly superior thoughts "*about*" what makes us superior or inferior as a species and as thinkers. And doing this, *doing what we say we do,* is forwarded as one type of bridge between man and animal, a materializing of theory–practice that animalizes thought as well as humanizing animality. As such, it will be one attempt to enact Cary Wolfe's commendation to posthumanist animal theorists not only to study animals at the level of "content, thematics, and the object of knowledge" but also at the level of style and approach:

Just because we direct our attention to the study of nonhuman animals, and even if we do so with the aim of exposing how they have been misunderstood and exploited, that does not mean that we are not continuing to be humanist—and therefore, by definition, anthropocentric. Indeed, one of the hallmarks of humanism—and even more specifically that kind of humanism called liberalism—is its penchant for that kind of pluralism, in which the sphere of attention and consideration (intellectual or ethical) is broadened and extended to previously marginalized groups, but without in the least destabilizing or throwing into radical question the schema of the human who undertakes such pluralization. In that event, pluralism becomes *incorporation,* and the projects of humanism (intellectually) and liberalism (politically) are extended, and indeed extended in a rather classic sort of way.[139]

The pluralism that admits the outsider *without* letting itself mutate as a consequence is no pluralism at all but an imperialism of thought. Here instead, we hope, not only is Laruelle's non-philosophy introduced as something strange and nonclassical but the nonhuman Real is introduced, or reintroduced, into "our" thought as well through a change of orientation within a non-philosophical practice.

OUTLINE OF A STRUCTURE, WITH TANGENTS

When recounting his intellectual biography, Laruelle mentions that his first university thesis—titled "The Absence of Being"—was inspired by Michelangelo Antonioni's film *La Notte* (1961). That the equalizing dark night (as opposed to the enlightening of philosophy) has subsequently been such a theme in his work is a choice morsel for any film-philosopher. That this philosophy thesis involved a renunciation of the greatest systematizer and "Absolute" thinker in philosophical history, G. W. F. Hegel, doubtlessly leaves my motive for making a film of non-philosophy (as a usurpation of philosophical sufficiency) all too transparent.[140] Yet the chosen film, *The Five Obstructions,* remains only *a* model for introducing Laruelle. For what matters most in any recounting, if only to be faithful to or consistent with the Real of Laruelle's non-philosophy, is that there is always a plurality of other accounts possible. There is no "best picture"

of the Real—nor then, to be consistent, any best picture of nonstandard philosophy. As Laruelle writes, *"for whichever phenomenon, one should be able to propose a multiplicity of equivalent interpretations."*[141] The model offered here, though it has a pentalateral shape, and so has five half-lives or chances of success, remains one model all the same. For Laruelle, by contrast, there are "multiple activities of modeling between philosophy and science, philosophy and art, leading all the way to risking a *modelist explosion.*"[142] In a finite book such as this, however, the reality of such an explosion cannot be accommodated (though the logical consequences of embracing such devices will be explored in chapter 2).

Another option, no doubt, would be to advance an explicitly *philosophical* introduction to non-philosophy—one that either explains its terminology in terms of its other parts or that uses another philosophy's (more familiar) terminology. Yet that merely staves off our ignorance a little longer or palms the explanation whole until it reaches a point where it is preaching to the converted (devotees of Kant, Husserl, etc.). Nonetheless, *both* would be types of explanatory circle, one narrow, the other broad (the radius of the latter being sufficiently large that its circumference is almost imperceptible). The use of illustrative examples (ostensive explanation) might be of help, but they would most likely suffer from the problem of privilege (the transcendental decision that selects one or more texts or concepts over others—one reason, perhaps, for Laruelle's avoidance of examples).

Our chosen route, though, is to approach the object *tangentially,* using myriad analogies and perspectives, not to represent *what the thing is* by averaging them out (or creating "more eyes" in a Nietzschean perspectivism)[143] but to instantiate how it works through the convergent movement between diverse images—always rectifying one image with another. This is not a relativism but a Real instantiation, using many disparate "samples" rather than circularly privileging certain favored examples.[144] As *Philosophy and Non-Philosophy* states, "descriptions must be multiplied and diversified in accordance with the thematics, whether *philosophical or otherwise,* that are available and chosen as material."[145]

Consequently, our own aim to model Laruelle five different times employs images that are only provisional (they too must mutate), so that even the concept of "posture" (the focus of chapter 3 and something of a

leitmotif for this study) does not exhaust non-philosophy. As *Philosophy and Non-Philosophy* goes on to say,

> it will be said that it [the One] is experience or affect, posture, inherence (to) self, lived experience, non-decisional (of) self, etc. But what will be described in the last instance by these multiple languages—none of which should be privileged—will no longer itself be an effect of language (or of metaphor). Hence the necessity of an ongoing rectification of these descriptions. . . . This description is not false in itself, it becomes so *if it is not pursued and rectified incessantly* under the pressure and function of this specific matrix of the One.[146]

Descriptions are only false when they attempt to stand alone for the whole, when they are not rectified "incessantly," when they do not mutate. That we are using a cinematic model to orchestrate these five other models does not give it a metalevel mastery, however: it is invoked partly on account of a set of resemblances and partly as another level of material constraint.

Clearly, Laruelle's non-philosophical project is not only epistemic (the "non-" as expanded explanatory scope): it also has an ethical axis—the "non-" as protest, as resistance to any concentration of power, to any exceptionalism or inequality. Hence, apart from shadowing the structure of the various remakes in *The Five Obstructions*, slightly reordered (von Trier's first and second reproductions being switched), the chapters' sequence is also oriented by issues set along an ethical axis that enquires into the origins of inequality. The first such issue remains closest to home: how and why has philosophy (which belongs to "the human par excellence," the perfect human) gained its authority over all other forms of thought, human and nonhuman?[147] This question then leads to four more like it, expanded in scope, but always concerning inequities and their origins as we travel from the perfect human through mutant paralogic (chapter 2), bodily behavior (chapter 3), and animality (chapter 4), before returning to the figure of the performing philosopher (chapter 5). These matters will not be addressed through a history of ideas, however (to prove one or other position), nor with any other type of empirical research posing as evidence. Rather, it is the answer-form itself that will be expanded, or rerendered, through a set of materializing, cinematizing, postures.

By wishing to introduce democracy into theory, equality into thinking, non-philosophy is also obviously utopian, opposed to the dystopias, or "miserable places," facilitated by philosophy. Its opposition is not "logical," though, but the posture of "a hiatus or collapse, truly a non-place or utopia."[148] Certainly there is also much circularity in utopian thinking. W. H. Auden once remarked that a literary critic should declare his "dream of Eden" because "honesty demands that he describes it to his readers, so that they may be in a position to judge his judgments."[149] So, in answer to the Marxist question "what is to be done?" or the Kantian question "what ought I to do?" (or even "what ought to be?"), we must have *already* decided on what has gone wrong: "what is to be done" begs us to ask, "In the face of *what*?"[150] We must know the reality of our dystopia before we can construct a utopia.

The five chapters of this study enquire into the question of the human, thought, the body, the animal, and art, oriented along an axis of varied *nonhuman* interests (once we understand that term in its expanded, non-philosophical sense). And, in this enquiry, it is a film that gathers these five together, partly through the force of invention and partly through the real equality that always already subsists between materials, when they are each seen from the vision-in-One. As Laura Mulvey writes, the cinematic inhabits a middle ground between the "animated human and the spectral inhuman." It is our project to introduce Laruelle by demonstrating how that middle ground has been segmented into unequal shares—a "partition of the sensible" (to borrow a phrase from Jacques Rancière) that ensures that the nonhuman *departs*.[151] Any utopia that might be inferred from what we will construct here, then, will be both discovered reality and invented fiction. In radical immanence, after all, the fictional also has the Real in view (rather than one more true, but circular, philosophy). As Laruelle himself emphasizes, "non-philosophical utopia has never been about creating a new philosophy. . . . Instead, it creates a new genre or generic practice, which might be called 'philo-fiction.'"[152]

1

PHILOSOPHY, THE PATH OF MOST RESISTANCE

> Contemporary philosophy is progressive and "open"; it seeks the Other, the stranger, the "non-philosophical." But it is only so revolutionary because it continues to suppose the validity of ancient thought, and thus metaphysics merely revolutionizes itself at the same time in order to further extend its offshoots into the future.... Philosophy is revolutionary and, like all revolutions, it persists in re-exhibiting the past and recognizing a normativity in it, assigning it an ultimately absolute validity. Non-philosophy must put an end to this hypocrisy and this conservatism
>
> FRANÇOIS LARUELLE, *Philosophy and Non-Philosophy*

THE BLACK BOX OF PHILOSOPHY

In this chapter, we begin our film of Laruelle's non-philosophy by taking the path of most resistance to his thought—philosophy itself—so as to expand on what he means by both philosophical circularity and authority. On one level, this will be the most orthodox of our five introductory obstructions. Indeed, using extant philosophies in order to make non-philosophy "identifiable" may be a hostage to fortune that—in virtue of any success it might have—would only add more evidence to the retort that non-philosophy is "just more philosophy." Yet these comparisons are only ever suggestive, as they each ultimately fail to correspond sufficiently well to be anything other than a gesture in one direction alone.

It should be noted straightaway that Laruelle's is not a *historical* thesis concerning philosophy but a *functional* hypothesis: it is an experiment that revises how we see philosophy function (at all times) rather than an empirical position based on historical evidence. Even the book that comes closest to a history of ideas, Laruelle's *Philosophies of Difference,* is primarily aimed at his contemporaries and their problematics *then*—Derrida and Deleuze. Here philosophy is the name of the position or phase (in any current practice or in "history") that distances itself from the Real, that withdraws and with that positions everything else relative to it. It

is the Copernican sun. Consequently, Laruelle does not wish to replace philosophy with a superior theory but only a more inclusive theorizing whose one inimical gesture is targeted at the exclusionary, "transcendent" position of *any* kind of thought (be it deemed "philosophical" already or only one entering a philosophical phase). Non-philosophy attempts to be a thought which, "without negating philosophy, without wishing for its death, without subordinating it once again, merely suspends its claims over the Real and makes a new usage of philosophy."[1] In other words, Laruelle only rejects that position or behavior of philosophy that mounts transcendent and exclusive truth-claims for itself, leaving *no room* for others. It occupies all "logical space" *totally*—the space of the *most* proper thought, or what he calls the "space-time of philosophical combat."[2] By contrast, Laruelle aims to superpose all theories in one *Real* space, so to speak, where all think "alongside" the Real and are on the one, same side ("uni-lateral," as he calls it).

On another level, the encounters between philosophy and non-philosophy set up here will help demonstrate just how similarly transcendent so many *different* philosophies remain (often unintentionally). This can be seen in how their "auto-positions" postulate that it is only thinking (of *their* kind) that genuinely encounters the Real, be it directly or indirectly, through affect or matheme, wild speculation or deductive inference. This power of self-affirmation—which we will see articulated through Deleuze's libidinal economics, Badiou's mathematicism, the new realisms, or indeed most overtly in Kantian representationalism—testifies to the prodigious ability of philosophical thoughts to recuperate themselves (circularly) despite wholly indifferent responses to them from the Real. Yet, it is precisely in this narcissistic gesture (or withdrawal) that each philosophy deludes both itself and others into a hierarchical vision of the Real. In each different manner of philosophical thinking, even be it in a thought of "difference" or "creativity," all we ever see is *philosophy* itself display its power, over and over again. This repetition is crucial.

In the first chapter of Deleuze and Guattari's *What Is Philosophy?*—on the topic "What Is a Concept?"—the authors ask a seemingly straightforward question: "what is the best way to follow the great philosophers? Is it to repeat what they said or *to do what they did*?"[3] The question is rhetorical insofar as (pace the power of repetition in Deleuzian

ontology) few would choose the first option without some trepidation as to how the interrogators might react. Our own introduction already spent a good time pondering issues concerning saying and doing (and doing what one is saying), so it would be appropriate to ask now how Laruelle might answer this query. On the surface, Laruelle often appears to be repeating the sayings of philosophy, though with just enough distortion to create monstrous effects (clones). But, in following this line, does he "do what they did" as well?

The answer to this question must be negative, because, for Laruelle, what philosophy does is perpetually repeat *itself,* even insofar as philosophers bend over backward *not* to repeat what was said before. Remembering the opening epigraph of our introduction, it stated that "there will always be philosophy...because what is essential for it is *that it is.*"[4] Philosophers, or the kind of thinking deemed "philosophical," never stop. Moreover, what *great* philosophers do (at least according to them and other philosophers) is *not* repeat but continually reinvent the discipline. Indeed, this is how Deleuze and Guattari respond to their own question: the (true) philosophers "create concepts for problems that necessarily change." For Laruelle, what we also have in this response is typical of the philosophical stance, for their definition of true philosophy is one that retroactively recasts the history of philosophical thought in their own image, as that of *concept creation* (as opposed to a host of other candidates). They repeat the philosophical gesture that exhausts, not only the Real, but any alternative modes of thinking that might hope to "access" the Real. And, in fact, all "great" philosophies use an image of the "history of philosophy" to negotiate their terms of engagement with each other. As Laruelle writes in *Philosophy and Non-Philosophy*:

> all philosophies...share the unique prize of Unity, which is in itself indivisible, and this rarity is identical to the war that they all wage reciprocally.... In this sense, the "history of philosophy" is the dominant practice in which all philosophies reconcile for a moment through the need that they have of making peace in view of their mutual auto-exploitation.[5]

Rocco Gangle also notes that, rather than denying the fact that philosophy has repeatedly reinvented itself, Laruelle takes the logic of "creative

difference and self-overcoming as the very essence of philosophy." Western philosophy, viewed as the "untotalised history of its own continual self-overcoming," is, at exactly the same time, "conservative, critical and creative."[6] Obsessed with legitimizing themselves through historical origins—sometimes even by disavowing them—philosophers, including radicals like Deleuze, "assume philosophy in order to prolong it, reaffirm it, or even deconstruct it."[7]

Of course, figures like Heidegger did think *differently*—through poetry—as Derrida did through literature, Badiou through mathematics, and Deleuze through rhizomatics. But were they ever sufficiently "different" to *stop* presupposing that *their* various modes of operation were mutually exclusive (of each other) and exhaustive (of the Real)? No (that was another rhetorical question)—it was always understood by each that his new position either supplants the older ones whole or incorporates them as its parts:

> Philosophy is indeed a revolutionary practice by its very essence. But for this reason it does not wonder how revolution—neither its gesture nor its operation—is possible, for it spontaneously practices it. In the 20th century it has therefore witnessed many ruptures: for example, Wittgenstein's introduction of language games, Deleuze's generalized serialism and univocal chance, Derrida's Other as absolute or Judaic Other (deconstruction).[8]

In his *Philosophies of Difference,* Laruelle points to the Pre-Socratics as the very first philosophers to enunciate this kind of exhaustive speech act: "*Everything is (Water, Earth, Fire, etc.).*"[9] What the *arché* is (air, water, or whatever else) is irrelevant; it is the formula "everything is . . ." that is problematic for Laruelle, as, likewise, would be any an-archic variation on the same theme, such as "everything is chaos," or "everything is difference," or "becoming," and so on. It is the formula "everything is . . ." that he challenges, not because "becoming," say, is incorrect but because it precludes coexistence with others in virtue of its all-encompassing representation of the Real. What Laruelle says of (psycho-) analysis in the following is generally true of all philosophical analysis in contrast with what he calls here "non-analysis":

non-analysis, as the *scientific* generalization of analysis, is neither a *super-analysis* (in the manner of Wittgenstein) nor a *meta-analysis,* neither a *hetero-analysis* nor a deconstruction, which are all philosophical generalizations and thus always restrained or restrictive by definition. . . . Non-analysis considers restrained analysis as a simple given, a function required by the science of man, such that what absolutely distinguishes it from this restrained analysis left to itself is the fact that it primarily suspends the latter's pretension, reduces its previous validity to the state of simple belief.[10]

The statements of non-philosophy about philosophy are not "meta" or "super" theories—a new species of generalization (or "theory of everything"). But they are a usage, or clone, of theories that say "everything is . . ." (it takes them "as a simple given"), and therewith comes the risk of non-philosophy *itself also* being seen as only one more totalizing approach.

So, the counterclaim that Laruelle *likewise* says "*everything* is . . . such that saying 'everything is' cannot be allowed" misses the point that Laruelle is *cloning* the statements of philosophy to dislodge them, to deauthorize them. Even "mentioning," remember, is itself *a kind of use,* a "clone" or "mutation" (non-philosophical clones are never perfect but are always slightly disfigured mutants). Similarly, when Laruelle says that the Real is "foreclosed," this is not another definition but an axiom or hypothesis that allows us to experiment with knowledge, with the idea that all thoughts are equal. Indeed, such charges as these against Laruelle are forms of philosophical reassimilation (or "renormalization," as Laruelle puts it)—the strategy of *tu quoque,* "you, too" ("are one of us") that we will examine later. These accusers argue that there is no other option than the philosophical one (at this level of thought at least), and so that everything already is philosophizable.

Philosophy *conserves,* and despite some of its manifest best intentions, it maintains both a "hierarchy" and an "inegalitarian spirit."[11] Yet what philosophy conserves most crucially is *itself,* which thereby forms the *template for every conservatism.* It pursues "one essential end," albeit through myriad and various means: that of "realizing itself, affirming itself." It is an "act of self-affirmation," at base upholding simply "that one is a philosopher," and yet also all of the authority that goes with that

(real or imagined).[12] Its "content" or message is finally immaterial: it is the form that counts, for philosophy's essence is an *"opaque identity,* this *black immanence* of a technological box or of 'difference.'"[13]

Should a philosophy seem to gain its authority by proxy of a science like mathematics or physics, *how* the science purportedly legitimizes that philosophy's position is ultimately unimportant. What counts is the *philosophical* assertion that it does. It is the philosophy that has the power (or is in the *position*) to assert. Yet *why* it can assert at all is left in the "box": "in spite of its rationalizations, at the heart of the relation of philosophy to itself or to science, there is a *black box,* an *unthought identity,* a technological, incomprehensible relation for which only the effect counts."[14] Anything can be in the box with (a) philosophy—biology, neuroscience, physics, set theory: it is the opacity or *promise* of the Real that they convey which is coopted by philosophical authority. Such authority and even "domination" can come in many forms—"by analysis, synthesis, dialectic"—but they are always "philosophical processes of overseeing."[15]

In what follows, we will try to prize open the black boxes operating at the heart of the philosophy of Deleuze and Badiou, as well as within Kantianism and certain "new" realist approaches in metaphysics. We will also look at the more mysterious aspects of non-philosophy, namely, its notion of "determination-in-the-last-instance" and its connection with philosophy's standard conceptions of the a priori and the transcendental. Before any of that, however, we must arrange the mise-en-scène for our first encounter with *The Five Obstructions* by examining the dystopias, or "worst places," that philosophical authority creates for the human.

PHILOSOPHY'S DYSTOPIAS: THE VICTIMS OF THOUGHT

According to Laruelle, philosophy is the "crowned power of domination," embodying (sometimes with religion in tow) the *"Principle of Arrogance"* within human discourse.[16] Whenever an intellectual (philosopher) "intervenes" in public debate (in France one might imagine figures like Badiou or Bernard Henri-Lévy), there is that same "gesture of overcoming" or "transcendence," a hubris that goes back to philosophy's Greek origins and that is still maintained at its "root."[17] Worse than that, however, when philosophy intervenes (be it from its left or its right wing) on behalf of the

persecuted, it is with a reciprocal logic that places victim and persecutor on the same plane, a "totalization" of the two that is "eminently Greek": Badiou's logic of force and Sartre's gaze, for instance, are both reversible (victim and tyrant can easily swap places) owing to the "victimological distance" that philosophy injects into every scene.[18] As a consequence, writes Laruelle, "philosophical utopias and the camps are models of each other."[19] Think of Badiou's definition of the human in his *Ethics*: there, he asks whether man is a "living animal or immortal singularity" and answers his own question by asserting that man is "an animal whose resistance, unlike that of a horse, lies not in his fragile body but in his stubborn determination to remain what he is."[20] Humans are not like horses because they rebel against their domination. And they do it alone from the bottom up, winning power through violent revolutionary overthrow rather than democratic, gradualist reform (or sentimental, "humanitarian," top-down advocacy). It is always a question of power, the capacity to stand up and resist one force with a greater force. But if power relations are reversible, then the meaning of "victim" vanishes in algebraical smoke. It becomes only a philosophical variable. Indeed, the characterization of man's resistance as a "determination to remain what he is" is actually the *self-image of philosophy* projected onto the human.

And what of the victim who cannot resist, or whose resistance *or* nonresistance in myriad, uncommemorated exterminations is not even recorded by history? Indeed, for Laruelle, "definitions by way of a subject, an attribute or a predicate, and in particular that definition of man as resisting animal—from my point of view, these philosophical definitions are no longer effective."[21] In contrast to the heroic resistance fighter, Laruelle calls attention to those unrecorded and unmarked casualties, "the Victim-in-person" or "the definitively defeated of history":[22]

What happens to the Victim who has not had the time or the unlikely courage to resist? Philosophy forgets her, evidently; she does not emerge, she is not interesting. As if we have chosen to be a beast or to be an immortal hero! The philosopher has passion for parousia and speech—either the Victim speaks or it is the philosopher who speaks: the Victim must let out a sigh that the philosopher can inscribe in his system. . . . The majority of victims are mute, dead, or reduced to silence there and then

in the very moment of the crime; they long ago lost the taste for the ambrosia of *logos*.[23]

The philosopher's victim is an abstraction, a surrogate for a position, a "victimological" distance (we see again, then, that this is a material rendering of philosophy in the image of distance itself rather than a personalized attack on certain philosophers). But the victim of philosophy is (Laruelle speculates) "the repression of another victim, too obvious to not be forgotten or unnoticed."[24] Laruelle is interested in these other victims (called "victims-in-person") who exist below the philosophical radar, unheard of, miserable, and without any "justification through history." He lists the persecutions of "religious heretics, dualists, and gnostics," and to that list we will add (in chapter 4) the most miserable, ahistorical, and "obvious" of all, those nonhumans (horses included) who are these "silent, dead or reduced to silence."[25] These unrecorded and sometimes unrecordable individuals are, in Laruelle's words, a *"multitude of victims, who have already been consumed or who are still virtual, those who make up the ground of history."*[26] They are the victims who cannot be victims, *in man's eyes,* and yet without them, there could be no heroic Victim, no suffering and resisting *anthropos* for the philosopher to champion.

Laruelle gives these forgotten victims, and the situations they inhabit, one name—"the worst"—this being a place from where another form of "struggle" (which is not about power) can be hypothesized: "we have not yet explored all the possibilities of thought, and so all the possibilities of struggle. *I form this hypothesis of the worst,* but under human conditions, so as not to sink into the worst of the worst."[27] To be clear, neither this "worst" nor the victim is proposed as a philosophical abstraction but rather as the non-philosophical rerendering of an abstraction:

Firstly, this is not Platonism, meaning that the Victim-in-person is not the Victim in-itself, an Idea or Model, a paradigm for the Victim. Secondly, this is no longer a concrete victim taken from the field of battle or the television screen. She is no longer the Victim as an Other [*Autrui*], as she can be within a generalized Jewish context; she is not another person [*autrui*] who will be persecuted by me or by the philosophical universal, but no longer is it myself who will be persecuted by another person. So,

what is the Victim-in-person? What is the identity of the Victim-in-person, her attributes? This is precisely the question that must be refused as it applies philosophical interrogation to things and to the World.[28]

The victim-in-person is the undefined person, the unknown victim who cannot be categorized by philosophy. For when philosophy appears on the scene, it is not only as a *witness* on the margins of the "crime-form of history" but as a key *protagonist* in creating the victim as "victim," in what Laruelle describes as its "victimology." The very last words of *Philosophy and Non-Philosophy* make it obvious that it is "the exploitation of man that philosophy *will have directed.*"[29] In its power, philosophy is the "ringleader and master of the game": all the autocratic forms of knowing—"'encyclopedia,' 'unified science,' the 'totalization of culture,' the 'acceptance of truths,'" and so on, stem from philosophy's first gesture of definition and withdrawn distancing.[30] As Alexander Galloway writes in his review of Laruelle's *Théorie générale des victimes*:

> the primary ethical task remains clear in Laruelle's book: to view humanity as indivisible, without resorting to essence or nature. The only way to do this, he suggests, is to radicalize the generic condition of humanity, not to universalize the liberal subject, as with the "we are the world" conceits of Western privilege, but rather to do the opposite, to underdetermine persons rather than overdetermine them, to admit to a baseline insufficiency of personhood.[31]

To protect the human against philosophy, we must undefine it, leave the human open and non-standard. Nietzsche already knew, of course, that "to philosophise is to dominate," and Laruelle is no less familiar with Lévinas's critique of both metaphysics and epistemology as forms of oppression, nor with Lacan's diagnosis of philosophy as a psychotic discourse of mastery. Yet, inasmuch as each still saves a philosophy (of metaphysical power, ethical powerlessness, and psychoanalytic privilege, respectively), Laruelle—while acknowledging their influence on his viewpoint—still believes that they did not get to the heart of the difficulty.[32] As the first epigraph to this chapter states, "contemporary philosophy is progressive and 'open'; it seeks the Other, the stranger, the 'non-philosophical.' But

it is only so revolutionary because it continues to suppose the validity of ancient thought."[33]

So, contra both the quasi-non-philosophical approach of Lévinas (who nonetheless retains a Judaic ethics of the identity of victims) and Badiou's arch-philosophical ontology of forces (or Deleuze's Nietzschean version of the same), Laruelle formulates the following axiom:

> the only weapon of the poor, stripped not only of all but once and for all of the All itself, is invention. It will be a matter of passing from absolute poverty (the philosophical loss of philosophy) to radical poverty as non-philosophical loss of philosophy.[34]

This "absolute poverty" is the "worst place," which Laruelle goes on to describe (with neither irony nor apparent hyperbole) as a "minimum of evil-world" or "the form of philosophy and in the form of an integrism of philosophy that ceaselessly returns like a repressed evil."[35] It is where the worst have been *placed* by philosophy. Badiou, in particular, presents the image of absolute poverty, the philosopher's poor, a pauperomorphism of the intellectual's imagination. The philosopher's poor is simply the inverted image of the rich philosopher, the philosopher at degree zero. These poor, these *"sans papiers,"* are really (again) philosophical abstractions, the specular image in reverse of the rich man (and "aristocrat," as all true philosophers are). The following quotation, from the penultimate paragraph of Laruelle's *Anti-Badiou,* makes the point clear:

> Let us pose a last question worthy to attract the mockery of philo-sophical opinion: how can we recognize a "poor man," and what does "pauperized"—or in more statist manner, "undocumented," really mean? For philosophy, it is almost self-evident, give or take a few definitions: the poor man *is recognized or can be identified* by subtraction, by the suspen-sion or privation of certain predicates, but without this touching on the sufficiency of philosophy, always ready to return because it is in reality that which assures this recognition. . . . The true Idea of an "authentic" poor man, as we come to understand, is that of the philosopher himself, who incarnates it as a paradigmatic character: the richest man, not necessarily yet actual or actualized, but endowed with a capital of potentialities that

enables him to wait for history to reach its end, or who himself comes to
his end.... What does "undocumented" mean, exactly? It is a matter of
a wholly negative subtraction by the philosopher who, himself, can then
return with all the positivity of the Good Samaritan.[36]

Badiou, the perfect philosopher and Good Samaritan, will be discussed
in more depth later in the chapter, especially given his (auto-) position
as philosopher-king in current circles (as modest as such circles are these
days). For now, though, we must turn to the *other* poor people, the other
Others, those "radical poor" to whom Laruelle alludes earlier. They are
the ones who refuse to be subjects for either philosophers or, indeed,
filmmakers and yet who are placed as worst by both.

A NON-PHILOSOPHICAL TANGENT: THE MOST MISERABLE PLACE IN THE WORLD

The ostensible purpose of the second obstruction set by von Trier for Jør-
gen Leth is to break down his detachment, his documentarian sensibility
that distances him from his subjects. His "modesty" is what putatively
allows him to be objective in his work, but no less importantly, it also
protects him from his subject matter. According to von Trier, the "highly
affected distance" Leth maintains to the things he describes needs to be
removed. Hence, the obstacle set to remaking *The Perfect Human* this
time is to locate the film in the worst, "most miserable" place in the world.
Moreover, despite being *set* in this dystopia, Leth will not be allowed to
show that place on-screen:

> VON TRIER: The highly affected distance you maintain from the things
> you describe, that's what I want to get rid of in my next obstruction.
> We talk so much about the ethics of the observer; I want to move
> you on from there, to make you empathize. I'd like to send you to the
> most miserable place on earth.

In addition, Leth must now play the starring role in this remake. It is an
interrogation, then, of both distance and the ethics of observation. In
film-theoretical terms, we can couch this as Krista Geneviève Lynes does,

namely, as an investigation asking "how cultural producers take responsibility for producing their backgrounds as they create their foregrounds."[37]

Within these optical aesthetics, furthermore, there is also the matter of thought and mastery. Von Trier asks whether, when choosing such a place, there are any limits for Leth, "any places, any themes one cannot exploit?" Is anything *unfilmable*? Leth cannot think of anything offhand, but he claims that he is not "perverse" (and would refuse, say, to film a dying child in a refugee camp). All the same, he agrees with von Trier that there is already a "degree of perversion" in maintaining a distance, at which point von Trier warms even more to the object of his challenge:

> VON TRIER: In the way you do things. How far are you prepared to go if you're not describing something? It'd be worth a laboratory experiment. Would anything rub off? I want you to go close to a few really harrowing things. Dramas from real life that you refrain from filming. You've done so before.
>
> LETH: Yes, it's a fascinating discipline.

In response to this "fascinating" experiment, Leth takes on von Trier's challenge with little hesitation. The most miserable place he chooses is the red-light district on Falkland Road, Mumbai, a place he has been once before under undisclosed circumstances, as he explains:

> LETH: Where are the most awful places I've seen? The first place to occur to me was a horrific experience of the red light district of Bombay. I'd seen it a few years previously. I'd seen it six or seven years ago. I thought it a horror beyond compare. The kind of thing you run away from, screaming. I am not afraid of prostitutes in general. But this was a picture from hell.

For this setting, Leth chooses possibly the most incongruous section from *The Perfect Human* to remake. The key sequence is from the original film's dining scene (the most important in the film, according to Leth), where Claus Nissen, dressed in a tuxedo, eats a sumptuous meal of salmon, potatoes, and *sauce hollandaise*, with a Chablis to accompany. Leth will now play Nissen's role as the perfect human, only now dining alone

surrounded by some of the poorest individuals in the world—the "cheapest" prostitutes living in Mumbai. The roles of the invisible filmmaker and (highly) visible subject are reversed, with Leth front of camera *before* the citizens of Falkland Road.

Leth, at least before the filming commences, seems unperturbed by the potentially harrowing experience awaiting him: "no matter what we film, no matter what I say to you, to the camera—it will still be a game. It will still involve stepping right up close—and then showing that distance." With this declaration, it is evident that Leth sees no way around the automatic distancing effect of the camera, or the impossibility of creating a filmic empathy (and even the inauthenticity of attempting to do so). Hence, he is untroubled, he claims, even if he has to "play the perfect human against practically any background." As Murray Smith notes, Leth allows us to "glimpse Falkland Road, but only as a beautiful backdrop, a tableaux of vibrant saris ... combined with a pointed refusal to engage with the 'social drama' of poverty and prostitution."[38] These things become "background" or "atmosphere" (two of the film industry's technical names for "extras," be they actors or nonactors).

Yet, even in his journey to Falkland Road on the day of the shoot, events conspire against the documenter, as Lynes relates:

> Leth is travelling through the streets of Mumbai in a taxi. A woman and child approach the window, begging for money. Leth says "I don't have any rupees. I don't have." The woman stays at the taxi window and waves. Leth asks the cameraman, "Do you have ten rupees?" He refuses to make eye contact with the woman who advances, shielding against the light with her hand to peer into the darkened cab. She speaks, but the micro-phone does not pick up her voice as she turns to say something to the driver. Leth tries to open the window and says, "It's unfortunate. I can't open the window." The driver finally helps him, and he hands the woman the rupees. She persists, making a gesture of putting food in her mouth. He replies, "I don't have." He does not want to look at her. They are stuck in the street and Leth looks to see what is delaying them. They eventually move on. After a few moments, Leth says, "That's the kind of scene Lars von Trier wants. That's what he'd like. That scene. Damn it! And he can have it."[39]

As Lynes then points out, the optics of the situation—with the voiceless begging woman set in the visual background and the filmmaker in the foreground (on his way to record himself dining lavishly among the poor)—thwart whatever distance Leth still hoped to maintain. Hence his mounting disturbance.

In the final, filmed scene, Leth does manage to control the situation somewhat better and gets the shots he wants. Moreover, in doing so, he actually compromises von Trier's rule regarding the invisibility of his subject, because he sets up his dining table *al fresco* in the street, only with a large semitransparent plastic sheet covering the entire background of the shot. Behind this membrane we see blurred images of mostly women and children, who stand quietly watching Leth consume his cordon bleu meal and recite his lines to camera. This framing device both shows and does not show its subject. As Lynes puts it, it "transforms the street scene into a literal 'moving picture.'" She continues thus:

> Leth firmly rejects Trier's demand that he be empathetic. Instead, he becomes modest with a vengeance. Rather than stand for the people of Falkland Road, Leth does less than represent them, he transforms them into a picture. . . . Although he puts himself at stake (in front of the camera rather than behind it) he can only repeat the violating logic of the film's distance within the film, enacting a doubled objectification of his subject (by the film as well as by the frame). . . . Leth thus refuses to take on Trier's task. His strategy is one of dis-identification, creating even further distance between himself and the subjects of his film. The people of Falkland Road become a backdrop to his scene. . . . For Leth, the lesson of *Obstruction # 2,* like the lesson of *The Perfect Human,* is that he can show the irreducible distance between himself and his subject, and thus make his own limitations as a film-maker visible. In doing so, however, he remains "modest." . . . His remobilisation of modesty in this instant protects him.[40]

On one level, then, Leth clearly transgresses von Trier's stipulations in this constraint (*not* to show his miserable subject). On another level, however, Leth disobeys him even further, using his creative talent and art to protect him from his subject, even as he *shows* the distance such "objective" and

"modest" filmmaking usually generates between itself and its subject matter. To put it clearer still, even when trying to thematize the ethics of observation, *another* distance is created, another subject is positioned (the documentarian's "objectivized poor"). Another victim, in other words, is created out of this victimology—one that, barely visible, is disregarded *and* made "obvious" in that act of semirepresentation.[41] The radically poor are hidden in plain (or quasi-plain) sight, having been transformed into a "moving picture" no less than philosophy also transforms the poor into an image of "absolute poverty" in its worst place.

TU QUOQUE; OR, YOU TOO ARE ONE OF US

The heart of this chapter concerns the power of philosophy, both to resist non-philosophy and also to perpetuate itself. This authority lies in philosophy's domination of the form of all thought, including that of humans. Even when it "empathizes" with the oppressed, it does so under *its* indomitable force, *its* position of distance, and so *its* definition and record of "victims." For Laruelle, however, to empathize with those who really suffer, philosophy needs to *suffer itself.* Yet to do this is impossible, at least while it remains the distancing thought par excellence. Of course, at this stage in *The Five Obstructions,* Leth's failure to abide by von Trier's rules—by remaining *too good* at making films, by being "creative"—places von Trier in his own position of mastery, on account, not of his role as the rule maker of the game, but of an implied position of moral authenticity (that Leth fails to live up to).

In our remodeling here, von Trier currently plays the role of a Laruellean critic of classical filmmaking (Leth) *and* philosophy. Roles may reverse to be sure (not to mention my own involvement as "introducer to Laruelle"), but for now the following question arises: what makes von Trier so morally superior? What gives him the authority to judge Leth? Is not his stance only another form of distance, a lack in *his* empathy for Leth's predicament (von Trier both admonishes and then punishes Leth for his failure in this obstruction)? Recall that Laruelle does not wish to replace philosophy but only to remake it with different eyes, so to speak, with a reoriented view of its relationship to the Real. That said, however, this charge of sanctimony against von Trier is one that is constantly set

against Laruelle too, by philosophy. It comes in the accusation that "he too" *(tu quoque)* adopts philosophical-style tropes when engaging with philosophy, that he too, despite protestations to the contrary, remains a philosopher like all the rest (irrespective of whether that definition of philosophy concerns its authority or any other characteristics).

On this account, then, Laruelle is a typical philosopher inasmuch as, for example, he argues for consistency and rigor, and against contradiction and circularity (wherein transcendence is modeled on a privileged experience). But who would ever disagree with those principles? They typify a host of philosophers from Descartes to Husserl, at least in what they espouse (what they actually practice in the rest of their work is another matter, naturally). As we noted in the introduction, if philosophers are sometimes hypocritical by not practicing what they preach, who can say that Laruelle does any better? For, indeed, perhaps it is Laruelle alone who is *doubly* hypocritical by not noting his own shortcomings when it comes to consistent practice and simultaneously pointing out this fault in others—*"judge not, lest ye be judged,"* and so on. Yet the retort of hypocrisy is *itself* a key concept of non-philosophy. It is a prediction of the "principle of sufficient philosophy" that philosophy will always riposte that its worst failings are *still* eminently philosophical all the same. Such is philosophy's narcissism that it sees itself mirrored in everything it looks at: in *its own rejection,* it sees philosophy, and even where it falls short of being *itself* (consistent), it sees another philosophy. So the idea that non-philosophy might *not* be more philosophy is simply impossible for philosophy to understand: philosophers look at non-philosophy and "see only a new philosophy that conceals itself or refuses to recognize itself as such."[42]

Yet this strategy is not the end of such "philosophical renormalisation." The main weapon used to make Laruelle come to his senses is *derivativeness*—that non-philosophy merely reinvents old philosophemes rather than anything new (even if only a posture or vision of what philosophy is). Of course, given Laruelle's modus operandi that uses philosophy—as material—there will always be visible similarities between his writing and that of standard philosophy. Hence there are doubtless aspects of his project that resemble those of Kant, Marx, Husserl, or even Wittgenstein and the Vienna Circle, as well as Michel Henry, Derrida, and Deleuze. But these "appearances emerge," as Laruelle puts it, only on the basis of

disentangling them "from all the philosophical (decisional and positional, and not merely doctrinal and dogmatic) content."[43] Indeed, as regards these last three figures (Henry, Derrida, and Deleuze), with the "varied twists and interlacings" of immanence and transcendence present in their work, it is no surprise to Laruelle that non-philosophy appears to be "a neighbor of these philosophers."[44]

This proximity is also a product of Laruelle's intellectual biography and the earliest influences on his thought (when we might say that we was still a philosopher). The "radical phenomenology" of Michel Henry, for example, is an important precursor to Laruelle—"a deviation of non-philosophy, though one that has preceded it," as the latter puts it.[45] Inasmuch as Henry took the principles of immanence and nonrepresentationalism to their limit (in his conception of autoaffection), there is an obvious inheritance in Laruelle's work and so a likeness between their two approaches.[46] Significantly, however, Laruelle soon came to see Henry as still overly philosophical because he retains too much faith in a certain idealist account of thought:

> Michel Henry seems to better elaborate radical immanence than Descartes, but in reality it is always *as the result of thought* that he elaborates it by depriving it of a possible autonomy of thought as knowledge and of a recognition of the relative autonomy of philosophy. . . . There is a return in Henry and those who use him to the paralogisms of a psychology that is no longer rational, but affective. This *affective or sensible idealism* is realist, that much is true, but in reality since the affect is inseparable from thought, it is still a realism-idealism, or an idealism-realism.[47]

Though Henry's work marks a significant advance over Descartes in ridding itself of representational structures, he still makes autoaffection *follow* thought—it still serves philosophy, and as such Henry remains a (cogitative) philosopher. If Laruelle is derived from Henry, then it is with an added level of radicality that reaches back to reconfigure that source at its root—for Henry's phenomenology, like every other, is actually "*a limited form of non-philosophy.*"[48]

Alternatively, one can take non-philosophy as a novel *mix* of different extant philosophies. Indeed, I have previously entertained the idea that

the Laruellean approach could be understood as a kind of Derridean deconstruction mixed with Deleuzian materialism. It takes an apparent "anti-philosophy" (aporetics) and materializes it through science (on various models, running from biology through geometry to physics) such that the seeming "failures" of philosophy are nonepistemic and actually physical (Real) processes. This "mix" would also explain why Laruelle is almost friendless within philosophy today (beyond the effect of his own less than flattering comments on others), inasmuch as this two-sided approach faces the antipathy of both the naturalists (Deleuze et al.) and the critical theorists (from the Kantians to Derrida).

Laruelle's early work compounds this impression in fact, the very title of his 1976 *Machines textuelles* already indicating his bilateral perspective. Reflecting on his attempt to bring deconstruction and machinism together, he asks himself whether it is

> a question of a *Difference of systems* . . . of Derrida and Deleuze?, since they should truly be called by their "proper" name? What difference can there be between two systems of *différance* and the most aggressive, most critical *différance*, between two systems that are more or less clearly undecidable on the basis of representation? In the same way, it's neither a question of making the decision nor of proceeding to an election. They aren't for sale . . . , furthermore, these are barely philosophers. I have merely tried to make the Delida/Derreuze [*sic*] series resonate . . . making intensive *différance* and the textual simulacrum communicate.[49]

As Rocco Gangle notes, if Laruelle once aimed to establish the transcendental conditions of the coherence of deconstruction, it was "in a Deleuzean spirit, [for] these would be conditions of reality rather than possibility."[50] Additionally, Laurent Leroy can perfectly well refer to "the common root" between Derridean deconstruction and non-philosophy, and even Laruelle himself can refer to his work as a form of *"post-deconstructionism"* and say that it borrows from the *"American way of thinking"* that has been so informed by deconstruction.[51]

Yet, all the same, Ray Brassier is also correct to point out that, unlike deconstruction, non-philosophy "involves a positive enlargement of the ambit of decision, rather than just an aporetic interruption."[52] Further-

more, according to Laruelle, this enlargement is not "the simple extension of existing deconstruction to new objects" but one that implicates deconstruction itself:

> Contemporary deconstructions of "metaphysics," of "logocentrism," of "mythology," are only supplementary forms of the old philosophical faith. They content themselves to vary, breach, break, displace, disseminate, differentiate, etc., the old knowing always assumed as real and valid.[53]

Non-philosophical thought, by contrast, "widens this fight to be against all forms of authority linked to transcendence in a state of auto-position."[54] It is notable that even in Laruelle's more "philosophical spirit" in *Machines textuelles*, if Deleuze and Derrida are to be engaged favorably, it is on account of both of them being "barely philosophers" (a negative judgment of State philosophy that Laruelle deems a badge of honor). However, five years after *Machines textuelles*, with the inauguration of non-philosophy proper in *Le Principe de minorité*, this mitigation would no longer be permissible, for both philosophies of difference remain forms of authority. Even the "Delida/Derreuze series" is too classically Greek—a blend is not enough.

What is true of that mixture is true of others too. So, for another example, seeing Laruelle as a materialist who realizes the aporias of (deconstructive) epistemology might put one in mind of Hegel vis-à-vis Kant—the dialect being the realization of the latter's antinomies of reason. Yet an important *disanalogy* immediately presents itself. Laruelle's principle of *insufficiency* entails that what is realized is not philosophical progress (dialectical or otherwise), nor any form of finality (positive or nihilistic), but *philosophy as material means*—its usage or performance, which comes in myriad forms (being "baroque," as *Anti-Badiou* puts it). It is practice that is real rather than philosophy's speculative self-perpetuation.[55] Or again, Laruelle himself has pointed out that one could see non-philosophy as an approach that "radicalizes, which is to say universalizes, the thesis of Duhem-Quine, ripping it away from its positivistic-scientific limits."[56] Hence it might be possible to see non-philosophy as a philosophical thesis concerning the underdetermination of theory by supposedly "neutral" evidence. But here's the catch: radicalizing the thesis of Pierre Duhem

and W. V. O. Quine (which holds that it is impossible to test a scientific hypothesis without one or more background assumptions) entails seeing *every singular* theory being underdetermined by *any kind of evidence, including that of both positivist science and authoritarian philosophy.* And this thereby undermines the philosophical status of the new version of the thesis, as philosophy too is implicated in its radicalization.

In the end, then, the similarities between non-philosophy and philosophy (be it single-malt or blended) are materially informed (the latter as "input" for the former) and result, optimally, in a gestalt switch that changes how we see philosophy in general. Philosophy can and will see this material formalism as philosophical, but there are alternatives. The *Principles of Non-Philosophy* puts the issue in terms of neither derivation nor mixture, for instance, but rather in terms of *translation*:

> Non-philosophy *is* this translation of Kant "into" Descartes, of Descartes "into" Marx, of Marx "into" Husserl," etc. That is to say under the condition of the vision-in-One as un-translatable Real. To put it more rigorously, no more than it is im-possible or un-symbolizable, the Real is not untranslatable, but is rather that which renders the possibility of translation real-in-the-last-instance, the Real itself being foreclosed, without negation, to any translation and not becoming the untranslatable other than as force-(of)-thought or, in this instance, *force-(of)-translation*.[57]

Admittedly, translation (of one philosophy into another) could be seen as an exercise in transferring representations, understood as disembodied propositions (or "information"), from one medium to another. Or it could be seen as a material *morphing* through the flat "medium" of the Real, whose own untranslatability is what enables not only philosophies but *anything* to be translated into anything else (even a film into a philosophy), if *one looks with sufficient care.* Such translatability does not come on account of one thing either applying or illustrating another but in view of the Real identity of every thing within immanence.

Hence, in the following analyses of Deleuze, Badiou, realism, and Kantian transcendentalism, we will attempt a series of translations that are also levelings or flattenings—an equalizing of thought that removes the authority or mastery from each approach.[58] Moreover, we will also

point to how, prior to this translation under the vision-in-One, even at their ethical best (i.e., when engaging with the inherent value of multiplicities and objects, or human universality and enlightenment), they remain forms of domination that engender inequality and misery—a source of myriad dystopias. The only place where they can genuinely coexist peacefully, waging war neither on each other nor on the human—is within a non-philosophical utopia.

DELEUZE AND BADIOU: TWO PERFECT PHILOSOPHERS

In this section we will briefly look at how two of non-philosophy's nearest neighbors, Deleuze and Badiou, still fall short of a radically immanent and consistent thinking, in Laruelle's eyes at least. Again, it is not so much the philosophers in person who are at fault as much as it is the position of philosophy that remains at the core of their thought that is under review. We saw in our introduction how, for Laruelle, Deleuze's philosophy of immanence is compromised by its philosophical articulation, that Deleuze makes thought immanent to the Real *in the name of his own philosophy*. As Laruelle argues, it "is a question of knowing whether immanence will be the Real as immanent only (to) itself; or whether it ultimately remains the property of a plane, a universal, or even an Ego."[59] The reference to a "plane" is an undisguised taunting of Deleuze (the one to "an Ego" is at Michel Henry's expense).

Yet, in their defense, is not Deleuze (and Guattari's) "plane of immanence" simply another term for the equality of all before Being, the univocity of the Real (where being is said in the same way of every different thing)? Still being "barely a philosopher," has not Deleuze already introduced democracy into thought by placing it on *one* plane? Besides, in Deleuze and Guattari's various references to Laruelle's non-philosophy in *What Is Philosophy?*, it seems clear that the two see much to approve of, Laruelle being engaged, they say, "in one of the most interesting undertakings of contemporary philosophy. He invokes a One-All that he qualifies as 'nonphilosophical' and, oddly, as 'scientific,' on which the 'philosophical decision' takes root."[60] Admittedly, Deleuze and Guattari then add, "This One-All seems to be close to Spinoza," this renormalizing gesture being another indication that at least Deleuze remains too much

the philosopher for Laruelle's taste (Spinoza being the "prince of philosophers," whereas Laruelle is a committed antimonarchist). Consequently, we have Laruelle's prolonged reply to Deleuze's endorsement ("I, the Philosopher, Am Lying"), which continued to accentuate the differences between them. This was done, not to refute Laruelle's inheritance (he has never denied his intellectual debts), but to restate where non-philosophy is unlike philosophy.

As we heard earlier, it first concerns how one answers the question "what is philosophy?": "Let's suppose that there exists a book called 'What is philosophy?' and that it claims to answer this question by virtue of its own existence or manifestation." For Laruelle, it is impossible to seriously question *What Is Philosophy?* because the book places itself "at the center of philosophy."[61] *What Is Philosophy?* answers its own question performatively, with one definition to the exclusion of all others. Of course, Laruelle also characterizes philosophy in one manner, but he does so with a minimum of essence (as auto-positional and authoritative decision) to align different philosophies as equals with regard to the (foreclosed) Real. Deleuze, however, practices *his* philosophy as the one true way—hence also his aristocratic style and distaste for "debate." We could say that "decision" is the lowest common denominator that equalizes all forms of philosophy, whereas "concept creation" is the highest uncommon factor that separates Deleuzian thought from all the rest. And as to the plane of immanence, it too is guilty of a form of judgment, according to Laruelle, of giving an image and even a face to the Real:

> The philosophically normal but theoretically amphibological concept of "plane of immanence" means that immanence continues to orbit around the plane and as plane; it continues to orbit around the "to" ("to itself") as axis of transcendence. Immanence thereby remains "objective," albeit devoid of any object; it remains the appearance of objectivity, and gives rise to a new image of the Real and thought. Instead of being absolutely faceless and unenvisageable, it assumes the face of a plane, of a topology, of survey and contemplation.[62]

Of course, Deleuze also says that "pluralism = monism" (the magic formula) in an apparent gesture of egalitarianism. And yet, rather than

pose his philosophy as *one* hypothesis among a plurality of others in the spirit of this multiplicity, it only *appears* to be pluralistic because Deleuze "molecularizes" the Real into "a thousand surfaces." At bottom, such multiplicity is neither here nor there—it is the singular position or positing of "Real = X" that makes of it one more attempted philosophical capture (of "All"), one more authority: "with philosophers there is always at least a philosophical positing, either as Multiple or as One or as One-all, that conserves philosophical authority."[63] The virtual and the actual, the plane of immanence, molecularities, and so on, far from being truly pluralist, reveal Deleuze's tendency to "Platonize in a frenetic manner" within the black box of multiplicity (differential calculus, thermodynamics, bioenergetics, etc.).[64] Whereas Badiou condemns Deleuze for his "Platonism of the One" (in favor of his own, purportedly true Platonism of the multiple), Laruelle would condemn them both. But this would not be on account of one or the other (or both) having or not having a truly pluralist posture but because they are both *performatively* monist—they both adopt singular (auto-) positions and therewith preserve the authority of *philosophy* itself.

Indeed, it was almost inevitable that Laruelle should have written *Anti-Badiou* eventually. With the death of Deleuze and then Lévinas in the 1990s, Badiou used the resulting voids in French philosophy as a springboard for his own creative interventions (*The Clamor of Being* and *Ethics*) that would prepare the way for a new philosopher-king with a neoclassical worldview: Plato plus set theory (this is his own black box). Evidently, Badiou had no qualms over his right to this throne and was well prepared to install this new-old paradigm as soon as his way was finally cleared. Hence it was not long after 2004 (and Jacques Derrida's demise) that Badiou became what Laruelle calls "an apogee of modern traditional philosophy." Introducing the heady mix of (Maoist) politics and mathematical science into philosophy was, at the same time, the gesture of supreme authority and a "re-education" that would also promise a "political action carried out upon philosophy itself."[65] Philosophy, and with it humanity, needs to be purified. With the authority of philosophical history behind him (Plato as the first true philosopher) and the cachet of mathematical science beside him, Badiou was almost too easy a target for Laruelle (to characterize him faithfully is almost to caricature him simultaneously).[66]

It might have been otherwise. Badiou's paramount innovation in *Being and Event*—the equation of mathematics with ontology—might have laid the foundation for a true non-philosophy were it only an hypothesis that thereby equalized philosophy with other knowledges. Instead, it was a *philosophical assertion* (as seen in Badiou's definition of philosophy itself as metaontology). Badiou should have pursued the consistency of this equation to the end and removed philosophy's—or *any* thought's—sole right to metatruth (the gathering of truths created by Badiou's four so-called truth procedures or conditions—science, politics, art, and love). But this was not the case. Philosophy retains a special role, as Badiou writes:

> the specific role of philosophy is to propose a unified conceptual space in which naming *takes place* of events that serve as the point of departure for truth procedures. Philosophy seeks to gather together all the *additional-names*. It deals within thought with the compossible nature of the procedures that condition it. It does not establish any truth but it sets a locus of truths. It configurates the generic procedures, through a welcoming, a sheltering, built up with reference to their disparate simultaneity.[67]

Each epoch of disparate yet simultaneous truths needs *its* archetypal unifier. And for our epoch it is Badiouism. Retaining the role of meta-ontology for (his) philosophy means that it is Badiou who *metaconditions* these four conditions *in the name of philosophy*—he still prescribes from a transcendent auto-position. As such, it is Badiou's philosophy alone that continues to form its world (in particular, the world of mathematics as ontology), even as it basks in the glory of an appropriated scientific rigor (set theory) and an imputed philosophical lineage (Plato, Descartes, Hegel, Sartre, and Lacan). On all these counts, non-philosophy tackles things otherwise:

> To the four "truth procedures" (of which science is one) that sustain philosophy proper ... [non-philosophy] opposes an open multiplicity of "unified theories," each of which takes as object-material the relations between the fundamental and the regional (philosophy + a determinate region of experience: philosophy and politics, philosophy and psychoanalysis, philosophy and ethics, philosophy and art, philosophy and

technology, etc.). Science has no exclusive privilege in non-philosophy, except for that which flows from its privileging within the philosophical material (which, precisely, is no more than a material).[68]

The modesty of Badiou vis-à-vis his discipline—philosophy merely gathers the truths of its epoch—belies the power he invests in his own work in its re-creation of a true Platonism, as well as its recuperation of the philosophical decision.[69] Hence it is no surprise that Badiou must take a classical stand against Laruelle's non-philosophy, reducing his rival's approach to the status of either a derivative or an anti-philosophy (religious mysticism). So, when discussing non-philosophy, Badiou claims that

> the strength of philosophy is its decisions in regards to the Real. In a sense Laruelle is too much like Heidegger, in critiquing a kind of great forgetting, of what is lost in the grasp of decision, what Heidegger called thinking. . . . When you say something is purely in the historical existence of philosophy the proposition is a failure. It becomes religious. There is a logical constraint when you say we must go beyond philosophy. This is why, in the end, Heidegger said only a god can save us.[70]

Of course, as we noted at the outset, Laruelle does *not* ground his approach on the history of philosophy as Badiou imputes here: it is not an empirical thesis based on exemplary proof. Non-philosophy is an experiment in thinking, in some cases in philosophical thinking itself—it is not a history lesson (which would only be one more authority in any case).

Chapter 4 will spell out the concrete implications, for humans and nonhumans alike, of both the position of Deleuze, with his ethics of multiplicity, and of Badiou, in regard to his philosophy of universalist reeducation. For Laruelle, each is seen as an attempt at morphing humanity, under the form of either multiple inhuman becomings or a universal model of (classless) generic humanity. These philosophically pure positions bode ill, however, for as Laruelle cautions us, "purification is always disquieting when we think of what it may have in store for humans."[71] By contrast, what non-philosophy aims for is something more akin to a "Marxist practice"—one that Laruelle depicts as "the transformation of the situation of humans in the world" (who are left undefined and so unpurified)

rather than as the transformation (through becoming or reeducation) of humans themselves. In no way does it rely on an "authoritarian materialist position."[72] It is the situation—the miserable places—that requires change, not their inhabitants.

THE NEW REALISM

The recent emergence of various new forms of philosophical realism and materialism (speculative, object oriented, and so on) might well commend themselves to Laruelle as a group of theories friendly to the non-philosophical approach, albeit still operating within the genre of philosophy. Admittedly, the turn to all things realist, objectile, and thing-like is an orientation in Theory with roots going back more than twenty years—be it the "returning Real" (Hal Foster), "bodies that matter" (Judith Butler), "the social lives of things" (Arjun Appadurai), the "parliament of things" (Bruno Latour), or even the "rights of things" (W. J. T. Mitchell). As Lesley Stern observes,

> the importance of objects is everywhere declaimed. Things—all sorts of things—are on the agenda, clamouring and demanding attention. Witness such recent book titles as *Evocative Objects, A History of the World in 100 Objects, The Comfort of Things, Paraphernalia* and *What Objects Mean,* an introductory textbook to thing theory.[73]

Only now, though, has such thing-theory gained a visible presence within certain philosophical circles. In philosophy of art, for instance, a recent text from this school argues that aesthetics must be expanded beyond the human appreciation of things to the appreciation of things by other things:

> Aesthetic events are not limited to interactions between humans or between humans and painted canvases or between humans and sentences in dramas. They happen when a saw bites into a fresh piece of plywood. They happen when a worm oozes out of some wet soil. They happen when a massive object emits gravity waves.[74]

Likewise, Latour's actor network theory posits itself as a true democracy of materials. As he puts it in *We Have Never Been Modern,* "we are going

to have to slow down, re-orient and regulate the proliferation of monsters by representing their existence officially. Will a different democracy become necessary? A democracy extended to things?"[75] Graham Harman glosses this democracy as the view that "all entities are on exactly the same ontological footing" and that "Latour's guiding maxim is to grant dignity even to the least grain of reality" such that "Latour insists on an absolute democracy of objects: a mosquito is just as real as Napoleon, and plastic in a garbage dump is no less an actant than a nuclear warhead."[76] Such egalitarian attitudes do indeed echo various theses from non-philosophy. More generally, there are at least three areas where non-philosophy and the new realisms share common ground: their anti-Kantian stance (the rejection of anthropocentric epistemology); their high regard for the sciences and a broadly immanent, naturalistic methodology; and their democratic invocation of matter as a worthy philosophical subject (in numerous senses).

And yet obstacles remain, the most important one being in respect to the practice of philosophy itself. The question of "doing and saying" discussed earlier has great pertinence for the materialization or realization of philosophical method in these movements—especially with respect to the meaning of thought understood as "speculative," as in "speculative realism" or "speculative philosophy." This nomenclature stems from A. N. Whitehead's famous account of speculative philosophy as any "endeavour to frame a coherent, logical, necessary system of general ideas in terms of which every element of our experience can be interpreted."[77] Straightaway, this sets up a contrast with Laruelle's approach to thought that does not see itself as "speculative" in that sense of *one* system of ideas that can interpret "every element of our experience."

Admittedly, Laruelle has sometimes discussed his work in terms of "hyperspeculations," but this phrase is normally equated with another name for non-philosophy—"philo-fictions" (to be discussed more fully in the following chapter)—which indicates that it is the dimension of the "hyper" that matters here, that is, what amplifies thought beyond any philosophical realism and into a quasi-fictional, para-realism:[78]

These non-philosophical representations of philosophy, which are organized by new rules, therefore have specific effects, more exactly: hyperspeculative or extra-speculative effects. But they are no longer

philosophical knowledges in the sense of the PSP [Principle of Sufficient Philosophy]. . . . Here one neither produces a literary effect with philosophy nor a philosophical effect with literature, etc.; all these combinations are possible, but they have no usage here except as simple material of hyperspeculation. . . . The products of the scientific and hyperspeculative usage of philosophy have no relevance for philosophy itself, but, since they are obtained on the basis of a material taken from it, they have a philosophical appearance that permits arranging them at least in fiction.[79]

This use of fiction is peculiar to be sure. To begin with, it contrasts with the self-serious rhetoric of most philosophy. Philosophy *takes* itself seriously, that is, it demands that it be viewed realistically (no matter what the content of its theses concerning reality or realism). So, bringing the fictional into philosophy, not as a "literary fiction" that would only sustain the autorealism of philosophy, but as the Real of fiction that disturbs philosophy's claim to understand fiction *philosophically,* must create a different effect from any straightforward antirealism (or idealism). Antirealism is a preeminently philosophical position, as is the view that "all is fiction"—both are serious matters, positions *on* the Real. This is why *Principles of Non-Philosophy* makes it clear that Laruelle is neither pronor antispeculative per se, so much as "nonspeculative"—attempting to expand speculation beyond its philosophical and representational limits. Hence he writes that "the Real does more than drawing specularity out of itself; it gives place to a new organization that we will call *non-speculative,* without which it would be opposed to specularity and its speculative development since it is rather the *identity of speculation.*"[80] The identity of speculation *is* the Real. Like all thought, it is a thing, an object too, *but it is only one*: it is not an exhaustive picture of the Real (as the "speculative realist" position attempts in its own metaphysical poses).[81]

Hence the ultimate difference between non-philosophy and the new realisms is that Laruelle's understanding of immanence is far more radical, involving the *practice of thinking itself*—that is his primary object or material. Understood through radical immanence, nothing can be outside of the Real, including "speculation." Indeed, there remain some among the new realists who claim to bypass the general Copernicanism of "Continental Philosophy" yet who, nevertheless, unwittingly abide by

a representational and anthropocentric imperative for their own thought; that is, they still believe in the power of *human* philosophy to account for the Real. This has even led to some from this quarter charging Laruelle and non-philosophy with "arrogance" for departing from such faith in philosophy. Moreover, the non-philosophical hypothesis of "decision" is itself condemned for a self-attribution of *even greater representational powers* than those attributed to philosophy. However, this judgment (*tu quoque*, again) can be traced back to an inability to interpret a *rejection* of arrogance (or rather, philosophy's "authority") as anything other than simply more arrogance or authority (philosophical narcissism). It is a blind spot in their vision of non-philosophy because certain critics can only think in one mold, that of representational thought, even as they disavow it.[82] In contrast to the verdict that condemns Laruelle's "arrogance," therefore, there remains the option to view his approach according to its own hypothesis: as a thought that is part of the Real as well as an open-ended experiment that revises what thought is—a new experience of thought as immanent.

In fact, one could even see things wholly the other way around and describe non-philosophy as the necessary bedfellow of the new realisms, being the thought that *reorients* realism toward the objectility or materiality of its own practice. In other words, it turns *toward philosophical thought itself* as a realist orientation, stance, or posture: as Laruelle writes, there is possibly "an unlimited multiplicity of descriptions without effect on their 'object' but which this object determines without reciprocity."[83] Objects—like worms or wormholes—determine our thoughts, not the other way around. For some, this reorientation toward thought itself might appear to be a regress to the subject. In fact, it is undertaken as the only way of radically understanding the Real and has no connection to any philosophical "subject" (be it substantial, historical, larval, evental, or whatever else).

Nor is this a metatheoreticism because, as we know, non-philosophy is not a metalevel reflexivity or higher-order representation. So, what might appear to some new realists as Laruelle's sub-Derridean recycling of the history of philosophy and its aporias is, in fact, a realizing of these aporias to render philosophy Real. Rather than simply dismiss the fact that much of the classical philosophical tradition—ostensibly reaching

its zenith in the work of Husserl—was indeed deconstructed on its own terms (a dismissal seen in a good deal of the contemporary backlash against Derrida), Laruelle expropriates these deconstructions into his own account to realize them, that is, to derelativize them of their post-Kantian coordinates. Aporias no longer indicate the performative failure of epistemology so much as the material resistance of the Real to one part of itself (*one* philosophy) attempting to capture the whole through withdrawal.

For Laruelle, therefore, the apparently egalitarian position of the new realisms remains just that, a theoretical position, and in that sense philosophical: "if there is realism it is of-the-last-instance and consequently there is a Real-without-decision-of-realism, realism being nothing but one philosophical position among others."[84] This "Real-without-realism" is not the product of philosophical speculation (no matter how inclusive) but a non-philosophical hypothesis, a posture and practice that takes philosophical speculation itself and reviews it as material. "Things" can only get better (and be treated better) by changing how we view (our) thinking itself. If the problem begins with "us" as "philosophers," the solution must begin with us as well. The Real cannot be captured by any one position, even a realism, simply because each and every -*ism* is *already* actually Real, albeit that the actuality the Real furnishes is always "in-the-last-instance."

This recurring formula of "the-last-instance" is something non-philosophy inherits from Marxist thought and that Laruelle transforms into "determination-in-the-last-instance" (DLI). It is part and parcel of his approach that allows an integrity to objects of all sorts, both human and nonhuman, especially in terms of their epistemic determination (a knowledge "of" them that is not ours but *theirs*). This integral worth of any "object X" is an axiom (from *axios*, "worthy"), a starting point or posture that also leads to Laruelle's reformation of Kantian philosophy on two counts. First, he expands the notion of the a priori beyond its usual remit of conceptual ideality and into concrete, ordinary experience. He does this by making experiences *themselves* an a priori, no longer objectified in an experiential position (a posteriori) by an anthropocentric subject. Second, and now using Nietzsche here, he reconfigures the concept of the *transcendental*, transvaluing it such that it is now understood as constant mutation or autotranscending.[85] It is these three areas of the a priori, the

transcendental, and determination that we turn to next, especially in the context of seeing whether non-philosophy's general approach can be equated with another philosophy: Kant's.

LARUELLE IS NOT KANT: FROM DETERMINATION-IN-THE-LAST-INSTANCE TO THE MUTATING TRANSCENDENTAL

For Marxist theory, the "base" that determines social structures is fundamentally economic. This does not mean that economic structures solely and directly determine everything else about us (many other noneconomic factors intervene) but rather that economics is the ultimate determining cause of every factor, "in-the-last-instance." Laruelle takes this deferral and indefiniteness of cause and generalizes it into the concept of DLI. In this view, there is no supreme "base"—be it material, neurological, linguistic, economic, or sexual (to name but a few candidates). DLI is the general indefinition of cause on account of the Real being the indefinite cause of all. Nothing transcends (is outside of) the Real, so all that occurs is Real, and yet this is not according to any defined chain of cause and effect (material, neurological, economic, etc.). Rather, on any "occasion" (for any event), there is, ultimately, a Real basis to it. This is not to be understood as a "first cause" or ultimate origin of things, no matter how abstract (God, Reason, Desire, the Void, Redemption, the Big Bang, or whatever else). Such purported first causes are still determinate or defined, chock-full of properties (mostly put there by philosophy). DLI is instead a "last cause," though one that is *in*-determining rather than determining.

One should thereby see DLI as an immanent causality, oriented from the Real to the thought-worlds created in philosophy. It is by no means intended to be mysterious, a causality from some kind of "world-behind-the-scenes," however. Though DLI is sometimes given the rather arcane name of "occasional cause," this is only because it is tied "to the moment where it manifests itself." Yet the *present* moment—whatever the occasion—is not the time of DLI as well: *its* temporality is futural and explains why this determination is always *hypothetical* ("what if thought were a thing"): "non-philosophy is entirely oriented towards the future and, more fundamentally, it is entirely oriented towards a utopia of the real."[86] The last instance "never comes," as Louis Althusser (one of the

later Marxist theorists of DLI) once said. In addition, this futurality is neither epistemic (a question of us not yet knowing how X was caused) nor ontological (the thing itself having a future anterior causal existence). The antinomy of being and knowing is a common version of philosophical circularity—whereas all knowing is Real already (but in-the-last-instance, that is, indefinitely).

It is ironic for Laruelle that early Marxist thought overphilosophized this form of causality, reducing it to a materialist position and so proceeding "through a philosophical decision rather than an axiomatic act of 'primary ultimation.'"[87] Both historical and dialectical materialism add an idealist mediation to matter (through history and dialectics) and so lose what is radically undetermined not only in matter but in all causality as such. Hence, and in contrast to this, Laruelle's DLI is an "underdeterminate and even indeterminate causality, the conjugation of the four causes having a part of their power become diminished."[88] Consequently, historical materialism is "profoundly transformed" in non-philosophy.[89] Aristotle's four causes—formal, material, efficient, and final—are left underdetermined rather than one or other of them being elevated over the other three. Significantly, each object is now allowed *its own causality,* in-the-last-instance, of its knowledge and status as a "known object":

> The "real" solution to this problem of the DLI as object and cause of its own theory must avoid Hegelian idealism even more than materialism does. Neither cause in exteriority or dialectical identity of contraries, the Real is cause through immanence and determines the knowledge of its own syntax, of its causality, through a process that we will call cloning. In other words, the object X to be known must be, *on the one hand,* tested as radically immanent (i.e. seen-in-One, object of the vision-in-One) so as to be able to itself determine this form, and, on the other hand, its own knowledge. This determination is a cloning through itself, but as One or immanent, of its knowledge. . . . The object X is identically—without being philosophically divided—cause-of-the-last-instance of its knowledge and known object.[90]

Each object has its own causality and self-knowledge restored, but only in-the-last-instance (otherwise it would be *causa sui,* a notion that

Laruelle rejects as philosophical). As we will see, in the Kantian terms that non-philosophy uses (but radically inverts), this means that each object, seen in-One, becomes its own a priori, without reference to the status of any subject's knowledge of it. The "object X" is an a priori all its own.

Beyond Laruelle's own work, the general turn to immanence in recent philosophy is often linked to a rejection or overturning of the subject-oriented thought of Kant and its Copernican Turn (be it through Deleuze or a host of other non-Kantian thinkers, beginning with Bergson).[91] As we know, what is different about Laruelle's approach is that he connects any inversion of Kant to *the mode of expression of philosophy*. This too must mutate, that is, it must be expanded beyond what we traditionally understand as the virtues of philosophical thought (clarity, analysis, speculation, description, argument, paradox, etc.) once we realize that these epistemic and methodological values are not neutral but are materials to be rethought or reviewed from an alternative posture. They too become immanent and objectile (rather than transcendent and objective).

Nonetheless, there are places where Laruelle, as Ray Brassier notes, "has certainly been guilty of encouraging" the impression that he is a Kantian philosopher using various Kantian terms in a wholly standard way. And this is especially true of his retention of the concepts of the a priori and transcendental.[92] Admittedly, Laruelle does say in this context that he must be allowed "the right, the legitimate right, to use philosophical vocabulary non-philosophically," that is, he should be permitted to use philosophical terms like *transcendental* non-philosophically (extracted from their transcendent and representational usage). Otherwise, he would not be doing non-philosophy at all.[93] As for Kant, he states that "the main axiom of non-philosophy can be formulated in entirely quasi-Kantian terms," but that it nonetheless remains "not anti-Kantian but simply non-Kantian."[94] Laruelle can thereby pose a question such as the following in *non*-Kantian terms:

> We abandon the question: "how are synthetic a priori judgments possible?" for this one: "what can we discover of the new, the non-synthetic, with the help of synthetic a priori judgments, i.e. with philosophy?" This is the whole problem for non-philosophy, *if we can summarize it and present it with Kantian material.*[95]

Consequently, this "Kant" is retained, not through subsuming non-philosophy back into the representationalist tradition but through a "new, non-Copernican path to the transcendental." The Copernican "Revolution," so-called, is thereby "radicalised, i.e. destroyed."[96]

This radicalization involves the transcendental as well, after it has been rendered mutational. This non-philosophical transcendental is what *self*-transcends, as opposed to the philosophical transcendental that auto-positions (and hopes to transcend the Real). In Laruelle's earliest, Nietzschean period, this was simply named "transvaluation," yet even then (in the 1970s) he regarded this as an immanent rather than metalevel procedure:

> transvaluation is not a super-method or a meta-method, it emerges with the transcendental itself, or rather, with its will to auto-suppression or decline. It is the *telos,* at once internal and external, of the method . . . a *telos* that programmes its own destruction.[97]

This nonstandard treatment of the "transcendental" is a feature that has remained present throughout Laruelle's work. In his later texts (*Philosophie non-standard* and *Anti-Badiou*), the vocabulary of the transcendental is made even more starkly immanent, having being physicalized as "undulatory" matter, or an "immanent undulatory [that] is also a transcending, but a simple one (an ascending), superposable and become under-determining."[98] It is now described as the (quantum) wave that embodies a "transcendental movement, the gesture of a surpassing of itself in itself."[99] Indeed, such is this internalization of the transcendental into the Real that Laruelle can also pass over to speaking of the "immanental" instead, so that it is immanence that transcends itself. As Anthony Paul Smith points out:

> In his earlier work Laruelle describes the "transcendental" as "rigorously immanent." In *Philosophie non-standard* Laruelle sees fit to simply coin a new term, "immanental," which describes the "non-relation" between immanence as such and experience. It is then a posture of thought, like the transcendental, but one that happens within (hence the non-relation) the experience and immanence itself.[100]

However, the nonrelation of immanence and experience does not leave the empirical *opposed* and outside of the Real—theirs is not an *anti*-relation.

Experience too has its non-Kantian transvaluation in terms of a realizing of the a priori that in Laruelle's hands is no longer an epistemic ideality. The following passage from *Philosophy and Non-Philosophy* shows how non-philosophy also reworks (philosophy's) a prioris into (its own) *experience*:

> The true advances, ruptures or mutations of thought do not consist in extending the existing phenomena a little further or in tracing the continuities, *in passing from the modes to the infinite or unlimited attributes, from the empirical to the universal a priori*—this is philosophical practice—but consist rather in relativizing the essences, which were presented as real or absolute, to the state of modes, effects or particular cases of a new thought; in treating the elements, ethers and attributes as modes, in treating philosophy's *a prioris* as the empirical; in unmasking the abusiveness of the so-called "universalities" that are always found to be forms of ancient thought seeking to perpetuate themselves.[101]

Here the a priori becomes an experience rather than the intraphilosophical "*form* or a *condition*" that it has been in philosophy from Kant to Husserl.[102] Indeed, Laruelle's earlier work described such real a prioris as "residual objects," a notion that can be related to Anne-Françoise Schmid's subsequent theory (not unconnected to non-philosophy) of "integrative objects" (which we will return to presently).[103] One might say that what Laruelle does to philosophy as a whole—render its conceptuality into a material for experimentation—is done in micro upon the a priori, only it is achieved by making experience come before philosophical "experience," by rendering it an a priori that no longer abides by the distinction between regional (or "ontic") and essential (or "ontological").

Another interesting philosophical influence on this view comes from Mikel Dufrenne's "inventory of [local] a prioris," which Laruelle cites in an early text.[104] As Edward Casey's introduction to the English translation of *The Notion of the A Priori* points out, Dufrenne extends the limits of the a priori by "taking the object's point of view first":

to the Kantian "formal" a priori he adds the "material" structures of the great regions of reality described by Husserl, as well as the entire group of values, affective qualities, and even mythical significations which compose the categories of feeling or imagination. This extension necessarily plunges the a priori into experience; in its "primitive state" [a l'état sauvage].[105]

Though experiential, these local a prioris cannot be learned—they are "already there, preceding all learning and genesis." And yet, though still a priori, these experiences are not universal either, and can even be missed due to enculturation—the "necessity of the a priori is not necessarily felt," as Dufrenne puts it.[106] He continues thus:

> To apprehend the essence, we must have recourse to experience, that is, to objects considered not as examples, but as problems: what are the specific characteristics of a certain stone? Yet when I discern something savory in the taste of fruit, grace in a dancer's movement, or youth in a child's countenance, I immediately discover the essence of the savory, of the gracious, or of youth. These essences do not serve as examples, but as notions by which my implicit knowledge is awakened or reanimated. Such essences are a priori because they are immediately given by experience and not learned more or less laboriously from experience; I already possess them in a certain sense.[107]

Such a leveling, with experience no longer merely in support of the a priori but identical with it (yet without resorting to idealism), has an obvious connection with Laruelle's stance. Does this make Dufrenne a non-philosopher avant la lettre? The preceding passages might lead one to respond positively. An irredeemable difference, however, lies in Dufrenne's retention of the phenomenological method in his general approach, for the experiences he has in mind are still anthropocentric rather than the radically asubjective experience that Laruelle utilizes. The "object's point of view" that Dufrenne supposedly refers to is still the object from a philosophical subject's point of view (a trait that also continues to be found in much "object-oriented" thought that begins from the phenomenological or technological perspective).

Therefore, no, Dufrenne is not yet a non-philosopher, despite his un-

usual approach to the a priori. While we are again making comparisons, two other putative similarities should be clarified here. First, some might argue that Laruelle's real a priori is simply what Kant would have called a "transcendental amphiboly," that is, "a confusion of the pure object of the understanding with the appearance."[108] According to Kant, this confusion can arise either by *intellectualizing* appearances, as he claims Leibniz's rationalism did, or *sensualizing* the concepts of the understanding, as Locke's empiricism is said to have done. Yet Laruelle would fall into neither camp as he places the Real a priori before the philosophical disjunction between sense and intellect. Indeed, making that division already begs the question in favor of Kant's solution to how mind and world interact (which is hardly surprising given the non-philosophical point of view on such circular positions).[109]

RESIDUAL OBJECTS AND INVISIBLE VICTIMS: THE PHILOSOPHICAL ESSENCE OF CINNABAR

This search for philosophical forebears to the non-philosophical Real a priori is something of a red herring in any case, as the following, final section of this chapter can reveal. In fact, the topic of the a priori allows us to finish by looking at an important debate between Laruelle and a number of philosophers that took place at the Société française de philosophie in March 1979. It exposes just how far from standard philosophy Laruelle had already gone, even in his most "philosophical" phase. Having just given an extensive presentation of his "Transvaluation of the Transcendental Method" to the assembled, the subsequent questions turned immediately to the traditionally Kantian distinction between what is lawful (*quid juris?*) and what is factual (*quid facti?*). In response, Laruelle says that he does not wish simply to reject the distinction but "displace" it onto the "residual objects"—or real a prioris—he has been discussing. He continues in the following vein, shifting the conversation from these philosophical distinctions to a peculiar cultural and scientific artifact—red mercury sulfide or "cinnabar":

> With regard to what I call residual objects—that is to say, a prioris that are not (or not just) ideal a prioris—the problem [*quid juris?*] is always

posed of their validity, i.e. the degree of their objective reality, of mea-
suring their capacity to enter into the empirico-ideal constitution of an
object. Because it is not a question of suppressing, in the transvaluation
of the transcendental method, the problem of the objectivity of objects
or of their constitution. It is precisely their unity, their identity, that we
must account for, and which is thus suspended by the method. This is
exactly what I wanted to suggest when I spoke about the "cinnabar" as I
did. Cinnabar is indeed something other than mercury sulphite [sic]. The
ideality of cinnabar, Cinnabar capital C, is an identity that is a circle of
reproduction; it supposes the passage, the composition or the synthesis of
a multiplicity of determinations. There are also various jokes that could
be made about the cinnabar. Cinnabar is an encyclopedia. The problem
always arises, therefore, of a legitimation of residual objects. The tran-
scendental method must, whatever happens, remain critique—a critique
of illusions that arise with respect to experience.[110]

Red mercury sulfide (chemical formula HgS) is being treated as more
than, but *not* other to, its chemistry. It is a residual object or nonideal a
priori that Laruelle is attempting to enrich with cultural inscriptions, while
still realizing "a multiplicity of [its] determinations." The reason Laruelle
chooses to illustrate his approach with cinnabar is partly because the same
example appears in a crucial passage from Kant's *Critique of Pure Reason*
(first edition) on the synthesis of reproduction in imagination:

> If cinnabar were now red, now black, now light, now heavy, if a human
> being were now changed into this animal shape, now into that one, if on
> the longest day the land were covered now with fruits, now with ice and
> snow, then my empirical imagination would never even get the oppor-
> tunity to think of heavy cinnabar on the occasion of the representation
> of the color red.[111]

For Kant, we need stability for any experience to be possible at all (this a
law, a *juris*)—or, as the first *Critique* asserts, "the governance of a certain
rule to which the appearances are already subjected in themselves." In
his actual address to the Société before the discussion ensued, Laruelle
had commented on this section from the *Critique* to show the economy
of his own method of transvaluing the transcendental:

The aim of a transvaluation is thus very simple: it is a matter of understanding why mercury sulphide is not merely mercury sulphide, but an ideality whose a priori constituents are not only scientific laws. "The" cinnabar is part and parcel with its circle of determinations that inscribe it into the web of culture, and first of all into the Greco-occidental field; with its poetry, with its force of imposing itself on us as a myth, and as a joke; of imposing itself on Kant also as an ideal object, an example of an example—without which imposition, perhaps, Kant (as obsessed by chemistry and perception as he was) would have seen that it was also cinnabar that Roman ladies used as lipstick; or that "the alchemical sign for cinnabar is a circle with a central point . . . [or that] the same symbol was later used, toward the end of the middle ages, for the philosophical egg, for the sun, and for gold." "Whence [so the encyclopedia I have just cited concludes sagely, more Kantian than Kant himself] various confusions, against which one must be vigilant." Even more so, Kant could have known that cinnabar is also that red paint known as "minimum" with which any Sunday philosopher, returning to his country home as to his island of truth, would begin by painting the shutters of his understanding, before clothing them in the discrete colours of morality. Did Kant know this? In any case, the *Critique,* which demonstrates so many things, does not demonstrate the true reasons that make of cinnabar an ideality.[112]

Poetry, fashion, domestic decor, humor, philosophical pedagogy—all of these are introduced into the "cinnabar" object alongside its scientific determinations, including the color red. It is an early prefiguring of what could be called an "integrative object" that gathers all discourses together and *into* the object—all of them *equally* real, in-the-last-instance. But the enriched ideality of cinnabar does not make it an *idea* for Laruelle; rather, it renders its new expanse material or objectile. The set of cultural "residues" accruing to it are no longer accidental (the accident–essence dichotomy being somewhat redundant now) but experiential objects *whose identity lies precisely in their being multifold and self-transcending* (rather than a phenomenological or culturally subjective positioning). Though this is an early text of Laruelle's (and so not yet a full-blown non-philosophy), we already see here Laruelle's striving to take philosophical precepts and reuse them in nonrepresentational forms of thinking (the only difference being that here, at this stage, he was materializing *particular* philosophical

concepts rather than philosophy and philosophical positions writ large).

The discussion at the Société then revolves further around the meaning of cinnabar, and it is worth reporting the final exchanges for reasons that will soon become clear. Laruelle's next question came from Jacques Merleau-Ponty (epistemologist and cousin of Maurice), who is left somewhat anxious by the younger philosopher's broad-minded approach:

JACQUES MERLEAU-PONTY: It seems as if you have destroyed chemistry. You yourself said "mercury sulphite" [*sic*]. What does that mean? Are there not questions to ask about mercury sulphite, about what the empirical is and what the rational is, what the formal is, what content is, perhaps what experience and the transcendental are? All these questions can be asked of cinnabar, because there are electrons, wave functions, experiments, etc. in there, but you did not pose them. Lipstick, very well, but...

FL: And why not! There are verses in La Fontaine where he speaks of cinnabar in relation to the complexion of young girls.

JM-P: There are also treatises on chemistry that speak of it.

FL: Chemistry enters partially into "culture." Precisely the object of the transcendental method is to take culture as its object and to "destroy" it.

JM-P: So chemistry must be destroyed in the process.

FL: Not entirely. The problem you raise is either one of chemistry, in which case it has nothing to do with the philosopher; or one of epistemology or the theory of science. As to the latter, I said just now, in responding to another question, that the philosopher intervenes therein only to "destroy" the strictly philosophical part that enters into that "mélange" that is epistemology.[113]

The first important phase in this last exchange is where Laruelle states that "the philosopher intervenes therein only to 'destroy' the strictly philosophical part" of the scientific and cultural blend that is cinnabar or mercury sulfide. Removing the "philosophical part" will then allow us to get to the *Real* identity of cinnabar, which is actually "indifferent to its properties," being itself "a point of condensation of *all of* culture, and not only an object of science."[114] This reference to identity is crucial.

Modernist philosophers like Kant typically understand the essence of an object in terms of one or more *stable* properties—like extension, indivisibility, color (sometimes), and so on—although no single one of then, nor even their aggregate, can identify it exhaustively. The identity of the Real object is described by Laruelle, conversely, as merely its "internal difference" that, contra Kant's stipulation (or law), actually destroys any stability. The identity of cinnabar is not logical but Real and differential: *all* of the object's "residual properties" are on a par, so no one of them *conditions* the rest. Laruelle is not interested in the certain conditions—dubbed "logical"—that make all experience possible. The transcendental is what self-mutates rather than what renders other things immutable. This processual thinking shows just how Deleuzian Laruelle remained at this stage in his thought (he would soon subtract even difference from the Real—as a philosophical projection—to leave it wholly nonrelational).

The second point to note in respect to this discussion of cinnabar is that this emphasis on essences in identifying the Real (object) has remained a hallmark of much philosophical procedure (and authority) long after Kant. Saul Kripke's notion of "rigid designation" is a case in point. Among its other innovations, Kripke's *Naming and Necessity* is celebrated for having argued for the concept of an a posteriori necessary identity (such as between certain aspects of our experience of water and its chemistry). This type of identity would be necessary, even though it is not immediately apparent (it would come *after* experience, a posteriori). So, for instance, that "light is a stream of photons, that water is H_2O, that lightning is an electrical discharge, that gold is the element with the atomic number 79," and so on, are a set of *apparently* contingent (a posteriori) yet still necessary identifications, according to Kripke.[115] In other words, water had to be *discovered* to be hydrogen oxide (H_2O), and it is even arguable that it might have had some entirely different physical basis (though in another world than ours). It is a necessary identity, yet it appears contingent. Kripke explains this anomaly by showing how the contingency of the identity actually belongs to an aspect of *our* understanding of water (some of its phenomenal properties to human perception, for example, may be inessential). This aspect is then confused with what *is* essential to both our understanding and hydrogen oxide, that is, with what is essential to both *in every possible world*. What is essential, then,

pertains to the "rigid designators" that describe the properties of the two (phenomenal water *and* the chemical H_2O) necessary for their detection in all possible worlds.

Yet the problem with Kripke's defense of necessity through scientific essentialism is this idea of "all possible worlds"—the philosophers' new essence—a black box wherein the means for capturing reality are stored. For this is a crucial element of Kripke's "rigidity" between possible worlds, which now takes on the role played by stable phenomena in Kant. A property is said to be essential to or rigidly true of a phenomenon if it is true of it in all possible worlds. Laruelle, conversely, would have to reject the necessity–contingency bifurcation at work here (for begging the question). Pointing to all possible worlds where, on one hand, certain properties reside and will so ever more (rigidly) and, on the other, certain other properties must cede their existence as ephemera testifies as much as anything else to a poverty of imagination.[116] More to the point, it exhausts the Real as only *one* possibility rather than seeing the Real as what makes *any* possibility ("possibly") real. For such a philosophy, the Real is a product of the possible, rather than, as for non-philosophy, the possible being a product of the Real.

Kripke thereby begs the question as to what is possible and what is real by deference to a certain *philosopher's* conception of science (it is quite instructive, for instance, that Kripke actually upbraids Kant for being *unscientific* when he identifies gold with a color, yellow).[117] It is a question of (scientific) authority and philosophical law. In Laruelle's view, however, the human does not "have to search for the real in the possible of the Law, for it is he who gives his reality to the Law and can therefore transform it; *he brings with him the primacy of the real over the possible.*"[118] There is much more possible than what philosophy can imagine (chapter 2's analysis of paraconsistent or philo-fictional worlds will explore why in more detail).

No less than the "rigidity" of water qua H_2O *cannot* exhaust water in *every* possible world (because there are more possible worlds realizable than philosophers will ever allow), so cinnabar is more than (but not other to) the chemical HgS.[119] Contemporary philosophical essentialisms today may turn to the mathematical and natural sciences, not to adopt their style of thought, as Laruelle would commend (their hypothetical

enquiries and experimentation), but to invoke a positive authority, to solve the "hard problems." Laruelle, on the contrary, attempts to deepen the residues of objects like cinnabar and, significantly in this case, makes ongoing and rather strange references to lipstick when doing so. This may well be because, from his "encyclopedia" of cinnabar, Laruelle must have also known that, before the twentieth century, the use of lipstick or lip rouge by a Western woman was often regarded as the mark of a prostitute. Though "ladies" of ancient Rome did also use cinnabar in their makeup, by Kant's era and well after, cinnabar would have mostly been seen on the faces of scarlet women (or actors). Yet this would have been an impossible example for a philosopher to use (at least morally, if not logically). Let me try to explain why.

This example of lipstick, of course, is also of something ephemeral—it wipes off of the mouth quite easily. But even more transient is the possible world to which it belongs—being one of the "worst," most "miserable" places of prostitution. Such a world is not *philosophically* possible within a discourse of authority. As we already learned from *The Five Obstructions,* it is the prostitutes who must stay behind the screen, for what can count as philosophical, what can be foregrounded as an essence, is what belongs to the authorities rather than the minorities (no matter their number). Moreover, philosophy cannot get close to "*really harrowing things*" (as Jørgen Leth refers to them) without transforming them into *its* representation, its "victimology." Certainly objectionable views, such as racism, can be tackled sensitively by philosophers, as can sexism or speciesism.[120] But the idea that philosophy itself—and so every positional -*ism*—is the prototype of all hierarchical thought, even the most benevolent, undercuts what ultimate good such charity can achieve. Philosophy is the medium, the space, of authority, where positions ("of" power) are articulated, where the "circle of determinations" is stabilized and fixed.

Doubtless the politics of privilege and power are at work in numerous domains and in various forms too. Yet, for non-philosophy, it is philosophy itself that is the "eminently political variable," the one that facilitates every inequality:

> From the point of view of non-philosophy, there is not a specifically political domain, though perhaps a political dimension may be possible as

a function of the occasional material that one decides to treat that might be concerned with specific problems of power. On the other hand, it can be called political in the last instance insofar as philosophy is a constant variable of all phenomena and is a "crowned power" of domination. Philosophy is the eminently political variable of non-philosophy.[121]

The prostitute (in Mumbai, or anywhere else) cannot be seen for herself, in person, by philosophy. As radical poor or victim-in-person, she resists and is indifferent to the philosophical lens. In any case, philosophy always holds the camera and casts itself in the main role, the image of the Perfect Human in the center of every shot, *even when it is apparently looking at victims.* As a non-philosopher, though, Laruelle has always been "on the side" of the fallen (including "fallen women"), the unrecorded victims and outcasts. This is not because he is their supposed spokesman or representative but because of the *orientation* of non-philosophical thought, which is cameraless and begins from their "side" by default.

Laruelle also uses the name "Stranger" for these perpetual outsiders to thought and describes them as follows at the end of *Anti-Badiou*: "Man-in-person or the generic Last Instance is he whose 'person' as Stranger prohibits me from recognizing him in himself or from identifying him through given predicates, and who is the object of an obscure or secret praxis that we have called the lived-without-life."[122] Philosophy is the giver of predicates and definitions, but they always only reflect itself and its position. Such narcissism, as we have seen, cannot also avoid rendering Laruelle's non-philosophy into philosophy, be it through Deleuze or Badiou, realism or (Kantian) transcendentalism. The "harassing" (as Laruelle calls it) of non-philosophy by philosophy leaves the former relatively uninjured, however, certainly as compared with philosophy's harassment of the human and how it normalizes man by foregrounding only *its* image of the perfect human (even including deviations from that perfection, which only perversely reinforce its norms). Real damage is done there.

We knew already that the identity of the Real cannot be documented by the "modest" filmmaker (even one who is unfazed by prostitutes), be it shown in a full-frontal image or when placed semivisible in the background. The camera always creates inequalities among images (the possibility of a democratic optics will be discussed later). In addition,

what Laruelle names "the lived-without-life" points in the direction of those *nonhuman* strangers who frighten philosophers even more than sex workers do. These monsters will be the topic of chapter 4, where Kant's second stipulation—after that against an unstable cinnabar—comes into view, namely, the one forbidding "a human being [that] were now changed into this animal shape, now into that one." Instead of the anthropomorphism that renders the world human (the Copernican revolution), Kant's nightmare is of a world where the nonhuman would morph the image of *anthropos*. It would be a counterrevolt against the human philosophy that created man's anthropological "essence" in the first place. This other, nightmarish possible world will only be analyzed, however, after we have looked at the possibility of impossible worlds in the next chapter, worlds where contradictory truths and fictions lie together as equals.

2

PARACONSISTENT FICTIONS AND DISCONTINUOUS LOGIC

Non-philosophy ... must then no longer be read with the codes, grids, norms of philosophy, lest it be unable to be accepted. It is not irrational and chaotic for all that: this is a rigorous thought in its own way. Simply its mode of presence or of reception is no longer the rational, the logical or the eidetic, the surrational or the metaphysical.

FRANÇOIS LARUELLE, *Philosophy and Non-Philosophy*

We do not propose this irreflective thought with reference to any regional model, any experience drawn from a particular scientific discipline. Logic itself is perhaps no more sufficient than any other such discipline. Rather than understanding blind or deaf thoughts on the model of logic, with its formal automatism and "principle of identity," we must render intelligible their practice of radical adequation through *Identity*, doubtless—but a real Identity, not a logical one

FRANÇOIS LARUELLE, *The Concept of Non-Photography*

LOGIC, OPTICS, CUTS

The preceding chapter concluded with the idea that the human, for Laruelle, *"brings with him the primacy of the real over the possible."*[1] In what is both a very Bergsonian yet also non-philosophical point, the Real cannot be conditioned by possibility, for the "possibles" (of philosophical imagination) are retroactively generated by the Real, by a "determination-in-the-last-instance" that attaches (in a manner we have yet to uncover) to human being. As we also saw, Laruelle is non-Kantian inasmuch as the philosophical conditions of thought do not interest him. The "conditions of possibility" of photographic thought, for example (or "non-photography"), is not "our problem," he says.[2] Non-philosophy is unconditioned thought—it is self-standing knowing or "gnosis." As *Philosophie non-standard* puts it, such a gnosticism denotes the "equality

in principle" of all knowledges, and its vision thereby strives to replace the "struggle" between thoughts with an "equalising" *(égaliser)*.[3] The following chapter is designed to examine this unconditional egalitarianism through two models or tangents to Laruelle's enterprise, paraconsistent logic and hyperkinematic film editing, two phenomena that instantiate such an equalizing.

The link between non-philosophy and editing is not being forced on us in virtue of our use of *The Five Obstructions* to introduce Laruelle, however. The references to the visual throughout his work are more than merely circumstantial, for there is an optics that is embedded in non-philosophy:

> non-philosophy is not an intensified reduplication of philosophy, a meta-philosophy, but rather its "simplification." It does not represent a change in scale with respect to philosophy, as though the latter was maintained for smaller elements. It is the "same" structure but in a more concentrated, more focused form.[4]

A "more concentrated" form: this is an idea of philosophical abstraction as physical concentration (which Laruelle also calls "extraction") rather than higher-order representation. One might even conclude, then, that *non-philosophy* is the altered frame rate of philosophy, sampling it according to principles different than those of representation and decision. In *Théorie des Identités*, Laruelle describes an "art of thought" that would be a "mutation in the conditions themselves of the 'optic' of thought."[5] Both film frame rates (as cuts and as captures) and paraconsistent thought are part of this mutation.

In addition, though we will see that editing down to the level of discrete frames brings us to similar bedrock as paraconsistent logic (in that each deals with the limits of what can be seen and thought respectively), the specifically *Laruellean* concept that brings them together is that of "philo-fiction." Just as "Man" is another name for the Real, so "philo-fiction" is another name for non-philosophy, though one that emphasizes more its association with art, and in particular the making of art from philosophical materials. It should be no surprise to note, however, that Laruelle cautions us over any mundane understanding of fiction as a form of misrepresentation:

> *fiction must no longer be thought as a mode of non-being, of the false, etc.*
> *but more positively as a mode of the (non-)One; no longer as a mode of*
> *philosophy, but as an effect of the real's unilaterality.* It then stops being
> *included* and confined in the real interpreted as Being.[6]

Fiction is here divorced from its usual bedfellows, ontology and episte-
mology (what do I know to be real?/what is really knowing?). Laruelle's
fiction is not a position *on* the real; or, as he puts it himself, "we see all
things without ever ob-jectifying or positing them—position is a law of
the World, not of the One-real—: this is what we call 'vision-in-One.'"[7]
Philo-fiction (also called "fictionale") is an experience rather than an
ontological position:

> These forms must not be understood as its continuous modes, it is rather
> the fictionale that must be thought as a new experience (very "ordinary,"
> but hidden from the eyes of philosophers and of the World) where fiction
> stops being the simple attribute of another activity and instead becomes
> a lived experience in-the-One in the last instance. Fiction is in itself a
> radical subjectivity and must be recognized as an autonomous experience
> before giving rise to technologically produced effects.[8]

If the Real is experienced as "nothing-but-real," then fiction, commensu-
rately, must no longer belong to the "order of the false," to a "least-real"
or "non-being."[9] And such a reconfiguration of fiction requires a rebel-
lion against "philosophy's authority" over it: fiction must no longer be
subordinated to the judgments of philosophy. Instead, philosophy will
be made to "reenter" through fiction and be conceived as a mode of the
"radical experience" of fabulation.[10] As an "avowedly *utopian*" form of
thought, the non-philosophical imperative is to hypothesize *and* construct
a better place for the human.

One of these experiences of fiction is of an a priori, but it is an a priori
of the "*im*possible" (contra Kripke's possibilist account). This experience
of both fiction and the impossible will obviously be crucial to an intro-
duction to non-philosophy in terms of both paraconsistent logic and
cinematic storytelling (especially one operating on the cusp of fiction and
nonfiction, as *The Five Obstructions* does). Laruelle clearly articulates the
terms for this engagement in his *Anti-Badiou*:

The Real as a priori is impossible—for . . . logical contradiction, but it is in this way that it gives or makes visible originarily (that is to say, transforms) logical contradiction, and all those principles that Aristotle charged philosophy and the real with, as Being and Thought. Alongside the truths of fact and the logical truths that are the funds of philosophical commerce, transforming them by "impossibilizing" them, the Real manifests necessary and impossible truths, truths whose impossibility is necessary. The Real is impossible when it acts as Other-than particulate or a priori; it is *the a priori of impossibility* necessary to under-determine or to transform the given world or the possible world, suspending the sufficiency of logical possibility, illegalizing legality without destroying it, putting into effect everywhere an impossibilization of functionings without annihilating them.[11]

Fiction, therefore, will be a key category for this chapter, but one that is nonconsistent with misrepresentation and a philosophical epistemology predicated on being (an idea that will give us an initial motive to compare Laruelle with Alexius Meinong's nonontological objects). And logic too will be central, but a discontinuous one that emerges from cinema's (visualization of) movement, a movement that some logicians (Graham Priest especially) have likened to paraconsistency, with the notion that a "cinematic account of change" is a form of realized contradiction.[12]

PERFORMATIVE REALISM: ON DERRIDA

This chapter's first epigraph notes that, for all its apparent heterodoxy from the norms of reason, logic, or *eidos*, non-philosophy "is not irrational and chaotic," being a "rigorous thought in its own way."[13] This rigor, we will see, is connected to fiction because it operates through "an invention by fiction and rigor of philosophical possibles."[14] But before engaging with the logic of fiction, we should first note the performative mode of logic, both consistent and inconsistent, that is largely operative in Laruelle's work. One must always remember: as performative, non-philosophy thereby "exhausts itself as an immanent practice rather than as a programme." Hence, one must ask what non-philosophy *does* (be it with philosophy or any other field), before asking what it is. Its being is its doing.[15] This

performative practice involves redescriptions or clones of philosophy "alongside" the Real, or as Laruelle also puts it, "the unlimited redescription . . . of vision-in-One itself."[16] And there is a radical consistency to this, because non-philosophy treats *itself* equally with how it treats others—as physical. This is another way of saying that it does what it says and says what it does; but it is also a way of underlining how non-philosophy "equalizes," how it aspires to be egalitarian *with itself.*

This nonreflexive, but performative, consistency is exemplified in Laruelle's renowned discussion with Jacques Derrida, held in connection with the publication of the former's *Philosophies of Difference.* In that book, Laruelle had faulted his former role model for not having been consistent in his critique of logocentrism and having established a new philosophical authority through the promotion of "*différance.*" What they once shared was the imperative to move away from philosophy qua logocentrism (even if complete escape was always impossible), or at least to dethrone it. Where they now differ is the degree to which one must utilize *other* means to enact this rebellion, and to what extent all thought—not just classical logocentrism—might be implicated as "philosophical." So this encounter marks the moment when Derridean deconstruction met with Laruelle's "postdeconstructive" or "non-Heideggerian deconstruction."[17] Of most significance for us, their dispute highlights a difference between them as regards the nature of fiction, as well as that respecting the Real. For Laruelle, fiction is not a literary or even linguistic genre into which philosophy can be subsumed but a "scientific philo-fiction" that "imposes upon philosophy a physical rather than a linguistic model." As fiction belongs to the Real, any consistent attempt to "literaturize" philosophy must implicate itself as a performance within the Real as well, irrespective of the bizarre outcomes that might follow.[18]

The poststructuralist turn in philosophy is often marked by Derrida's interventions of 1966 and 1967 (especially the lecture "Structure, Sign, and Play in the Discourse of the Human Sciences" in 1966). Here certain positive terms of structuralism, such as *law, science,* and even *structure* itself, were put under the same differential analysis that structuralism had already applied to its classical objects—authorship, meaning, consciousness, history, and so on.[19] Doing this left the primary status of structuralism's core concepts undecidable, thereby rendering structuralism's claim

to be an objective science untenable. When structuralism turned (on) itself (and so mutated into poststructuralism), it still did so, however, in an avowedly reflective and reflexive mode of heightened self-awareness. Of course, this metatheoreticism is not amenable to Laruelle because non-philosophy is not an order of representation, higher or lower. That is why, for him, Derridean metaphilosophy is simply more philosophy, and no less so even when in its latter modes of literature-as-philosophy or theology. Even at its most transgressive, it still represents philosophy, literature, or religion through the exalted form of philosophy, which is the philosophical gesture par excellence.

That, at least, is what Laruelle puts on the charge sheet against deconstruction. Is it reasonable, though, and is it actually *consistent* of him to have done so? The conflict between what Laruelle sees as Derrida's still all too philosophical work and his own mutation of it into performative practice, and so non-philosophy, will give us call to question whether Laruelle's logic of consistency is itself immune from non-philosophical mutation. It is certainly debatable whether Laruelle is fair to Derrida in seeing him tied to (one definition of) philosophy. All the same, one highly visible outcome from their dispute is that Derrida does come close to saying that, irrespective of what philosophy might be, Laruelle is practicing an impossible thought by *any* philosophical standards. And it is this notion of "standards" that Laruelle contests.

To begin with, then, the following quotation is indicative of Derrida's general problem with non-philosophy:

> My first question—a big one—concerns the reality of this real which you constantly invoked in your talk.... You oppose reality to a number of things; you oppose it to totality—it is not the whole, beings as a whole—and you also stressed its distinction from effectivity and possibility. The distinction between reality and possibility doesn't look all that surprising. But what is rather more surprising is when you oppose reality to philosophy. If we were to ask you in a classical manner, or in what you call the ontologico-Heideggerian manner "What is the reality of this real?," and whether it is a specification of being, you would I suppose dismiss this type of question, which still belongs to the regime of ontologico-philosophical discourse, and even to its deconstruction, since it is easy to assimilate the latter to the former.[20]

Derrida here adopts the pose of the "classical" philosopher, assuming the pertinence of a certain kind of question, even to those who absolutely disagree with the view that philosophy can question *everything*. But given this pose, Derrida then goes on to ask Laruelle about the provenance of his idea of non-philosophy: if it does not come from philosophy itself, where does it come from? And to this provocation, Laruelle replied:

> *I get it from the thing itself.* This is as rigorous an answer I am able to give. Because the criterion for my discourse was a rigorously immanent or transcendental criterion, there is no other answer I can give.[21]

Here is the instance of bizarre, yet rigorous, consistency. If Laruelle is to avoid offering a sufficient (philosophical) reason for his account of the Real, then he must abandon all discourse of "accounts of" in favor of performances that emanate directly from the Real—yet without representing it. He begins, as he puts it, "directly from the One, which is to say from the most radical experience there is. You have to start from the real, otherwise you'll never get to it." Thought is not *about* the Real (its putative substance, its identity, or its difference); rather, it is seen anew as aligned to the Real in a nonrepresentational manner. The Real itself, of course, is "absolutely indifferent to philosophy" *no less than* it is indifferent to non-philosophy, understood as a thesis *about* the Real.[22] That is why non-philosophy must be understood as a performance that practices the Real, a "performative realism," so to speak, that sees all thoughts as equivalent, each one being as equally foreclosed to the Real as the next. (How Laruelle's practice might be evaluated as "more" performative than Derrida's—given our earlier discussion of the immanent performativity of everything—will be addressed in our final chapter.)

Unsurprisingly, the philosopher's reply to all this will be "how does he know?" How does Laruelle *know* that non-philosophy thinks "alongside" the Real, for example, rather than "about" it? As he acknowledges elsewhere, philosophical questions "have" to be asked, or at least they "will" be asked (their necessity is entirely philosophy's). How, for instance, "is this exit of the One out of philosophy possible, this detachment of the real from the metaphysical will?" To this Laruelle responds by saying that "there is no scientific and dualitary answer to this question"—that is, there can be no non-philosophical answer to a question posed philosophically

and demanding a philosophical response, which would be, of course, that it is "impossible to 'exit' radically from the circle of unitary philosophy, because the real, at least half (difference), is comprised by philosophy and because philosophy's decision is the real's co-production."[23] Philosophy holds all the keys to the exit doors and keeps them locked.

Naturally, Derrida does not see Laruelle's realism in these non-philosophical terms. Instead, he views it as a species of trickery: "here, all of a sudden, I said to myself: he's trying to pull the trick of the transcendental on us again, the trick of auto-foundation, auto-legitimation, at the very moment when he claims to be making a radical break."[24] From Derrida's vantage point, Laruelle speaks like a philosopher, thinks like a philosopher, and so is a philosopher. The indictment against Laruelle is that he is guilty of either self-deception or philosophical disingenuousness, as indeed Laruelle then acknowledges in his next response:

> I have to tell you that this is an absolutely standard, normal, common objection; it is always the one people put to me first: "You use philosophy in order to talk about something which you claim is not philosophical." Listen . . . the objection is so fundamental that it is tantamount to indicting me of a crude, rudimentary self-contradiction. It is entirely obvious that I allow myself the right, the legitimate right, to use philosophical vocabulary non-philosophically.[25]

Yes, Laruelle uses terms like *transcendental* non-philosophically (that is, extracted from their transcendent and representational usage)—they are performed or enacted to give them a new status and produce a different experience. And doing so also ensures that Laruelle does not fall into self-contradiction: "since I take as indissociably given from the outset a certain use of language, which is not that of the logos, and the One which founds it, I do not contradict myself, I do not relapse into philosophical contradiction."[26]

Yet we should also note this telltale reference to "philosophical contradiction" again, as Laruelle equally claims that "I absolutely do not overturn philosophy; were I claiming to overthrow it, it would be a pointless gesture, a zero-sum game. The entire enterprise would then be contradictory."[27] These references to noncontradiction—one of the three tenets of classical

logic and philosophy—beg the question as to what kind of *nonstandard* noncontradiction, if any, might be in play here, and so also what other kinds of consistency. Might there be types of the two such that non-philosophy, *to be itself,* must not and cannot argue along the old lines that invoke "a requisite degree of internal rigor or consistency" as though these were neutral, one-size-fits-all ideals?

Picking up from our last discussion of this inconsistent rigor in the introduction, we are led to a number of questions. Are rigor, consistency, and noncontradiction philosophically fixed and transcendent, or are they mutable? Is it judicious of Laruelle to insist on non-philosophy being consistent throughout his work? Indeed, is his insistence on consistency or rigor in formal argument a legacy from philosophy that he cannot do without? Furthermore, is Laruelle being consistently non-philosophical in his constant valuation of consistency?

That philosophy adopts a *singular* consistent approach to consistency is all too evident to Laruelle. It is a "habit" of philosophers, *Philosophies of Difference* tells us,

> of somewhat artificially raising problems of doctrinal coherence in order to give oneself the function and the "benefit" of resolving them. "There were no contradictions! See how good and clever I am, how I have saved this author!" "There is an insurmountable contradiction: see how I know the author better than he himself, how I myself am a good author, more Kantian than Kant, more Spinozist than Spinoza!" In order to avoid this Samaritan poison, we will postulate immediately that all these authors are not only systematic but—taken in their totality—coherent up to the point of their sometimes unbridled manner of making Difference play. We will posit their internal rigor in order better to reject them globally.[28]

The philosophers who make "Difference play"—Nietzsche, Deleuze, Heidegger, and Derrida—were the subject of *Philosophies of Difference* in 1986. Yet five years later, Laruelle could write in *En tant qu'un* that "non-philosophers are not anti-philosophers. They are without doubt more Spinozist than Spinoza, more Nietzschean than Nietzsche, and perhaps also more Heideggerian than Heidegger, etc."[29] Consequently, the question that has to be asked is whether Laruelle himself is trying to

be more Derridean than Derrida. Is the rigor and consistency that pushes the logic of antilogocentrism to its absolute end in Laruelle's practice not *itself* a fall into a peculiar self-contradiction of his own making, hoist by his own petard, so to speak?

This demand is certainly a standard kind of philosophical retort, seeing any consistency (even of inconsistency) as uniform and uniformly applicable and, thereby, self-annihilating or suicidal. Such a strange inconsistency as Laruelle's (concerning consistency) might be assuaged, however, through a typing process that would hypothesize different types of noncontradiction and consistency at work here too. Of course, it is difficult to deny that an ongoing condition of any thought is the desire to avoid contradiction, even at a metalevel (in the consistent implementation of inconsistency as a value, for example). Alternatively, though, one could also question whether Laruelle's suicidal logic is one and the same throughout its enactment or performance. It might be that this very act of Laruelle, the suicide bomber that "mimes" Derrida, is actually necessary qua performative gesture because it could also *force* the creation of new forms of (in)consistency *through its performance.* The logic *is* suicidal or auto-destructive, but it can also be seen as creative ("explosively" so, as we will learn) when it forces another way of envisioning Laruelle's acts beyond the usual judgments of arrogance, naïveté, self-deception, or disingenuousness.

When non-philosophy is turned around to look at its own key term of consistency, *in a non-philosophical mode,* it will then be to inflate its meaning and so also the meaning of non-philosophy. Or rather, when it performs consistency in a non-philosophical mode, as a more "focused" image (of) philosophy, it thereby generates new forms of consistency, which we might label "paraconsistencies," so long as that term is not understood to be solely reducible to classical logic. The threat of precisely that reduction occurring will be examined in the following.

A PHOTOGRAPHIC TANGENT: THINKING, FAST AND SLOW (THE TWELVE-FRAMES OBSTRUCTION)

The topic of consistency toward philosophy with which we have begun this chapter is both an echo of earlier philosophical encounters in Laruelle's career (in the present case, Derrida) and the release of the topic

into a non-philosophical context, a consistency that is thought *without* philosophy. We will eventually investigate whether there is any original-ity in such a liberated version of the concept when it is compared with theories of paraconsistency in contemporary logic. Our aim, though, will neither be to resist a subsumption of non-philosophy into that logic nor to extol the discovery of a model in logic for it. Rather, it is the idea that paraconsistent logic can be materialized, that it is a material (like all thought), that can act as another introduction to non-philosophy. And we will arrive at this material view of logic through cinema, in particular, the technologies of photographic capture and editing.

Certainly Laruelle's own concept of "non-photography" is first posited against any standard philosophy *of* the photograph: "photography must be delivered from its philosophical interpretations," he declares.[30] There is a radical experience of photography—its own a priori—that must be recovered from beneath the layers of mediation cast over it by two cen-turies of philosophy of art. Indeed, the (non-) philosophical thinking that belongs to photography is what Laruelle gestures to throughout *The Concept of Non-Photography*: "for photography, when we think it, also thinks; and this is why it does not think like philosophy."[31] Laruelle's usual task of discerning all the philosophical hybrids, correlations, or "empirico-transcendental" doublets blocking our view of the Real can also be found in philosophy's overbearing relationship with photography:

> If we wish simply to describe or think the essence of photography, it is from this hybrid of philosophy as transcendental photography that we must deliver ourselves, so as to think the photographical outside every vicious circle, on the basis of a thinking—and perhaps of a "shot"— absolutely and right from the start divested of the spirit of photography.[32]

By contrast with the circular attempts "to photograph photography (the philosopher as self-portrait of the photographer)," we are offered a non-philosophical exercise in "describing it as a thinking."[33] Photography is "a technique that simulates science," offering us the same "flat and deaf thinking, strictly horizontal and without depth, that is the experience of scientific knowledge." As its own "purely transcendental science," the photo feels like those "flat, a-reflexive, ultra-objective thoughts that are a discovery of scientific modernity."[34] In fact, it was such flat, "irreflective

thinking" as this that enabled both the "non-Euclidean" and the "non-Newtonian" mutations in geometry and physics. Photography, then, shorn of the philosophical aesthetics it must so often endure, is a science, a non-philosophy, and it makes real discoveries. To be sure, Laruelle is not the only person to say that photography must divest itself of philosophical aesthetics (Vilém Flusser's work also comes to mind), but the broader context in which he says it, involving the radical inversion whereby photography might change philosophy too, is strikingly different.[35]

If one purpose of *The Concept of Non-Photography* is to relieve photography of its "philosophical residues," then one of these residues must be the representationalist fallacy ("thought is *about x*," "images are *about y*"): "for common sense, and still for the philosophical regime, an image is an image-of . . . a photo is a photo-of."[36] But for non-photography the photo is no longer *of an object,* it is its own Reality: it photographs, or puts "in-photo," the Real. Hence Laruelle seeks an "*a priori* photographic content—being-in-photo."[37] This is the most materially abstracted, simplified, or condensed aspect of what he calls the "photographicity" of photography. And this photographicity, or being in-photo, is a "pre-analogical" or "prepredicative" semblance, one that stems neither from "iconic manifestation nor from pragmatics or the norms that make of the photo a visual index, but from the photo's non-specular manifestation of Identity."[38] In other words, the thinking of photography, or "shot," is not *constructed* by an extension of a philosophical model of thought (in its illustration through a photograph). Rather, it is native, or immanent to the photo, and is only discovered by a non-philosophical stance or "posture" toward it.

One of the a prioris for cinema, that is, one of the perceptual constants that allows it to exist at all, is the frame rate of capture and projection. Below a projection rate of eighteen frames a second, "seen movement" is not seen at all. Instead, and depending on the slowness of speed, what is seen is a set of phenomena ranging from one still photograph replacing another to a flickering mélange of still images. At about eighteen frames a second and above, however, smooth movement is seen.[39] With the introduction of sound into cinema from 1925 onward, twenty-four frames a second became the standard projection rate to provide both seen movement and sufficient sound quality. Images can be *captured* at various

speeds, of course—through slow or fast "cranking"—but the projection rate is a less plastic condition if we (or at least neurotypical *Homo sapiens*) want to see certain "reality effects."

Editing is another cinematic a priori inasmuch as certain maxima (long takes with no cuts) and minima (cuts every *n* number of frames) are involved in what allows us to discern figures, movements, and even story. Above a maximum, and one has no cuts at all, just a one-take film such as Alexander Sokurov's *Russian Ark* (2002). This upper limit is benign enough in terms of individual films because all of them do have at least one cut, at the very end (without it, we would not have *a* film at all). The lower limit, however, is far more influential, with edits that can reach the level of single frame numbers and thereby render films unwatchable. One might call the first obstruction that Lars von Trier sets Jørgen Leth, therefore, an impossible a priori. The demand is that he must cut his film such that no single edit lasts longer than twelve frames, or half a second (at the normal rate of projection). By comparison, the average shot length for a highly kinetic contemporary film like *The Bourne Ultimatum* (2007) is 2.4 seconds. Moreover, as Barry Salt's cinemetric studies have shown, the average shot length for films in the golden age of Hollywood (the 1930s and 1940s) was between nine and ten seconds. Cinematic time has evidently accelerated since then, but it would seem that von Trier is simply being "sadistic" in his demand for a remake of *The Perfect Human* at such a visually incomprehensible rate.

The others parts of the obstruction are not so onerous: the questions that the original short asks—"what is this human doing?," "how does he move?," and so on—have to be answered in the remake; the film must be shot in Cuba (where Leth has never been); and finally, Leth cannot use a set for the film (as he says he would have preferred). It is the stipulation of twelve frame cuts that is least possible in all of this. Indeed, von Trier believes that this demand will ensure that *The Perfect Human* is "ruined," and he will have thereby fulfilled his agenda to push Leth "from the perfect to the human." We should note that this positions *Leth* as the philosopher (in quasi-Laruellean terms), one who distances himself from ordinary humanity in favor of perfection—an orientation that von Trier aims to reverse. Von Trier states that he ultimately wishes to "banalize" Leth (and his work), and the imposition of a basic psychophysical limit would appear

to work well in this respect. As Leth remarks, "It's completely insane! No edit more than 12 frames long! It's totally destructive. He's ruining it from the start! It'll be a spastic film."

Naturally, von Trier chose this constraint—enough of a challenge for any filmmaker—in the full knowledge that this would be particularly difficult for Leth on account of his realist preference for long takes in his own work.[40] This is his "soft spot." For Leth, "the part of a film I enjoy the most is when one can feel time flow through a single scene. There should always be room for time. A film should breathe naturally."[41] In his project to destroy *The Perfect Human,* von Trier has done his best here to eliminate this time, yet without going all the way to a film of still images like Chris Marker's *La Jetée* (1962). Mette Hjort detects von Trier's strategy in this obstruction as follows:

> The aim, more precisely, is systematically to target some of the discernible regularities that are likely to figure centrally in any style description associated with Leth. A particular use of the long take is, as Leth himself points out, a recurrent feature of his filmmaking practice, an expression of his philosophy of time, and a reflection of the creative influence that other artists have had on him: "[John] Cage's ideas are reflected in the confidence I invest in the long take, where the contemplation of time and events within a single frame goes on for quite a while."[42]

In the twelve-frame shot, film does not breathe so much as hyperventilate. And yet, in the final product, Leth's ingenuity comes to the fore once again. As Murray Smith describes it, "Leth edits together shots in forward and reverse motion, overcoming the 12-frame limitation to create the impression of smooth, sinuous motion."[43] Sometimes each cut brings a new image, either due to its subject matter changing from a city to a room to a face, and so on, or more often simply by cutting in between mostly medium shots, close-ups, and extreme close-ups of the same subject, which is normally a man or a woman performing one or other action. Most frequent of all, however, shot size and subject are both maintained, but the cuts loop back and forth within one action to create a quasi-movement, albeit one with myriad tiny jump cuts throughout. In terms of content, the recurrent motifs are variations on the themes of smoking, shaving, and falling,

with much emphasis placed on a male performer who adopts a series of poses comprising multiple shots, each of which is no more than half a second in duration.[44] Some scenes have a continuous jazz score, others have a more stop–start musical accompaniment. Throughout, nobody with apparent Parkinson's disease features in the film, nor is there the impression that the cinematographer is "spastic"—rather, the film gains its strange identity of hyperkinetic movement through constant reiteration of the smallest elements.

Leth is pleased with himself and the result he has created for von Trier: "we've got things under control. . . . The 12 frames are a paper tiger!" And even von Trier has to congratulate him: "The 12 frames were a gift! It was like watching an old Leth film!" (though he also comments that "one always feels furious when it turns out that there are solutions"). Paisley Livingston is equally impressed by Leth's solution to the challenge:

> Rapid editing is a clever response to an externally imposed and perfectly arbitrary rule. Looped or repeated shots constitute an ingenious way of obeying the rule while thwarting its limitations, allowing rhythmic editing with short and "longer" shots constructed through iteration of relatively static shots not longer than 12 frames.[45]

The first and most obvious analogue for non-philosophy in all this is the *equality* imposed on the film by this editing restriction. Akin to the equality of notes in musical serialism, the equality of shot length (all are at most twelve frames) is a material implementation of democracy, though it is one that the director, and his editors, discovered when pushed by necessity. Normally, of course, the director is allowed the freedom to pace his or her film edits according to a set of significations that arise from the "demands" of either the narrative or some aesthetic objective. Here the shot length is equalized, or rendered "banal" (to use von Trier's term). Leth gets around the banality or ordinariness that might have ensued from such equality with his own aesthetic skill so that a certain quasi-pacing of different durations is restored. And, no doubt, even if Leth had been unable to achieve this, he might have created visual inequalities (and interest) through the remaining devices left to him—image composition, color, and sound.

All the same, the notion of what constitutes an "instant" is forcibly

destandardized. As Leth admits in an interview after the release of *The Five Obstructions*, "I find it very inspiring to think about what I call 'the instant,' the idea of time as an almost liquid substance. There are these instants that pass and they have to be captured and framed."[46] Leth, of course, understands the instant in terms of a *long take*—a habit that von Trier tries to recondition by reducing the instant to a more literal half-second. The tradition that such temporal realism emerges from, though, is Bazinian. André Bazin, himself a champion of the long take and critic of excessive montage, held that "the narrative unit is not the episode, the event, the sudden turn of events, or the character of its protagonists; it is the succession of concrete instants of life, no one of which can be said to be more important than another, for their ontological equality destroys drama at its very basis."[47] For Laruelle, though, it is neither the short nor the long take, qua duration, that does or does not capture the Real. It is the idea that *any one absolute formula*—philosophical or photographic— could ever capture anything that he disputes.

Indeed, a philosophy *of* fiction and *of* the possible (one that posits both as respectively unreal and prior to the real) only understands thought as enduring "a speed and a slowness that are absolute from the outset."[48] By contrast, in what Laruelle calls "the law of fiction" or "the production of the possible," time can accelerate and must be passed through "diachronically, step by step, necessarily with a wild speed." It is the variance that counts, not because (again) "difference" captures the Real (this would be a Deleuzian cinema theory) but because no one time can ever capture the Real—and this is *equally* true of all, this is their democracy of *varying* instants. There is neither one nor many psychophysical laws that succeed as laws. But there is a multitude of such "laws" that can become non-philosophical objects or materials.

This connection between philo-fiction and variable, nonabsolute speeds of thought merits further investigation. It is notable, in fact, that Murray Smith turns to David Bordwell in his discussion of *The Five Obstructions*'s editing, specifically with reference to this alteration of its basic element:

> It is this "theme-and-variations" structure that bestows on the film its strongly—if not decisively—formalist character. David Bordwell has

proposed the term *parametric* for films which make the systematic atten-
tion to and variation of style a primary focus (a "parameter" being any
dimension of style—shot scale, editing rhythm, film score, for example—
which can be systematically varied). One of the enabling conditions for
such parametric form, according to Bordwell, is "banality" of theme.[49]

Oddly enough, though, Smith does not connect von Trier's stated aim to
banalize a great work of film *(The Perfect Human)* with Bordwell's view
that *all* such parametric films, inasmuch as they operate at a metalevel
to focus the viewer's attention on form over narrative content, are the-
matically *banal* as a result. Bordwell's own view is that parametric films
function by overt contrast with the standard form of cinema, which has
become the classical Hollywood narrative work over the last seventy years
or so. For Bordwell is an essentialist: films fit into two general categories
of norm and transgression, and he rejects the idea that there is *nothing*
cognitively or metaphysically fixed about the conventions of cinema.[50]

No less than Laruelle connects philo-fictional thought with variable
speeds, so too Bordwell links classical Hollywood editing to thought. Here,
though, it is to a forced thought based on the rate and manner of infer-
ences made by the viewer in response to the visual stimuli in any one film:

> When Antonioni or Ozu dwells upon a locale that characters have left,
> or when Dreyer insists upon a character's slow walk across a parlor, the
> viewer must readjust his or her expectation, reset the scale of significance
> to be applied to the syuzhet [story organization], and perhaps play with a
> more open set of alternative schemata. Rhythm in narrative cinema comes
> down to this: by forcing the spectator to make inferences at a certain *rate,*
> the narration governs *what* and *how* we infer.[51]

Some of these inferences are produced in a top-down direction, through
the viewer's own speculations, so to speak. Others are hardwired and
generate more predictable thoughts. In either case, "both bottom-up
and top-down processing are inferential in that perceptual 'conclusions'
about the stimulus are drawn, often inductively, on the basis of 'premises'
furnished by the data, by internalized rules, or by prior knowledge."[52] As
Bordwell's *Narrative in Fiction Film* asserts, the Hollywood story is "the

product of a series of particular schemata, hypotheses, and inferences."[53] When it comes to editing in particular, Bordwell's approach is extremely instructive:

> All of the films I have picked out contain passages of rapid editing, and some present shots only one frame long. Often this technique is motivated by violent action or by tense emotional confrontations; the rapidly cut battle scene or police attack is a convention of these works [in early Soviet cinema]. Just as often, though, accelerated rhythmic editing functions as the narration's instrument. Fast cutting not only embodies causal climaxes but creates rhetorical ones. Any rapidly cut sequence becomes ipso facto significant (not least because fast cutting tends, paradoxically, to stretch out the syuzhet duration devoted to an episode). For the spectator, rapid editing is the most self-conscious effort of the rhetorical narration to control the *pace* of hypothesis formation. We have repeatedly seen that any rapid flow of fabula information [the unorganized story], via editing or other means, compels the spectator to make simple, all-or-nothing choices about story construction. Under the pressure of time—certainly long before half a second—we must give up trying to predict the next image and simply accept what we are given.[54]

For shots longer than half a second, spectators are less passive and able "to apply rhetorical and narrative schemata" according to prototypical units such as "battle," "strike rally," or "police attack," for instance. Ironically, their "decisions" are generated by the material. Shorter than that, and we are in the grip of the film entirely.

The idea that thought itself might have a velocity will strike many as odd, perhaps. How many thoughts can one have before breakfast? Or in a second? Are complex thoughts slower or faster than simple ones (leaving aside what makes any simple or complex)?[55] How long does it take one to draw a conclusion? For Gilbert Ryle, for instance, this type of talk is nonsense:

> "Inferring" is not used to denote either a slowish or a quickish process. "I began to deduce, but had no time to finish" is not the sort of thing that can significantly be said. . . . A person may be quick or slow to reach

London, solve an anagram or checkmate the opposing king; but reaching a conclusion, like arriving in London, solving an anagram and checkmating the king, is not the sort of thing that can be described as gradual, quick or instantaneous.[56]

By contrast, Deleuze and Guattari do attach speed to thinking (when discussing concepts in *What Is Philosophy?*), but only with the more plausible (though ultimately no less fanciful) notion that thought operates at an "infinite speed."[57] This has been literalized in the work of Deleuzians like William E. Connolly, who also argue for a range of velocities of thought, often with evidence taken from neuroscience.[58] Bernard Stiegler similarly talks of intelligence as a "type of mobility, a singular relation of space and time, which must be thought from the standpoint of speed, as its decompositions."[59] But one does not have to be a philosopher to believe that thinking might come in fast and slow variations.[60] Perhaps the oddness here lies mostly in thinking that such speeds could be *measurable* at all (rather than that they simply have a kind of pace). Yet Bordwell's cognitivist variation on this theme is indeed to link *inferential* thought to the measurable speed of its raw input or stimuli: the faster the pace of the filmic material (its editing), the more the inferential processes must be carried out automatically, bottom up. At half a second (and even "long before" it), we must "give up trying to predict the next image and simply accept what we are given."

In Leth's remake of *The Perfect Human* in half-seconds, however, something more than simply automated thought occurs. In Bordwell's terms, its transgressive, accelerationist cutting highlights its own status as an "art film." On one Laruellean level, its almost complete equality of shot lengths—at least according to von Trier's original intent to banalize Leth—created a democracy of instants, a serial film where no shot is allowed to speak louder than any other. Leth got around this constraint, however, and therewith restored a number of narrative values and inequalities as well. And yet, a second Laruellean dimension occurs at just this moment. For Bordwell, thought (qua pace of inference) follows film (qua rhythm of editing). But Bordwell's essentialism determines that certain kinds of inferences—those maintained by the tenets of cognitivism—are fundamental, and are indeed those that classical Hollywood filmmaking elicits more

successfully than any other cinematic tradition. To put it in the simplest terms, Hollywood caters best for the brain's default inferential system. Anything that transgresses its norms ("art film") tends to be enjoyed at a formal, metalevel only, that is, at the level that brings attention to the banality of the film qua film itself, rather than at the level of a narrative content that the brain is actually designed to enjoy. Consequently, Bordwell's essentialism is naturalistic.

Now, we can imagine a non-philosophical rendering of Bordwell's position without great difficulty: the Real of film is made to conform to one theory (cognitivist philosophy). To invert this, we would have to see the Real of film as foreclosed to any one theory, because each theory-world is immanent to it, equally.[61] Each theory-world (concept of "film") can be as fast or as slow as one wants, for theory-and-film are made for and by each other; or rather, they are the two sides of those philosophies that mediate the Real of film in various ways. Seen through this inversion, one could just as well say that film speed *is a kind of thinking,* or at least the picture of a thinking, and that a "parametric" film thinks at a certain nonstandard frame rate. Film is materialized and made to think in one and the same gesture. The speed of thought becomes the speed of cutting, but not as an input *for human* inferences, but as its own nonhuman form of thought.

In this sense, Leth's restoration of value (and inequality) in the remakes also reverse engineers the very genesis of the cinema in Eadweard Muybridge and Étienne-Jules Marey's protofilmic experiments (that decomposed animal movement into poses). Using his own half-second poses, Leth re-creates a quasi-movement too. In addition, he thereby actually replicates the film projection apparatus (that generates movement from still photographs) in his filmmaking practice. Of course, we can deauthorize this process further and set aside Leth's "genius" (Was not the first remake partly von Trier's idea too? Weren't Leth's editors, Camilla Skousen and Morten Højbjerg, also instrumental in the work, and so on?).[62] Taking this orientation to its radical end, what finally counts is this: what we call "the film-object"—beyond any specific theory of who authors what—*thinks.*

There is indeed a logic attaching to this speed of film-thought, a logic that relates to frames per shot as well as the frame rate of projection.[63]

This would be a physicalized logic that renders abstraction, and the local a prioris of cinema (its "perceptual constancies" of seen movement), as speeds of *extraction,* or *cuts.* This notion of physical "extraction"—close to Laruelle's own use of the abstract, as we will see—will also be linked to his paraconsistent logic on two grounds in the second half of this chapter. First, the equality of cuts in "flattened" editing creates a democracy of thoughts (however miniscule each "decision"—or cut—is) that juxtaposes (or superposes) contradictory positions. Second, the very notion of "consistency" is multiplied in material fashion, such that it now operates as both practice (doing what one says/saying what one does) *and* as the physical manner in which poses are held (or edited) together ("consistency" from *con-sistere,* "to stand still, together"). The physical has multiple consistencies (and logics) all its own, as seen in the (dis) continuity of a scene (or an argument), which is never perfectly smooth but always has jump cuts (or "leaps of logic") of varying dimension, some of them more perceptible than others.

The visual metaphors of logic are neither ornamental nor rhetorical, in other words. Sayings that describe formal logic as a "snapshot" of thought or an "x-ray" of reason can be given a literalist makeover that takes these metaphors seriously. After all, Milič Čapek has shown long ago that, despite the seemingly imageless nature of modern mathematics, there remain "subtle" and "elusive" elements of spatiality *"even in the most abstract mathematical and logical thought."*[64] The metaphorical status of "logical space" in Wittgenstein's *Tractatus,* for example, is clearly open to interrogation on this account: if it is merely a metaphor, why has the particular metaphor of space been chosen and been so effective?[65] According to Čapek,

> there is a perfect isomorphism between physical atomism and the logical atomism of Wittgenstein: the objects of *Tractatus* are as immutable, discontinuous, indivisible and simple as the indivisible and homogeneous particles of classical physics. In both kinds of atomism, change is reduced to the changing "configurations" . . . of these ultimate units.[66]

In what follows, then, a different kind of visual-space will be explored, one that offers up the most far-reaching thought about logical identity,

consistency, and contradiction and that operates alongside what it calls a "cinematic account of change." It is comparable with what *The Concept of Non-Photography* describes as the *real* identity of the photo—"a non-decisional self-identity."[67] The photo itself communicates the "affect and the experience of 'flat thought,'" which is why Laruelle maintains that the photo is an "emergent, novel representation, a discovery, and that it precedes photography."[68] Its identity is neither classical (a "logical" x *or* y) nor a "synthesis of ground and form, of horizon and object, of sign and thing, of signifier and signified." Flatness equals democracy and equality in art and thought, when seen in-One. Flat thought also disallows any disparity between one fundamental domain (philosophy) and other regional ones (photography, cinema, performance). As Laruelle states in *Principles of Non-Philosophy* in reference to the great schisms in Kant's first *Critique*, "one of the particular effects of this transcendental 'democratization' and generalization is that Logic, as elsewhere the Aesthetic itself, escapes the disjunction of intellectual or sensible forms."[69] A non-Kantian cinema, then, no longer has to choose between intellectuality and sensibility: like non-philosophy, it can be both.

LOGICAL CONTRADICTION AND REAL IDENTITY: INSIDE MEINONG'S JUNGLE

"If there is a logic of identities, and moreover an identity-(of)-logic or of the symbols of thought, it is transcendental in the 'pure' or rigorous sense where we have understood it."[70] Laruelle's rigor is his radical consistency of practice: hence, as this quotation declares, it is the identity of logic that is as much in play as any logic of identities, and taken together, they must thereby mutate (understanding the transcendental as a transvaluation). From this perspective, logic has its own objectile identity, but one that shifts and so is multiple. The identity between philosophy and cinema, for example, is material and Real, involving cuts as one example (there will be others). Rather than solely involving the classical logical relation of "A = A" (cinema being philosophical, as if both were themselves immutably self-identical), it is the Real identity of what Laruelle sometimes calls "force (of) vision" or what he later calls "idempotency." Idempotency in mathematics and computing is a feature of repeated operations that do not result in anything additional to their first implementation.

"A + A = A" is idempotent, that is, a nonsummative addition. Likewise, on this view, "cinema + philosophy = thought," equally but differently, and so nonsummatively: they do not add together to *give* us the Real— or something closer to the Real—but are rather equally part of the Real by *not* giving it to us. Where Real identity differs, then, from a singular logical identity is in the varying physical *forms* it takes. And this is true of Laruelle's work too: consistency *in* non-philosophy is not classically or logically identical throughout (which would be a failing in Laruellean terms): it is *really*-identical, that is, it is *non*-consistent in the sense of performing a broadened, *paraconsistent* notion of consistency.

This makes Laruelle non-Aristotelian in a conspicuous fashion. And as J. C. Beall informs us, in this matter at least, such a position still remains heretical within philosophy at large:

> The classic source of much thought about contradiction comes from Aristotle's Book Γ of the *Metaphysics*. To this day, many of Aristotle's views have been widely rejected; the conspicuous exception, despite the work of Dancy and Łukasiewicz, are his views on contradiction. That no contradiction is true remains an entrenched "unassailable dogma" of Western thought—or so one would think.[71]

Nevertheless, Beall goes on to note that more recently, "due in no small measure to progress in paraconsistent logic . . . the 'unassailable dogma' has been assailed." Graham Priest is one of the heretics who has begun the assault on this dogma. The idea that affirming a contradiction leads to triviality, *ex contradictione quodlibet* ("anything follows from a contradiction"), is itself, he argues, a tenet that needs to be challenged. Logic needs to evolve, as indeed it already does in other ways:

> The history of logic, too, bears out the fact that the fallibility of logical theory is no mere theoretical possibility. Our current logical theory has a relatively recent origin. It has been accepted for less than a century, and is very different from its predecessor, Aristotelean logic. It is not even consistent with it. (For example, the theories are inconsistent on the question of the existential import of the A form, and on their analyses of relations.)[72]

The first modern to discover the truth in contradiction was, of course, Alexius Meinong, whose *Gegenstandstheorie* (Theory of Objects) allowed for such hypothetic exotica as square circles and perpetual motion. Non-existent items can still be objects, he affirmed, albeit the objects of an act of *intentionality* rather than as some notionally external thing (he was here still following the neo-Aristotelian stance of his teacher Franz Brentano). Prompted initially by debates in the psychology of play and make-believe, Meinong began developing his theory of "objects outside being" (as Peter Simons dubs it) in 1902, reaching its "programmatic statement" in 1904.[73] Contradictory entities are objects, but not because they actually "exist" or have being *(Sein)*. It is because they have properties *(Sosein, or "being so")* that we can talk about, even if only because "in order to know that there is no round square, I must make a judgment about the round square."[74] Actual being or existence is not the be all and end all for Meinong:

> Now it would accord very well with the aforementioned prejudice *in* favor of existence to hold that we may speak of a *Sosein* only if a *Sein* is presupposed. There would, indeed, be little sense in calling a house large or small, a region fertile or unfertile, before one knew that the house or the land does exist, has existed, or will exist. However, the very science from which we were able to obtain the largest number of instances counter to this prejudice shows clearly that any such principle is untenable. As we know, the figures with which geometry is concerned do not exist. Nevertheless, their properties, and hence their *Sosein,* can be established. Doubtless, *in* the area of what can be known merely *a posteriori,* a claim as to *Sosein* will be completely unjustifiable if it is not based on knowledge of a *Sein*; it is equally certain that a *Sosein* which does not rest on a *Sein* may often enough be utterly lacking in natural interest. None of this alters the fact that the *Sosein* of an Object is not affected by its *Nichtsein.*[75]

Meinong is here talking about abstract, mathematical objects. Alongside actually existing objects (humans, horses, cats), there are various other kinds of objects that do not exist but that we can still think and talk about. Some of them are abstract (circles, sets, numbers), some of them are fictional (Sherlock Holmes, Pegasus, Schrödinger's cat as an imaginary example), some of them (an even smaller number) are contradictory

(round squares, God as necessary freedom, Schrödinger's cat as both dead and alive). But the properties of these last objects *are*, irrespective of their *Nichtsein* ("not being"). Roderick Chisholm further explains this strange idea as follows:

> The two basic theses of Meinong's theory of objects *(Gegenstandstheorie)* are (1) there are objects that do not exist and (2) every object that does not exist is yet constituted in some way or other and thus may be made the subject of true predication. Traditional metaphysics treats of objects that exist as well as of those that merely subsist *(bestehen)* but, having "a prejudice in favor of the real," tends to neglect those objects that have no kind of being at all; hence, according to Meinong, there is need for a more general theory of objects. Everything is an object, whether or not it is thinkable (if an object happens to be unthinkable then it is something having at least the property of being unthinkable) and whether or not it exists or has any other kind of being. Every object has the characteristics it has whether or not it has any kind of being; in short, the *Sosein* (character) of every object is independent of its *Sein* (being).
> ... This doctrine of *Aussersein*—of the independence of *Sosein* from *Sein*—is sometimes misinterpreted by saying that it involves recourse to a third type of being in addition to existence and subsistence. Meinong's point, however, is that such objects as the round square have no type of being at all; they are "homeless objects," to be found not even in Plato's heaven.[76]

The fact, no matter how odd, is that we *can* talk about the different features of square *circles* and square *squares*. It is not pure nonsignifying noise. In which case, what are we talking *about*? As Francisco Miró Quesada explains in "Does Metaphysics Need a Non-Classical Logic?,"

> most authors, like Russell, Quine, and others, consider that inexistent objects are always the same: the null-set. But this belief cannot be accepted because there are nonexisting objects that can be perfectly well differentiated. The traits that distinguish the Olympian god Zeus, are completely different from the traits that determine the Hipogriff.[77]

These homeless objects, from Zeus through Sherlock Holmes to round squares, exist in what was first described by William C. Kneale as "Meinong's Jungle." Other pejorative descriptions for the Austrian philosopher and his views refer to "the unspeakable Meinong" or "the horrors of Meinong's jungle."[78] In his famous essay "On What There Is," W. V. O. Quine likens the jungle to a "slum" (presumably a step up from being "homeless"). Using a caricature of Meinong ("Wyman"), he asserts that his "overpopulated universe is in many ways unlovely":

> It offends the aesthetic sense of us who have a taste for desert landscapes, but this is not the worst of it. Wyman's slum of possibles is a breeding ground for disorderly elements.... By a Fregean therapy of individual concepts, some effort might be made at rehabilitation; but I feel we'd do better simply to clear Wyman's slum and be done with it.[79]

The philosophical distaste for this democracy of objects—that does not bow down to the authority of ontology, a commitment to "what there is"—is obvious. For Quine, as Priest points out, "that which exists is that over which one can quantify; and that's that."[80] By contrast, Richard Sylvan thinks of the jungle as much more than a desert (or quantity survey): it is full of "beauty and complexity, richness and value." It is not the "world of fear, danger and chaos popularly imagined and repeatedly portrayed by Hollywood, but a complex, beautiful and valuable biological community which obeys discoverable ecological laws."[81] Indeed, Priest, following Sylvan, believes that one must posit "impossible worlds" to do full justice to Meinong's views with the idea that, contra Russell, Quine et al., "every term denotes something."[82]

But is this egalitarianism comparable to Laruelle's democratic Real? Yes *and* no. Laruelle's Real is indeed democratic toward entities *almost* to the point of being anarchic—a kind of chaos or "*chôra*," standing against the ontological *archés* of philosophy ("everything *is* water," or "fire," or "difference").[83] Against such encyclopedic thinking come diffusion and leveling: "every encyclopedia will be dispersed, and dispersed by a chaos of identities rather than disseminated or differed by a new encyclopedia."[84] Laruelle is, moreover, highly aware that the main argument of philosophers against non-philosophy is its "ultimate freedom of 'bad chaos,' the precariousness

of the arbitrary, the insane anarchy of whatever conceptual aggregations."[85]

All the same, the psychologistic nature of Meinong's theory is one obstacle to an equation with Laruelle, even when pared down to the most abstract concept of intentionality. The anarchy of Laruelle's Real is nonintentional, that is, it is not due to the waywardness of any representational model of relativism (anything goes *because nothing is real*). Instead, it is an *immanent* democracy that equalizes all thoughts as Real.[86] As Laruelle puts it:

> The old problem of the possibility of knowledge is resolved not by the appeal to a transcendental subject or a ground but by the being-foreclosed of the Real to knowledge, of every object to its knowledge, a being-foreclosed which does not render knowledge possible but determines it.[87]

There *are* comparable traits between Meinong and Laruelle, however. Everything has a standing in the Real, no matter how idiotic or illusory (and that includes the hallucinations of philosophical authority as well). Even references to what is unthinkable (which then at least has "the property of being unthinkable") actually denote what Laruelle would have once called a "residual object"—an object that gathers myriad discourses together. But the language of reference and denotation is actually too transcendent for Laruelle—the intentional object is not a representation, it *is* the object at a distance from the Real. It is the radical immanence of the Real that renders everything "real." We begin with the Real rather than either a mind or a logic still accountable to classical philosophy:

> On the other hand, the vision-in-One is not an intuition or the givenness of an object. Not a givenness, but a given-without-givenness such that the I = I, at its limit, signifies a givenness-without-given or a position-without-posed. Nor an object, which is to say a given through phenomenological distance; it excludes any transcendence from itself. It is neither a substance nor an act, but an identity whose entire consistency is inherence or immanence (to) itself.[88]

Each thing (object, being, life, process) "denotes" itself alone. As a consequence, no philosophy, qua thought *of* the Real, can undo its own

transcendent pose, can reverse its self-imposed distance from the Real. So, for example, where Priest forwards the Liar paradox as both the greatest paradox in Antiquity *and* a contradictory object for modern logic, from the non-philosophical perspective he misses the true target.[89] "A man says that he is lying. Is what he says true or false?" For Laruelle, the paradox must be generalized. It is philosophy that always lies, not merely in this special case of paradox. When discussing what he calls the "last antinomy" in his essay "'I, the Philosopher, am Lying': A Reply to Deleuze," Laruelle asserts that philosophy is always deceptive as regards saying what it does and doing what it says:

> We are now ready to formulate the final problem. If this book [*What Is Philosophy?*] proclaims, more naively than ever before, philosophy's idealist lie, and if it is philosophical *par excellence* (this is its naiveté), is it truly capable of telling this lie or is it lying once more? Does this double lie constitute a new truth or simply a new abyss for truth? Let us give the paradox of Epimetheus [*sic*] a slightly more interesting form by generalizing it: "I, the philosopher, am lying" as the paradox of all possible paradoxes. In order to dissolve this antinomy, which is more powerful than others, would not a radical, absolutely transcendental concept of science be necessary, rather than a weak and "logical" concept of thought as science? ... Philosophy's avidity for "life" and "joy" inclines towards the grave. It is a premature birth kept alive only through artificial means; an abortion that draws life from those who identify themselves with it. It needs this identification to survive. But we who provide it with life, will we one day be capable of no longer lying in the name of survival and of recognizing what is in fact the case: that we continually judge survival in the name of life?[90]

Philosophy, even at its *least* judgmental—as with Deleuze—still deceives because what it judges now is *life* in order to perpetuate *itself,* in order for *philosophy* to "survive" (super-live). Though Deleuze aspires to have Life judge (State) philosophy and morality, what he practices is a judgment of Life by (his) philosophy, whereby "Life" (with certain definitions, hierarchies, exclusions—such as "morality") does the philosopher's conceptual bidding. The practice remains auto-positional, an enactment of itself.

FROM CONTRADICTION TO PARACONSISTENCY: TRIVIAL EXPLOSIONS

If we leave Meinong aside, though, there are other ways to relate non-philosophy to contradiction. As we know, it is possible to read Laruelle's work as a project in realizing aporia—taking deconstructive antinomies as real objects (rather than irreal, failed, representations). This would make the experience of non-philosophy that of realized contradiction—which could then be compared with Hegelian dialectic. In his *Lesser Logic*, Hegel famously comments that

> according to Kant . . . thought has a natural tendency to issue in contra-dictions or antinomies, whenever it seeks to apprehend the infinite. But Kant . . . never penetrated to the discovery of what the antinomies really and positively mean. The true and positive meaning of the antinomies is this: that every actual thing involves a coexistence of opposed elements.[91]

Instead of the antinomies stopping all metaphysical ambition, they become the motor of the Absolute's historical progression. Reality is contradictory in its becoming. Coming from a logical point of view, Graham Priest in his turn argues in tandem with Hegel that "the world is contradictory."[92] Priest looks to Hegel's dialectical logic alongside modern logic as well as various anomalies and inconsistencies in science (such as Bohr's quantum mechanics) to substantiate his approach.[93] He admits that such thinking will not appeal to certain philosophical minds:

> It is presumably the desire to obtain something more algorithmic that is behind the demand that all contradictions should be rejected. . . . Such a demand cannot be met. Neither is there any reason why it should be. These demands are just the last outpost of the "Euclidean" desire for certitude, which, while once common in the philosophy of science, can now be looked upon only with nostalgia.[94]

The reference to Euclid is salient. Indeed, one of the pioneers of con-tradictory or "paraconsistent" logic in the 1950s was Newton da Costa. Significantly, da Costa considered his analyses of inconsistent thinking along the same lines as the development of non-Euclidean geometry.[95]

So, there is initially something for non-philosophy to engage with here. Laruelle would be in accord with this widening approach to paradigm change: "the usage of the non- from which non-philosophy's departure is inspired is that of 'non-Euclidean geometry' in the sense that the non- (which has finally replaced the expressions 'metageometry' or 'pangeometry') simultaneously determines the limits of the Euclidean in geometry and generalizes the latter."[96]

In the contemporary era, that is, from the 1980s onward, paraconsistency was pioneered in Australia through the work of Sylvan and Priest, becoming known as "Dialetheism" in the latter's work especially. *Dialetheia* means a two-way truth, where some sentences are simultaneously true and false. Dialetheism was first mooted as a response to both the liar paradox and Russell's paradox.[97] As Zach Weber points out, though, there is a spectrum of paraconsistent logics, ranging from weaker ones that are simply correctives against incoherence (explaining how we revise our theories and false beliefs) to the "very strong" views (such as Priest's) that hold that contradictions really are true: "this thesis—dialetheism—is that sometimes the best theory (of mathematics, or metaphysics, or even the empirical world) is contradictory."[98] And Priest's dialetheism, moreover, rests its account on nonbeings, on the negativity of contradiction.

Similarly, then, there are places in Laruelle's work where he appears less interested in consistency than inconsistency. The evidence for this comes from his identification of the Real with the One as nonconsistent. In one essay he says that it is

> devoid of ontological, linguistic, and worldly consistency. It is without-being and without-essence, without-language and without-thought, even though it is said to be thus with the help of being, language, and thought, etc. This non-consistency entails that the One is indifferent to or tolerant of any material, any particular doctrinal position whatsoever.[99]

That said, however, Laruelle's identification of the Real with "Man-in-person" describes the latter as "foreign to all inconsistency. It is the without-consistency. Man-in-person or identity can be defined . . . as *the separated middle,* which is neither included nor excluded, neither consistent nor inconsistent, etc."[100] This nuance is important. Nonconsistency is not the

same as inconsistency (nor consistency). The *non-* functions again as a kind of destandardization. Hence we should remain mindful that Laruelle is not Hegelian and regards neither contradiction (qua the negative or nonbeing) *nor* inconsistency as primary. As he writes,

> Fichte arrives at the Hegelian critique which rightly exploits all possibilities of logic, including contradiction and thus the destruction of logic. But with Hegel, this concerns an anti-logical generalization of logic, a complication of Reason, never of the discovery of the conditions of the pure transcendentality of thought.[101]

For this "pure transcendentality," we should turn to Laruelle's more recent language, modeled on quantum mechanics and algebra: "it is enough to understand that the term 'identity'—perhaps not the happiest of terms, given its logical associations—assures the passage between the One (the perennial object of our research) and that of quantum 'superposition,' our key concept at present."[102] A superpositionary logic is a paraconsistent logic, but not a dialectical one (such as Priest's is). Indeed, the difficulty of breaking with logic, contradictory or not, is clear to Laruelle throughout his work. In Heidegger's attempt to "deliver thought from logic," for example, he only proves that

> abandoning logic leaves the primacy of the *logos* untouched and undertakes to *differentiate,* from the real of the essence of Being, this primacy. Wittgenstein, too, attempts to free logic by *breaking,* through language games, this "mirror." But like Wittgenstein, Heidegger fails in the radicality of this project; they ultimately remain "naïve" philosophers because they begin by admitting the pertinence of philosophy and thus of its logical substrate and ask themselves after the fact (even if it is not only after the fact) how to limit logic in thought and the claims of thought over the Real.[103]

There is a contrast between consistency and coherence in contradictory logic that is instructive here, for it too marks out the philosopher at work once more. *Ex contradictione quodlibet*—this "anything" that follows contradiction is sometimes called a logical "explosion." Paraconsistent

theories resist the explosion in the name of avoiding *triviality,* a position or theory wherein *everything* said is true ("anything does go" but only because *everything* is real). Priest and those like-minded can give up on consistency, but must do so coherently, that is, nontrivially.[104] As Priest claims, "everything (including the Aim of it All, the Absolute) is inconsistent. It follows that Hegel would certainly not have accepted that inconsistency implies incoherence."[105]

And yet, following Laruelle's commendation of the "*modelist explosion,*" we might still want to embrace the explosive "suicidally" and ask, what is wrong with triviality, with the claim that everything really is true?[106] The thesis has in fact been seriously defended.[107] And this thesis is not the same as stating that "nothing is real," because this version only saves a pluralist truth *outside* of a representational paradigm: what counts here is that *everything* ("claims" and "statements" included) *is immanently* Real, first and foremost. Truth is plural because it is immanently real. For indeed there are aspects of Laruelle's radically democratic and flattened thought that would point in such a direction: "given the powerlessness of language as for the real, this rule then specifies that *any utterance whatsoever by right can be treated in this way* (and thus can also be reduced to the state of inert material)."[108] Once again, it would appear that if paraconsistency is to avoid "classical recapture," it must think through its equality of statements more thoroughly and engage a wider notion of just how parametric paraconsistency can be—that is, the idea that *anything* can be material, even *consistency* itself.[109] After all, the law of identity in Aristotelian theory is a logical identity (not a Real identity) that rests on a consistency and equality, of "A = A." But that *type* of consistency (and corresponding inconsistency, as in "A v ¬A," "either A or not-A") is also *material.* Bivalent (either–or) logic is molded on one specific type of matter and material consistency, the "classical dimensions of perception and perhaps of philosophical objects," as Laruelle himself puts it.[110] But there are many consistencies to the material Real that we are a part of, not just the one logic of solids (Čapek's logical atomism) but also other possible logics of fluids or gases or quantum events. Consistency has different forms, one of which concerns the way in which a substance, like a liquid, holds itself together—its thickness or viscosity. Cinema too has a variable consistency, how it edits together ("stands still, together"). And Jørgen

Leth, we recall, thinks of time as "an almost liquid substance." Cinematic logic, then, is plastic logic.

Consequently, not all logics have the hardness that a philosophically "rigorous or consistent" argument is said to *have* to follow (by philosophy). This imperative is basically an argument *from argument itself* (the principle of sufficient philosophy). Here a "pure" philosophical thought is understood as logical identity—its asymptote of rigor being circular identity itself. Its first terms are either axiomatic (undefined) or defined in other terms, which are themselves defined in other terms, and so on... that are eventually defined in the first terms ($A = B = C... = A$). The radius may be vast, but it is still a circle. It is on account of such linkages—ones sufficiently complex and lengthy—that the trick can keep going. Such rigor, though, is ultimately the rigor of sameness, of sterility: a rigor mortis—the stiffness of the dead body launched against the living (a notorious Etruscan and later Roman torture). A consistent body of thought is populated with "rigid" designators and robust logic.

This is not to privilege imagination, say, over a hardened consistency (singular) per se, which might then become the hobgoblin of the small-minded. It is to show that there can be different theories of rigor and consistency, though some might find it *hard* to call them "theories" at all, looking as they do more like performative acts. As we will see in the final chapter, the material Real also includes so-called representations as performing parts (with all their various attendant logics). And even axioms, for Laruelle, are not "given" as obvious "truths" but are postures that give rise to so many "axiomatic emissions, the take-offs [*en-vols*] of axioms."[111]

THE CINEMA OF DISCONTINUOUS THOUGHT: A NON-HEGELIAN MOVIE

Throughout his book *In Contradiction*, Priest argues as a modern logician who has taken a Hegelian turn for the "dialectical idea that contradictions may be realised in a process of change."[112] Change *is* contradiction, A *and* ¬A, being *and* nonbeing. Of course, this reduces change to ontological *states*, something that many philosophers of time (such as Bergson) would argue against as inherently nontemporal (time is composed of numerous plastic *durées*, not timeless instants). Priest acknowledges this but nonetheless asserts,

Thus, in a sense, there is no change in the world at all, just a series of states patched together. The universe would appear to be more like a sequence of photographic stills, shown consecutively, than something in a genuine state of flux or change. We might call this the cinematic account of change.[113]

Change is in the instant of transformation, as when a cup "breaks into pieces" and so is right *then* "a cup and not a cup." Or, as when "I walk through the door" and so am right *then* both inside and outside the room (these are both Priest's examples).[114] These are not "vague" states according to Priest (which a fuzzy logic might account for) but real contradictions in the world. Hegel is brought to the cinema by Priest, who then quotes the *Science of Logic* approvingly: "motion itself is contradiction's immediate existence. Something moves not because at one moment of time it is here and at another there, but because at one and the same moment it is here and not here"; or "contradiction is the root of all movement and vitality; and it is only in so far as something contains a contradiction within it that it moves, has an urge and activity."[115] Like cinema, from the point of view of philosophical logic, change is both inconsistent *and* real.

Curiously, Bergson's vitalist account of temporal change, as *durée*, has sometimes been equated with the Hegelian position too, as Stanley L. Jaki points out:

this abandonment of the principle of contradiction and identity was the basis of the claim of Hegel and all pantheists, and of evolutionists such as Bergson, that "becoming is its own reason," in which case reality becomes a "realized contradiction." The very opposite was true in classical or Aristotelo-Thomist metaphysics.[116]

Yet what we see here is, in fact, a real difference of view: Hegel bases the realization of contradiction through retaining the latter as the basis of change; Bergson, like Deleuze after him, dissolves contradiction, or, more precisely, nonbeing, into change—nonbeing is *produced* (by life or desire). Likewise, if Laruelle *realizes* the aporias of deconstruction (Derrida crossbred with Deleuze), it is by reducing its antinomies to the products (hallucinations) of philosophy and its auto-positioning at a distance from

the Real: in contrast to this, "the One does not see any contradiction but only a chaos."[117] Hence it is appropriate that Laruelle, applying his own optical analogy to Hegelian dialectics, chooses the "stroboscope" rather than cinema—an instrument that shines a flashing (philosophical) light to reduce real movements into a series of states or poses (akin to Priest's "photographic stills, shown consecutively").[118] One might call this an even more extreme *single* frame obstruction, to Real movement itself.

Nor is it odd, conversely, that Priest sees so much value in Zeno of Elea's paradoxes of movement that reduce motion to contradictory states: that is exactly why movement is inconsistent (for both men) and yet also real (for Priest alone). Achilles's movement, or the arrow's, *really is obstructed*. However, placing nonbeing (contradiction) at the heart of change is above all an ontologist's move (of being in Zeno's case, and of being *and* nonbeing in Priest's). In Leth's Cuban remake of *The Perfect Human*, alternatively, there are the ongoing movements of cinema that *produce* contradictions out of movement. We recall, for instance, that alongside the twelve-frame obstruction set by von Trier was another that Leth should also answer some of the questions that the original film posed, such as "what is this human doing?" and "how does he move?" In the remake, the answer to the latter comes in one scene—made of twelve-frame edits of course—of a man dancing in a room, with the following narration accompanying it: "There is music in the room. There isn't any music in the room. There is music in the room. This is how he moves." The room is and is not filled with music. The man moves, but his movement is only made of twelve-frame immobilities by immobilization. The spasmodic "jump cuts" (what Deleuze in *Cinema 2* calls "irrational movement") that make up the man's movement only instantiate *one kind of cinematic movement* and, so, *one kind of logic with one kind of discontinuous consistency.* Cinematic inferences (Bordwell's cognitions) come in many forms or edits, but they all belong to cinema. It is a philosophical abstraction that absolutizes one of them, be it as naturalistic (Bordwell) or dialectical (Priest, Hegel).

Yet, for Laruelle, such abstractions are philosophical positions, cuts (from the Real), that are better viewed as "extractions" under a non-philosophical redescription ("philo-fictions" that create non-philosophical statements out of philosophical statements—hence non-philosophy's ongoing "family resemblance with philosophy").[119] The abstract a prioris that

they work with (natural or dialectical, as one wishes), *when seen instead as local and empirical a prioris,* however, do not come from philosophy (as act of abstraction): they are extracted by the Real (or One) itself. As *Philosophy and Non-Philosophy* puts it, "rather than *abstracted* by an operation, the reflection is from the outset *extracted* from the material by the One itself and for the One alone"; and "this extraction—i.e. manifestation of the *a prioris*—is solely real and only real by the One and for it."[120] The absolutes of philosophies and certain logics are the products of cuts or extracts, and do not come from being, nonbeing, nor their ultimate contradiction.

MISE-EN-FICTION

Nor is fiction to be thought of in non-philosophy as a form of nonbeing. This is clear from Laruelle's stance on science and fiction, as we should note again. The relations between philosophy and science in French thought have always been multifarious. One tendency has been to mix scientific evidence with philosophical truths (from Bergson to Badiou, Merleau-Ponty to Lacan). Another tendency belongs to the philosophy of science, or French epistemology (Cavaillès, Canguilhem, Bachelard, Foucault), being less interested in using "evidence" *for* other philosophical ends than it is in the evaluation of evidence in general. A third group sees philosophy and science linked through literature and fiction. In fact, Deleuze wrote explicitly on the need to see philosophy itself as a species of science fiction. In *Nietzsche and Philosophy,* he also wrote of how

> Nietzsche had his own conception of physics but no ambition as a physicist. He granted himself the poetic and philosophical right to dream of machines that perhaps one day science will realise by its own means.[121]

The same thing could be said of Deleuze himself as philosophy's preeminent science fiction writer on rhizomes, desiring machines, and time-images. Derrida, moving in a different direction, saw philosophy as a species of fiction within literature; while Alfred Jarry, in still another fashion, characterized his "'pataphysics" as a science of "imaginary solutions" employing all the playfulness of a literary and theatrical avant-garde.[122] Laruelle, then, could be seen as a figure uniting both of these literary

positions, though one who is operating within a broader paradigm still, using philo-fiction as the overarching category for an equalizing approach to science, philosophy, art, and every discourse. Naturally, the "fiction" here is not opposed to the Real, for it is itself coming from the Real and so functions according to the "nonclassical" concept of (Real) identity we have been analyzing here all along:

> Accept the completion of fiction's derealization: radicalize the historical but fruitless attempts to retract every claim to reality or co-production of reality from it. This obviously requires non-classical means (the real no longer as the autoposition of an identity) which are not deconstructive (the real can no longer be the Other first and foremost).... The "fictionale" is therefore this ultimate essence of all fiction or its phenomenal given. It is what makes fiction real, i.e. accessible to every man before its very usage under the technical conditions of literature, of art, of philosophy.[123]

By disassociating fiction from any claim to *approximate* reality (naturalism, verisimilitude, neorealism, and so on), its own radical Real can emerge. In some respects, *The Five Obstructions* supports this approach, not because it blends fact and fiction, nor because it is unclassifiable as one or the other (as Paisley Livingston claims), but in virtue of it operating, as Leth himself claims, "*exactly* on the border between fiction and non-fiction."[124] This border can be taken philosophically and divided up as either epistemic (vague or undecidable), ontological (inconsistent or imperceptible), or some mélange of the two (ambiguous or indiscernible) in a kind of "'pataphysics" or "parafiction."[125] But the action *of the border itself*, its immanent performance, can also be viewed as a vector that directs its own orientation. Such a border creates numerous different "fictionale" effects, depending on the fields it touches:

> It seems that, rather than a total thought which would again claim to synthesize every experience or simply to make them intercede diagonally, non-philosophy is situated at the only point of reality capable of joining without decision or contradiction the effects of philo-fiction, poetry-fiction, religion-fiction, science-fiction, etc.—on condition of understanding that these fictional aspects, far from simply extending philosophy, poetry, etc. in imaginary forms, are instead the image of

themselves that the wholly-other which non-philosophy is gives upon the mirror of philosophy, of poetry, etc.[126]

Non-philosophy frees philosophy, Laruelle says, "as a fiction, which no longer has anything but one last link with philosophical sufficiency." It delivers it from "the substantial or humanist burdens of the Real," that is, from the demand to approximate the Real.[127] Whereas the parceling out of the possible and the impossible—as psychological, epistemological, physical, metaphysical, or logical phenomena—is itself *a philosophical enterprise*, philo-fiction, we recall, is the "invention by fiction and rigor of philosophical possibles." It is a "generic *mise-en-fiction* of epistemology and its universals," or what Anne-Françoise Schmid names a "*mise en hypotheses.*"[128] It is the "*mise-en*," the setting, vector, performance, or use, that *invents* a "usage of philosophy qua fiction."[129] Philo-fiction, as "pure invention," has the rigor or consistency of fiction, therefore, much like Badiou follows the rigor of mathematical conventions, but without suturing it to the authority of mathematical science (as Badiou does). As *Philosophie non-standard* explains it: a "scientific philo-fiction" involves a "statistical production of quantum and probabalistic fictions."[130] Hence, two things, two truths, may be quantum superposed, but on the basis of the Real rather than dialectics. And this coincidence has a fictional rigor to it, that is, an invented rigor (the rigor of invention, not convention) akin to the science of the quantum, where life and death can coexist (Schrödinger's cat).[131] Performative invention can *move* through the contradictions, "impasses," or *aporia* of sufficient reason, when it *enacts* a new kind of thought, logic, consistency, or movement.

It was in *Philosophy and Non-Philosophy* that Laruelle coined the term "fictionale" to denote the "*primitive element of opening or of possibility of every thought, science and art included: the possible in the originary state.*"[132] As we heard at the outset of this chapter, the Real suspends "the sufficiency of logical possibility."[133] Where philosophers like Derrida, Kripke, or Priest can exhaust the philosophically possible in this world (in very different ways, to be sure) and/or thereby create imaginary possible worlds (or even impossible worlds in paraconsistent logic), for Laruelle, both the possible and the impossible are *invented* by the Real. Indeed, such a Real, says the *Anti-Badiou,*

impossibilizes logic and theory without destroying them, instead simplifying them into their materiality, reducing them to the state of fiction—but a logic-fiction or philo-fiction. It gives to deployed theory, to all of fictional materiality, its force of "formalism," for which reality, the empirical, and ideality are all *of* fictional materiality, but without constitutive effect *upon* it.[134]

Fundamentally, philosophy has never been able to think through the fictionality of fiction other than as variants of "least-being," a "limitrophy of the real," or a "nothingness that echoes supposed real referents as well as its contraries: science, truth, being, perception, etc."[135] Kant and Fichte, for example, founded it on imagination. Nietzsche saw it as a willed entity. In sum, then, the history of

fiction's philosophical ambitions is without appeal: it is a failure. Not only has fiction ultimately found philosophy *opposing* it once again to the instance of the real and limiting it in its will to power, but it has also not been able to acquire a concept, a reality and an autonomous dignity at last: it remains too close to the artifact. However, the reasons for this failure are clear: fiction has always been thought in philosophy's framework and has combined with the history and crossroads of philosophy. Philosophy tolerates fiction on condition of announcing itself to it and deciding on its essence. Thus, what is being investigated here is not a particular philosophical position of fiction in relation to the real but philosophy's legislation or right over it.[136]

For Laruelle, then, fiction can no longer be thought of as a "mode of non-being, of the false."[137] Seen in-One, there is no distance from the Real that would allow a fiction to miss its target. It is its own target, and Real.

PHILOSOPHICAL BOXES AND IMPOSSIBLE BOXES

In the chapter titled "Fiction" in Priest's *Towards Non-Being* (where he compares Meinong and paraconsistent logic), there is an appendix, a short story called "Sylvan's Box." For a moment, Priest says, he writes as "both an artist and a philosopher." Priest's engagement with Meinong was

heavily influenced by the work of his late friend and colleague, Richard Sylvan, the author of *Exploring Meinong's Jungle*. In this fictional story, Priest relates how he once journeyed to Sylvan's farm near Canberra, Australia, soon after Sylvan's death. With the permission of Nick Griffin, Sylvan's literary executor, Priest was allowed to go through various of his old papers and personal effects. One day, he happened on a very strange object, as he relates in the following:

> As I was putting the last batch of papers back, I noticed a small box located between that pile and the one on Meinong. It was too small to have papers in, I thought; maybe it contained some more letters. I picked it up and examined it. It was of brown cardboard of poor quality, made in a developing country, perhaps. The lid was taped down, and on it there was a label. In Richard's own handwriting . . . was written "Impossible Object." . . . Carefully, I broke the tape and removed the lid. The sunlight streamed through the window into the box, illuminating its contents, or lack of them. For some moments I could do nothing but gaze, mouth agape. At first, I thought that it must be a trick of the light, but more careful inspection certified that it was no illusion. The box was absolutely empty, but also had something in it. Fixed to its base was a small figurine, carved of wood, Chinese influence, south-east Asian maybe. . . . One cannot explain to a congenitally blind person what the colour red looks like. Similarly, it is impossible to explain what the perception of a contradiction, naked and brazen, is like. Sometimes, when one travels on a train, one arrives at a station at the same time as another train. If the other train moves first, it is possible to experience a strange sensation. One's kinaesthetic senses say that one is stationary; but gazing out of the window says that one is moving. Phenomenologically, one experiences what stationary motion is like. Looking in the box was something like that: the experience was one of occupied emptiness. But unlike the train, this was no illusion. The box was really empty and occupied at the same time. The sense of touch confirmed this.[138]

The brown cardboard box contains a phenomenological experience as much as a physical artifact. It is the *experience* of an "impossible object," being both empty and not empty (somewhat like the box for Schrödinger's

cat, to which Priest alludes as well).[139] It is an object that is now one thing, and now another, contradictory thing. Like Kant's shifting red cinnabar, it loses its consistent identity, and yet it is still experienced. So far, so philo-fictional, perhaps. But the box is also a philosopher's "black box," opened for all to see. Not only does it contain (or is) an impossible object but it also has the impossible relation between a (logical) science and a philosophy that gives the latter its authority (or at least appears to, for it remains a *philosopher's* box in the end). As *Principles of Non-Philosophy* puts it, this is a "*black box*, an *unthought identity*, a technological, incomprehensible relation for which only the effect counts."[140]

And this is the reason why even Priest's paraconsistent and fictional world remains tethered to standard positions of philosophy and logic: because "Sylvan's Box" is only an interlude in the text, a literary exception. After the artistic fugue has passed, Priest returns to the factual matters of mathematical objects and multiple denotation, the topics of the final two chapters of *Towards Non-Being*. In Priest's own text, then, it is fiction itself that is put aside (boxed in with its logical guarantor) and proper philosophy that continues. The black box of paraconsistency is that of philosophy and logic, with the latter mysteriously underwriting the former. We do not mean to be uncharitable over what might otherwise be read as a harmless flourish: it is because the story is positioned as an aside that a prodigious use of fiction (but not in a literary mode) becomes so important. Were Priest to be consistent (and do what he says), the fictional interlude would not be so bounded. But this would also mean giving up on the philosophical image of "coherence," which he is so desperate to maintain, and allowing inconsistency to run to its trivial, explosive end.

It is true that Priest does introduce inconsistencies into the telling of his fiction—the story concludes contradictorily with the box being buried on the grounds of Sylvan's farm *and* it being taken away by car—and he even claims that such inconsistency "is no accident; it is essential to the plot."[141] Yet others have found such devices entirely reducible to standard logic. David Nolan, for instance, has produced a consistent reading of "Sylvan's Box" by showing how the story "makes a lot of sense if instead we read it as a story where Priest believes he has found an inconsistent object."[142] It is a matter of belief—self-delusion in this case—rather than essential inconsistency. Beyond belief, Nolan also argues that the literary

convention of the unreliable author can also be invoked to save consistency, irrespective of whether that unreliability is unintentional (because the author is deluded) or intentional, because the author is *lying*.[143] In other words, consistency can be reinserted here through a metafictional stance that positions Priest's piece as standard fiction (along with all the literary tropes that might go along with that). Indeed, when Priest's story of Sylvan's box first appeared in the *Notre Dame Journal of Formal Logic*, there was a coda where he described its events matter-of-factly as "entirely fictitious."[144]

Indeed, in contrast to the philosophical authority that Priest uses to assess the ontological and logical status of fictions (i.e., to assess fiction with onto-logic), Laruelle's project is to create a philo-fiction out of *all* philosophy *and* itself. This project is not a temporary relief or diversion that would actually facilitate serious ("nontrivial") philosophy to continue unchecked. Paraconsistency, in non-philosophical terms, must be radicalized to point equally to itself (as a performative thought) as well as to "regions" like "fiction." Philosophy's "technological box" is always working, covering any content and allowing every type of "conjuring trick." The kinesthetics of movement on the train only generates an "illusion" or "fictional" fiction if one maintains that, *somewhere else,* there must be a permanent point of immobility, the factual and serious center (if only through the "sense of touch" of solid logics). If, however, one is open to the prospect that everything is mobile—including the terra firma on which one stands, the absolute grounds of philosophy—then one realizes that only a "global mutation" of logic, a mutant logic, is appropriate:

> The problem is no longer that of the death or the end of philosophy, of its gathering into itself, of its repetition or its recommencement. The project is less than this, but at the same time more ambitious: the problem is of that of its global mutation, of the loss of its sufficiency, that of finding a philo-fictional, and religious-fictional (and also science-fictional) formalism that explains these phenomena.[145]

The mutation, as we said earlier, operates as a border between fiction and nonfiction, though one that *is itself an agent*: it is not the passive gap produced between two given blocks (of fact and fiction) but the

performative line that fictionalizes any "serious" field it touches, creating clones and even mockeries out of it.

We said near the beginning of this chapter that our interest in paraconsistency as a model for non-philosophy rested primarily on the hypothesis that paraconsistent logic could itself be materialized. This materiality of logic, as well as its attendant fictionality (its *hypothesis*), had a physical form—how it stands together, how it *consists*—that could be rendered photographically. We began this process by using Laruelle's depiction of non-philosophy as a concentrated image (of) philosophy. Turning to *The Five Obstructions* extended that model, with von Trier's stated aim to "banalize" a film work by pushing its shot length to a psychophysical limit. Rather than ruining the film, however, we saw how the twelve-frame constraint might equalize the cinematic experience, creating a "flat thought" of democratic inferences (contra Bordwell) in what Laruelle also describes (ironically) as "blind or deaf" thoughts.[146] In other words, these filmic thoughts, like all others, are ultimately (or "in-the-last-instance") nonrepresentational, nonintentional thoughts—they are their *own* material, real, object. *What* such thoughts might be we *cannot* comment on, for that would be to make of a film, like *The Five Obstructions*, a mere illustration of a readymade position: we can only gesture toward, or suggest, such thoughts, leaving them as indefinite as possible.

Derrida, though acknowledging the radicalism of Laruelle's stance, still believed it to be impossible philosophically, an impossible thought by *any* philosophical standards. When Laruelle tries to sidestep the philosophical decision, for Derrida he only enacts another decision, another philosophy. In the next chapter, we will attempt to understand decision in an alternative manner as a kind of behavior, one taking the "Philosophical Decision as undivided totality of its operations or acts, forms, ends and matters."[147] This *non*-logical behaviorism will involve a further amplification of the materiality of thought, even beyond that we have seen through (in)consistency. Paraconsistency and its possible–impossible worlds will become parallel worlds, "backgrounds," "membranes," and cinematic screens (hiding the "worst places" in the world). How we see them, how distant we are from them, will result in various forms of vision, some of them "in-One," others "hallucinatory"—some of them a product of posture, others the mutation of posture:

philosophy's spontaneous exercise, philosophy's belief-in-itself-as-in-the-real, is a transcendental illusion; it means the call or the seduction of objective philosophical Appearance is a hallucination, not as appearance but as "objective," an objectivity which therefore no longer recovers the real for science detached from philosophy. The other consequence, which envelops the preceding one, is that, on the basis of a real usage of decision, it becomes possible to radically renew its practices, to *found a real usage of the fictional and hallucinatory virtualities of philosophy— non-philosophy.*[148]

In terms of behaviors or postures, even the hallucinations or fictions of philosophy are real. They become hyperfictions in the Real rather than fictions or parafictions *of* the unreal.

3

HOW TO ACT LIKE A NON-PHILOSOPHER

> One cannot understand a philosopher, unless one is a philoso-
> pher. One cannot understand Dasein, one is oneself Dasein. It
> is an "auto-" system; philosophy is an activity of auto-definition
> (a very complex one, of course) and of auto-position.... My
> problem is that of the re-orientation of thought.
>
> ROBIN MACKAY AND FRANÇOIS LARUELLE, "Introduction:
> Laruelle Undivided," in *From Decision to Heresy*

REMAKING THE ONE

In 1998 Gus Van Sant directed a shot-by-shot remake of Alfred Hitchcock's
1960 classic horror film *Psycho*. Although the new film was in color, rather
than the original's black and white, and was set in a contemporary era
with a new cast, it otherwise retained nearly all of the first film's audiovi-
sual structure—including Bernard Hermann's score.[1] Indeed, such was
its fidelity to the 1960 film that some critics called it a (rather pointless)
"duplicate" rather than a remake.[2] A duplicate like this, presumably,
would lie somewhere between a mere reprint of an original and a true
remake. Van Sant's replica, however, is not the only model of copying
with minimal difference. Projection, rather than production, can also be
a variable. Five years before Van Sant, the artist Douglas Gordon created
24 Hour Psycho, an art installation involving the projection of the 1960
Psycho at two frames per second instead of the normal twenty-four. This
deceleration results in a projection time of twenty-four hours rather
than the usual one hour forty nine minutes. Here we are in the realm of
speeds and slownesses again, the manipulation of perceptual constancies
(a prioris), though this time in terms of rates of projection rather than
editing (cuts). Something new has been created through how the art
object is exhibited and perceived—to such an extent that whether what
was being shown was *intended* as horrific or comical was now a matter
of the spectator's personal orientation (in various senses).[3] Obviously, we
are very much concerned with the potential of such "remakes" and how

far that term can be stretched vis-à-vis changes made to content, form, and "consumption." Moreover, if a remake is to be more than a duplicate, then *what* exactly is being remade (if it is not an audiovisual structure)?

More directly, we want to look again at the most contentious element of Laruelle's investigation of philosophy, that which operates through the structural invariant of "decision," or as *Principles of Non-Philosophy* puts it: "if philosophy is this material, it must be analyzed within all of the *de jure* dimensions of its structure, as 'Philosophical Decision.'"[4] What are these "dimensions"? Can the "decision" itself, the cut itself—an "offcut" *(de-caedere)* from the Real—be understood as a problem of reorientation, following the epigraph to this chapter quite literally? This would involve introducing a *spatial* and *behavioral* element even more explicitly into our introduction, a philosophical behaviorism (or behavior-*without*-behaviorism) that renders the decisions and "positions" of philosophy into acts—of withdrawal, of cutting, and ultimately of posture. According to Graham Priest, behavior—as opposed to belief or even movement—cannot evince contradiction: "characteristically, the behavior patterns that go with doing X and refusing to do X cannot be displayed simultaneously."[5] In this chapter, however, we will look to philosophy—and cinema—as behavioral movements that not only display what looks like contradiction (something being both a part of the Real and a decisive withdrawal from the Real, or, in a film like *24 Hour Psycho,* something being both a comedy and a horror) but do so through orientation or postural mutation rather than negativity, ambiguity, or undecidability.[6] This will be the most naturalistic or physicalist introduction we will offer, then, using acting and behavior to render non-philosophy. In doing so, we will also look at the significance of position and posture (in photography); the rise and fall of (philosophical) Behaviorism; the concepts of withdrawal, hallucination, and orientation in Laruelle; and finally, the role of mime and gesture in both acting and Laruelle's concept of the clone. Most important, though—and through it all—we will be reexamining the nature of decision.

The need to find a non-philosophical perspective on Laruelle's theory of decision is certainly pressing, given the frustration it can generate among some commentators and many readers. What Ray Brassier, speaking from an empiricist standpoint in philosophy, writes is typical: "Laruelle's insistence on identifying the essence of *la philosophie* over and above

any listing of all those things which are named 'philosophy' seems as misguided as would be the attempt to define the essence of *le sport* over and above a list of all those activities which we happen to call 'sport.'"[7] He continues like this:

> Ultimately, the claim that decisional auto-position embodies the essence of philosophy saddles Laruelle with an intolerable burden. Either he continues to insist that all philosophers are Hegelians, whether they know it or not—a claim which is exceedingly difficult, if not impossible to defend; or he maintains that those who are not are not really philosophers; in which case vast swathes of the philosophical tradition, from Hume to Churchland, must be excised from the discipline since their work no longer qualifies as philosophy. Alternatively, and more sensibly, Laruelle can simply drop the exorbitant claim that his account of decision is a description of philosophy *tout court*.[8]

Clearly Brassier has a point here, but only so long as "decisional auto-position" is indeed regarded as a Hegelian artifact, or in other words, that it is read and normalized as *already* philosophical (and in one peculiar form of philosophy to boot). Yet the whole point of non-philosophy is *not* to offer up one more metaphilosophy, one more philosophy of philosophy (be it from empiricism, Hegelianism, or any other standpoint). Decision is a non-philosophical notion of the minimal essence that makes philosophy philosophy, an essence understood as a material state rather than an immaterial idea. We have looked at it also from an ethical vantage point (the dystopias of philosophical authoritarianism) and a logical one (the coexistence of contradictory truths). Now we are shifting our approach to a more behavioral description. In each case, we aim to explain decision, but without philosophy. This might appear to many to be merely creating another circle—with non-philosophy explaining non-philosophy—were it not for the fact that we keep shifting approach, we keep mutating our posture from ethics to logic to behavior and so on, which is to say that there is no *one* form of non-philosophy to explain all the others but only a chain of different non-philosophical tangents that *appears* to create a circle.

In *Principles of Non-Philosophy* the question is this: "what experience do we have of thought *qua thought* but without reflection or without

'thought of thought'?"—that is, without a "philosophical form of thought." Indeed, the question may no longer even be a "question" because "all of these hesitations, disjunctions and questions still assume the *power* of thought."[9] Thinking thought *non-philosophically*, if it is possible at all, will consequently have to be something different. And in this chapter we will look at it further as a physical and spatial behavior, a posture, rather than a self-styled reflective, transcendent position. Or rather, "position" too will be embodied or "postured" as behavior, with the transcendence, representations, and disembodied propositions of philosophy reviewed as forms of physical orientation toward the Real—being determined as real, "in-the-last-in-stance." Conversely, this would then be another form of democracy of thought, now involving "decision" too, "generalizing any philosophical decision whatsoever, to all of experience, as an a priori."[10] Decision becomes an experience (of) posture or orientation. And in the third remake of *The Perfect Human*—where Jørgen Leth is given *no* obstructions at all in how he makes his film—the obstruction now becomes the fact that *he must allow the Real to act on all decisions*. Through this nonobstruction, a difference between "posture" and "position" will emerge that renders decision into a stylistic, "actorly" manner: ideas are turned into behavior, are "cloned" or mimed, only in a type of *immanent* mimesis, *remakes* without representation.

FIVE TAKES ON DECISION

There are numerous ways in which to understand philosophical decision without reference either to individualized, voluntary, intellectual deliberation and judgment, at one end of the scale, or unconscious desire, sheer blind will, or forms of false consciousness, at the other end. Some of these may well adopt some kind of mid-position between the two—blending together different measures of cognitive belief, conative desire, and pragmatic action. Some others, however, may avoid such scalar measures in toto, either by eliminating decision altogether in favor of deterministic forces (standard naturalistic approaches) or by embedding it within a larger hermeneutic of sorts. Stephen Pepper's *World Hypotheses* is one example of the latter. Here Pepper describes four basic philosophical positions—mechanism, organicism, formism, and contextualism—in terms of their

"root metaphors": the machine, the organism, similarity, and the ongoing act "in its context," respectively.[11] Philosophical decision is rendered as the elaboration of a metaphorics, though how and why there are *these* four positions only remains unclear. Another hermeneutician of a sort is Alain Badiou. But his approach, by contrast, takes the arbitrariness and contingency of decision, not as tokens of the liberal subject's choice of metaphor, but as exemplary of the exceptional event of a "truth" that ruptures the status quo (and coengenders that subject).[12] In this event-ualization of choice, the subject engenders herself in the acknowledgment of an event emerging through one of four procedures—erotic love, revolutionary politics, creative art, or science: "the subject *must* intervene within the indiscernible and decide for the undecidable—the subject *must* choose for the event, that an event *will have happened.*" Again, however, how and why we only have these four regimes are left unexplained.[13]

In comparison to this futural decision, within Gottfried Leibniz's rationalist paradigm, the decision is *antedated* by God's divine concepts. If there is a "complete concept" of a substance like Caesar or Adam, say, then no doubt there is the complete concept of Leibniz too, which would include his philosophy. Leibniz's principle of sufficient reason covers all things and so, turned on itself, could in theory provide a Leibnizian version of philosophical decision. But the principle could also be generalized to all other philosophies, so that it also includes the principle of *philosophical* sufficiency itself and all its decisions (known solely and necessarily to each philosopher-God). Here, though, the freedom of decision would be problematized by its very conceptualization, as an already completed concept simply being played out in the world.

To protect the voluntary aspect of decision at an existential level, however, we can turn to Sartre's notion of the "fundamental project." This rests on neither occasional deliberations nor unconscious forces but on a *biographical* rendering of decision across a subject's whole life. The identity of each biography, a Flaubert, or a Genet, or a even Sartre, is revealed as a unity formed by an "original project."[14] No one or group of empirical features or "tendencies" within a biography can capture who a subject was or is, but their aggregate *is* aggregated by his original "choice" or "project of being."[15] For Sartre, the tendencies point to a fundamental decision clarified through biography:

in each inclination, in each tendency the person expresses himself completely, although from a different angle, a little as Spinoza's substance expresses itself completely in each of its attributes. But if this is so, we should discover in each tendency, in each attitude of the subject, a meaning which transcends it.[16]

Decision becomes the life of the subject, encapsulating each and every inclination or tendency in that life. Yet, we might now ask what would result if these tendencies, understood as movements, *were* seen as the project itself (rather than merely as its sign). That is where Bergson takes this line of thought, whereby the project becomes a *pro-jection*. Instead of one meaning transcending the myriad directions taken in a life, there is ultimately one movement that animates every philosophical life. Bergson's argument is that each philosopher "has never said more than a single thing . . . he has said only one thing because he has seen only one point: and at that it was not so much a vision as a contact: this contact has furnished an impulse, this impulse a movement."[17] Indeed, according to Bergson, were that philosopher to have lived in a different era, it would nonetheless be the same movement that is expressed in his thought, even if through different materials: "not one chapter perhaps of the books he wrote would have been what it is; and nevertheless he would have said the same thing.[18] Here philosophical viewpoint becomes a direction of movement, a vector. And a remake (of a thought) is not a replica of its words but a new instantiation of its movement.

A BEHAVIORAL TANGENT: BEING TRUE TO THE IDEA (A FILM DU LOOK)

Each philosopher says one thing only, as a movement. Or, each philosophy *is* one thing, as a life (Sartre), or a concept (Leibniz), or an event (Badiou, but only *if* there were philosophical events).[19] Significantly, the French filmmaker Jean Renoir once declared that "a director makes only one movie in his life. Then he breaks it into pieces and makes it again." So how might this process of filmmaking inform our researches into decision here?

 One way of reading *The Five Obstructions* is precisely as an enactment of Renoir's adage, with von Trier forcing Leth to recompose *The Perfect Human* again and again following certain constraints. But the obstructions

to each remake nonetheless facilitate a creative reproduction rather than a faithful replica. This has been accounted for partly through the use of *constant stylistic innovation*. As von Trier writes of his own work, "you can become so good at producing things that they become nauseatingly boring to look at. That might have happened had I continued to make the same film again and again, as some people do."[20] Von Trier is known for not repeating himself, *at least stylistically*. Yet von Trier insists on a partial repetition in each task given to Leth, albeit that the added obstructions generate innovation in style. Mette Hjort comments on this, saying, "The commitment [to renewing styles] throughout, it transpires, is to a form of self-provocation that involves *abandoning* the cinematic techniques as they are mastered in favour of new challenges."[21] In what follows, we will attempt to transform our own preceding qualification, "at least stylistically," such that the issue of style becomes a highly significant approach toward the physical rendering of philosophical decision as behavior or posture, one that is always renewed, that is constantly mutating. As Murray Smith writes of the film,

> in *The Five Obstructions* the game of style is narrativised; the variations in style have an overt motivation in the narrative contest recounted by the film. Even so, the variations are not motivated in the traditional manner as apt stylistic expressions of theme.[22]

Indeed, qua posture, style is embodied in a nonstandard naturalism, and decision is made physical *within the film itself* (and not simply a philosophical view of its maker's motivations, her biography, or her concept).

In the first obstruction, set in Cuba, a certain behavioral attitude is already assumed. Adopting the same pseudo-anthropological pose as its original, *The Perfect Human* asks questions such as, "What is the perfect human thinking? Is he thinking about happiness? Death? Love?" And yet the answers eventually provided to these and other questions are often pseudo-answers, at least for those who are looking for *sufficient reasons*. Paisley Livingston describes the situation thus:

> The response to the question: "Why does he move this way?" is a comical flaunting of Trier's injunction to answer the questions raised by the

narrator of *The Perfect Human*; the proposed answer ("Because women like it") does not really answer the question, while seeming to do so in a blunt way; all the other questions remain willfully unanswered in the remake, which reinforces the thought that Leth has cleverly slipped past this obstruction.[23]

Or, as Mette Hjort confirms when writing about the original,

human beings are represented doing typically human things, but we are given no sense of how it is for them to do those things. It is as if they are mindless. Consider, for example, the hollow monologue Claus Nissen delivers during the dinner scene. One does not get the sense at all that this man is really inquiring into the fleetingness of joy; neither does he seem genuinely concerned for the loss of "you"—whomever she may be. So, here is a perfectly unedifying—because so rabidly third-person— representation of humankind.[24]

And yet, before we categorize Leth's approach *simpliciter* as comical or unedifying, we should note that Leth studied ethnography in the 1960s and that a good deal of his later film work continued to be inspired by the anthropologist Bronisław Malinowski. As we know from our first chapter, keeping a certain "objective" distance is a feature of Leth's approach that von Trier has been challenging throughout *The Five Obstructions*, mostly with little success, it has to be said. We ourselves likened it to the authoritarian stance of philosophy over its subjects (as Laruelle describes it). Now we are attempting to review that distance *without* ethics—if we can—precisely to redo "distance" itself as behavioral, as a way of seeing the philosophical decision *without* judging philosophy. Or, at a minimum, to see it also as a product of the Real.

Having returned from Mumbai, the most miserable place, Leth presents a film that displeases von Trier, at least as regards his demands for the second obstruction. Leth has made a good film, no doubt, but it is not what he was asked to do—because he has shown his subject (even if only through a semitransparent screen). In that Leth has prioritized his film aesthetics over his instructions—by always trying to "make a better film"—he has not been "*true to the idea*" according to von Trier.

The punishment for his misdemeanor is perverse: either he goes back to Mumbai and remakes the remake *to the letter* of von Trier's stipulations, or he remakes the original *The Perfect Human* without any constraints at all. The perversity arises because Leth initially asks for an alternative punishment whereby von Tier would provide a new set of obstructions for him to endure: as he says, "I prefer you to make the decisions." So, precisely because that would be *Leth's* preference, von Trier decrees that it is *Leth* who must make *all the decisions* in complete freedom for this third remake—that is the penance he must pay. Among the final exchanges at their meeting, the following are noteworthy:

LETH: That would be mean. That would be no good.

VON TRIER: That's the way it's going to have to be, Jørgen. I am sorry, but to assert my authority—I'll have to ask you to make that film again the way you think best.

So, why then is such total freedom an imposition for Leth (beyond the usual psychoanalytic–existential responses concerning the intolerable burden of personal responsibility)? For a start, it is simply because von Trier shares with Leth the idea that constraints are crucial for creativity in filmmaking, such that imposing a free-style film on his former teacher "can only be a straightforward negation of Leth's characteristic approach."[25] But second, and more decisively for us, it is because of the nature of the decision-making process in film production, as seen from their shared point of view. This emerges when Leth returns to von Trier to present the free-style film (which he makes in Brussels) and is subsequently tasked with his fourth remake and obstruction. Now, he has to remake *The Perfect Human* as a cartoon, an animation. This is taken as an even heavier blow to Leth because von Trier knows that Leth despises cartoons—indeed that, like von Trier, Leth actually *hates* cartoons. Why? Because making a cartoon involves *constant* decision making: "The great advantage of doing it as a cartoon," says von Trier, "is that you'll be faced with loads of decisions. The aesthetics and all that. It can only turn out to be crap."[26]

We must remember that Leth's model of optical filmmaking involves patience, that is, a certain kind of passivity: "I normally find places and then isolate something I want to examine. That's the method. And then

I frame it very precisely and wait for the right moment. I believe very strongly in waiting and observing."[27] Leth allows the moment to be captured to present *itself*—to let the randomness of the Real to take *its* course. Admittedly, it is he who selects the "decisive moment" to record (to borrow one of Cartier-Bresson's terms), but its emergence is spontaneous. Let us say for now that it belongs to the Real. Hence, forcing all of the decision-making process onto Leth—as the animated form in the fourth obstruction would seem to do—actually removes his artistic freedom, oddly enough. Retrospectively, then, we can see that ordering Leth to make any film he wishes in the third obstruction is actually an imposition of sorts as well: less the burden of responsibility than the burden of creativity. Leth's natural preference is to let the Real offer up the "concrete instants" that he will passively record, rather than that he conduct all affairs (a very Bazinian realism, at first glance). Naturally, Leth is free to escape from his freedom, in this third film at least, by reverting to his usual long-take realist aesthetic. And yet, this is not what he does. Instead, he offers up a highly stylized, rather formal piece, using split screens, cryptic monologues, and quite clichéd "art house" imagery (a mysterious man and woman; sexual encounters in expensive hotel rooms; a sense of political or criminal intrigue; slow-moving limousines; clandestine meetings in rainy, desolate locations, and so on).

And so, here is our twist. Might we say that the cartoon (according to Leth and von Trier at least) amounts to what Laruelle calls "position," in virtue of its subject-centered control of decision? And might we add that the filmmaking that takes its cues from the Real—its *subject matter*—and that decides not to decide is more akin to what Laruelle calls "posture"? Indeed, the formula "to decide not to decide" is not itself a decision but the posture that physicalizes decision as well as the axioms prior to decision—the "axiomatic emissions, the take-offs [*en-vols*] of axioms," as Laruelle puts it.[28] We could call these "bottom-up" decisions, oriented by the Real, rather than "top-down" ones oriented by the director–philosopher, but this would still intellectualize matters too much (unless we take the vertical axes in this spatial image at face value with no aesthetic judgment). These are neither "logico-formal, nor logico-real" axioms but what Laruelle calls "lived decisions" that are "real or immanent in-the-last-instance."[29]

We will return to this analogy later when we explore posture more

deeply through Laruelle's own texts, but before that we should note in more detail the behavioral traits of the third film that Leth finally produces for von Trier. We have already mentioned the anthropological, objectivist approach (be it deemed serious or parodic) in both the original and its remake. The narration of the remake (in English) goes as follows:

Here's the man. Here he is. What's he want?

Here's the woman. Here she is. What does she want?

Here's a man. We don't know him. I don't know what to say about him. We love that he is special, unreasonable. A distant look, a loss of soul, a distant look.

I would like to know something more about him. I can see that he is here, and that he works. I have seen him smoke a cigarette. I didn't see him write. Is he good at describing death? Does he think about fucking? He is alone, preparing himself. He goes out and takes care of things. He's the perfect man.

In this and other sequences the question as to what the man is thinking is reiterated but never answered. All we are given are external details, visuals of movement, of smoking, of shaving. Alongside this unanswered enquiry comes the peculiar mannerism of this version, with a certain "type" of art house cinema ("*du Look*") being replicated throughout. Paramount in this, however, is the acting role of the male protagonist. Leth himself is no longer the stand-in for Claus Nissen. Instead, Leth casts Patrick Bauchau almost entirely because of his presence and style. Murray Smith remarks on this:

the casting of Patrick Bauchau in *#3: Brussels,* for example, [was] inspired by Leth's admiration for his performance as the protagonist of Eric Rohmer's *La collectionneuse.* Intriguingly, Rohmer's film was, like *The Perfect Human,* released in 1967; it as if [sic] Leth has chosen a better-known counterpart to Claus Nissen—an equally handsome actor from the same generation, both born in 1938—in order to stress the effects of time and experience on the model-like "perfection" of the figures in his original film (Leth notes the importance of Bauchau's "well-bruised" quality to his casting in *#3: Brussels*).[30]

Nonetheless, it is not as if Bauchau is given much to do by Leth in this film, for he mostly poses in rooms and has little dialogue, and even less interaction, with other actors. He is there because of his "look." Leth is obviously delighted with his casting, stating that he is "really pleased with him. He looks great. . . . He is well . . . well bruised as a person. He has experience of life. He has lived a life. His story is fantastic." Bauchau, then, stands for a certain type and remakes the Claus Nissen protagonist through a distinctive acting style, almost bordering on nonacting: he is a man who "takes care of things" just by looking like such a man. Indeed, of all six films, the original and the third versions of *The Perfect Human* place the most emphasis on acting style (as opposed to editing in one, location in two, animation in four, and performativity in five). And it is Murray Smith, once more, who finds the right idea on this front when describing the original *The Perfect Human*:

> *The Perfect Human* is an enigmatic, spare narrative film, depicting a man and a woman engaged in various generic activities—eating, dancing, undressing, shaving—mostly in isolation from one another. . . . The setting of the film is abstract in the extreme: the performers are afforded certain minimal props (a razor, a bed, a dining table) but the space behind them is so overexposed as to lead the eye into a white void. The man and the woman are beautiful, young, chic; much of the time they are doing little more than *striking poses* in the featureless zone that they occupy.[31]

Mette Hjort adds to this point about acting and style by referring to Arthur Danto's claim, in *The Transfiguration of the Commonplace*, that "style is a gift" (it cannot be directed) and expresses individual "ways of seeing the world."[32] Danto himself goes even further, arguing that "style is the man." When someone paints in the style of Rembrandt, for example, "*he* has adopted a manner, and to at least that degree he is not immanent in the painting in the way Rembrandt is." All the same,

> the language of immanence is made licit by the identity of the man himself and his style—he is his style—and by transitivity of identity Rembrandt *is* his paintings considered in the perspective of style. . . . What, really, is "the man himself"? I have argued a theory to the effect that we are systems of representations, ways of seeing the world, representations incarnate.[33]

It is the human—who may be an actor in the strict sense, but always a performer in the broad sense—who is these "representations incarnate," this way of seeing. We will examine subsequently that role of the actor as embodied thought.

There is a further moment of what we might call "externalism" in Leth's remake that we should pause over here. In one "behind-the-scenes" section of the third film, we see Leth talking with his assistants about a certain effect he is after, one that involves the arrangement and rearrangement of garden furniture on a building rooftop. He says that he sees this as a

> kind of ghostly ballet—with the chairs. We go up to them and move them around... haphazardly. Into a new, interesting arrangement.... "Somebody has moved them around in the dark," right? A mystery. *That's the idea we're keeping from the original scene.*

What is peculiar about this is that there is no scene in the original *The Perfect Human* that is in any way like that (there are barely any chairs at all visible, other than those glimpsed when a man is seated as he undresses or eats). So just what is the *idea* ("ghostly" or otherwise) that is being reproduced? When von Trier accused Leth's second remake of not being "true to the idea" of his constraint, he was referring to the stipulation that Leth's subject (in the most miserable place) should not be seen. It is ironic, then, that in this remake (a punishment for his prior crime), the idea from the original film that Leth tries to reproduce is itself invisible. Unless, of course, the idea simply is that of mystery, of haphazard movements (rearrangements) performed as if "in the dark"? Both films have an air of mystery to be sure, though the first's is far less dramatically intriguing and more a matter of intellectual curiosity. There is really no idea (no "concept" or "propositional content") in either film, then, that might be transferred from the one to the other, but rather a manner, style, or atmosphere—the behavior of the enigmatic, "how it moves" so to speak. What is carried across is not an idea-in-translation (a copy) but a kind of gestural, postural materiality (which is also transformed as it is transferred).

All in all, then, be it through this externalization of ideas, the behaviorist and anthropological approach adopted, the role of the actor as a *type* of performer, or the difference between Leth allowing the film-subject

to make his "decisions" for him qua posture (as opposed to him imposing his decisive positions on the film), this third version of *The Perfect Human* enacts the question of just what a remake, replica, or clone is on a number of different levels. For the most peculiar thing is that, having been given the utmost freedom to make this version, as compared to all the others that Leth had a direct hand in making, the third film is probably the least like the original.

POSTURE, PHOTOGRAPHY, AND THE GAME OF POSITIONS

The question of "posture" now needs to be elucidated further in non-philosophy's own terms. Though it is not given the same explicit emphasis by Laruelle as, for example, "vision-in-One" or "determination-in-the-last-instance," its place remains fundamental and is found throughout his work. Indeed, in terms of non-philosophy *not* being an anti-philosophy, posture is crucial ab initio: "philosophy, far from being dissolved, forgotten or critiqued and hastily rejected, and consequently its resistance increased, is the object of a theoretical posture and very positive pragmatic, albeit transcendental." Likewise, the notion of the "fictionale" we met with in the previous chapter is described as "non-thetic or non-positional," that is, as postural.[34] In the section of *En tant qu'un* titled "Changer de Posture," the connection with mutation, as a radical change, is elicited through "these 'postural' mutations," which are deemed "more profound again than the changes of philosophy or 'positions.'"[35] *Theorie des identités* even refers to a "postural realism," while *Philosophy and Non-Philosophy,* when also speaking about an "immanent," "basic," or "postural" realism, claims that "vision-in-One is the posture or the very essence of thought":[36]

> vision-in-One—this is what its [non-philosophy's] grounded or postural realism (in order to oppose it to philosophy's voluntarist idealism) is called—does not suppose the One, or at least does not refer in the last instance to the real without experiencing it, without "postulating" that it experiences it as a radical immanence (to) self, deprived of operations of decision or of transcendence.[37]

The link between posture, the Real, and vision (in-One) is somewhat clarified here, especially in its contrast to the voluntarism and decisionism

of philosophy and its positions. *Principles of Non-Philosophy* takes this further still in relation to non-philosophical practice (which Laruelle states is not a "methodology"): "this identity of practice is the unobjectifiable cause of science-thought. And we cannot decide on the cause of this, *it can only assume itself as an immanent posture, the force-(of)-thought.*"[38]

On the other side of "position," Laruelle connects philosophy to the notion of games in a significant passage. Philosophy, he writes,

> is a game of positions: not only are the positions finite in number (however many variations they may be capable of), but the *positionality* of philosophy, its nature as game of positions, encloses the virtual infinity of positions into the finitude of a structure or circle. Hence its capacity for repetition, which is its very essence.[39]

Philosophical sterility emerges as much from its circular presuppositions as its positionality, which are at heart one and the same: its pre-sup-posed. But it is two texts, written almost twenty years apart, that delineate the posture–position duality most fully. We recall how *Philosophy and Non-Philosophy* is adamant that posture designates a holding

> not of self, but *in* self, the *how* this holding (is) held insofar as it has essentially never reposed except in itself. Posture is more subjective, corporeal and undivided than position; more internal, spontaneous and naive than will and decision. Posture is too immanent and completed, it indivisibly involves the individual's entire being too much to reinstate a decision or make it equal to a 'position,' which is always relative to another position, always alienable and revocable, always to be taken up and taken back up.... In other words, it is necessary to distinguish the *figurative,* but also the *figural, relational* and *positional,* from the *postural,* but as the necessary kernel of reality that precedes them absolutely and instead constrains them to be distinguished from it as mediated by unreality.[40]

Whereas position is relative and changeable, but only because it is invested in nothing but its own authority and survival, posture, being properly *in* itself, is both of the Real and, when it mutates, does so according to the Real. Nineteen years later, Laruelle's *Introduction aux sciences génériques*

continues in a similar vein, though here giving more time to explaining position as a mode of *human* self-alienation and conflict:

> We call "posture" the generic *a priori* dimension of Man. Position and posture are two different ways to take or be a decision. Man is a postural being rather than a positional reason, position indicating an act of transcendence by which he would depart from himself. Phenomenologically, posture seems to be more subjective and global than position, and, from this point of view, the term "generic" suits the former. It is certainly more real than position—which is always divided and in opposition with others—because posture is *immanence before all decision*. What specifically distinguishes a posture from a position? Position is 1. an ontological act that in reality is divided and reflected, and whose essence is to be self-position; 2. an act that is subject and object at once, an essence that wishes to exist, a way of being, it is even the proper manner of Being; 3. an anonymous act that is supposed to generate a me or a self; 4. an act that eventually has a being for an object. Posture, however, is not an identifiable identity but an immanent or non-identifiable identity, an invisible idempotency.[41]

Putting all of these ideas together involves a certain dexterity, not least the thought that posture might be an "a priori," that the human is a "postural being," or the fact that position *and* posture would be "two different ways to take or be a decision" (rather than the former alone being decisional). Hence, decision too can be rendered non-thetic and nonstandard: "non-philosophy is the opening of a new space, but *for* philosophy: *from this opening or this radical possible, it becomes possible to acknowledge decision as a particular case of 'non-philosophy.'*"[42] And, therewith, position itself becomes *non*-positional: "it is possible, at least by right, to describe, for example, position as a non-positional event by utilizing the philosophical language of position."[43] A less abstract rendering of posture emerges through Laruelle's work on the concept of non-photography. Indeed, the *non-* of *non-photography* must be grasped, he says, through the twin concepts of "photographic posture" and force (of) vision.[44] According to Laruelle, philosophers question photography in terms of the "being of the image," whereas he

wishes to incite a "new experience of visual representation," with the photographic process understood through its immanent "cause" in the idea of posture, here parsed as "force (of) vision." He even connects the notion of posture with the antiauthoritarian stance of non-photography—refusing the dictates of philosophers saying what photography *is*:

> what does it mean for the transcendental posture to realise itself as force (of) vision, if not to suspend from the outset or to immediately reduce this transcendence of the World, and all the phenomena of authority that follow from it, and to pose all the real problems of photography as a function of the immanence of force (of) vision?[45]

Here again we are reminded that nonstandard philosophy is rooted in a nondecisionism that reverses philosophy's withdrawal from the Real, which appears here on the basis of posture. As the *Concept of Non-Photography* also states, *posture* means "to be rooted in oneself, to be held within one's own immanence. . . . If there is a photographic thinking, it is first and foremost of the order of a test of one's naive self rather than of the decision."[46] Self-immanence is postural, behavioral; there is a photographic behaviorism in this materialist and immanent sense, then: "the experimental act of photographing that is its postural model."[47]

Yet we should also note that posture is not tied to a *subjectivist* immanence (like Michel Henry's) but a *subjective* immanence that also connects with other variables. As Laruelle states, "what we must really consider as an indivisible whole is the 'photographic posture,' a conjugation of optical, perceptive, and chemical properties that can only be fully understood as those entangled, non-local properties of a generic matrix."[48] Where posture was once described as the "generic *a priori* dimension of Man," now this matrix of posture conjugates the human with many other "non-local properties."

This matrixed complexity of posture is worth reflecting on. When writing on gestural pointing as "situated practice," Charles Goodwin says that

> the visible body is a complex entity that can construct multiple displays that mutually frame each other (e.g., points can be framed by larger postural configurations). The body is thus a very different kind of entity

than, say, the *feature* that constitutes the target(s) of the points here. Thus, parties engaged in the activity of pointing must attend to not only multiple visual fields, but fields that differ significantly in their structure and properties.[49]

Even pointing is a complex bodily attitude, and where Goodwin here thinks of it in terms of "attending," this can also be understood immanently as a matrix of exchanges between bodies (rather the representation of one body perceiving others). Indeed, the bodily (subject) is not tied to any objective image: this much we know already, of course, from both the phenomenological tradition of Husserl and Merleau-Ponty *and* the Nietzschean one of Deleuze and Guattari.[50] But just how a non-philosophical rendering of the same idea would operate concretely, in photographic art for instance, remains open to interpretation. Stella Baraklianou's photographic work—building on ideas from Bergson and Giorgio Agamben—provides one indication of a postural analysis of "the very act of photographing," through *walking*:

> Walking as an artistic and intellectual practice has had a substantial trajectory within the history of painting and photography: from the early artists of the picturesque movement to the more contemporary ones, including the urban walks of the Situationists" or those of the Land Art movement. . . . The photograph as a form of artistic expression contains not only the imprint or index of a recorded reality, but reflects the process of obtaining this image. This process, linked to time, is what makes the photograph unique compared to painting or sculpture, but not dissimilar to film. Whilst working on a series of images of trees in the landscape, I became interested in exploring the notion of photographic time as a quality beyond a dichotomy of before or after but rather as a reflexive state whereby landscape, photographer and camera all form and inform the very act of photographing. With the common denominator being defined through walking, the emphasis is placed on the fluid and instantaneous, the porous and limitless.[51]

Employing the term *pasearse*—a self-reflexive verb that can be translated as "to take oneself for a walk"—Baraklianou describes a matrix of artist,

camera, landscape, and photographic act through posture. In the course of this, there are moments "wherein the field of subjectivity between who operates what, becomes, for a short instant, ambiguous." This postural notion of *pasearse* even extends into the postproduction phases (development, cropping, etc.). She continues her immanent self-walk, or *pasearse*, as follows:

> Now the yellow brushes with the orange, slightly dissolves into it. Now the edge of the shadow is blurred, mixed with the contaminated colours. Contaminated inside of the film the chemicals are quick to adapt. Two different forces melt into one. Now the heat rises through my fingers piercing the film. My heart beats faster; extending the pulse that reaches the tips of my fingers. Seeking to dive into the image, the movement of my hands breaks the frame. I cut; my small scissors lashing out everywhere around the places where the image is still securely fastened. I cut; I am surprised at what my own hands can do. Guided by the cuts, the fingers reach the sliced edges; the act is now blind; the fingers seek an opening to reach the image. Now; a little bit more before the chemicals will join forever. The sticky substance gives way. I pull; the two pieces of film are detached from each other.[52]

In her *pasearse,* there are still "cuts" to be made, decisions that divide the matrix. Nonetheless, the cut too can be rendered postural—hands and fingers continuing the body's orientation—by removing any transcendence, for any cut purporting to represent the Real is, all the same, immanent to it.

RADICAL BEHAVIOR

It is also notable that Laruelle's *Introduction aux sciences génériques* adds a Marxist dimension to the contrast between this couple, with position "continually developing intervention effects that are actually interpretive," while posture "produces or determines effects of transformation."[53] Positions only interpret the world in various ways; the point, however, is to change it, through posture. This might sound odd (aren't positions just another name for interpretations?), but the idea is clearer if we literalize

"position" as a material source or bodily a priori for interpretations. Indeed, if we recall the remarks of Agnes Heller on radical philosophy in our introduction, her definition of left-wing radicality involved being both democratic and humanist. And in this she was following Marx: "to be radical, said Marx, means to go to the root of things. And, he added, the root of things is human beings themselves."[54] For Laruelle, however, Marx's humanism remains a philosophical position, whereas what he *aims for* is a properly transformative (mutating) human posture, and a radical one at that. From what we learned earlier about Laruelle's understanding of consistency, posture can be understood as the *root* of a "radical inversion" of philosophy in relation to the Real—for it means "to be rooted in oneself, to be held *within one's own* immanence."[55]

Laruelle is certainly fond of using the word *radical* in his work: "radically immanent thought," "radical liveds," "radically immanent phenomenology," "radical subjectivities," "radical atheist," "radical fiction," "radical experience," the "radically immanent structure [of thought]," and so on.[56] Hence it is especially significant that "radical" is described by Laruelle as "self-immanent," because the etymological root of *radical* is "forming the root," coming from the Latin *radix, radic-,* "root."[57] Consequently, the radical concepts of non-philosophy are such because they are consistently used, both toward itself (its root, its source) and others. Its concepts are amplified ones, that is, they are applied generically, beginning with themselves, their own roots. If there is any reorientation (transformations), it is also a self-orientation. And so we have the following statement on radicalism from *Principles of Non-Philosophy*:

> A radical modification not of the World but of our vision(-in-One) of the World, non-philosophy cannot appear weak or inefficient unless measured by the still metaphysical and violent ends of philosophy. Radicality, which is to say thought from the vision-in-One, is always less violent than philosophical "radicalism." The Radical or the Real does not imply "radicalism," which is a philosophical position.[58]

Given this radicality-without-radicalism, the contrast between *radical* and its oft-cited interpretation as "extreme" is significant here. The reading of *radical* as extreme emerges in discussions concerning "limits"

and "margins"—How far is too far? What is fanaticism? What is the true minority view? and so on. Coming from the Latin *extremus,* meaning "outermost," the extreme would connote that aspect of the radical that entails going beyond or outside a certain threshold—a transcendence or withdrawal (which, of course, is an image of decision that non-philosophy uses). Yet these thresholds and limits can be either *logical or psychological,* categories that are difficult to conflate such that one could define an *absolute* limit or "condition of possibility" (unless one cleaves to the Kantian view that logicizes one image of the human mind). Indeed, throughout his own work, Laruelle continually contrasts the immanent "radical" with any notion of the "absolute" (which remains transcendent). That said, the radical can explain the absolute: as he writes in *Anti-Badiou,* "the radical, for its part, does not eliminate the absolute, but allows for a genealogy of the absolute as immanental appearance."[59] (We will see in chapter 4 that this "genealogy of the absolute" allows for a discussion of the appearance of hierarchy within equality, wherein all things and all thoughts do *not* appear equal.)

A further meaning of radicality stems, significantly enough, from the very idea of a "radical behaviorism." Within the contemporary reconception of what B. F. Skinner's radical behaviorism can mean for current thought, psychologists such as Niklas Torneke now see it as a *consistency* between the practitioner and her subject:

> Being radical can be taken as being extreme. [But here] "radical" implies not "extreme" but "consistent." Radical behaviourism entails not a departure from fundamental behaviouristic principles but the application of them in an all-inclusive way. . . . As a scientist, I do not hold an objective or exclusive position. I am not outside or above the principles I study. If this understanding is applied consistently, all claims to representing the ontological truth have to be dropped. Based on this position, we cannot maintain that "this is the way it really is." . . . The scientist's attempt to study something is a behaviour as well.[60]

According to this formulation, Laruelle's approach is radically behavioral (rather than behaviorist) because it seeks, he says, "a new conditioning or usage of philosophy itself" in the spirit of consistency. But this

"conditioning" is not philosophical (Kantian) but materially scientific (in the non-philosophical sense), operating "through and on the a priori knowledges, by *universal* 'condition' or 'conditioning' rather than by general and regional laws."[61] It is behavioral.

In *The Perfect Human*, remember, the human is an actor—he is eating, shaving, sleeping, dancing. Questions as to motivation (why does he move like that?) or thought (what is he thinking?) are not answered with reports of internal states but skirted around with further external, anthropological descriptions of behavior. Jørgen Leth is a behaviorist, therefore, with what he claims is his *"fascination"* for *"working in an empty space, in which you put words, bodies, movements, gestures—in observing what's happening."*[62] Indeed, if Leth is a behavioral anthropologist *manqué*, then von Trier is trying to radicalize his approach, that is, he is attempting to reorient Leth's behaviorism onto himself (turning the camera onto the filmmaker in an act of consistency).[63] Yet the real "empty space" here is the human as such, or at least its supposed "interior," another black box that *acts as* a placeholder for every definition that philosophy is wont to throw into it.

In terms of philosophy (rather than science), then, the images of posture throughout Laruelle's work might also bring to mind ideas coming from "philosophical" or "logical" behaviorism in the work of Ryle, Wittgenstein, Quine, the early Merleau-Ponty, or even the more contemporary approach of Daniel Dennett.[64] In Laruelle's extrapolation of this paradigm, however, it is the intentions (and decisions) *of the philosophers themselves* that are rendered behavioral. If one maxim of philosophical behaviorism was that "the human body is the best picture of the human soul," then Laruelle's behavior-without-behaviorism would tell us that posture is the Vision-in-one of philosophy.[65] That said, we know that there is no *one* "best picture" of philosophy—nor indeed one best picture of non-standard philosophy either: there are only the myriad forms of postural mutation. What all philosophies share is the decision, the withdrawal from the Real, but that is all—any further, more fine-grained markers are *verbal*, that is, actions. Hence this chapter's titular concern: "how to act like a non-philosopher" (or a philosopher).

So, for instance, in *Anti-Badiou,* Laruelle describes Badiou's thought as an "affirmation, a style, a posture, a statue that forms around it the type of circular void to which young badiolisers will gravitate." Badiouism (as

opposed to Badiou) is a void of circulations. Treating his thought in this manner (in an "exercise of philo-fiction") transforms it into "a body or a part of nature, a new philosophical object upon which we would carry out an experiment or provoke a reaction."[66] But, as Laruelle continues, the "characteristic, celebrated and foundational gestures" of other philosophies can also be transformed into verbal objects: "founding, reducing, subtracting, withdrawing, suspecting, critiquing, anticipating/retarding, overthrowing, meditating, elucidating, analyzing, synthetizing, deconstructing and constructing, etc."[67]

Let us try to extend this analogue some more. "Courage," as when we say "Nina has courage," is not a state of mind, according to Gilbert Ryle, an immaterial private interiority (the "ghost in the machine"); rather, it should be described "thickly" in an aggregate of exterior public behaviors either as adverbial properties (Nina runs *courageously*, Nina speaks *courageously*, etc.) or subjunctive conditionals (Nina would run courageously..., would speak courageously...). Likewise, the philosophical decision would not be an occurrent state or moment within a philosophical mind but rather a global descriptor of certain behaviors ("overthrowing, meditating, elucidating"...). They are different for each case, yet they contain family resemblances or likenesses with others. In *The Concept of Mind*, for example, Ryle translates inner states of "thinking" X into behavioral particulars, such as talking or writing X *heedfully, purposefully,* and so on:

> So when a person has, or is at home with, a theory and is, therefore, prepared, among many other things, to deliver to himself or to others a didactic statement of it, he is ipso facto prepared to deliver the required premiss-sentences, conclusion-sentences, narrative-sentences and arguments, together with the required abstract nouns, equations, diagrams, imaginary illustrations and so forth. And when called on to give such an exposition, he will at particular moments be actually in process of deploying these expressions, in his head, or *viva voce,* or on his typewriter, and he may and should be doing this with his mind on his job, i.e. purposefully, with method, carefully, seriously and on the *qui vive.* He will be talking or writing, heeding what he is saying. So we can say, if we like, that since he is at particular moments heedfully

deploying his abstract terms, premiss-sentences, conclusion-sentences, arguments, graphs, equations, etc., he is then and there "thinking" what they mean.[68]

This use of adverbs is not merely a fanciful description of behavior—a "mindless" mechanism in itself (a "machine")—but the restoration of rich meaning to worldly acts. Rylean behavior is permeated with "purposiveness and intelligence"—it is not a set of relatively dumb reflexes.[69] Other, contemporary forms of behaviorism take an even more embodied perspective. When Massimiliano Cappuccio writes about "contemplation," for instance, the concept of posture returns:

> Contemplation—it should be clear at this point—is not an alternate modality of experience, opposed to interaction, but one that completes interaction through the residuals, the useless traces of abandoned interactions. Contemplation predicts specific postures, attitudes, and a certain readiness to dealing with virtual circumstances whose possibility is only disclosed through an actual impossibility. But it is a peculiar form of readiness, one that asks to neutralize all the other forms of readiness (e.g., readiness to reach, to grasp, to manipulate), in order to reflect on the situation from a distance, and allow detached decisions on it.[70]

Contemplation becomes a readiness set to neutralize other gestures and so allow a reflective "distance" and "detached" decision.

All we would add—to exorcize these ghostly states consistently—is that such reflection is already indicative of *distance* and that the decision is already in the (particular form of) *detachment*. Consequently, in this general manner, we can begin to divest decision of its associations with intellectualism, voluntarism, and reflexivity (at least in terms of how these might usually be comprehended) by translating it—via particular verbal acts ("gerunds," adverbs)—into real behaviors. By expanding the notion of behavior—that is, by making it nonstandard—it can be seen that the concept of philosophical "decision" is neither conscious nor representational but a matter of orientation or posture as regards the Real. As *Philosophy and Non-Philosophy* puts it, "this slogan—to treat philosophy as a whatever material—discovers its origin here, in this

suspension that makes the philosophical ultimately appear 'such as it is' or the material as 'whatever' in the sense that it is deprived of all signification or of all explicit or virtual philosophical function."[71] The same work then adds,

> The primary philosophical text is re-written or "rectified" in the language of the "non-thetic," which eliminates all references to a decisionality (break, leap, transcendence, nothingness, annihilation, will, etc.) and to a positionality (project, opening, horizon, reference, world, plane of immanence, totality, etc.).[72]

Yet it is not so much the "elimination" of position per se as its translation into posture that Laruelle follows, and with that its deauthorization (its claim to transcendence). Occurrent philosophy (its actuality, *en acte*) is no longer based on its *own sufficient reasons* (or "inner states") but becomes behavioral, though following a nonreductive model of what that entails—one that opens it up to concepts of "tendency," "vector," or "orientation." We then have a parallel between the behaviorist's "bracketing" of consciousness and non-philosophy's reorientation *away* from the worlds constructed by philosophy, and *toward* the Real—a Real-oriented posture.

In terms of crude methodology, however, instead of bracketing consciousness, we would begin by bracketing the *authority* of philosophical representation—*its attempted capture of the Real in its own image*. What remains are lived, public behaviors: to be precise, the observable descriptions of philosophical behavior—non-philosophical clones. *Whose* observation, and which *public*, will always be moot, of course. Ideally, it should be a democracy of all possible observers (a Vision-in-One) that allows all eyes (human and non-standardly human) their own regard. The strong descriptivism that Wittgenstein claims to "leave everything as it is" need not be anthropocentric.[73] The fact that certain humans *are* nevertheless anthropocentric will be a topic for the next chapter to address.

Of course, behaviorism in philosophy (Ryle and Wittgenstein) and psychology (Thorndike, Watson, and Skinner) has been in mostly low standing since its drubbing at the hands of Noam Chomsky in 1959 and the advent of the "cognitivist" paradigm. Following this, it was understood that there was much more to mind than external behavior could explain

because certain interior psychological states were deemed ineliminable, if only as the functional states of matter (realized in the heady mix of cognitivism and neurology that later became and remains part of the orthodoxy). The ghost in the machine was replaced by a function (such as "Universal Grammar") in the machine. Yet there has been a resurgence of a more sophisticated use of behaviorism in recent times: in Daniel Dennett's theory of "stances" in the philosophy of mind, for example, or in "Relation Frame Theory" in psychology (such as Niklas Torneke practices).

More to the point, the status of the supposedly fatal problem, for *philosophical* behaviorism at least—that of the indefinite proliferation of behavioral descriptors—is highly debatable. The problem is said to concern behaviorist renderings of mental states such as "Nina loves science." If we translate this state into behaviors, such as "Nina reads science books" (or "works in a science department," "looks at science programs," etc.), or dispositions (Nina *would* read science books . . . , or *would* work in a science department . . .), some might still find this account unsatisfactory because of a loss of explanatory scope. Whereas I can indeed justifiably infer from "Nina loves science" that she might "read science books" (or work in a science department, look at science programs, etc.), I cannot do the reverse. That is, I cannot reasonably infer from "Nina reads science books" what other kinds of behavior follow (because I do not know her private *motives*—after all, she may have become a scientist purely to make a living). So, there is a loss of explanatory scope in the translation that can only be supplemented by a proliferation of other behavioral descriptions: reading, working, looking, talking, practicing, and so on, ad infinitum. Crucially, this proliferation is deemed fatal for behaviorism because it *cannot* be stopped—each behavior calls on further behaviors to help fulfill the translation in a never-ending series of supplementations. The explanation of behavior *explodes,* so to speak, into other behaviors. Hence, it is argued, one must make recourse to an *inner state* (preferably hardwired) to find a *finite* explanation for these intentional and affective conditions.

However, we might respond to this critique by asking, what is so wrong with an explosion of descriptions anyway (the so-called regress problem)?[74] On one hand, if a rich behavioral description requires an

indefinite sequence of terms within a radical externalism—so be it (nature might be that way inclined, that is, indefinitely rich at all levels rather than increasingly simple at supposedly fundamental levels). On the other hand, there is little to say in principle against a behavioral rendering *also* being ascribed to these "inner states." We can envisage them as a proliferation of microbehaviors (as we will consider later) rather than palming the explanation onto neurology *without* acknowledging the necessary homunculism that results thereafter (neurons that are "translating," "communicating," "encoding," or even just "adding" and "subtracting" with each other). In fact, we can *openly* adopt the stance that sees mind as a multiplicity of microactors, performing homunculi, or "actants," while still being careful of the negative as well as the positive aspects of such anthropomorphism. In other words, the proliferation of behaviors can both *explode* along a macroscale of explanation and (seemingly) *implode* along a microscale, the latter being merely a miniaturization of the explosion.

We might call on Dennett's work to aid us here. According to his parabehaviorist approach, it is possible to interpret any object according to three different "stances": physical, design, and intentional.[75] The *intentional* stance enters us into a hermeneutic circle with a *presumption* of mental intentionality that is thereafter either increasingly reinforced or not, according to the wholly external behavior of the object. This object could be a human, an animal, or a computer, for instance. We are both "creators and creatures" of such interpretation. To this approach we would only suggest the following: if we are to understand these "stances" consistently, then they themselves must become behavioral rather than hermeneutical (i.e., representational). Understood as bodily posture, then, we can see the possibility of a "human stance"—that which shapes the Real in one kind of human image, be that image miniaturized (a homunculus) or not. If the non-philosophical ambition is to see all philosophy through its "style," "allure," or "gesture" (as Laruelle puts it), and therewith to purge philosophy "of its transcendent models (science, logic, perception, right, etc. . . .)," then this means that humans too will be "taken 'in-body' in their generic materiality" rather than as a defined species of thoughtful (inner) animals.[76] Behavior integrates everyone into the Real equally. (We will return to this in the next chapter when discussing anthropomorphism and the "charitable" attribution of "being human.")

THREE DISTANCES: WITHDRAWAL, HALLUCINATION, ORIENTATION

We know that one of the ethical imperatives for Laruelle is "avowedly *utopian*": to "hypothesise a better place for the human." Yet we may, again, take even this notion more literally than is normally deemed appropriate, as a form of space. The utopian "no-place" becomes an elimination of distance. Philosophy, by contrast, is "interested in the world only via some withdrawal or difference," because, as we also heard, "to philosophise on X is to withdraw from X; to take an essential distance from the term." Yet this distance is not an *object* of philosophy: it is the *form* of philosophy—"transcendence or Distance," the "pure or abstract transcendence, the *identity-(of)-distance.*"[77] In this section of the chapter, we will look at Distance through three of its names: withdrawal, hallucination, and orientation.

Rocco Gangle rightly says that Laruelle is unhappy with the spatial metaphors of philosophy and that rejecting "'position,' 'neighbourhood,' 'path,' 'shift,' etc.—will be one of the key elements of his thought."[78] Still, this does not mean that Laruelle will not also take these metaphors seriously, that is, demetaphorize them into their literal elements. Hence, when Gangle names one section of his guide to *Philosophies of Difference* the "Self-Dislocation of Philosophy," he is not wrong or inconsistent here either.[79] Philosophy *does* dislocate itself from the Real, and non-philosophy attempts to undo that action within a reoriented view or a kind of dis(-dis-)locating. A parallel can be found in Heidegger that might explain this apparent duplicity of Laruelle's attitude toward distance and space. Massimiliano Cappuccio cites Heidegger's "What Calls for Thinking?" when discussing gesture and refers to pointing as what "'draws towards what withdraws,' where the sense of the withdrawal is precisely an internal turn, or a possible outcome of the very act of drawing towards and its implicit possibility to fail."[80] Indeed, for Heidegger, it is the *object* that *withdraws* itself *from* we philosophers—and truth (as *Aletheia*) that (un) conceals itself. Yet here in fact is also where a useful contrast emerges between the two. For Laruelle, it is *philosophy* that immanently withdraws from the object or Real, and non-philosophy that must invent a means to discover how to restore philosophy to the Real. That restoration does not involve negation, sublimation, or destruction (the usual philosophical

operators that continue to invent new *positions*, which, for Laruelle, only perpetuates the withdrawal). It is simply a reorientation, the discovery of how to see what is already there. In the following from *Anti-Badiou*, the idea is posed in terms of "subtraction":

> To subtract without withdrawing into oneself and without exiting (from oneself) to go capture a prey, but instead to subtract by superposing—this is the non-acting which, thus, does not act, but does however subtract from the symbolic the means of future action upon the latter. . . . The subtraction of the Real itself is already done (and is to be redone or re-sumed); it is already subtracted and resumed qua subtracted, but is not itself the object of an explicit operation of subtraction.[81]

The Real *subtracts itself*—this is not a *new* operation (*our* subtraction on top) but the philosophical withdrawal reviewed immanently, through the vision-in-One. It can be likened to how von Trier and Leth see the difference between cartoon animation and photorealism, vis-à-vis the source of decision: the former has the constant decision making of the subject–artist, whereas the latter has the decisive moment of the real object.

This leads us on to the question of philosophical illusions or errors. For Laruelle, philosophical error is no longer understood as misrepresentation but optical *hallucination*—a phenomenon of self-imposed distance or auto-position:

> measured against and related to science, philosophy conversely is reputed hallucination. Such that, for science taken as ultimate or first point of view, the act of baptizing these representations as "fictions" is still a procedure of self-defense or already an effect of the hallucination of the real. In other words, these are the same representations each time, and *the science of decision is philo-fiction.*[82]

These hallucinations are more like misplacements and are certainly not *fictional*. Hence, as *Anti-Badiou* also states, "*the notion of transcendental illusion has no purchase here; it is an immanental appearance.*"[83] It then continues:

Thus, the denunciation of illusion, of the very existence of illusion, is ambiguous: K/F [Kant/Fichte] and Badiou place it at the ultimate service of philosophy, so that illusion is still perceived through philosophy itself, as if it were to be its mistress one last time—in this case, we get materialism. They cannot accept that the illusion is total, since they "are" philosophers; whereas for NP [non-philosophy] it is the whole of philosophy that must be denounced, and precisely not as philosophy, but as positive immanental illusion that could be or could become the object of a science. . . . NP denounces illusion *in immanent exteriority or through the exteriority of real immanence.*[84]

To "hallucinate" means to have "gone astray in thought," just as to "err" is "to stray." But one cannot stray so far that one falls into a void. Hence a function of non-philosophy is to recuperate such "error" through "dis-hallucination" rather than epistemic correction:

> a *dis-hallucination of philosophical decision, its absolute dependence in terms of an undecided real.* [Yet] dis-hallucination is not the nihilism by which unitary philosophical decision is infected (with) itself. . . . There is no illusion *of* the World; the World is not illusory or misleading, this is not a phantom, a cloud, a veil which would hide reality from us.[85]

A cloud does not cover (conceal) "its" raindrops—it *is* raindrops, only *at a distance*. There are no "*petit perceptions*," only different perceptions (some of which are seen *as* small from another point of view). The "hallucination," qua error, is in seeing the cloud *as* epiphenomenal, as less than real. It is one image attempting to be every image, or the All: *that* is the "illusion"—the illusion of being the whole rather than a perspective on the whole.

"*Orientation*" is, doubtless, another key term in understanding Laruelle's approach, both in relation to distance as well as in terms of behavior. The reorientation of thought is his problem, after all, in that uni-versality and uni-laterality, being toward the One or alongside the One, is the constant direction taken in his own thought. Orientations abound here: non-philosophy is "*universe-oriented*" or "degrowth-oriented," whereas philosophy is "*world-oriented*" and self-oriented alone (each world being

what philosophy conjures up as it perpetuates itself).[86] Now, we could turn to any number of thinkers to help unpack the meaning of this orientation: Mikel Dufrenne's local *a prioris*, for example, as "*an original orientation of the body*"; or Henri Lefebvre's social and political production of the "individual's orientation"; or, among more contemporary figures, Bernard Stiegler's "originary disorientation" of technics, or Sara Ahmed's "queer" orientations."[87] All four of these other figures, though, practice a phenomenological orientation (Lefebvre with a small *p*), with the arrow of intentionality guiding them. As phenomenologists, then, their representationalism ultimately harks back to Kant, albeit in different ways.

So it is not incidental, in this connection at least, that Kant also wrote an essay on "What Is Orientation in Thinking?" Despite his own technically abstract style, in this work Kant is quick to agree that "however exalted we may wish our concepts to be, and however abstract we may make them in relation to the realm of the senses, they will continue to be associated with *figurative* notions."[88] In the course of his argument, he takes the concept of orientation and extends it through various means, beginning with the "geographical" relation of one's body to the sun, the horizon, and its own left and right hands; he then moves to "a purely *mathematical* sense" of orientation (i.e., one within any "given space"), until he finally reaches orientation "in *thought, i.e. logically.*"[89] This last orientation acts as a "signpost or compass" for all "rational wanderings in the field of suprasensory objects." Yet even it is answerable to another, ultimate guide:[90]

To employ one's own reason means simply to ask oneself, whenever one is urged to accept something, whether one finds it possible to transform the reason for accepting it, or the rule which follows from what is accepted, into a universal principle governing the use of one's reason. Everyone can apply this test to himself, and when it is carried out, superstition and zealotry will be seen to vanish immediately, even if the individual in question does not have nearly enough knowledge to refute them on objective grounds. For he is merely employing the maximum of the *self-preservation* of reason.[91]

The last sentence of this passage reveals a great deal: it is not reason, nor even any particular form of reason (universalizability), that should direct

us but the moral imperative of the "*self-preservation* of reason." For Laruelle, this really means the self-preservation of *philosophy*. Philosophy must exist—its performative actuality (which is precisely *not* to do what it says) *is* its ongoing existence, which we might even call its auto-ontological argument. Non-philosophy, alternatively, attempts to reverse this orientation wherein everything now must follow *(from)* the Real: "everything must be reversed—or rather: can never reverse again, not even to reverse the reversal once and for all. Everything must be 'uni-lateralized' and thought in a rigorously irreversible way."[92]

"Reversals" too, of course, have a long and august philosophical lineage (in Bergson, Husserl, Heidegger, Deleuze, et al.), so Laruelle most often prefers to avoid thinking in these terms. The orientation of the Real (from where everything stems, for everything is equally in the Real) is *irreversible*. Philosophy reverses this irreversibility; indeed, it is the very image of *reversibility* itself, such that non-philosophy must invert this reversibility to thereby restore the image of irreversibility. Yet this inversion, qua inversion, is more like the "negation of the negation" (which is a positive act and only negative indirectly). It is only secondarily "inverse": "the order of vision-in-One is inverse and still something other than inverse."[93] If this is a reversal, then, it is what we could call a "reverse mutation" that suffers no possible reinversion.[94] This is a concept from biology whereby the "wild-type" phenotype spontaneously restores itself by undoing the man-made genetic alterations of the laboratory. Borrowing from this biological model, then, we could say that what happens in the philosophy laboratory (all the various mediations and distortions of the Real wrought by philosophy's decisive quest for mastery, for ultimate authority) "reverse mutates" to be no longer seen as the best picture of reality but only as a product or effect of the Real. The orientation is inverted, *from* the direction of Philosophy to the Real, *toward* the direction of the Real to Philosophy. The mutation, therefore, is not of things but of vectors, because the mutation reorients thought-as-an-orientation itself:

> The philosopher wants to fold the real onto his thought and decrees through idealism that the real does not exist if he cannot think it. Vision-in-One constrains us to do the opposite: fold our thought onto the real by modifying the concept in accordance with it; no longer to be able to be willful, decisionist, idealist, but to be necessarily naive, experimental,

realist, and to modify our traditional practice of thought and language in accordance with this experience of the One-real that we take as our transcendental guide.[95]

The non-philosophical approach looks with a mutated orientation, looks back or in reverse, and therewith creates a new description, even of what counts as "forward" and "reverse," progress and regress, growth and "degrowth."

MIMING PHILOSOPHY: A GAME OF POSTURES

In *Principles of Non-Philosophy*, Laruelle speaks of a philosophical "ventriloquism" of the Real. Yet his own seemingly quasi-mimetic approach to philosophy can equally be seen as a ventriloquist's act that revoices philosophical material (in an immanent mode).[96] We could thereby see *non-philosophy*'s performative posture as one that "plays the dummy" so that it can reenact the speech of philosophy. This is also another way of understanding what Laruelle means when he says that non-philosophy "clones" philosophy. These clones "are not doubles or exact reproductions of philosophy," yet they are remakes of a sort—mutants.[97] Perhaps a more suitable analogue for this cloning comes in an alternative to the philosophical "game of positions": the non-philosophical game of *charades*. Charades is a "parlor game" whereby players attempt to guess correctly a proposed film, book, or play, the identity of which is conveyed through mime alone. Four basic approaches to playing charades can be compared with philosophy and non-philosophy. The first and most common method involves one player analyzing the title of a film, book, or play into its component parts—either words or, at a finer level of analysis, syllables. Then these words or syllables are mimed to the other players; that is, an attempt is made to show what those individual words refer to in the world so that the players might guess the title correctly. The problem with this method is that, all too often, the player who first guesses correctly does so on account of *already knowing* the relationship between the mime and the words being mimed (frequently because the guesser is sufficiently familiar with the person doing the mime to know the way that her mind works, that is, the associations that she habitually makes in their shared world). The method is circular: they have arrived at the title by miming

a world of words *already* shared with others, but *not* by miming the film, book, or play *itself.*

A second, similar strategy involves ignoring the name of the film entirely and miming one of its iconic images (such as a shark fin for *Jaws*). Once again, though, any success earned this way rests on a set of shared cultural associations ("fin" equals "shark" for land dwellers first and foremost). The third most common strategy is to take the individual words or syllables of the film title and convey them by analogy with other words that they sound like *and* that are easier to mime, perhaps because they are terms coming from more concrete domains (the biological or the physical, say). This would be a reductive approach, however, that only achieves its win by making the verbal analogy an end in itself—miming a physical phenomenon—rather than the work's title.

Non-philosophy, however, takes the fourth, least common, and most "abstract" approach. It tries to mime the film, book, or play *in one gesture, in itself and as a whole (not via its name).* If philosophy as a whole were the chosen object, then non-philosophy *mimes* philosophy in-One, that is, in One gesture, and as part of the "Real-One":

> The One as clone is their essence [the "remainders" of philosophy] and, in this way alone, is the essence of philosophy not *as* philosophy but as *the identity of philosophy.* It determines philosophy to be non-philosophy, which is to say to enter as material into non-philosophy, which is the identity of philosophy.[98]

Philosophy is not broken down into its component terms as though *one* of them could stand for the whole of philosophy: Aristotelian wonder, Cartesian doubt, Hegelian dialectics, Heideggerian questioning, or, in a less personalized but more "iconic" mode, pure argument, analysis, logic, and so on. This would only work for those who *already* believed that *all* philosophy is, in essence—that is, when "proper" or "true"—Heideggerian, Hegelian, analytic, or some such thing. Nor is philosophy conveyed by reducing it to *another* domain such as physics, neuroscience, or linguistics. That, again, would simply assume that this reductive domain already *is* identifiable with philosophy, a move begging the question as to what philosophy is (which was the point of this special charade in the first place—to mime philosophy as a whole).

Instead, Laruelle would take the charade seriously because he wishes to convey the identity of all extant philosophies equally—not just of one of its parishes to its own congregation. Such a charade is also a mime that engages the whole of philosophy, while at the same time (re)viewing it in a new light: "what I call cloning is . . . the essence of human action. It's not the manufacture of a double for some existing reality, under an identity which would be common to them."[99] Once cloned, philosophical statements are "stripped of their philosophical dimension or sense," and yet their transcendence "is not destroyed *as such* but sterilized *as is.*"[100] Non-philosophy takes the terms of philosophy and follows the procedure of *"simplification or reduction"* such that they are "reduced to the state of *first terms* deducted from the philosophical field and deprived of their philosophical 'signification' . . . of their formal philosophical trait of auto-position."[101] Nothing is destroyed, deconstructed, or negated. Everything is reviewed, mimed, or "postured."

If this is a mime, then it is what Laura Cull describes as an "immanent mimesis" rather than a species of representation or mere copy, one "dissociating mimesis from referentiality."[102] It might also be likened to the *moiré* effect created by the superimposition of patterns (which can generate an impression of color from black and white lines). As Stella Baraklianou writes, "moiré points to the asignifying symptom of non-image formation and the mathematical formulas of an immanent reading of representation."[103] She continues, relating the *moiré* effect to non-philosophical cloning, as follows:

> Conceived through the moiré pattern, Laruelle's matrix becomes the excessive account of the same as it doubles, parts from itself, mirrors itself, separates and departs from any direct register of the real, demonstrating the formula of a lived algebraic formulation. An immanent appearance of the photographic, the matrix, or moiréd image, becomes an indefinite process, one that includes the apparatus and the observer within the very subject of the image. Index may form part, but not the only part of the image.[104]

Instead of merely being an artifact, illusion, or error, the "interference" between images, or "failure of register," becomes a "positive re-enactment," a clone or immanent mimesis.[105] So what Laruelle calls "photo-fiction,"

for example, is for him a "theoretical act 'miming' the material act but which is irreducible to it."[106] The mime is not a picture *of* X, a philosophy (and certainly not the "best picture"), but a continuation that reorients philosophy's sense of direction (its line stemming now from the Real *to* philosophy, rather than vice versa). As an *immanent* mime, therefore, it apes, parrots, or copycats philosophy, rendering it behavioral. As Laruelle writes, "science is not a question of *decision*…; it is a question of 'posture,' which is to say of 'behaviour' or of 'seating' in oneself, realised solely by the means of immanence."[107] It is noteworthy here that the etymology of *mime* goes back both to "a buffoon who practices gesticulations" and to the Greek *pantomimos*, "imitator of all."[108] The buffoon, naïf, or transcendental idiot makes a mockery of the philosopher's truth by cloning it as a "philo-fiction" (this idiot will reappear in the next chapter, as an animal philosopher).

CRUX SCENICA: PHILOSOPHY'S FIRST POSITION (VERSUS THE HUMAN POSTURE)

According to Karen Jürs-Munby,

> the disciplined art of acting which corresponds to this aim is elaborated in instructional texts as late as Franciscus Lang's *Dissertatio de Actione Scenica* (1727). As here illustrated, the actor is taught to assume the basic posture, the so-called *"crux scenica,"* in which the feet were placed at a ninety-degree angle, while performing strictly prescribed physical representations of the emotions. By thus controlling his body according to the rules, the hero proves that he is also in control of the affects that storm in on him.… The comic figure—Pickelhering, Hanswurst, or Harlequin—similarly violates all the rules of this highly regimented acting: rather than keeping his body taut and controlled, he bends his knees and upper body, shows his naked behind, and gestures obscenely below the waist.[109]

Earlier, we noted that the actor playing the perfect human for the third remake in *The Five Obstructions*, Patrick Bauchau, was cast in part for his "well-bruised" quality. He performs the "Man in Brussels" in a set

of poses, his world-weary face doing a good deal of the acting for him, mute. Early cinema acting, following its theatrical forebear, was hugely influenced by the tradition of mime and gesture (Agamben goes so far as to name gesture the essence of cinema).[110] And, as Jürs-Munby says of the "*crux scenica*" in theater acting, there were standard (heroic) and nonstandard (comical) postures in such acting that were characterized as deviations from the relaxed, erect, symmetrical pose. David Mayer explains this in more detail as follows:

> To convey such an individual, the actor's stance is the prescribed *crux scenica*: the relaxed body upright, arms similarly relaxed to gesture easily, knees slightly flexed, heels together, toes apart at a ninety-degree angle. This posture, which coincides with the development of ballet positions, we recognize as First Position. In any departure from a posture in which the body is always in control, denying or subduing all unruly and antisocial impulses, the actor begins to define character. Should the actor assume another stance, the audience, reading these signs, may make inferences about the character depicted. The *crux scenica* identified the man or woman of intellect and self-discipline. Self-control—a few key gestures and a virtual absence of multiple histrionic gestures—allowed an admirable person to survive intrigues without needing to reach for his sword or break her fan.[111]

In the 1830s, the Parisian elocutionist François Delsarte (1811–71) codified a "gestural vocabulary" for the stage. Delsarte kept to this early-eighteenth-century notion that any stance that deviated from the *crux scenica* could be read as a sign of (bad) character. This gestural acting, while not realistic by present-day standards, was nonetheless regarded at the time as verisimilar performance.[112] Crucially, because absolute reality was deemed unknowable, acting *Truth* was more highly valued than a putative *acting realism*. As James Naremore relates, this is what theater historians "now call the mimetic or 'pantomime' tradition—a performance technique that relies on conventionalized poses to help the actor indicate 'fear,' 'sorrow,' 'hope,' 'confusion,' and so forth." This was opposed to the position of "psychological realism" found in naturalism and later Method acting.[113]

Clearly a parallel can be made involving the *crux scenica,* with its

basic and deviant postures, *and* non-philosophy's distinction between the first positions adopted by each and every philosophy and the mutant non-standard postures that do not attempt to represent the Real. Every philosophy is its own "first philosophy," positions itself as first—or rather, *is* thought in the position of firstness. Non-philosophy, by contrast, is the deviant, comical posture, the obscene gesture practiced behind the Master by the court jester or Harlequin to create a new effect. What more can we say about these character attitudes as postures? Jean-Claude Schmitt has written about how the concept of attitude *(modus habendi)* is closely associated with that of *figuratio.* It results from the pausing of the movement that forms an ideal figure.[114] Similarly, Elisabeth Engberg-Pedersen tells us that "differences in body posture link with emotionally different facial expressions to signal sequences of discourse with shifted attribution of expressive elements; this signals the intended character, but is not indexical, as changes in body posture do not indicate a locus."[115] In many respects, Henri Bergson also belongs to this tradition of physicalized attitude, only now displaced onto philosophy. When writing on attention, he discussed "attitude" (from *attitudine,* "fitness, posture") in terms that went on "to define attention as an adaptation of the body rather than of the mind and to see in this attitude of consciousness mainly the consciousness of an attitude."[116] In his 1912 lecture "The Soul and the Body," *thinking* itself is equally vectorized in a clearly behaviorist manner, albeit also being internalized as a tendency, "performed in the brain":

> Consider thinking itself; you will find directions rather than states, and you will see that thinking is essentially a continual and continuous change of inward direction, incessantly tending to translate itself by changes of outward direction, I mean by actions and gestures capable of outlining in space and of expressing metaphorically, as it were, the comings and goings of the mind.... These movements, by which thought continually tends to externalize itself in actions, are clearly prepared and, as it were, performed in the brain.[117]

Here we have the aforementioned microbehaviors of the brain alongside macrobehaviors of bodies in relation. Such a duality would shortcut the traditional disputes, between "central state materialists" and functionalists on one side and logical behaviorists on the other, by rendering behavior

neurological while *simultaneously* upgrading cerebral motor-mechanisms to something more than just "mindless" mechanical movements. Causal or functional reduction (of one by the other) would not be entailed, for the macroposture would simply be the "externalized" translation of many micropostures, none of which are determining because each domain is equally in the real, in-the-last-instance.

From acting emotion to bodily attention and even philosophical position, these various theoretical approaches to posture can throw new light on Laruelle's use of the term as well as its analogue in cinema. Why was Patrick Bauchau the best actor to play the part of the man in the third remake of *The Perfect Human*? Why, conversely, was Gas Van Sant's audiovisual duplicate of *Psycho* deemed such a failure? Because sheer repetition is never invention, even when the repetition is of novelty, as when philosophy attempts to re-create itself through difference. What is remade is never a fixed image or sound, a propositional state or story. What is remade, or cloned, is a posture—a bodily immanence seen in-One.

But what of the *human* posture cited earlier? And what of the Real as "postured"? Are they both mere anthropomorphisms once more? Both "human" and "posture" can be connected to permutations of the formula "in-the-last-instance" (DLI), which we read in chapter 1 in terms of temporality. *Now* it may be more pertinent to read DLI spatially in terms of "stance," the Real being human in-the-last-in-*stance* (or posture). Would this help us to understand when Laruelle says that something "is real ... only because it is in-the-last-instance human"?[118] *Instance, instant,* and *stance* all share etymological roots going back to the verb "to stand." And posture is therewith indeed connected to the human:

> Posture is the dimension of truth that inscribes knowledge as a True-without-truth. We distinguish postural (or postured) force, which is that of the Man-in-One, from necessitating necessity, as inclining strength.[119]

"Man is a posture."[120] There are, of course, more standard approaches to posture, such as we see when Bernard Stiegler writes in *Technics and Time* of how the human "erect posture"

> determines a new system of relations between these two poles of the "anterior field": the "freeing" of the hand during locomotion is also that

of the face from its grasping functions. The hand will necessarily call for tools, movable organs; the tools of the hand will necessarily call for the language of the face.[121]

In becoming upright or erect, we become human—tool using and facialized. The *crux scenica* is not only an actor's device, therefore; as rectitude it is also the scene where the human emerges. Of course, Stiegler is only following his guide, André Leroi-Gourhan, here, who wrote that "it is conceivable that monkeys and humans had a common source, but as soon as erect posture was established there was no more monkey in humans and, consequently, no half-human."[122] The *crux scenica* is equally the scene or stage of the "first position," a term common to dance as well as philosophy, or at least the perfect philosophy of the human who faces down all opposition. In the following chapter, however, we will look at the nonstandard, nonstanding, imperfect humans who deviate from the erect posture but who, at the same time, "body forth" a poetic animality (to use J. M. Coetzee's phrase). Humans, we said earlier, can be "taken 'in-body' in their generic materiality" rather than as a defined species.[123] These will be the mutants, the "comic figures" of the stage, or what Laruelle calls the "transcendental idiots." They are also the nonhuman. And it will be in the fourth remake of *The Perfect Human* that we will also see a poetic degenerate (or "degrowth") emerge, an animality that belongs to cinema, through *animation*. According to von Trier and Leth, though, being forced to make all the decisions when directing a cartoon ensures that the result will be "crap"—it will be idiotic, naive, stupid. Yet it may also demonstrate an animal philosophy, one not so far staged.

4

THE PERFECT NONHUMAN

Philosomorphism and the Animal Rendering of Thought

"Man is the most terrible of beings" (Heidegger); "Man is a wolf to man" (Hobbes); "Man is a monstrous living being" (a neuro-biologist). Now, "the philosopher is the man par excellence" (philosophers). And the conclusion is . . . ?

FRANÇOIS LARUELLE, "The Degrowth of Philosophy"

Maybe we could universalise non-philosophy even more. It would require making a body of knowledge accessible not only to humankind but to all individuals. So is that possible "for all individuals"? I don't know. I don't believe that it would be possible. It has to pass through this mediation, this distorted mediation that is humankind.

FRANÇOIS LARUELLE, "Non-Philosophy, Weapon of Last Defence"

EVERY ANTICOMMUNIST IS A DOG: INDEFINING THE HUMAN

Within the history of psychology, behaviorism has a lot to answer for: in experimental study and clinical practice, its abuse of unfortunate animals, both human and nonhuman, is probably beyond redemption. Some of the simpler behaviors ("operants") observed during its first iteration were doubtless prone to basic conditioning. But the long-term suffering it caused was probably an indication that even these observations were superficial, formed through extraction from a much richer ecology (and duration) of behaviors that were neither visible in experimental settings nor conducive to manipulation. Just what is given externally and recorded in observation statements are both in the eye of the beholder, a beholder who is at any one time the product of another ecology with its own set of internal ("psychocultural") and external ("biophysical") variables. And where the line is set between what counts as *these* internals and externals is not simply given either, but (arguably) a variable generated elsewhere.

And so on. What is culture and what is nature, as we will see, is a dividing line that can itself be treated as cultural or natural. The border between outside and inside mutates, and every mutation calls forth another mutation. As Bergson would say, "*questions relating to subject and object, to their distinction and their union, should be put in terms of time rather than of space.*"[1] So far in these introductions, we have looked at the variations between philosophy and non-philosophy in terms of space (the dystopias and distances of philosophy), time (the equalized and democratic speeds of "fictionale" and paraconsistent thought in non-philosophy), and certain combinations of the two (the actings, behaviors, and postures of both philosophy and non-philosophy). In the present chapter, we will put more flesh on the bones of this third spatiotemporal mélange.

To do this, we finally come to the animals. The so-called Animal Turn in philosophy and the humanities in general is, to be sure, perfect raw material for non-philosophical treatment. This relatively newfound field of research for philosophy reforms not only our understanding of the animal as a consequence but also, at least potentially, our image of what counts as a proper philosophical object and thereby of what counts as proper philosophy. In this new turning, it might even be said that philosophy runs the risk of being animalized through the interventions of Deleuze, Derrida, Agamben, and (with only a little help) Laruelle. Perhaps the analogy is a little trite, but, losing its conditions of possibility in *universal reason* (whatever the model), opens up philosophy to new, behavioral conditions and inhuman conditioning (*of* posture and *by* the Real, though only "in-the-last-instance").

And film-philosophy can aid this movement, for the reality effects of both cinema and philosophy are (superficially) Pavlovian.[2] Linda Williams has famously written of the three "body genres" of cinema that most obviously disturb our flesh (melodrama, horror, and pornography). Undoubtedly, when images arouse our tears, screams, and genitalia, we do approximate a Pavlovian dog, overexcited by stimuli.[3] Yet these responses need not only be understood as dumb reflexes but also as potent forms of imaged-based thought—rich behaviors that even Diogenes, the dog philosopher, would be proud of. The capacity film has to make us see and think differently is less about its representations and more about its materiality as an animal mode of thought in sound and lighting, foreground

and background composition, as well as movement and editing—indeed the whole panoply of experimentation that film invents and explores as both technology and art.[4] Works by Akira Lippit *(Electric Animal)*, Anat Pick *(Creaturely Poetics)*, and especially André Bazin highlight this potential. Indeed, writing in 1955 on "Les films d'animaux nous révèlent le cinéma," Bazin went so far as to claim that "animal films have, amongst other merits, the ability to connect us with the extreme powers of cinema, and its limits."[5] For these theorists, cinema marks a point of indiscernibility between human and nonhuman thinking: its power is the power of the animal that we (always) are when we think in images.

And what of the human in all of this, particularly given Laruelle's repeated contention that "non-philosophy is fully and simply human. Non-philosophy is the philosophy of man"?[6] In fact, the question of anthropomorphism, which assertions like this surely raise, is linked here to the issue of the (non-)human too. Philosophy, according to Laruelle, not only anthropomorphizes the Real, it also *anthropomorphizes Man* (or as we will say, it "philosomorphizes" both after its own image).[7] So, what is the human for non-philosophy? Is Laruelle's resistance to any definition of man a token of Sartrean existentialism—placing existence before any essence? Yet we learned that even this is no doubt too philosophical for Laruelle (being predicated on an ontology of negation). By contrast, Sartre himself certainly knew what a human was by the time he wrote the first volume of the *Critique of Dialectical Reason*:

> This is the contradiction of racism, colonialism and all forms of tyranny: in order to *treat a man like a dog,* one must first recognize him as a man. The concealed discomfort of the master is that he always has to consider the *human reality* of his slaves (whether through his reliance on their skill and their synthetic understanding of situations, or through his precautions against the permanent possibility of revolt or escape), while at the same time refusing them the economic and political status which, *in this period,* defined human beings.[8]

The inserted qualification "in this period" is *not* what gives Sartre's essentialism away, however (*that* actually points to his consistency—man is what he makes of himself in each situation). The real point is that, in

recognizing "human reality," the slave owner must recognize a different *nonhuman* reality *as inferior.* To mistreat his slave, the slave owner must already (think that) he knows what a dog is, and so also what it is to *treat a dog like a dog.* This "human reality" is what *should not be treated like a dog's reality.* Sartre's humanist essentialism is vicarious but an essentialism nonetheless. Indeed, this corollary is hard to avoid, and it is something that the master's politics shares with Sartre's politics. After all, being both a humanist and a Marxist allowed Sartre to declare that "every anti-communist is a dog" (albeit that Sartre could presumably see the potential for even an anticommunist or slaver to recognize himself eventually as something nondog, i.e., a human).

Laruelle, by contrast, has no recourse to nothingness or any other philosophical concept to account for the human (be it an ontology of the void, like Badiou's, or the negation of dogs, like Sartre's). As we already heard Alexander Galloway state, "the primary ethical task" is clear for Laruelle: "to view humanity as indivisible, without resorting to essence or nature."[9] Negation is just one more philosophical essence—be it attributed to the human or anything else. For here is the thing: Laruelle will not account for the nonhuman either, *especially* should the *non-* be understood as negation. The question of the human *and* animal, then, is equally live for non-philosophy and sets up the possibility of the animal as *nonstandard* (the "animal-in-person") alongside the human or "Man-in-person."[10] It will also raise the question of animals as nonstandard, or extended, humans.

Inasmuch as the influence of Marx on Laruelle's thought might also be credited with the latter's "humanization" of the Real, we should introduce an important distinction here. Marx's elaboration of the concept of "species-being" *(Gattungswesen)* envisages *Homo sapiens* as unique among animals, not only on account of its exceptional mental powers but also because "man" alone freely and consciously produces both himself and the natural world through his material labor. It is this labor that constitutes man's species-being:

> In creating an objective world by his practical activity, in working-up inorganic nature, man proves himself a conscious species being. . . . Admittedly animals also produce. . . . But an animal only produces what it

immediately needs for itself or its young. It produces one-sidedly, while man produces universally.... An animal produces only itself, whilst man reproduces the whole of nature.... An animal forms things in accordance with the standard and the need of the species to which it belongs, whilst man knows how to produce in accordance to the standards of other species.[11]

Marx's "primitive narcissism" here ("man reproduces the whole of nature") has been criticized by, among others, anthropologist Eduardo Viveiros de Castro. However, in Viveiros de Castro's glossing of this passage from Marx's *1844 Manuscripts,* a distinction emerges that pertains to non-philosophy as well as Viveiros de Castro's own research on Amerindian perspectivism (to which we will return later):

> While apparently converging with the Amerindian notion that humanity is the universal form of the subject, Marx's is in fact an absolute inversion of it: he is saying that humans can "be" any animal—that we have more being than any other species—whilst Amerindians say that "any" animal can be human—that there is more being to an animal than meets the eye. "Man" is the universal animal in two entirely different senses, then: the universality is anthropocentric in the case of Marx, and anthropomorphic in the Amerindian case.[12]

Marx, following Hegel's post-Kantian thought, remains anthropocentric. We are going to show how Laruelle's non-Kantian humanization of the Real is a kind of (radical) anthropomorphism akin to this Amerindian perspectivism that sees all animal beings as "human." In places, Laruelle can indeed sound like Marx, writing with an almost cosmic optimism of humans as "perhaps an imitation, itself inventive of the universe."[13] Yet we will see that Laruelle's anthropomorphism is one that also mutates the human and the animal, not in a metaphysics of becoming, but in a continual "indefinition" of both human and animal that allows both to escape philosophical domination.

Katerina Kolozova thinks of the non-Marxism of Laruelle as a Marxism for the nonhuman.[14] As an extension of Laruelle's project to show that philosophy does not have a monopoly on exemplary thought (and

so, conversely, how one thought is authorized to be "philosophical"), this chapter ultimately concerns the politics of an extended Marxism, that is, of how some people are authorized to be "persons" (being "more equal"), how others come to be seen derogatively as "animals" or even "objects" ("less equal"), and how these processes might be inverted.[15] What kind of structure of regard or vision has come about to allow this to happen, and how can we mutate it for the democratic good of "all individuals"? This is not a mere relativism or historicism but a consistent democratization of what one might mean by "us," by "Life," and by "human." And it also touches on both what we mean by "person," "people" (or *dēmos*), no less than "self." The *dēmos* must be democratized.[16] How this democratization functions in the fourth remake of *The Perfect Human*, however, remains to be seen. Its connection with the animated form of cinema, though, will be crucial to its understanding.

INDIVIDUALS, STRANGERS, POSTHUMANS

Daniel Dennett, as we heard in the previous chapter, forwards the concept of an "Intentional Stance" whereby certain animals and objects can be interpreted charitably as mindful—like humans. We then hypothesized that there might be a Human Stance or Posture that can be adopted, in-the-last-instance, toward nonhumans (albeit in a quite noncognitivist and nondecisionistic manner). This would be an expanded act of charity or radical anthropomorphism that gives the benefit of the doubt to myriad others. This is not one more philosophical thesis, inference, or interpretation that inflates the "nonhuman" (via panpsychism, say), as if we *already knew* what human and nonhuman mean. It would be the theoretical practice—axiom or posture—that enacts an expansion of "human" through a revision, according to the Real, of the various philosophical anthropologies of Man. It would be one way of reading what Laruelle means by a "radical humanisation of thought" whereby "philosophy . . . has to be identified with man rather than the inverse."[17] This expansion reverses the narrowing action of philosophy that always contracts the Real into one type, in this case reducing "Man" to "animal" (as Laruelle is at times wont to say), but also (we would add) reducing undefined others to "animals" too, and even further to "objects." The terms *animal* and *object* always

serve as empty placeholders for whatever reduction we have in mind for these "others = X." As Laruelle himself writes:

> I refuse to define those first terms I give myself or I define them only in an axiomatic way, meaning implicitly. So I can say that Man is that X which determines-in-the-last-humaneity (and not "humanity") the subject, and does so on the basis of conflicts or philosophical contradictions. . . . I prefer "humaneity" to designate the human Real rather than the abstraction "humanity."[18]

It must be admitted, nonetheless, that Laruelle's humane philosophy can at times speak *uncharitably* of the animal, especially in contrast to these undefined humans. Certainly Laruelle has a menagerie of animals in his own (non-) philosophy, most of them abstract: fish (the immanental *poisson-eau* that, "being generic or idempotent, superposes himself with his element"), cats (of the non-Schrödinger variety), as well as all the animate processes of cloning, mutation, the "*genetic code of non-philosophy,*" and so on.[19] Moreover, apart from a theoretically motivated discussion of the "animal-in-person" in *General Theory of Victims* (to which we return later), Laruelle's explicit references to animals appear lopsided in favor of the human (whatever that might be). Indeed, the language of "Man" and "Man-in-person" can easily sidetrack the reader, not only on account of its gender specificity (which is mostly an artifact of the French language) and anthropomorphism (equating Man with the Real) but also because of its apparent speciesism.[20]

Yet we believe that these first impressions are misplaced. *En tant qu'un* makes this all the clearer with a more helpful vocabulary. It is the question of the "individual" that has directed Laruelle from the start; it states: "how can one think the individual and the multiplicity that is attached to it?"[21] The individual is the undivided One, the Real. It is certainly not the Kantian (philosophical) subject: "the subject is not a centre . . . I reject the Copernican revolution. The Kantian version of subjectivity . . . must be abandoned with philosophy."[22]

In a further shift in vocabulary, Laruelle's subsequent book, *Théorie des Etrangers,* is interested in "human multitudes" and "Strangers" beyond the "empirical cleavages (nation/people, nation/race, group/individual,

state/civil society, subject/sovereign, proletarian/capitalist)," and, we would add, man/animal.[23] Hence Laruelle can write that "humans, in so much [*sic*] as [they are] Strangers, exist-multiply" and, furthermore, imply "that man only exists as absolutely relational." Strangers are not persons, individuals, or subjects in the philosophical sense of these words. Even more, the Stranger is the very "identity of all relation," or of the multiple as such.[24] Hence, where the animal is seemingly discriminated against by Laruelle, this is most often as a caution against one form of philosophical authoritarianism over the human:

> This is a traditional concept, wherein man is defined as a philosophiz-
> ing animal, an animal superior to his becoming-victim but who remains
> an animal. The identity of the Victim absolutely does not amount to
> this natural or bestial state. I think that this sort of particularly excit-
> ing formula—and I do recognize that excitement—for the grandeur of
> man and his heroism is what we now would have to try and overcome
> or understand differently.... In our desire to give man a more elevated
> predicate than that of the beast, we are entering once again into the war
> of predicates. Philosophy, police officer of the predicates! "Victim, show
> me your papers and prove your state!"[25]

The seemingly given nature of the animal, "beast," or even "natural" here—intentionally reminiscent of Badiou no doubt—belies Laruelle's treatments in other texts, which declare that "what is needed is a reflec-tion upon the non-separability of man and animal, and on the animal as, at once, model for man and clone of man."[26] There is even mention of a "nonhumanism" that would nonstandardize the human. And therewith, we have at least one "internal" rationale for animalizing non-philosophy; for alongside asking the question "how do some thoughts come to be seen as philosophical while others do not?" (the Laruellean norm, so to speak), we are behooved to ask the following: "how do some individuals come to be seen as humans while others do not?"

The relationship of such a putative nonstandard humanism with transhumanism and posthumanism must remain moot, if only in virtue of the myriad forms of each in the latter fields. What is notable about the second two, for us at least, is when the term *human* itself is brought up

for conceptual appraisal *before* the processes have begun of technological, genetic, or cultural prosthesis, substitution or elimination. As we heard Cary Wolfe say in the introduction, "just because we direct our attention to the study of nonhuman animals . . . does not mean that we are not continuing to be humanist—and therefore, by definition, anthropocentric."[27] Likewise, in *The Paradox of the Posthuman,* Julie Clarke comments that much posthumanistic thought remains "grounded in a series of oppositions that appear to signify contradictory states such as human/nonhuman; nature/culture; animate/inanimate; male/female."[28] Wolfe also notes that much of the progressivism of important strands of posthumanism rest on "ideals of human perfectibility, rationality, and agency inherited from Renaissance humanism and the Enlightenment."[29] It is even more remarkable, as Steve Fuller observes, that "the key theorists" behind nonbiological posthumanism (Norbert Wiener, Herbert Simon, and Ray Kurzweil) were or are "all Unitarians, devotees of the tradition of Christian dissent that identifies human uniqueness with divinity itself."[30] The idea that we must transcend humanity's "contingent" biological condition through silicon is seen in the contemporary thought of FM-2030, Kevin Warwick, Bart Kosko, and Nick Bostrom; but it has its historical roots in Julien Offray de la Mettrie's *L'Homme Machine* of 1748 and the subsequent work of the Marquis de Condorcet, who wrote in 1794 that "no bounds have been fixed to the improvement of faculties . . . the perfectibility of man is unlimited."[31] Any Laruellean nonhumanism will always be much messier than this, resting a good deal more on a non-philosophical *imperfectability* than on man's approximation to the divine, the infinite, and the perfect. It will also be futural in another sense altogether, based on recapturing what individuals have always been before philosophy deigned to enlighten the people (given that it is the philosopher who is always "man par excellence").[32]

For other theorists, however, we have either never been "human" (the notion was deconstructed long ago) or we have always already been posthuman (the only thing uniting the human being "the fact of technicity," as Bernard Stiegler argues).[33] For Laruelle, the identity of the human is that of the Real—the simplicity of this statement belying the complexity of the thought behind it. Uncovering this complexity also returns us to the earlier question of mimetics and cloning, understood in the present

context through the idea that the animal is merely the imitator of men: parroting, aping, or mocking perfect humans. It also sends us further back again to our first mutation, aptly enough the one concerning the conceptualization of change itself in Kant's philosophy. Would not the meaning of "cinnabar" be ungraspable if, Kant asks, it "were sometimes red, sometimes black, sometimes light, sometimes heavy"? And would we not also lose any definition of the human, too, "if a human being were now changed into this animal shape, now into that one"?

Clearly some forms of philosophical anthropomorphism operate in a restrictive direction, a "projection" that narrows the human to one unchanging type, even when it defines it as a "becoming." This must be contrasted with an expansive, *introjective* vision that allows the definition to mutate and multiply continually in the face of the Real's resistance to any totalizing representation. These mutations are not ad hoc redefinitions to salvage a losing argument but pluralizations that allow an expanded philosophy, now considered as raw material, to think alongside the Real. Here there is a reorientation going *from* the Real back *to* philosophy (which mutates in a "reciprocal redescription of the One and of the material").[34] When one starts down the first, contracting route—projection over introjection—one is led inevitably through all the elitisms, vitalism, speciesism, racism, sexism, and ageism, until one finally arrives at the egological autoaffection of the solipsist. Laruelle, evidently, by discarding the definitions of the philosophers—each of them self-promoted as "first philosopher," as *the* friend of wisdom—is happy to leave Man undefined, such that his entire project is about restoring an indefinite status to the human: "man only exists as a multitude of Strangers, in a manner that gives meaning again to the old concept of *multitude transcendentalis* and of posing democracy at the heart itself of the science of men."[35] Again, *not* defining man is Laruelle's way of protecting the human, or victim, from humanism:

> this only goes to show that there is no absolutely determined knowledge of the human, of man; and in particular it aids the struggle against every dogmatic definition of human nature—against racism, for example: if one has no absolutely certain knowledge of human nature, it is far more difficult to develop a racist thought.[36]

Laruelle contrasts this undefined Stranger with the "poor" of the philosophers, the *sans papiers* who need their aid, who need to be identified—sometimes even against the State—but always with some form of predication. What is crucial about the Stranger, though, is not that he or she resists identity *simpliciter* but that the Stranger "*works at transforming*" all definitions:

> From the poor man of philosophy, who always hopes for a minimum of documentation, we must distinguish the radical Stranger—very different, neither with nor without documentation, neither with nor without identity, *but who works at transforming, with the aid of the world, the definitions of himself that he has received . . . no Samaritan comes to the help of the undocumented.* Or if a "subject" can come to the aid of the Stranger, it will be the *generic subject, that is to say the humans of-the-last-instance* rather than the philosopher who, in fact, instead plays the role of the Bad Shepherd.[37]

It is a question of constant, real mutation rather than (philosophical) negation.

AN IDIOTIC TANGENT: ANIMAL OBSTRUCTION (THE STUPIDITY OF ANIMATION)

As we heard in the previous chapter, von Trier's fourth obstruction for Leth has just "one single condition," that it be a cartoon. Both Leth and von Trier "hate" cartoons—the reason given being their overtly artificial and entirely man-made aesthetic (that requires all-encompassing decisions at every moment). This is the cruelest gesture on von Trier's part and therefore "way out of line," as Leth subsequently declares. For both of these "realist" filmmakers, animation is antifilm, and von Trier knows that he is actually asking Leth to make what each can only regard as a nonfilm in the truly *negative* sense of the phrase. Indeed, Leth admits later that he can "see the logic of it" in terms of creating the ultimate obstruction for a film director like him—it is a complete inversion (or, as von Trier puts it, "I'd like to achieve that feeling of a tortoise on its back"). After all, realist theories in film, from André Bazin's to Stanley Cavell's, have often had to fend off the accusation that their apparent optical chauvinism leaves

animations in a problematic situation—that cartoons are somehow not really films at all.[38] If such realism sees all film as a form of photographic record (no matter what the subject matter before the camera, fictional or documentary), it would seem to imply the view that animation *cannot* be cinematic because its art rests on pure construction rather than a recording medium. (There will be a twist to this account when we return to Bazin's neorealism subsequently.)

While reluctantly accepting his latest challenge, Leth insists that he will not learn any new technology nor work on "a stupid drawing board" to get the cartoon made. Indeed, the stupidity of animation is a recurring theme in Leth's response to the obstruction. Speaking after his meeting with von Trier, he remarks that his challenger would "prefer [the remake] not to have any freshness—inspiration, ideas or poetry. He'd like it to be sloppy or stupid. It ought to be stupid. But I can't do that. I refuse to. We must make something of it." Leth refuses to be made to look like an idiot, to make something idiotic.[39] Trevor Ponech has written in this regard that

> Von Trier shiftily associates victory with eliciting "that feeling of a tortoise on its back." A feeling in Leth, as of being? In von Trier, as of looking at? Leth, too, observes, takes notes—"Yes. Tortoise. I'll write it down"—and one-ups von Trier by keeping the turtle [sic] right side up and mobile. Winning for him is a matter of staying upright, like his "role model" footballer Michael Laudrup, who "attracted obstructions . . . and elegantly always avoided to fall or get injured." . . . Not falling means drawing fodder for imagination from the obstructions. "The trouble," complains von Trier, "is you're so clever that whatever I say inspires you." "Yes," Leth responds, "I can't help it."[40]

In this fourth obstruction, however, Leth's cleverness—his ingenious avoidance of stupidity—emerges most perspicuously through one particular decision made at the outset: to delegate all of the creative animation work to another filmmaker, Bob Sabiston. Hence much of the hated decision making is left to someone else. Sabiston is best known for his use of "rotoscoping," a form of animation that reuses live-action film. Murray Smith describes how rotoscoping is able to trace over "outlines and textures to create a basic animated image, which can then be subjected to further

treatments." What is significant about this animation method for a realist like Leth, however, is that it

> preserves a connection with live-action footage—and in the case of documentary footage, with that bit of the world captured by the camera and microphone. Leth thus eschews the complete "detachment from the world" afforded by traditional animation—the creation of an alternative, infinitely plastic universe in which just about anything can happen.[41]

Though Sabiston did not invent the rotoscoping technique—it dates back to Max Fleischer's cartoon series *Out of the Inkwell* from about 1915—he is credited with inventing its computerized version used to great effect in Richard Linklater's films *Waking Life* (2001) and *A Scanner Darkly* (2006). As Smith further explains, Sabiston's software (named "Rotoshop")

> enables "interpolated rotoscoping," in which two non-adjacent frames on a strip of live-action footage are hand-traced, the drawings for the intervening frames then being calculated automatically by the computer. The interpolated lines and shapes produce extremely fluid motion, creating the distinctive Rotoshop texture in which the smooth development of the interpolated frames is conjoined with the rougher-hewn quality of the hand-drawn frames. The hand-drawn frames also establish the "template" for the particular graphic style of any given Rotoshopped sequence.[42]

It is notable, then, that much of the imagery for this remake of *The Perfect Human* is actually created by Sabiston and his computer rather than Leth. The decision-making process is subcontracted to a man–machine combination.[43] And yet the raw material for the technique remains Leth's own work, reusing scenes from the various new and old versions of *The Perfect Human* as well as sequences from Leth's 1989 film *Notater om kærligheden* (Notes on love), which also featured Claus Nissen. The rotoscoped perfect human is both original and clone, a collage of reused materials that morph into a new reality, or as Smith puts it, "far from simply removing us from life—to recall [Karen] Hanson's characterisation of the aesthete's impulse—this seems to open the door to the 'imperfect' disarray of reality."[44]

Of the film itself, then, there is not much more we can say: it opens
with shots of Leth shaving (reused from the second obstruction) followed
by a tortoise, right way up, progressing across the middle of the screen.
Clips follow from the other remakes as well as *Notater om kærligheden*,
all of them heavily and artfully rotoshopped in various highly stylized
manners. The film must be seen to be seen. The film's English narration
(in the original), however, does say a few words that we can reuse here:

> The perfect human—that's just something we say. While hoping he can
> do what we says he can do.
> Just walk a little, say a few words, it's not too much.
> We want to see what he can and cannot do. Is he perfect enough?
> Or not entirely? Is he free?

From the perfect (optical) human to the "imperfect disarray of reality,"
cloned or morphed in animation, this fourth film opens up numerous
avenues for discussion, not least the question of saying and doing, de-
ciding and not deciding. For whose film is it anyway, Sabiston's, Leth's,
rotoshop's, or some nonhuman hybrid of all three? We should recall that
von Trier wanted to move Leth "from the perfect to the human" as if it is
the human that is imperfect and even idiotic. So, is the clever, wise hu-
man *(Homo sapiens)* to disappear entirely within this stupid animation?

PROTECTING THE HUMAN

According to Laruelle, philosophy constantly harasses the human with its
theories and definitions of what is human. Non-philosophy must protect
the human, then, from these anthropologies of philosophy—Laruelle's
slogan being "philosophy is made for man, not man for philosophy."[45] As
we have seen, Laruelle's exploration of the various empirico-transcendental
doublets employed by philosophy (virtual–actual, substance–accident,
reality–appearance, noumenal–phenomenal) has been a cornerstone
of non-philosophical practice. And this is no less true of his critique of
philosophical humanism. Indeed, such humanism, being continually
based on some form of philosophical anthropology, may well be the
ultimate empirico-transcendental dyad. There is always some empirical

feature of one or more individuals—now dubbed "true" humans—that is highlighted for all humans to have "in principle" (transcendentally). A few examples (some individuals or even just features of some individuals) are defined as the essence of all, but an "all" that is refracted through the few.[46] *This* is intelligence, *this* is language, *this* is culture, and so on. One defines thinking or tool using, for instance, in such a way (X) as to mirror only one set of individuals (who embody "true–genuine–proper" thinking or tool using) that thereby creates an *exception* ("species-being") and excludes—in fact, *must* exclude—other definitions that threaten to reintroduce continuities with counterexamples. As we heard Marx state, "admittedly animals also produce.... But." (We might name this general strategy the "also ... but" move, one of Locke's "postures of the mind" akin to his position that "all animals have sense, but a dog is an animal.")

Empirical exceptions to the transcendental rule of exception (putative humans who do not think, say, or use tools like X) are precisely that, mere exceptions to the rule, *no matter their empirical prevalence.* Moreover, the exception to the exception that might replace the discontinuity with a continuity (with outsiders or "Strangers") must be outlawed most vigorously, even if to do so one is forced to redefine X continually in more and more esoteric terms. The "No True Scotsman" fallacy—constantly redefining one's exemplary cases in response to counterexamples—becomes the "No True Man" fallacy. Consequently, faced with cases that reinscribe a continuity between the human and nonhuman animal, for instance—in reasoning ability, language powers, thinking, or tool use—one redefines what true (i.e., "transcendental," "virtual," "ontological") thinking, reasoning, or language is for humans. And this must be the fact of the matter even should the vast majority of humans never manifest this true version (in which case, all humans will have it *in posse* rather than *in esse*). The dice are loaded from the start. *Who* these humans actually are in sum total, given their hidden shared ability (X), must remain unknown—another black box—beyond which we can only say that "they," and "we," are human. This "they–we" is not an objectifying corruption of human existence (Heidegger's *Das Man*) but its essential and objective bulwark to protect the position of philosophy.

Certainly the mixtures that Laruelle sees in philosophical anthropology are myriad in number yet fairly invariant in form, jumping back and forth

between "devalorisation" and "overvalorisation," between the philosopher and the unremarkable man, between the public intellectual and the private man or "idiot"—always exceptional in either case:[47]

> As a philosophical concept, man is a humanoid simultaneously traced from the anthropoid which has hardly gone beyond Greek anthropological thought and the Judeo-Christian "creature." . . . Philosophy desires the inhuman, the pre-human, the all-too-human, the over-human without recognizing the "ordinary" nothing-but-human. The philosophical heaven is populated with anthropoid and artificial creatures, *Dasein* included, which escape from a cloven thought and lead to a host of masks and travesties, after which demons and angels become fully rationalized. Humanism is an inferior angelism and a lie concerning man. Because of this dishonor, philosophy is saved with great difficulty through the thesis of a theoretical anti-humanism (Althusser) which will not have been sufficiently radicalized.[48]

The "Man" of philosophy, even in the Greco-humanist tradition, is effaced by Being and its avatars, so that it can only appear in mediated form as "daimon-man, creature-man, individual-man, subject-man, overman-man, *Dasein*-man, etc." Man is likewise submitted to "Being, to the Cosmos, to *Physis*, to God, to Spirit, to the Subject, to *Dasein*."[49] There is even "a 'humanist' racism" in Western philosophy, according to Laruelle, whereby "man is a wolf, an eagle and a sheep, etc. for man" (the theriomorphic medium for this racism is notable).[50] Hence Laruelle is skeptical of approaches such as Deleuze's animalist philosophy, wherein Man is seen as a "bridge," "becoming continuous, the becoming-animal of man and the becoming-human of the animal."[51] For non-philosophy, these are all reductive (constricting) orientations, even when they purportedly "inflate" the human.

PET THEORIES: ON PHILOSOMORPHISM

Clearly what Laruelle says of anthropology—that it uses Man *for* philosophy—can also be said of any philosophy (or representation) of the animal: if the animal appears by name at all, it is as a proxy for one or

other philosopheme of what the animal means to (human) philosophy. Traditionally and in separatist mode, these appearances have only been to inflate the human at the animal's expense. The human is defined in wide-ranging ways, with some depictions simply opposing properties attributed to "animals" (man as the nonanimal, the immaterial, the preternatural, and so forth), while others offer continuist images of humans as sentient animals, conscious animals, rational animals, linguistic animals, political animals, temporal animals... Hence Aristotle describes man as exclusively political, Descartes as exclusively conscious, Kant as exclusively rational, Heidegger as exclusively temporal, Davidson as exclusively linguistic, and so on. This positive account consequently provides us with another list of attributes for the animal: the nonpolitical, the nonconscious, the nonrational, the nontemporal, the nonlinguistic, etc. And alongside these prosaic descriptions, one can line up all the more fanciful ones—of man as the animal who has the right to make promises (Nietzsche), or who is what he is not and is not what he is (Sartre), or even who goes to the movies (Agamben). All of this is simply the flip side of Laruelle's anthropological harassment of Man, which harasses animals to an even greater extent.

The question, then, is whether the Animal Turn in Theory really has gone beyond the uses of the animal associated with so much previous philosophy. The initial answer is that it would seem not. Be it the bleak picture of "bare life" drawn by Agamben, or the more positive image of the "animal that therefore I am" deployed by Derrida, philosophers of various hue have shown increasing interest in the idea of the animal as both a normative category and a metaphysical one (as when Badiou depicts Deleuze's philosophy as one of "the Animal" in contrast to his own of "Number").[52] Yet these myriad philosophies still mediate the animal for their own philosophical advantage by seeing it as only an instance of aporetic *différance* (Derrida), proliferated becoming (Deleuze), bare life (Agamben), or even the very model of "bad philosophy" (Badiou): the animal does indeed only appear as a proxy of one or other philosopheme.

As a matter of fact, these reductions of the animal to that of a surrogate for *différance,* rhizomatics, or bare life gain their apparent force in part by ignoring other aspects of the animal that are placed in the background, namely, those that do not fit (or resist) the philosopher and her favored philosophemes. It is not simply that Derrida's *animots* are not

like Heidegger's *weltarm* animals, or Agamben's, or Deleuze's, but that the ontological leverage acquired through reference to the animal always has an ineliminable remainder, some parts of which are occupied by other rival philosophical positions on the animal, other parts of which escape Theory altogether.[53] However, this is not always only a one-way street. Indeed, in terms of the actual lives (and deaths) of animals, in the following brief treatments—of Derrida, Deleuze, Badiou, and Agamben—we will see that the same life (and death) can have effects on their definitions of metaphysics and politics, and even of thought and philosophy. The animal animalizes philosophy, at least to some degree.

Derrida, for instance, clearly believes that his work on the animal opens up new meanings for philosophy, as seen when he speculates that when "the animal looks at us, and we are naked before it. Thinking perhaps begins there."[54] When his cat looks at him there is a thoughtful encounter (in Derrida's scenario, when he is undressed). All the same, Derrida's critique of "biological continuism" (the approaches of Peter Singer, Tom Regan, Mary Midgley, and others) as the basis for an animal advocacy can be seen as predicated on his own theoretical inclination toward difference over identity. Our "crimes" against animals, according to Derrida, are an extension of the violence that begins in self-identical speech *(logos),* spreads itself through patriarchy (phallocracy), and completes itself by implicating our entire species in its war, now aptly redubbed "*carno-phallogocentrism.*"[55] So, when Derrida turns to Jeremy Bentham's famous line ("the question is not, Can they reason? nor, Can they talk? but Can they suffer?"), he does not invoke suffering as an *ability* (à la Singer)—or indeed any other shared power such as language, consciousness, or reason—but as a fundamental *passivity.* Suffering is a vulnerability, a finitude, that we share (in a noncontinuous way) with the animal, and it is *this* that makes us animals. Derrida is not interested in erasing any demarcating lines (to create a continuum) but prefers rather to multiply the lines on all "sides," while also thickening and thinning them as he goes. Hence there is no "Animal" (which may or may not include the human-animal) but only *animals* plural.[56]

Donna Haraway's criticism of Derrida in all this, however, is that he still remains too negatively anthropomorphic—caring more for *his* reaction to the gaze of his "little cat" and its hypothetical response, as

though the cat had no *real* life of its own. How the actual cat actually regards him, without any reference to human interest (projected or not), is left unnoticed amid all of Derrida's "worrying and longing" over the cat's reaction.[57] He lacks the curiosity (of a cat) to enquire after its own inner life and needs, preferring to remain within a relationship built from one-sided pity and mutual exclusion. Likewise, Jonathan Burt highlights Derrida's attraction to the negative, and ultimately to death, as a mark of his work that also mediates the animal.[58] Death refracts his thinking about animals, and the animal—as mute, as other—becomes an effect of (his) morbid writing:

> This anachronism in the contemporary philosophization of the concept "animal" has significant consequences for the gaps it opens up, almost in spite of itself, between metaphysics (theology, ontology) and language on the one hand, and the animal's specific place(s) in the contemporary world on the other. The morbidity of the former runs deep. . . . But this conceptual version of the "animal," with all the connotations of muteness and melancholy that underpin its symbolization, is a consequence of this thinking rather than constitutive of it, despite the claims of the theory that sacrifice is a foundational act in the cultural categorization of beings. The animal is, in other words, a writing effect that latches onto a more generalized, and inflated, concept of otherness.[59]

It is what we are calling a "philosomorphic" attribution that is at work here—using the animal as a stand-in for vulnerable, silent difference. Finitude, vulnerability, death, difference, thinking; the animal is here more philosomorphic creature than real animal. And still, conversely, we might also ask whether Haraway's call to attend to the animal's own response inevitably falls foul of the usual Cartesian demand—how does she know that she is any less incorrect than Derrida for *not making that attribution*? Nevertheless, it is the very inevitability of this pitfall that led Mary Midgley, for one, to disavow the whole anthropomorphism debate. We are anthropomorphic all of the time with other life-forms and with each other in numerous different ways too, and yet we do not coin names for our supposedly illegitimate pedomorphism, gerontomorphism, andromorphism, gynecomorphism, or even plutomorphism and

paupermorphism.[60] Bruno Latour captures this same thought as well, though within an even more expanded view:

> The expression "anthropomorphic" considerably underestimates our humanity. We should be talking about morphism. Morphism is the place where technomorphisms, zoomorphisms, phusimorphisms, ideomorphisms, theomorphisms, sociomorphisms, psychomorphisms, all come together. Their alliances and their exchanges, taken together, are what define the *anthropos*. A weaver of morphisms—isn't that enough of a definition? The closer the *anthropos* comes to this distribution, the more human it is. The farther away it moves, the more it takes on multiple forms in which its humanity quickly becomes indiscernible.[61]

The question for both Midgley and Latour is not whether we are anthropomorphic (as it is ubiquitous and unavoidable) but *in what manner* we practice it—singly or multiply, restricted or unrestricted. But note the potential circularity even in Latour's position: if the definition of *anthropos* is precisely as a "weaver of morphisms" *that "it" can move closer to or away from*—then this metamorphosis (moving closer to or away from such weaving or distribution) itself becomes either a circular or an empty definition of the human.

Returning to Derrida's animal, then, how is it to respond at all *in its own way* to the philosopher's call for a response (from it) and (our) responsibility (to it)? For Derrida, there might be an answer, only, "it would not be a matter of 'giving speech back' to animals but perhaps of acceding to a thinking, however fabulous and chimerical it might be, that thinks the absence of the name and of the word otherwise, as something other than a privation."[62] Absence as more, not lack—not as privation but as differentiation. This is not a differentiation *of* any thing (*ousia*, presence, *logos*) but for itself as an end in itself (ethically *and* metaphysically). Derrida's philosophy of difference is perfectly suited to adopting the animal as one more face for its own philosopheme. A "chimera," needless to say, is an animal composed from parts of multiple other animals—a creature of deconstruction.

Indeed, it is pack animals, animals as assemblages of other, smaller (molecular) animals, that precisely also mark out the Deleuzian

philosomorphic approach that is predicated on a metaphysics of becoming. Wolves, cockroaches, and rats are the stars of this menagerie, especially rats:

> We think and write for animals themselves. We become animal so that the animal also becomes something else. The agony of a rat or the slaughter of a calf remains present in thought not through pity but as the zone of exchange between man and animal in which something of one passes into the other. This is the constitutive relationship of philosophy and nonphilosophy.[63]

Pity, of course, would be a *reactive* relation that does neither the dying animal nor thinking philosopher any good. Derrida's pity for the animal is a morbid response that Deleuze's (and Guattari's) vitalist thinking cannot stomach. Where Derrida focuses on the suffering and death of the animal, Deleuze concentrates on (its) life. And if there is an ethics in our relationship with the animal, it is strictly affective, concerning forces, or degrees of motion and rest. It is also asymmetric—not in the Lévinasian mode of being *for* the other but in the philosophically *aristocratic* mode of being for the greater good of a healthier, more joyful relation. It is *the relation* that is the end in itself: "Man does not become wolf, or vampire, as if he changed molar species; the vampire and werewolf are becomings of man, in other words, proximities between molecules in composition, relations of movement and rest, speed and slowness between emitted particles."[64]

Admittedly, Luce Irigaray famously took Deleuze and Guattari to task for also insisting upon a "becoming-woman" that would incorporate both "molar" women *and* men within a greater molecular process, to the neglect of any actual identitarian politics (whose achievements had been hard-won by molar women).[65] Indeed, the fact that Deleuzian men can piggyback on becoming-woman (as the "key to all the other becomings") smacks of an opportunistic avoidance of political responsibility. Might not the same be said of this "becoming-animal"? Pace Deleuze and Guattari's assertion that they think and write "*for* animals" and even become animal "*so that* the animal also becomes something else," it is really only *human* becoming that interests them. The animals' part in this pact most often appears as only a means to an end: "the becoming-animal of the human

being is real, even if the animal the human becomes is not."[66] Indeed, if becoming-woman were the key to *all* other becoming, then every *nonhuman* becoming would be seemingly impossible, and Deleuzian thought would reduce to a type of Heideggerian anthropocentrism, with only gendered humans being "rich-in-becoming" and animals being "poor-in-becoming."

Perhaps we should not be so hard on Deleuze (and Guattari), however: much of what they say has a relevance for a proto-Laruellean stance on animal philosophy. On one hand, it is doubtless that the commendation of process over product is part of an antirepresentationalist, antimimetic tendency in Deleuzian thought specifically. To "be the Pink Panther," one must imitate and reproduce "nothing"; but like that big cat, one "paints the world its colour, pink on pink; this is its becoming-world."[67] Deleuze's "animal philosophy" (as Badiou dubs it) is a philosophy of life that, like its forbear in Bergson, is utterly immanentist—there is no *state* outside of becoming to become. Molarity, be it of the human or the nonhuman, is not to be imitated; even further, it *cannot* be imitated (hence what looks like reproduction is always a new production, a productive repetition).[68] The fact remains, though, that there are kinds of animals that Deleuze prefers over others in this all-encompassing molecular becoming: domesticated (pitied) and individuated (molarized) animals are unhealthy, reactive, and sad—this being the motive behind the infamous proclamation that "anyone who likes cats or dogs is a fool."[69] Likewise, State animals (the lions, horses, and unicorns of empires, myths, and religions) are to be renounced. It is the "demonic" or pack animal that is the Deleuzian favorite, the *philosopher*'s pet. So, qua *animal* becomings (rather than the becoming-animal of humans), the true animal is always a multiplicity (as in a wolf pack) and a process (every such pack is a *wolfing*).

On the other hand, however, qua becoming-animal, what should be (at least) a two-sided process involving active becomings for all participants does indeed invariably only profit the human. For example, in the plateau on the "War Machine" in Deleuze and Guattari's *A Thousand Plateaus*, the nomad invention of the stirrup involves a human becoming-animal within a "man-horse-stirrup" assemblage. Similarly, the bridle used in masochistic practice is itself derivative of a human "becoming-horse."[70] It seems that, as a State animal, the horse can only serve a Deleuzian becoming when

participating in *human* enhancement. Obviously, Deleuze and Guattari are fully alert to the danger here of "becoming-animal" manifesting itself as merely an imitation of a "molar" image (*playing* "horsey"), or as a form of abstract "horseness," or as a part-object fetish. This is supposed to be a process of re-creating certain speeds and slownesses—a metamorphosis rather than a representation. Yet they seem oblivious to the politics of their own examples, horses in particular. How can a stirrup involve any kind of *becoming* for the horse when we remember that Deleuze's (Nietzschean) conception of genuine becoming must be *active* and not *reactive*? The stirrup is a control device and so cannot be part of anything affirmative (in Deleuze's sense). A domesticated horse may take pleasure in fulfilling some of its functions, but that is only because it has been broken in, made into a sad animal (no less than a dog is a sad wolf, according to Deleuze). The technology itself is reactive—a policing, disciplinary, and control-ling of life rather than its further production. And, as for the agony of a dying rat or slaughtered calf, the technologies involved in "pest" control and factory farming can hardly be deemed life affirming, at least *from the point of view of the animal lives involved.*[71]

There seems little place for the animal's *own* "becomings," therefore, in the alter (animal) side of a human becoming-animal. What can be said of *its* or their "becoming-human"? Can it only ever be a token of domestication and anthropomorphism—a matter of "our" projection, sentimentality, and pity? Where is the example of human and animal change as a real co-becoming, such as the wasp and the orchid enjoy in *A Thousand Plateaus,* that is, as an active, joyful "deterritorialization" for *both* creatures?[72] As things stand, the animal, demonic or domestic, is a philosophical myth in Deleuze's thought, a philosomorph that must play a lesser part in the architecture of becoming, for any such process is always evaluated from the perspective of the human alone (of one defined kind, moreover).[73] Indeed, such is the immanence of Deleuzian thought, it is even arguable that the animal *must* remain the outsider of genuine becoming if, as he says, its agony and slaughter are constitutive of a zone of exchange between human and animal as well as philosophy and non-philosophy. The dying animal is here the permanent outsider of thought too, the shock to thought, and so the non-philosophical as such (in the negative rather than Laruellean sense of the term). To be allowed

its own life and vital becoming would be to allow the animal too much philosophy, too much thought for itself. And yet this very withdrawal of privileges is itself a token of the philosomorphic use of the animal pervasive in Deleuzian thought.

Indeed, Alain Badiou's criticism of Deleuzianism as an animal philosophy builds on this inconsistency in Deleuze and rectifies it. As a result, Badiou sees it as an animalization of the human that thereby strips humanity of value. Yet Badiou's intervention is not only to run Deleuze's animals in a new direction but also to protect his own avowedly humanist project from any possible animalist extension. The perceived threat is to Badiou's universalist *and* extensionalist politics of emancipation. Given that, according to *Being and Event,* no "intensive" human quality (like gender, race, or nationality) can be permitted to restrict the scope of political change (an Event) on account of Badiou's universalism, it follows that the *vast* scope of a political vitalism promises to undo *any* humanist agenda. In other words, the challenge for Badiou is to keep nonhuman members of the universe *out* of a universalist politics so that he can keep the program *human* (yet without any turn toward essentialism). The central question becomes this: what *can* be defined as "human" if one is not allowed to define the human intensionally, that is, through some or other potential quality—species-being, gender, race, nationality, civilizing power, or whatever else?

Badiou's answer to this problem turns toward mathematics—the science of *extensional* quantities. His concept of universalism (be it in art, science, politics, or love) has a mathematical basis: *everything can be counted* (it is pure quantity, not quality). Moreover, just as Heidegger in *Being and Time* decided to approach the question of Being through human *Dasein* as the most appropriate method *because only humans ask the question of the meaning of Being* (despite initially arguing against confusing Being as such with *any* particular beings), so Badiou must justify his anthropocentric ontology in the most parsimonious way possible: *through mathematical ability.* Though every thing can be counted, because only *humans can think infinitely,* that is to say, *can do mathematics,* only humans can enjoy political subjectivity. Furthermore, mathematics is so defined by Badiou here so as to exclude any animal facility for mathematics. Despite all the evidence demonstrating that animals can

count and can do various mathematical operations, only "humans" count as human for Badiou because they *alone* (supposedly) can do the right kind of (infinite) mathematics (the "also . . . but" posture again).[74] The finitude that Derrida saw the animal and human sharing is here echoed in reverse for Badiou, for he emphasizes the infinite power of human thought *over* any (supposedly) "animal," embodied finitude. This is the one intensional property that Badiou must willingly opt for, as well as appropriately define, so as to ensure that his humanist agenda is saved from his universalistic methodology and that the concept of the human does not leach into the nonhuman via an unintended continuity. Hence Badiou must reject the "contemporary *doxa*" that reduces "humanity to an overstretched vision of animality" as well as the "humanist protection of all living bodies."[75] Here, again, although the animal is playing a negative role (rather than the ostensibly positive role that it plays in Deleuzian thought), it remains crucial to Badiou's project that it *keeps* to that role, that it plays its philosophical part without resistance, and that it conforms to the philosomorph designed for it.[76]

Though appearing more ambivalent in his speciesism than Badiou, Giorgio Agamben too (in his work on Heidegger in *The Open: Man and Animal*) is alarmed by "the total humanization of the animal [that] coincides with a total animalization of man."[77] As Kelly Oliver notes, "in some passages in *The Open* Agamben seems to accept a Heideggerian abyss between man and animal, an abyss that Agamben suggests is not wide enough in Heidegger's thought."[78] The threat to this protective abyss is the double-sided "anthropological machine" that results in "a monstrous anthropomorphization of . . . the animal and a corresponding animalization of man."[79] This monstrous anthropomorphism, born in the modern era through nineteenth-century biologism, forms the basis of contemporary biopolitics. But the machine has a longer history than this, given its role of creating social inclusion through a posited "missing link" that is neither properly human nor social but animalized and "bare." It is another kind of black box. Yet this box or machine works in various ways:

> On the one hand, we have the anthropological machine of the moderns. As we have seen, it functions by excluding as not (yet) human an already human being from itself, that is, by animalizing the human, by isolating

the nonhuman within the human: *Homo alalus,* or the ape-man. And it is enough to move our field of research ahead a few decades, and instead of this innocuous paleontological find we will have the Jew, that is, the non-man produced within the man, or the *néomort* and the overcomatose person, that is, the animal separated within the human body itself. The machine of earlier times works in an exactly symmetrical way . . . here the inside is obtained through the inclusion of an outside, and the non-man is produced by the humanization of an animal: the man-ape, the *enfant sauvage* or *Homo ferus,* but also and above all the slave, the barbarian, and the foreigner, as figures of an animal in human form. Both machines are able to function only by establishing a zone of indifference at their centers, within which the articulation between human and animal, man and non-man, speaking being and living being, must take place. Like every space of exception, this zone is, in truth, perfectly empty, and the *truly human being* who should occur there is only the place of a cease-lessly updated decision in which the caesurae and their rearticulation are always dislocated and displaced anew. What would thus be obtained, however, is neither an animal life nor a human life, but only a life that is separated and excluded from itself—only a *bare life.*[80]

The machine creates anthropomorphs through its decisions (animals become human), but also and more dangerously, theriomorphs (animalized humans). The political dangers of actual and potential abuse through the second category are clear to Agamben (as they are to Badiou). And yet, as Oliver also points out, Agamben seems indifferent to the dangers for animals stemming from both versions of the machine, anthropomorphic and theriomorphic. Instead of the avowed "Shabbat of both animal and man," what Agamben is mostly interested in is finding the means, in his own words, "to render inoperative the machine that governs our conception of man."[81] And that is because, for Agamben, the animal *already resides within the space of the missing link.* The "zone of indifference" or "space of exception" is at the same time (Agamben's) philosophical black box (a second one alongside that of the anthropological machine). In terms of any putative *philosophical* worth—reasoning power, language skills, political subjectivity, or even the ability to die properly (rather than simply cease to exist)—*such fictions of both the animalized human and the*

humanized animal are already possible types of real animal in Agamben's account. Because such perfections (reason, language, subjecthood, death) are proper to human life alone according to Agamben, the impure product of any splicing of the human with the animal results in and belongs with animality. The "truly human being" (perfect human) "who should occur there" in this zone is the animal rendered imperfect. The animal is put into the black box (of the philosopher's making) as bare biology. So Agamben is disingenuous when he argues that bare life is "neither an animal life nor a human life" because, as described, it is much closer to the former in value. In terms of *philosophical value,* animals lack all perfection: any putative perfections in speed, grace of movement, strength, and so on, are always, pace Nietzsche, an imperfection of sorts (and even Nietzsche had his "low" animals whose other kinds of virtue left him unimpressed). And, like other humanists before him, Agamben must place the animal within this Christianized version of the philosomorph—in the horror of mixture. In other words, the bareness of bare life *belongs properly to the animal* (as a human stripped bare of its distinguishing qualities).

Akira Lippit puts the kind of speciesism at work here in a clear light by using, significantly, the context of cinema. Agamben's animals are too dumb to die—and any facility they may have for it will have to be palmed onto the prelinguistic (gestural) powers of film (which Agamben has also forwarded, as we saw in chapter 3):

> If, according to the strained logic of Western metaphysics, the animal cannot die—to the extent that death is seen as an exclusive feature of subjectivity and is reserved for those creatures capable of reflecting on being as such in language—then the death of the animal in film, on film, marks a caesura in the flow of that philosophy of being. The animal dies, is seen to die, in a place beyond the reaches of language.[82]

As Jonathan Burt glosses this idea, the animal never dies because it is constantly reanimated, repeating "each unique death until its singularity has been erased, its beginning and end fused into a spectral loop." In that manner, cinema keeps the animal "alive": away from the dialectics of language, it cannot undergo a "proper death."[83] Yet it is

precisely within the "horror" of the mixture of human and animal *in cinematic form* where we might also see the political threat, or promise, of *the animal not being an "animal"* either. The animal would be neither the index of death (Derrida), Life (Deleuze), nor the industrialized transformation of human life into death (Agamben). Indeed, we will later see how film opens up the possibility of an animalization of all these philosomorphs—offering a perspective, or posture, on *its* "response," *its* "agony" and "slaughter," *its* industrial death, and even *its* expulsion from the political (Badiou).

RADICAL EQUALITY

It is not that we can avoid philosomorphism altogether: as a subspecies of anthropomorphism, it will always be the case that some kind of leap of faith, act of charity, "theory of mind," or hermeneutical "stance" is needed to understand one's other, whatever or whoever "it" may be. Anthropomorphism can even be a very useful methodological tool in ethology.[84] What is so often the trouble with anthropomorphism, however, is that it is one way and partial. So, for example, in *The Natural History of Religion*, Hume notes that

> there is an universal tendency amongst mankind to conceive all beings like themselves, and to transfer to every object those qualities with which they are familiarly acquainted, and of which they are intimately conscious. We find human faces in the moon, armies in the clouds; and by a natural propensity, if not corrected by experience and reflection, ascribe malice and good will to everything that hurts or pleases us.[85]

The transfer is one sided and partial. *We* do it to *them*. What is required first is a *radical* anthropomorphism: this would not merely involve projecting some of the molar aspects of "human" behavior onto another being, alive or inert, in a partial manner; rather, it would entail, initially, axiomatically, the *radical* leap of attributing *everything* to the other in a "principle of charity" without end, as well as introjecting from that other all that one can in the same movement. Here is Laruelle:

The Stranger is not the Other encountered in the space of the World or as Infinite, but myself in-the-last-instance. This is the transcendental organon of the World and the absolute condition of democracy.[86]

Anthropos is expanded, morphed, in and through the *nonhuman* (in Laruelle's positive sense of *non-* as broadened, mutated). Hence, and second, an radical anthropomorphism also reshapes both the *subject* (*anthropos*) and the *project* (animal). It is a two-way projection that is also an introjection. The expansion is the charitable act, the benefit of the doubt, a gift and benefit that comes *before* all forms of representation (leaps, gift giving, and even Cartesian doubt).[87] And in doing so it must reshape what the human can be, what the "we" can be—a radical consistency of saying and doing.[88]

So, where this language of projection and introjection may sound too voluntarist and representational, it should be understood that these terms are only descriptions of real processes of exchange and mutation. As the Laruelle scholar, Anthony Paul Smith, argues,

> we can begin to think of the relative analogies between human beings and other creatures as an effect of the Real. The complete rejection of anthropomorphism is a commonality between theologians and radical ecotheorists, which even seeps into more popular "Green" discourse. But this actually ends up putting a barrier between human beings and other creatures as it sets up the old division between humans and Nature.[89]

Seeing X "*as* human" is a specific kind of seeing-as, an honorific seeing. It is also an axiomatic seeing, or posture, that is equally axiological. Seeing-as-human is an attribution of value or authority *before* it attributes any specific essence, properties, or perfections (which will always be cut to size depending on the contingent definition of "human" at play in that moment). Before X *is* human, X is *as* human (the details of *is* can be filled in later). Being-human is value creating, not in the Sartrean ontological sense of *bringing* value (qua Nothingess) into Being but in the sense that being-human is value per se, the cut away from the rest, the withdrawal from the others, who must now fall back into the background as lower in value—whatever that may entail. The complex history of so-called

moral progress (the "expanding circle" that gradually conquers tribal-ism, nationalism, racism, sexism, ageism, etc.) can thereby be linked to the varieties of morphism listed by Mary Midgely earlier. Each different anthropomorphic projection projects a different *anthropos* each time, and simultaneously indicates to any outsider *who* was "inside" the circle (of defined-humans) in a particular period, such that what might have been a pro-jection for an earlier era can be no such thing (the status quo) for a subsequent one.

Siobhan O'Sullivan calls this "an internal inconsistency" in relation to the differing levels of regard given to animals, one that reflects the good or bad luck of whether a particular animal is a "pet" (and of what kind), an ag-ricultural animal (and of what kind) or lives in the wild (and where).[90] Cary Wolfe adds to this in terms of such inequalities that also rebound on the human. He describes the varying modes in which human and (currently) nonhuman animals are regarded: "*animalized animals,*" who bear all the "ongoing practices of violence against non-human others"; "*humanized animals,*" the pets who are normally "exempt from the sacrificial regime by endowing them with ostensibly human features"; *animalized humans* (signifying "all manner of brutalizations"); and finally the "*humanized human,* sovereign and untroubled."[91] These restricted distributions of the "human" are not what a radical anthropomorphism commends (being more indicative of what Laruelle calls the "anti-democratic spirit of hier-archy, primacy or domination which is that of philosophy").[92] As Bruno Latour, writing of the possibility of a "Humanism redistributed," states, "so long as humanism is constructed through contrast with the object that has been abandoned to epistemology, neither the human nor the nonhuman can be understood."[93] Something other than gradual change, or more thought, is required to change this position.

POLITICIZED ANIMALS: FROM THE MAN-IN-PERSON TO THE ANIMAL-IN-PERSON

But what of Laruelle's own "position" in all this talk of animality? In *Philosophie non-standard* he writes that the last possible gamble "is a wager on man." Indeed, the great task of nonstandard thought, we recall, is always to *discover* who or what man is:

We will not say that nothing is lost and that one wins everything [*tout*]. But that, losing the sufficiency in simplifying the Whole [*Tout*], one wins the possibility of an ethics in particular, an aesthetics, and also of a faith, by wagering on humans as generic subjects.[94]

Hence we can still ask how *any* wager (or fiction) is connected to a humanism indefined as "generic subjects" rather than any particulars. If determination-in-the-last-instance is a wager and a hypothesis, it can also act as a *test* of other-mindedness (in the other) *as well as of mind-sightedness or mind-blindness* (in the self). It gives the "benefit of the doubt" concerning others' minds—disorienting a Cartesian doubt that now, in the last-instance, benefits everyone, "human" and "nonhuman" (at least as an axiom or posture). Overcoming doubt becomes a reorientation: it is less Dennett's "intentional stance" than the lived, bodily posture that "gives" the benefit of doubt as unknowing, as a positive indefiniteness as regards what mind, thought, and even otherness itself may be.[95] The *benefit,* the "good deed" of doubt, is given or donated-without-giving and operates in a posture that goes beyond our solipsism and solitude. As Laruelle says in *Anti-Badiou,* instead of forwarding the Platonic Idea of the human, or "humanity function," we should look to

> humans as they exist in-generic-body or -stance. The question of what is concretely generic is one of the fundamental points of the OV/NP conflict: is it the old philosophical individual in the position of transcendent subject as "humanity function," or instead individuality as existence in-generic-body or -*stance*?[96]

Consequently, for all that some of Laruelle's texts, like *Théorie des Etrangers,* appear to put some distance between "Man" and "animal," they do so without defining the human either against or for the nonhuman (in the negative sense of that prefix): the human is definitively undefined, generic, or nonhumanist: *"generic man is a man without humanism."*[97] Moreover, there are many points in Laruelle's writing when the nonhuman *is* allowed to stand on its own two or four (or more) feet, without either contrast or (indirect) negation:

Rather than an anti-humanism, the set of these new perspectives on man constitute a sort of "non-humanism," a science of man more universal than all philosophy and capable of integrating this under the title of a simple meta-language without authority, pragmatically then, an *a priori* of all experience. Critical and legal humanism, to return to this example, from now on is one decision amongst others.... The non-humanism that results is the set of rigorous knowledges that relate to the Ego and the Stranger and not to the negation of humanism.[98]

Nonhumanism is a "science of man more universal than all philosophy." A later text, *General Theory of Victims,* gestures even more toward a radicalized democracy when discussing the establishment of a "unilateral complementarity . . . between Man-in-person and the animal." Now it transpires that the animal is "a figure of the Stranger among us, such that it is the responsibility of humans that the animal itself attains, as it were through this mediation or safeguarding, the status, if one can say so, of *Animal-in-person.*"[99] And yet, as Laruelle continues, this accession of animals to the status of "Animal-in-person" would also be "defending humans in the very act by which they not only subjugate animals, but also assign them their last usage, an of-the-last-instance usage in which animals escape the vicious circle of slaughter, and in particular of suffering, to also become victims-in-person."[100]

One implication of Laruelle's democracy of theory is that all Strangers, all Individuals, are equal, that is to say, they are equally One. To respond to this with the query "equally one *what*?" is to miss the point of the gesture, for even to say "equally different" (with Deleuze), or "equally Being" (Heidegger), or even "equally multiple" (Badiou), remains too philosophical for Laruelle. Individually, they are all One—and this is first a performative posture before it becomes an ontological thesis (position): "He who, in virtue of being performed or of his humanity-in-the-last-instance, also does what he says and says what he does, or supports the axiom—*there is philosophisable equality but this equality is not Real, or must be determined in-the-last-resort by individuals.*"[101] Individuals *make* equality, they do not possess it (as a philosophical property of difference, multiplicity, etc.). Hence, even a Christocentric (and so seemingly anthropocentric) text like *Future Christ* can be read as widening the meaning of individuality

through "the new cogito in which the Future Christ performs, that is to say every man or every Lived thing [*Vécu*] that becomes a subject."[102]

Indeed, with the return of the subject in Continental philosophy through the work of Badiou and others, one might have thought it quite uncontroversial that there could be an emancipatory politics for animal subjects too. One might even ask whether such a politics could be one of Badiou's non-philosophical truth conditions or explore its connections with the "nonphilosophy" Deleuze relates to the pained animal, or Agamben's definition of "first philosophy" in terms of the "becoming human of the living being." Can such a pained or "vulnerable" animal (for Derrida) be a political subject, can it too "become human"? Alas, Badiou, for one, is adamant that it cannot. Quoting one of his masters, Sartre, he is wholly against the possibility of animals being political subjects: it is still the case that "every anti-communist is a dog."[103] Hence, in *Logics of Worlds*, he mounts a number of attacks on animal advocacy. Nevertheless, we may still ask if it is possible that what *Agamben* described as the "non-man produced within the man" is *not* the opposite of "first philosophy" (a "becoming-human" or "anthropogenesis" as he also calls it) but actually its fulfillment in the non-philosophical extension of the human, a Laruellean "human-without-humanism"?[104]

In his text "Thought Creatures," Eugene Thacker writes as follows on the connection between political vitalism and animation:

> Political vitalism is the sovereign correlative to the kind of vitalism-without-content that Agamben critically speaks of. It is the "animation" of sovereign power as legitimized by a higher order, or by a vital principle that is not immanent to the field within which politics possibly takes place.... Thus the question: What would we have to "abandon" in the political-as-human in order to think beyond this political vitalism and consider a different kind of "vital politics"?[105]

According to Katerina Kolozova, in fact, it is pain *behavior* that extends Laruelle's notion of victim so that it also involves "animals" within a new politics, one that Laruelle himself may be thinking of with animal "victims-in-person." In her book *The Lived Revolution*, a solidarity with any "body in pain" becomes the new "political universal" (and not

simply a provocation for philosophy à la Deleuze). The real, lived revolution becomes a bodily stance or posture against pain, shared by human and nonhuman animal alike: "at the root of the Human is that which is beyond (or rather, *behind*) Humanity—the Body, the organism subjected to pain and confronting the irrevocable call for self-preservation, always already immersed in the struggle for survival."[106] Moreover, she continues,

> The animal, both human and non-human, is ontologically deprived of the potentiality of recognition and of achieving its own liberation. The body or the animal can produce a sheer gesture, pure act of revolt— it can produce a speechless revolution, brutal and bodily. And it will exhaust itself in that brutal bodily revolt, without bringing the necessary recognition. . . . François Laruelle's non-philosophical theory, the thinking in terms of the Real and by means of radical concepts provides an epistemological *stance* which makes the Thought in fidelity to the Animal-Body possible.[107]

With this notion of "sheer gesture" and "stance" there is a "solidarity-with-the-suffering (bodies)" of human and nonhumans.[108] Such a solidarity has much to overcome, however, for there is much that needs to be reoriented.

CINEMATIC ANIMALS: THE HORROR *FOR* NONHUMANS

Cinema, perhaps, can help in this task. John Berger famously wrote that a strange distribution of value has always been a part of "our" regard of animals:

> Animals came from over the horizon. They belonged *there* and *here*. Likewise they were mortal and immortal. . . . This—maybe the first existential dualism—was reflected in the treatment of animals. They were subjected *and* worshipped, bred *and* sacrificed. . . . A peasant becomes fond of his pig and is glad to salt away its pork. What is significant, and is so difficult for the urban stranger to understand, is that the two statements in that sentence are connected by an *and* and not by a *but*.[109]

The contemporary incomprehension of this duality, or superposition, comes from a general inexperience of animals within Western urban existence. The Lockean posture of "but"—hardened as a "position"—reigns over that of "and." We no longer live alongside animals, and any remaining relationship we have has become specular, a matter of voyeurism through zoos, cinema, and television. This withdrawal *from* the animal, and our subsequent supplementation of that lack through cinematic imagery in particular, has been an important theme of writers such as Akira Lippet and Jonathan Burt.[110] The contemporaneous rise of cinema and the disappearance of animals is no mere coincidence for them. It is incontrovertible, of course, that animals have always been an essential part of our cinematic experience, being there at the very start in the proto-filmic experiments of Muybridge and Marey. The very first film stars included the superstar dogs of the 1920s, such as Strongheart and Rin Tin Tin, and the first films often showed spaces where animals were on display: in arenas (horse races, bullfights, circuses), city streets (parades, transport, public ceremonies), and zoos. It is noteworthy that horrific cruelty toward animals was often involved in these spectacles. Even Muybridge staged the killing of a buffalo to have a "guarantor of authenticity."[111] Animal suffering and vulnerability were equally present in the early "actualities," such as the Edison Company's *Electrocuting an Elephant* (1903) or in the works of the Surrealists (*Un Chien andalou,* 1929). Subsequent cinema history displays a persistent recourse to pained and dying animals in films, ranging from the sensationalist—*Ben Hur* (1959), *The Godfather* (1972), or *Cannibal Holocaust* (1980)—to the artful: *Apocalypse Now* (1979), *Heaven's Gate* (1980), or *Caché* (2005); each record of violence serves to heighten the "authenticity" of their referent.[112]

The horror, can, of course, be double-edged, as when we heard Eric Dufour state in our introduction that cinema begins in the horror of the inanimate background coming alive and moving to the foreground. Cinema was horrific before the invention of the "horror" genre, and its horrors are of the order that brings things to life, of animation. Agamben has written that "man is a moviegoing animal," but we would transform that to say that "man *is* animal when he goes to the movies" or, in other words, that cinema restores the animal that we always are.[113] Again, this is not simply about the gestural (Agamben) or "body genres" (Williams) within

cinema animalizing us but the notion that horror—and monstrosity—carry within them an inhuman philosophical horror *and* wonder (*deinon* and *thaumazein*). Eugene Thacker even links this horror of the nonhuman world to a kind of non-philosophy: "*'horror' is a non-philosophical attempt to think about the world-without-us philosophically.*" And further:

> what genre horror does do is it take aim at the presuppositions of philosophical inquiry—that the world is always the world-for-us—and makes of those blind spots its central concern, expressing them not in abstract concepts but in a whole bestiary of impossible life forms—mists, oozes, blobs, slime, clouds, and muck. Or, as Plato once put it, "hair, mud, and dirt."[114]

Horror as first philosophy, at least in the genealogical sense—as the first experience of perspectival difference in others (between the normal and the abject) but also within oneself (the experience of oneself as a monster, an outsider, as pure "outside").[115]

Yet it is cinema that makes such "concept horror" all the clearer.[116] Film makes things live, it animates them; or rather, it reanimates those who have become dead to our eyes—it is the great reanimator. *Cinema makes an animal, an animate, of all.* Indeed, Alan Cholodenko, following Lev Manovich, has argued that all cinema *is* animation: "not only is animation a form of film, film, all film, film 'as such,' is a form of animation."[117] As Deac Rossell has also observed, before the cinema of narrative, before even the "cinema of attractions," the earliest film exhibitions astounded audiences as much for the people moving in the visual foreground (already seen long ago in magic lantern shows) as for the *background movement of things normally left unnoticed,* such as the shifting leaves in the trees.[118] In this respect, animation is the great leveler, where everything lives (and such a leveling can be horrific for those who thought *they* were the exception). Cinema, qua universal animator, has animistic powers (as Jean Epstein also thought)—it gives (or reveals) life.

On this view, horror is not *in* the story qua narrative genre, or in the presence of a monster, or in the performances, or in any other element of the mise-en-scène. It is potentially in *all* of these contents inasmuch as film can make things weird and horrific in all sorts of small ways. But it

is always in the *how,* how these contents are shown, how they appear (or make themselves appear) out of the background. The how of film, when horrific, is a way of showing and sounding that *reorients* the standard forms of optical and auditory perception. And this "how" is actually film being most itself.

Cinema can, no doubt, be horrific in its literary origins too, as when H. G. Wells's 1896 novel *The Island of Dr. Moreau* was adapted for cinema in 1932 as the *Island of Lost Souls.* Erica Fudge describes this vivisection story as follows:

> the horrors and possibilities of the link between humans and animals are brought to one logical conclusion. The vivisector Moreau cuts up animals to make them more human-like, for, as he says, "it is a possible thing to transplant tissue from one part of an animal to another, or from one animal to another." . . . Moreau's animal-men are monstrous creations used by Wells to speak against vivisection. The very possibility of the link between animals and humans reveals how close those groups are and, because of this, vivisection—the absolute objectification of the animal—becomes a nightmare.[119]

This is a tale of chimera, of "bare life" or "animal-men"; only now, contra Agamben, it engenders horror more from the perspective of the other, animal, side than the human one. It is notable, then, that the 1932 film adaptation was banned until 1958 in the United Kingdom and even afterward was heavily cut by the censor (as a story about vivisection). Yet it is arguable that film's material form is even more monstrous than its story lines: Paul Coats, for instance, writes that "the horror film becomes the essential form of cinema, monstrous content manifesting itself in the monstrous form of the gigantic screen"; while Linda Badley cites Clive Barker's "Sons of Celluloid," whose monster "feeds on the projected emotion of motion picture audiences."[120] Or, finally, there is Jean-Louis Schefer in *The Enigmatic Body,* stating that "at bottom, the cinema is an abattoir."[121] Vivisection and the slaughterhouse—needless to say—perform all kinds of cutting: the decision made flesh.

Such a horrific equation brings another dimension to the cinematic animal: alongside its animations, there is also its killing, such that the

simultaneous emergence of cinema and the disappearance of animals at the turn of the twentieth century becomes even more disturbing. Nicole Shukin exposes this equation in all its brutality. In *Animal Capital: Rendering Life in Biopolitical Times,* she refers to "Slaughter's Cinematic Disposition" and explains the macabre truth of the word *render*:

> *Rendering* signifies both the mimetic act of making a copy, that is, reproducing or interpreting an object in linguistic, painterly, musical, filmic, or other media (new technologies of 3-D digital animation are, for instance, called "renderers") *and* the industrial boiling down and recycling of animal remains. The double sense of *rendering*—the seemingly incommensurable (yet arguably supplementary) practices that the word evokes—provides a peculiarly apt rubric for beginning to more concretely historicize animal capital's modes of production.[122]

Cinematic technology has become animal in a new digital manner— as an animator in an even more literal sense than simply giving life (Cholodenko). Before digital cinema, moreover, analogical film stock itself was animal stock too, for the "inconspicuous yet pivotal role" of photographic *gelatin* in the manufacture of film is "derived from the waste of industrial slaughter."[123]

But it is the nature of film's sequential form, as rendered in production and consumed in spectatorship, that creates even more perspicuous models of animal slaughter. Reporting the fact that in the late nineteenth and early twentieth centuries, guided tours of the new meat-processing plants were extremely popular in the United States, Shukin argues that through "the visual consumption of the rapid sequential logic of the moving line [of animal bodies] that they encouraged and in their stimulation of affect, slaughterhouse tours arguably also helped to lay the perceptual tracks for cinema."[124] It is, therefore, highly significant that

> *this* moving picture was being consumed on guided tours of Chicago's Packingtown at the same time that Eadweard Muybridge's zoopraxis-cope, a device that put still photographs into motion under the zoosign of animal life, was beginning to capture attention as a novel mimetic machine bringing Americans closer to the attainment of mass motion

picture technologies.... The discrete, numbered "stations" strung to-
gether into a moving sequence by the pace of slaughter and the eyes of
the tour-goer were analogous to the "frames" reeled at high speed past a
cinematic audience to produce an ocular semblance of seamless motion.
The technological mimicry of both moving lines thus suggests a com-
plicity in their economies, although their material outcomes were radi-
cally divergent.... Tours of slaughterhouses ... follow the same insistent
sequential sense as the cinematic reel, a logic that frames the impassive
stages of deanimating animal life as an inexorable progression.... It is in
this sense that the disassembled animal can be said to constitute the mate-
rial negative of cinema's mimetic effects. Here, in particular, the double
entendre of *rendering* describes the contradictory vectors of time-motion
ideologies insofar as they simultaneously propel the material breakdown
and the semiotic reconstitution of animal life across the modern spaces
of slaughter and cinema.[125]

Besides the sequential form of cinema, how it is later edited or cut cre-
ates new levels of sequence as well; but, if we follow Shukin here, it is
doubtless that they too are no less mimetic of the slaughterhouse. We
will return later to the question of film animation and digital rendering
(especially "rotoscoping") as models that both give and take animal life.
But if philosophy begins in such horror alongside the cinematic butcher
and vivisector—surely in the worst places of all—then non-philosophy
can be regarded as the anticut, the antivivisector that attempts to reorient
these stations, frames, or positions of withdrawal from the Real, including
the Real of other nonhumans.

TRANSCENDENTAL IDIOCY; OR, THE INSUFFICIENT ANIMAL

We have been exploring the possibility of a radical or complete
anthropomorphism—wherein the "human" (philosophy's "the-man" as
Laruelle puts it) is also altered by the Real in a posture of consistency.[126] In
Laruelle's words, this would be a "simplified and unfolded Humanity ... a
hyper-philosophical generality.... We call this universal Humanity." He
then continues: "Man is this Idiot who exists also as universal Humanity or
Stranger." He, or she, or it, then, is certainly not the "wise one," the master,

but the Idiot, or, we might add, the "stupid beast" *(bête bêtise)*.[127] This turn
to what Laruelle also calls the "transcendental Idiot of an ante-decisional
simplicity" would, nonetheless, be a "non-rousseauian mutation"—that
is, it is not supposed to be a return or mere reversal to an idealized past
of noble savagery.[128] The question of the clever philosopher versus the
simply human, the naïf or ordinary idiot, has already appeared in this
study. And only recently we have seen von Trier and Leth sparring over
the latter's incorrigible cleverness—"you're so clever that whatever I say
inspires you" (this, coming from the director of *The Idiots*, is possibly a
backhanded compliment). So, we need to ask, what does *Laruelle* mean
by transcendental idiocy or *"transcendental naivety"*?[129]

Part of its meaning comes as a reaction against and clone of Deleuze's
Difference and Repetition and its attempted appropriation of a theory of
stupidity (which we came across last in our introduction). Deleuze there
forwards a theory of stupidity over a theory of error (standard within the
traditional "image of thought" in philosophy). Error is a matter of actual
facts, according to Deleuze:

> Who says "Good morning Theodorus" when Theaetetus passes, "It is
> three o'clock" when it is three-thirty, and that $7 + 5 = 13$? Answer: the
> myopic, the distracted and the young child at school.[130]

Empirical idiocy, that involving mere actual facts, stems from the poor
sighted, the absent-minded, and the uneducated. Then, in an apparent
gesture of humility, Deleuze wonders whether "philosophy could have
taken up the problem [of error] with its own means and with the neces-
sary modesty, by considering the fact that stupidity is never that of others
but the object of a properly transcendental question: how is stupidity (not
error) possible?"[131]

It is interesting to note that Bernard Stiegler reads Deleuze's transcen-
dental magnanimity here quite "personally" (in *our* non-philosophical
sense): "One would clearly understand nothing... if one did not pos-
it... that 'stupidity' [*bêtise*] must be understood as my stupidity [*ma
propre bêtise*]."[132] Moreover, this self-attribution of stupidity concerns
the *transcendental* conditions of *human* perception—it is not about the
superiority of human intelligence over that of the animal:

Between *being* (stupid), *doing* (stupid things), *and saying* (stupid things), the question of stupidity would be at the same time older, deeper and lower than the *question of being and of spirit,* including in *Of Spirit: Heidegger and the Question,* where Derrida *approaches* the question of the animal "poor in world." The *default* of spirit, that is, the *feeling* of *not having any:* such would be the commencement of spirit starting from that which is stupid.[133]

Stupid is as stupid does—and as stupid says: at least (human) stupidity is *consistent.* As Stiegler has it, Deleuze is following Gilbert Simondon in trying to think stupidity from out of the "pure ground" of "individuation": "it is in relation to this inseparable ground [*fond*] that stupidity takes place as a transcendental structure of thinking." [134] Moreover, Deleuze himself makes it clear that stupidity is not the same as animality, despite their shared French etymology: "stupidity [*bêtise*] is not animality. The animal is protected by specific forms which prevent it from being 'stupid' [*bête*]."[135] In other words, animals are too animal *(bête)* to be stupid *(bête).* They lack the "individuation as such" that is "inseparable from a pure ground." In this respect, animals are protected because they are beyond cleverness *and* stupidity. For, as Deleuze says,

animals are in a sense forewarned against this ground, protected by their explicit forms. Not so for the I and the Self, undermined by the fields of individuation which work beneath them, defenceless against a rising of the ground which holds up to them a distorted or distorting mirror in which all presently thought forms dissolve. Stupidity is neither the ground nor the individual, but rather this relation in which individuation brings the ground to the surface without being able to give it form (this ground rises by means of the I, penetrating deeply into the possibility of thought and constituting the unrecognised in every recognition).[136]

Stupidity is a matter of the (transcendental) faculties, which belong to the human (Kantian) I and Self. The ground interferes with the surface, and stupidity emerges. Laruelle, however, is suspicious of Deleuze's moves here, not so much *vis-à-vis* the animal but as regards the human, especially the human philosopher as transcendentally stupid versus those

ordinary humans ("nondescript" men) that are only empirically stupid (the distracted, the child, the shortsighted, or perhaps even the "fool" who likes cats or dogs):

> if man is re-submerged into pure immanence, then one turns him into what Deleuze calls an idiot. But since there are (at best) two kinds of immanence or real, there will be two idiocies. If immanence is absolutely devoid of transcendence, the ego or man will be a transcendental idiot. If, on the contrary, as in Spinoza and Deleuze, it includes the pure form of transcendence, then man will be at once a transcendental and a transcendent idiot, which is to say, half-idiot and half-philosopher—a concept which, from our point of view, is rather transcendent.[137]

As we heard before, such a move that demarcates a special status for the philosopher is typical of philosophy's incessant authoritarian positioning and cutting. Hence the division remains between "man and philosopher"—a hierarchy, despite this egalitarian spirit, between "the philosopher who constructs the system and the idiot whom he talks about.... Once again the philosopher does not really want idiocy, he limits it."[138]

This, of course, begs the question as to what an ordinary idiocy looks like from within non-philosophy, one that, should it retain the name "transcendental idiot," is nonetheless *not* a philosophical projection. And here is where we can resort to the findings of our previous chapter for a moment. For it is the ordinary transcendental idiot who is *non-philosophically stupid,* that is, who does not think deeply, who has no depth and, moreover, *cannot see depth or distance properly.* "Distances" are non-philosophically reoriented within a new posture of idiocy. This literalized understanding of depth and distance is doubtless superficial and stupid (in a *trivially* non-philosophical manner) from the philosophical perspective. But stupid is as stupid does—if nothing else, we are consistent.

The infraction of our normal faculties, of our perceptual constancies, is also in violation of Kant's views on how we are able to think at all—"if cinnabar were now red, now black, now light, now heavy, if a human being were now changed into this animal shape, now into that one," and so on.

Shape and size, depth and distance—these object constancies are what they are to enable us to perceive any object aright, according to this view. And yet the constancies belong to the human perceiver, not the object in itself. In his *Phenomenology of Perception,* Merleau-Ponty makes this point from the (post-Kantian) phenomenological perspective:

> By rediscovering the vision of depth, that is to say, of a depth which is not yet objectified and made up of mutually external points, we shall once more outrun the traditional alternatives and elucidate the relation between subject and object. *Here* is my table, *farther away* is the piano or the wall, or again a car which is standing in front of me is started and *drives away.* What do these words mean?[139]

Merleau-Ponty also refers to how "the train coming towards us, at the cinema, increases in size much more than it would in reality."[140] *La Ciotat* again. The disparity between this "reality" and our subjective impression is not itself objective—it is a question of *context*:

> is not a man *smaller* at two hundred yards than at five yards away? He becomes so if I isolate him from the perceived context and measure his apparent size. Otherwise he is neither smaller nor indeed equal in size: he is anterior to equality and inequality; he is *the same man seen from farther away.* . . . When we say that an object is huge or tiny, nearby or far away, it is often without any comparison, even implicit, with any other object, or even with the size and objective position of our own body, but merely in relation to a certain "scope" of our gestures, a certain "hold" of the phenomenal body on its surroundings. If we refused to recognize this rootedness of sizes and distances, we should be sent from one "standard" object to another and fail ever to understand how sizes or distances can exist for us.[141]

It is the gestural, phenomenal body that takes hold of the object, that provides a context that ensures that an object "far away" is not *actually* smaller. Only the transcendental idiot—scrambling "ground" and "surface," in Deleuzian parlance—could make such an error. For Merleau-Ponty's more anthropocentric approach, conversely, this kind of error

would be a confusion performed by the human phenomenal body. But it would be no less an impossibility for Merleau-Ponty for this to happen than it would be for Kant (we would "fail ever to understand how sizes or distances can exist for us"). Such positions remain too philosophical for Laruelle. It is only an *ordinary* idiocy—the uneducated, inattentive, nearsighted—that can truly scramble the Kantian codes, that is, a transcendental stupidity in the Laruellean sense of a mutant posture. *These idiots don't follow the codes of distance*—far away things really can be different, small things.[142]

Of course, the senses need to be "educated," and it was Plato who discussed this first in the *Republic* under the title "The Education of the Philosopher."[143] Here Socrates teaches Glaucon (Plato's brother) about those "contradictory" perceptions that "call for thought" (a passage Deleuze addresses just before his discussion of stupidity in *Difference and Repetition*).[144] Even when looking at the fingers of my own hand, I need *thought* to "distinguish properly whether they are large or small," that is, "to investigate whether one object has been reported to it or two." Sight alone "perceives large and small as qualities which are not distinct but run into each other," says Socrates, and hence "to clear the matter up thought must adopt the opposite approach and look at large and small as distinct and separate qualities—a reverse process to that of sensation." "True," replies Glaucon. The educated philosopher reverses perception to create the represented object—it forces the anthropocentric perspective that measures the Real object according to a human measure. The non-philosopher, by implication, would invert or reorient that reversal to restore the Real. Or rather, he would destroy that distance, his own withdrawal. *Philosophy cannot perform this task as it is itself the phenomenon at issue*: the distance created by "intelligence," by the clever animal.

We might ask, then, whether we could find a non-philosophical means for doing this in cinema. Ironically, what is called "forced" perspective in film actually inverts the forcings of standard human perception, creating nonstandard assemblages that confuse foreground and background, bringing everything into the same plane, equally.

Figure 1a, a still from *Beasts of the Southern Wild* (2012), creates a large beast out of a near beast. Figure 1b (discussed by David Bordwell when ana-

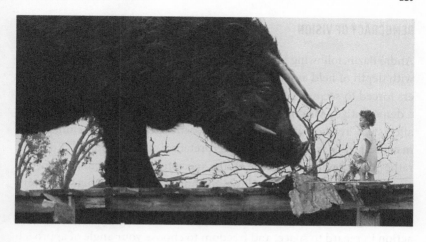

FIGURE 1. "Forced" perspectives: (a) a still from *Beasts of the Southern Wild* (2012) and (b) a line drawing of pictorial depth cues.

lyzing "pictorial depth cues") creates a small beast out of a faraway beast.[145] What is being forced, or unforced, here is itself a matter of perspective, no doubt. On this ambiguity, Bordwell writes that "the construction of objects, their three-dimensional shapes and layout, and their movements call upon bottom-up, involuntary perceptual processes," before then adding, "still, more strictly cognitive activities such as prior acquaintance with representational tradition doubtless also play a role."[146] Cinema can play with these representational traditions (to some degree) and in so doing makes "idiots" of us all: it uneducates us in everyday fashion.

DEMOCRACY OF VISION

André Bazin, following Merleau-Ponty in fact, understood cinema's playing with depth of field as a form of visual democracy. No longer were viewers forced to see one plane *or* another—they could explore all planes in a democratized vision. The ambiguities released by "shooting in depth" affects the "relationships of the minds of the spectators to the image and in consequence it influences the interpretation of the spectacle."[147] Depth, rather than forcing one image on the spectator, brings an uncertainty or openness to the image that allows for numerous perspectives (in every sense). It enables the freedom for the spectator's "eye" to explore, thus projecting a democracy of vision: "by cinema we understand liberty of action in regard to space, and freedom to choose your angle of approach to the action." In neorealist cinema especially, reality is never "the servant of some *a priori* point of view."[148] Bazin's (neo-)realism is not about optically recording the Real as a fixed object but rather about instantiating the randomness of the Real—its contingencies, its unpredictable movements, its tiniest details.[149] Realism here should be understood in terms of democratic equality and not as a mere correspondence with some supposed one and the same external world.

Oddly enough, this democracy *given* to the viewer's eye is also the viewer's eye *made* democratic by no longer merely observing according to standard codes, no longer disregarding the background (the field) in favor of the figure, *or vice versa*—each can be given its own time. On Orson Welles's use of depth, for instance, Bazin writes that "*he made it force the audience to use its freedom of attention,* thereby making it experience the ambivalence of reality."[150] This is a strange mix of freedom and force, of human and nonhuman. The field, the mise-en-scène or "decor," becomes a nonhuman agent, just as the human actors become objects or objective. In *Ladri di biciclette* (1948), for example, "the worker had to be at once as perfect and as anonymous and as objective as his bicycle."[151] Indeed, because "neorealism knows only immanence," according to Bazin, cinema makes not just the actor disappear into the film but also the set, the story, and, ultimately, the viewer, when film will "remove us quite finally from our role as spectator."[152] Everything is equalized in immanence, and depth no longer means separation (observation) but coexistence

within the Real *without* distance.[153] As Laruelle puts it in the context of a "non-photography," "the distinctions form/ground, horizon/object, being/entity, sense/object, etc., and in general the distinction between the transcendent thing and the transcendence of the thing: they are now strictly identical or indiscernible."[154]

Such a cinematic democracy—against distance, for immanence—pushes us to the point of no longer properly understanding objects, backgrounds, or foregrounds: a "poetic reordering of the world" as Bazin put it (such that, in one Fellini work, a friar is revisioned as an angel due to the bundles of sticks he is carrying on his back).[155] It teaches an idiocy of revision. But it also makes us animal. Various commentators have rightly connected Bazin's well-known fascination with animals to his "core cinematic vision."[156] Seung-hoon Jeong and Dudley Andrew write that

> Bazin's post-philosophical relation to animals is influenced by his immersion in cinema. . . . Bazin felt the cinema capable of staring at the otherness of animals with a preternatural eye. . . . Like animals, the cinema hovers at the edge of familiarity.[157]

Indeed, the animal, neither permanently in the background plane of inert decor nor permanently in the foreground plane of mindful, human life, is thereby a marginal, transitional figure in Bazin's view of cinema. This is not Agamben's "zone of indifference" where animals are stripped bare (as also on Dr. Moreau's island) but the utopian reorientation that restores the fullness of actual animals. The life of the animal on-screen, as moving and potentially mindful (to "us"), is what both ruptures and enforces the depth of field with its own random movements (neither fully "trained" nor wholly spontaneous or unperformed).[158] It reaches out to us from the middle ground. Naturally, this can horrify some, especially those who infer that *it is they alone* who must enter into a "reordered" space where there is always the threat of being *permanently* absorbed as *only* shallow decor (rather than seeing the mise-en-scène in all its depth as a protagonist too). In *The Fundamental Concepts of Metaphysics*, Heidegger argues that the essence of the animal is to act as "a suitable background against which the essence of humanity can now be set off."[159] To think otherwise, for him, would be unthinkable and horrifying. This is the tragedy of the

background, or rather, the tragedy of anyone who is rendered as an object in the background, "animals" being the name for those of us selected for this fate by some: *one is not born but rather becomes an animal.*

It was also the tragedy of the prostitutes of Falkland Road in the second remake of *The Perfect Human.* They are placed into the background, behind a plastic screen, as the perfect human eats his salmon dinner in the foreground. For Krista Geneviève Lynes, as we heard already, this inequality demands that we enquire into the nature of *any* cinema such as Jørgen Leth's:

> A further investigation would ask how cultural producers take responsibility for producing their backgrounds as they create their foregrounds. What is the relationship between the lens, the plastic sheath, the glass and the mirror in the representation of the other?[160]

Can we respond to this, therefore, by saying that the cartoon version of *The Perfect Human,* through its flattened aesthetic, through its animated lives, and through its giving life as animation goes some way to restoring the equality lost through the objective lens? This would be the equality of lives that photographic, "optical" cinema (digital or analogue) can only *aspire* to address.[161] Hence, cinema most often falls short of pure equality on account of its spatializing, distanciating representations (even those who acknowledge the miserable lives of the prostitutes still overlook the fate of the fish on the dinner plate). Cartoons—*the* stupid genre, *the* nonfilm, according to Leth and von Trier—enter cinema into an equality that transforms its formal origins in animal slaughter into an animated democracy.

FROM COSMOLOGICAL PERSPECTIVISM TO RADICAL ANTHROPOMORPHISM

When, in *Difference and Repetition,* Deleuze discusses Socrates's education of Glaucon on sameness and difference (between large and small fingers), he refers to Plato's need to interrupt any *"mad-becoming."*[162] In his own essay, "Touched by Madness: On Animals and Madmen," René ten Bos begs to differ with Deleuze here. While noting that Deleuze distances the animal from this madness completely, he prefers to place the folly

of animal madness in and as the background to human, moral madness (especially as studied by Michel Foucault):

> One might argue therefore that an animal madness (*folie*) opposes a moral madness (*déraison*), but Foucault's entire point is that the first kind of madness, that is, the animal form is the background of the moral form. What heretics, witches, and fornicators are doing, is opening the door to animality and this alone justifies the severest measures imaginable. The madness of a heretic, witch, or fornicator does not only reveal moral degeneration but also the abysmal freedom of the animal in each human being.[163]

Laruelle, of course, is the archetypical philosophical heretic, and in this chapter we have been putting him en route to animality, via idiocy and cinematic depth (over distance). We now wish, finally, to reorder perspectives, radically and completely, such that the nonstandard human becomes something far more uni-versal (oriented to the One). To do this, we begin with Laruelle himself. In a lecture titled "Life in-the-Last-Humanity: On the 'Speculative' Ecology of Man, Animal, and Plant," he speaks about his latest ideas concerning the quantum nature of nonstandard philosophy. In the final section, he concludes,

> Man has no exorbitant or metaphysical privilege in quantum thought, even when it is about life, it is an *a priori* of the lived like the other combined variables. We obtain inverse products, MA (man as animal) and AM (animal as Man), but also MP (Man as Plant) and PM (Plant as Man) which form unequal and above all non-commutative products for the knowledge of life.[164]

Here it is argued that there is a "being-in-the-last-humanity or being generic" that is not opposed to animal (or plant) but is, rather, "the power of life to know itself across all types of livings."[165] To this strange idea, he adds the following:

> What they get or subtract from the physico-biological representation, is what we will call, for lack of anything better, the clones of human

individuals, animal and plant, represented clones of the three types of living. That does not mean returning to the representation as in itself, it is about the generation of clones which corresponds to the three givens of the representation. So we have the matter for three clones, in accordance with the three stases of the living: the clone derived from the matter of the animal-man represented or named "Man" who populates the cities; that one derived from the man-animal represented or named "Animal" which populates the earth; finally that one derived from the man-plant and named "Plant" who populates the forests. The ordinary man, the ordinary animal, the ordinary plant are obviously represented under a philosophical condition, but also and more profoundly clones, that is livings deprived this time of philosophical or macroscopical properties.

There is a generic *of* life "across which life experiments on itself and knows itself." This idea is quite reminiscent of Michel Henry's "auto-affective Life," only it is here deanthropocentrized and universalized as generic (Henry always resisted the nonhuman implications of his idea of cosmic and vital autoaffection in favor of a Christian, humanist reading). By contrast, we can see Laruelle moving in the direction of an inverted humanism, that is, a nonstandard humanism that does not restrict the referent of "Man" but shows how, beginning with a *generic* form, it becomes narrowed into one or other species. This is not simply the reproduction of the classical Greek idea of *zoé* (which Agamben adumbrates as "the simple fact of living common to all living beings") versus *bios* ("the form or way of life proper to an individual or group").[166] Rather, it is the clone of all such philosomorphic positions: Bergson's élan vital versus nature, Deleuze's pack animal versus the domestic animal (or virtual becoming-animal versus *any* actual molar animals), or even Agamben's own bare life versus animal life (which ultimately dovetail into each other).

In his book *Forme et objet*, Tristan Garcia cites the work of Eduardo Viveiros de Castro—that we already encountered—on Amerindian cosmologies. From these points of view, what counts as human is entirely perspectival (in a nonrepresentational sense). For this approach, "in the world *for us,* an animal species amongst others, we are 'human,' but in the world of the jaguar, another animal species, the jaguar is 'human' for itself" (he is not, like the Pink Panther, only there for humans to

become).[167] This is also Laruelle's generic human or "in-the-last-humanity," which indefines and democratizes what humanity means in the non-human and nonperson (or "in-person"). Whether this non-philosophical and nonhumanist strategy itself escapes the charge of being anthropomorphic or even of being another form philosomorphism remains debatable. Indeed, the real question may be whether it actually needs to escape it at all. A *radical* philosomorphism—like its anthropomorphic cousin—refracts and mutates both the (nonhuman) animal *and* (human) philosophy into something new, a philo-fiction that is no less part of the Real.

Viveiros de Castro's work on Ameridian perspectivism is a useful tool for understanding this idea of a generic humanity. In Amerindian language, what is normally translated as "human being" does *not* denote "humanity as a natural species":

> They refer rather to the social condition of personhood, and they function (pragmatically when not syntactically) less as nouns than as pronouns. They indicate the position of the subject; they are enunciative markers, not names. Far from manifesting a semantic shrinking of a common name to a proper name (taking "people" to be the name of the tribe), these words move in the opposite direction, going from substantive to perspective (using "people" as a collective pronoun "we people/us").[168]

To be seen as a (human) person is a perspective, which we can translate as being revisioned in-person, or as adopting the generic human posture. Instead of "shrinking" Man down to a substance, an essence, Amerindian cosmology enlarges or undefines it, sees it as generic, as nonrepresentationally universal ("a perspective is not a representation").[169] And this pertains to what "we" call animals too: "animals are ex-humans, not humans ex-animals." Indeed, the very idea of animality as a "unified domain, globally opposed to that of humanity" (Sartre's human reality vs. dog reality) is inverted within these Amerindian cosmologies:[170]

> Typically, in normal conditions, humans see humans as humans, animals as animals and spirits (if they see them) as spirits; however animals (predators) and spirits see humans as animals (as prey) to the same extent that

animals (as prey) see humans as spirits or as animals (predators). By the same token, animals and spirits see themselves as humans: they perceive themselves as (or become) anthropomorphic beings when they are in their own houses or villages and they experience their own habits and characteristics in the form of culture—they see their food as human food (jaguars see blood as manioc beer, vultures see the maggots in rotting meat as grilled fish, etc.), they see their bodily attributes (fur, feathers, claws, beaks etc.) as body decorations or cultural instruments, they see their social system as organized in the same way as human institutions are (with chiefs, shamans, ceremonies, exogamous moieties, etc.). This "to see as" refers literally to percepts and not analogically to concepts, although in some cases the emphasis is placed more on the categorical rather than on the sensory aspect of the phenomenon. In sum, animals are people, or see themselves as persons.[171]

Amerindians allow animals to become-human in a manner Deleuze never countenanced because he only saw the human as a molar substance.[172] From our perspective—you and me—we are human persons: indeed, having or being allowed a first-person perspective at all is *the same as* having or allowing a human perspective, "human" being here another name for "first person." This "having" is not reflective, however: it is not a thesis or position. It is a posture, a body. As Viveiros de Castro writes, "animals see in the *same* way as we do *different* things because their bodies are different from ours." My bodily behavior, from the first-person perspective, is deemed "cultural"—those of nonhumans is "natural": "if Culture is the Subject's nature, then *Nature is the form of the Other as body,* that is, as the object for a subject."[173] The human is postural, culture is postural. So, for example, individual French people do not see themselves as "French"—*they* do not hear their "accent," only their voices. The Irish do not see themselves as "Irish," and they are not, for themselves, "such friendly people." Save for the refractory (even "contradictory") representations received from others (that reflect their difference back to them), all groupings see themselves as human-without-qualities, without-humanism (Irish-without-Irishism), and so on.[174] Only when these perspectives destructively interfere with each other do cultures appear as natures—as accents and demeanors—and so our centers are decentered. And yet, these "decenters" are still centers,

these differences still have an identity—this being precisely when they are taken up as material in non-philosophy (this being the "genealogy of the absolute," or the structure of inequality within equality—explaining how some equalities become "more equal" than others).

And this includes nonhumans. There is not simply one "border" between man and animal, therefore, but many mutating ones: *"the original common condition of both humans and animals is not animality, but rather humanity."*[175] Consequently, it is not that the shift, or postural mutation, from "substantive to perspective" removes *all* chauvinism, all exceptionalism: it is only a vector, an orientation toward the Real, and not the pure equality of the Real itself (otherwise there would be no need for *continual* mutation). As Bruno Latour writes in *We Have Never Been Modern*, "the human is in the delegation itself, in the pass, in the sending, in the continuous exchange of forms. Of course it is not a thing, but things are not things either."[176] And this vector is what reveals the fictionality of one's *own* authority, one's own cleverness and wisdom. In a posture of consistency, it reveals oneself as the idiot, at least momentarily.

TOWARD AN ANIMAL PHILOSOPHY: FROM SLOTERDIJK TO FLUSSER

The mice in Douglas Adams's *The Hitchhiker's Guide to the Galaxy,* far from only being science's favorite laboratory animal, were—it turns out— actually running a long-term experiment of their own into the meaning of the universe. Likewise, in the famous passage from his essay "An Apology for Raymond Sebond," Michel de Montaigne forwarded the following conundrum: "when I play with my cat, how do I know that she is not passing time with me rather than I with her?"[177] We may think that we are playing with the cat, but how can we be sure that she is not playing with us? Montaigne both states and then reverses the question, and in doing so radically changes the scene: through reorienting his vision he turns the object (cat) into a subject that thereby transforms Montaigne too. These are not simply examples of reverse humor, however, but serious points about behavior. We should recall the behaviorist Niklas Torneke from chapter 3, who parsed "radical" to mean "consistent" rather than "extreme." He goes on to say how this distinction has important consequences for practice:

For example, take the principle Skinner used to describe operant condi-
tioning. . . . This principle implies that our actions are influenced by the
consequences we have previously encountered following a particular
action. The probability that a pigeon will peck at a certain point increases
if it has earlier received food after pecking at that particular point. But if
this is to be applied in a consistent way, in keeping with Skinner's position,
then this principle also holds for me as a scientist. I do what I do (in my
experiment with the pigeon) as a consequence of outcomes of similar
experimentation earlier. . . . Radical behaviourists are not claiming to be
"uncovering reality"; rather, we maintain that this method, the scientific
method of radical behaviourism, is a method that works for what we want
to do. *The pigeon in Skinner's experiment could say something similar:
"Pecking this spot works when it comes to getting Skinner to give me food."*[178]

The bird "could say something similar," but it does not (so far as we can
tell). Or, its possible utterance remains a fiction, at least for now. For Laru-
elle, this fictioning is not only an ability to imagine oneself as another but
the philo-fictional posture that allows any communion between minds
at all. In a similar vein, Slavoj Žižek cites G. K. Chesterton's *Everlasting
Man* for its proposal that, instead of asking what animals are for humans,
we should ask what man is for animals, imagining the monster that man
must seem to the animals that encounter him.[179] A failure of imagina-
tion, conversely (as in Damien Hirst's *The Physical Impossibility of Death
in the Mind of Someone Living*), is not a representational problem (the
wrong position) but a postural one, a matter of orientation (which, in the
next chapter, will become the matter of practice). For Wittgenstein in the
Tractatus Logico-Philosophicus, "the world of the happy man is a different
one from that of the unhappy man."[180] Obviously, then, changing worlds
is impossible for a mere "position" (which is always *in* its world)—what
is needed is a new world, a utopian posture.

Feats of imagination like this (Adams, Montaigne, Torneke, Ches-
terton) are forms of postural mutation first and foremost. J. M. Coetzee,
imagining the internal world of his character Elizabeth Costello in *The
Lives of Animals,* is able to picture himself as seventy-one years old
(twelve years older than he was when he published the book), female,
and Australian—gerontomorphism, gynecomorphism, and Australo-

morphism (Coetzee is South African by birth). But Coetzee is also, contra Hirst, able to imagine himself dead by proxy of Costello ("for instants at a time . . . I know what it is like to be a corpse"), and also as an animal—all by way of fiction: "if I can think my way into the existence of a being who has never existed, then I can think my way into the existence of a bat or a chimpanzee or an oyster."

So, finally, we ask, what is it to imagine—or posture—an animal philosophy? We turn to four authors here who might help us: Coetzee (again), and along with him, J. S. Mill, Peter Sloterdijk, and Vilém Flusser. In Coetzee's work, for example, Costello explicitly ponders the question of "what thinking is, what understanding is. Do we really understand the universe better than animals do?"[181] And she regards poets, like Ted Hughes (in his "Jaguar" poems, for instance), as literally "bodying forth" an animal understanding, the human as animal:

> By bodying forth the jaguar, Hughes shows us that we too can embody animals—by the process called poetic invention that mingles breath and sense in a way that no one has explained and no one ever will. He shows us how to bring the living body into being within ourselves. When we read the jaguar poem, when we recollect it afterwards in tranquility, we are for a brief while the jaguar. He ripples within us, he takes over our body, he is us.[182]

It is through sympathetic imagination, the fictional placing of oneself in another creature's place, that Costello–Coetzee shows a kind of thought at work, with "stories about made-up people" rather than authoritarian forms of reason.[183] But the fictions themselves are embodied, which, for Laruelle and the idea of a generic body of (philo-fictional) thought, allows us to see them as non-philosophical.

We should remind ourselves of Laruelle's assertion from our introduction: "thought is not the intrinsic property of humans that must serve to define their essence, an essence that would then indeed be 'local'; it is a uni-versal milieu."[184] Significantly, in J. S. Mill's *Utilitarianism*, we see a perfect example of quite the opposite sentiment, and a classic statement of humanist speciesism as well. Nonetheless, it also offers us an amazing feat of imagination:

It is better to be a human being dissatisfied than a pig satisfied; better to be Socrates dissatisfied than a fool satisfied. And if the fool, or the pig, is of a different opinion, it is because they only know their own side of the question. The other party to the comparison knows both sides.[185]

What is most impressive is that, whereas the pig and the fool (or idiot) only know what it is to have their own perspective, the human and the clever philosopher know "both sides"—they know what it is to be both human and animal, foolish and clever (in varying states of satisfaction and dissatisfaction). But how? Surely Mill was never a pig, in this life at least, nor a fictional thinker. The philosopher, as the human par excellence, or perfect thinker, is always self-satisfied (irrespective of whether she is happy). He is easily pleased, but mostly with himself and his own position.

In fact, on the question of happiness, Nietzsche, a great admirer of "cynical" thought, took a very different view: "for the happiness of the animal, as the perfect Cynic, is the living proof of the rightness of Cynicism." Peter Sloterdijk follows this commendation of "kynicism," the dog philosophy, as an "animalist philosophy" of embodiment: "Greek kynicism discovers the animal body in the human and its gestures as arguments; it develops a pantomimic materialism."[186] Less poetic that Coetzee's jaguar thought, the embrace of the "low" is part of this gestural, bodily philosophy of the Cynics. Sloterdijk sees this especially in Diogenes the Dog ("a Socrates gone mad," as Plato is said to have called him) and his "pantomimic theory." Diogenes "assigns positive values to the animal side of human beings and does not allow any dissociation of what is low or embarrassing." Such "lowness" included public masturbation, copulation, urination, and defecation.[187] Sloterdijk writes:

> What Diogenes demonstrates to his fellow citizens through his life-style would be designated now as a "regression to the level of an animal." Because of this, the Athenians (or perhaps it was the Corinthians) derogatorily called him "dog," for Diogenes had reduced his requirements to the living standards of a domestic pet. In doing so, he had freed himself from civilization's chain of needs. He thus also turned the Athenians' nickname around against them and accepted the insult as the name of his philosophy.[188]

Diogenes practices a reverse mutation—a regress that is actually a progress for him (from human reality to dog reality—much as Sartre would have found this inconceivable). And he taught others this philosophy by example, through his own practices:

> As soon as the kynic meets someone who wants to impress upon him that he is not an animal, Diogenes pulls out his organ from underneath his toga: Now, is that animalistic or not? And anyway, what do you have against animals? When someone comes who wants to dissuade human beings from their animal foundations, the kynic must demonstrate to his opponent how short the way is from the hand to the organ. Did human beings not initially through their upright stature find themselves in the position where their hands were precisely level with their genitals? Is the human being—seen anthropologically—not the masturbating animal?[189]

The erect animal, the tool-using animal, the masturbating animal, the obscene animal. Laruelle too is fond of citing various "obscenities of philosophy" in quite a Cynical manner. He lists a good number of them in one short essay on the things philosophers do with philosophy: "inebriated and bastardized by Plato, liquefied and cogitated into concentrate by Descartes, moralized by Kant, whipped by Sade, devoured by Hegel, disgorged by Sterner, officialized by Husserl, shooed out by Nietzsche, swallowed down the wrong way by Derrida, turned over by Heidegger, crapped out by Deleuze, thrown up by Laruelle, and it would ask for more if we let it."[190] Thrown up or vomited—perhaps: or ventriloquized, pantomimed, aped. Not in the act of the clever, wise ape, *Homo sapiens*, but with an ordinary naïveté or idiocy. Laruelle the jester, Harlequin, or fool. There is something Cynical and monstrous in Laruelle's work for sure, but it is not because it is wholly "alien" or outside. Rather, it is because it is both like *and* unlike philosophy, an uncanny clone of philosophy, with some features misaligned, with philosophy's self-seriousness performatively ridiculed, exaggerated with excessive accents and demeanors. And this is all to bring our attention to philosophy's materiality: when the original and the disfigured clone are superposed, it produces a nausea, much like the moiré effect can sometimes induce. It is not that Laruelle acts as a monster (by performing bodily functions in public); rather, he exposes

how philosophy *already is* monstrous, how it already is a *bodily* function. Significantly, in an interview in *En tant qu'un,* Laruelle's approach is likened to the monster from the film *Alien* (1979), a "rigorously faceless" and monstrous Other.[191]

So, whereas we have not yet demonstrated what *a dog's* philosophy would look like, we have done more than simply play at "doggy" philosophy (to invoke one of Deleuze's charges against imitation) or used the animal as a "pretext." In this last regard, even Vilém Flusser's 1987 *Vampyroteuthis Infernalis,* for example, does not contain the formula we seek here (despite its eponymous hero being described at one point as "Aristotelian" in its realism toward the world).[192] While there is much to admire in the animal thought within *Vampyroteuthis Infernalis,* Flusser's own acknowledgment that the "vampire squid from hell" is part of a "fable" dilutes its value. As a fable, it is for him

an attempt to critique our [human] vertebrate existence from the molluscan point of view. Like every fable, this one shall also be mostly about men, although an "animal" will serve as its pretext. *De te fabula narrator.*[193]

The stories told by Flusser about *Vampyroteuthis* serve and reflect the human, and the squid becomes less and less animal as a result, becoming an aquatic "analogue" and "mirror" of man as well as some of his given properties (thought, society, art). Conversely, should who or what counts as "man" (or thought, society, art) too become a fable—a possibility that we should not discount too quickly from Flusser's text—our reading would alter *radically.*[194] As things stand, though Flusser's attempt to "overcome anthropocentrism" and "grasp evolution from a vampyroteuthian point of view" is clearly of significance, it would be all the more so were overcoming anthropocentrism something in the "animal" as well as in "man" (a double morphism), in the meaning (or posture) of their "existential interest" or attempted "objectivity"–"intersubjectivity" as well.[195] It would not only be in the philosopher Flusser-as-*Vampyroteuthis* but also, within the same movement, *Vampyroteuthis*-as-philosopher.

So, when Flusser states that "every attempt to limit mentality to the human species is condemned to failure," the stakes could not be higher when *deciding* whether this is taken as a "fable" (and so for Flusser is really about

humans and only a "fiction" about animals).[196] In an interview from 1988, Flusser comments on *Vampyroteuthis Infernalis* as follows: "could it be possible to take up an animal position towards ourselves and to persevere in this position, that is, to view ourselves with the eyes of an animal—not a mythical creature, but an animal as described by biology?"[197] The difference between Flusser's "animal position," or rather reposition, and the postural mutations we are exploring here is the difference between seeing the human with an animal's eyes in a fable qua "fiction" and seeing the human *as* animal *and* the animal *as* human in-One (a "seeing" or vision that would also be a posture and a philo-fiction).

Having said all this, however, *Vampyroteuthis Infernalis* also contains the following thought about animal posture:

> There are only two fundamental postures of the organism. In the first the organism curves outward in a convex manner, distancing the mouth from the anus. In the second it curves inward in a concave manner, approximating the mouth to the anus. The first posture is rigid, the articulation of the Thanatotic tendency, of death. The second is soft, the articulation of the libidinous tendency, of love. The first posture, "chest out," is the military posture and reinforces the cramp, the personality. It is self-affirming. The second posture is coital and relaxes the cramp through orgasm. It is self-sacrificing. The first posture is of war, the second of love. Every political and social reaction is founded upon the first posture, and every revolution and instance of creativity upon the second.[198]

The vampire squid's posture is revolutionary: but when the notion of posture is extended beyond an anatomical *cause* (as it appears here in Flusser) and into a physicalized worldview, we come even closer to our objective.[199] Animalizing philosophy, then, is neither about *human* bodily poetics nor *human* bodily obscenity alone (though it is these too). Nor does it only concern fables made to mirror *human* bodies. It is about showing the *body of philosophy*, both human and nonhuman.

This suggests how even a perfect intelligence, a perfect thought, and a perfect human philosophy are still and the same, bodily postures, material and animal. Rather than reject all forms of philosomorphism as misrepresentations, therefore, we splice them together and review them

as equal, immanent parts of the Real. Doing so, we also mutate what counts as philosophy in a radical or complete philosomorphism through the animal (just as philosophy mutated the animal to its own ends). This entails rethinking what counts as thinking and vulnerability (Derrida), thinking and non-philosophy (Deleuze), thinking and political subjectivity (Badiou), or thinking and humanity (Agamben). But again, *we are not trying to outwit these philosophies, to be more intelligent than them.* We are trying to revision them together, en masse and as a bodily mass—each being a part of the Real, and none having authority over the other. In this sense, we "render" these philosophies together, slightly shifted in shape, marginally disfigured, and let them morph into each other (through a mimicry of the logic of "critique"—their inconsistencies, circularities, etc.).

EQUAL INTELLIGENCES

In a true cosmopolitanism, where "*everyone is of equal intelligence*" (to quote Rancière from *The Ignorant Schoolmaster*), a genuine political change—that is, the enfranchisement of a genuinely *different* group— means a change in what counts as the "political" as well (rather than a simple extension of it).[200] As such, it must also bring with it a change in our concepts of "liberation," "enfranchisement," and, if need be, "intelligence" (should that be a variable). Deleuze's "uneducated" (ordinary) idiots, no less than Plato's educated philosophers, must both be leveled. Rather than merely having an extension of extant politics by making the Other conform to the Same, what changes, in-the-last-instance, is politics (or equality) itself. It is not about the *position* (representation) of a new in-group or a new out-group (though such positions do emerge from a changed posture). Nor is it that "*human* intelligence" changes quantitatively, wherein it is discovered to be shared with great apes or dolphins, or that the great apes or dolphins are now seen to be intelligent "like us." It is both the human *and* intelligence that actually change (mutate), and *from that, new* virtual "poles" (positions of inside and outside) are subsequently created. This is a postural mutation rather than a change of position: a mutation that changes everything, globally, *universally,* in a new posture—that can *then* be seen "virtually" to have generated new members. Moreover, posture here does not mean "relation" or "event"—with "positions" equating to

"relata" or "situation": it is neither a qualitative change (Deleuze) nor a quantitative one (Badiou). Postural mutation is not a matter of "reciprocally determining" dyads (Deleuze) nor "trans-being" events (Badiou) but the engendering of each dyad or event via a new, mutated posture (in the Real/One). It is universal, cosmological, ongoing mutation. The dilemmas of morality remain unresolved if we begin with "us," if we merely extend "our" position: we must mutate who "we" are, our posture, before we can do any real good or even hope for a true utopia.

Equating the animal with Laruelle's use of the postural *can* be seen as just one more philosopheme, of course. Yet it will not be of the same type so long as we radicalize it, self-implicate or self-enfold it, squid-like. In other words, we must perform this equation with proper consistency. We do not attempt to anthropomorphize the Real through *one* image but allow it to anthropomorphize "us" through a host of images that expand (the meaning of) *anthropos* (and *dēmos*) in a mutation that comes from the Real to us "human philosophers." We begin, Laruelle says, with "The One, The Real, Man" as an undivided, uncut, real identity *in-the-last-instance*. Hence, in wagering on such an axiom or hypothesis, we also add the name "Animal" to the Real to test what happens to thought.[201]

The death and life of the animal: in an animation that gives everything life, and at the same time in a (computer) rendering that also takes life, slaughters it (or vivisects it—cuts life into picture pieces). All of this is done in the flattened aesthetic (or "flat thought") of a cartoon caricature that is not a fiction but a philo-fiction—a clone or mockery (charade) that revisions these philosophies as part of the Real: "the clone is thus 'transcendental' and not real, but it remains real-in-the-last-instance or, more precisely, the clone is the concentrate of the entire structure of determination-in-the-last-instance as such."[202]

5

PERFORMING THE IMPERFECT HUMAN

> A Non-Parmenidean Equation: Practice = Thought.... In order to clearly distinguish philosophy, we will say that practice and thought are identical in-the-last-instance, or even that practice is the presupposed that determines thought. This is the non-Parmenidean paradigm and it must put an end to theoreticism and idealism, which are both the effect of philosophizability.
>
> FRANÇOIS LARUELLE, *Struggle and Utopia*

> A last word. They tell me I am an artist-without-art and a philosopher-without-philosophy, that I take the "pose" of an artist without the practice, or a philosopher without the doctrine—and I would add that of a believer without a religion. This criticism recognizes me by subtraction: I am exactly not one of the sincere liars that the artist, the philosopher, and the believer are.
>
> FRANÇOIS LARUELLE, "Artistic Experiments with Philosophy"

A PERFORMANCE PHILOSOPHY

It was Albert Camus who described actors as sincere liars ("*l'acteur est un menteur sincère*"). It is not that they do not do what they say or say what they do but that *they do not even say what they say.* Is Laruelle one of those (if only "by subtraction")—some kind of poseur, ironist, or dissimulator? Or does he do quite the opposite—posing *and* practicing, or even a posing that *is* a practicing? What kind of actor or performer is he anyway? As we know, when Laruelle extends a philosophical idea, it is not a *quantitative* "easing" that merely generalizes an extant concept—printing more of the same (thought of) philosophy, the human, or even thought itself. Rather, it is a distension that mutates what it shares in the very act of sharing. This is the founding gesture of non-philosophy—to extend, to admit more, only to do so through self-mutation: "science is widened

to every phenomenon that, from now on, can become the 'object' of a science, or rather, give place and indication to a new science."[1] The science becomes a *new* science when it encounters a new phenomenon—it mutates. As always, the *non-* of *non-philosophy* wagers on what *could* count as thought: "Non-philosophy is not 'the highest' exercise of thought; this no longer means anything for a non-philosophy which does not know the 'superior form' of thought."[2] It expands rather than negates philosophy and so opens it up to the Real rather than relativizing it into nothing (via language, history, or culture). It indefines or underdetermines (verb), not to generate a vagueness for the sake of vagueness (noun), but to simplify in such a way that the copious, warring definitions of philosophy are revisioned materially in-One. As such, it is always a practice, a material behavior. Where the Parmenidean Equation is that "Thought Equals Being" (as seen in Badiou's philosophy, to take only the latest instance of this supreme sufficiency), Laruelle performs the "Non-Parmenidean Equation": "Practice = Thought." Consequently, the *dualism* of practice and theory dissolves:

> A great misunderstanding in fact threatens non-philosophy, that of its spontaneous definition as a theory or even as a practice. It is neither one nor the other, of course, neither practical theory nor theoretical practice or "of" theory, but *a future thought or in-the-last-instance, determining a subject for the (non-) relation of theory and practice.*[3]

We examined this "(non-) relation" previously when looking at the notion that non-philosophy is "a new practice of philosophy" as well as Laruelle's inheritance from Derrida's performative-oriented thought.[4] Let us tackle some of these ideas one final time. Non-philosophy's practice is connected to its performative language, such that "to the widespread question: what is it to think?, non-philosophy responds that thinking is not 'thought,' but performing, and that to perform is to clone the world 'in-Real.'"[5] Non-philosophy is equally described in turns as "*transcendental practice*," an "*immanent* pragmatics" (that ensues "*from the One—of simple philosophical material*"), or a "universal pragmatics" that is "valid for ordinary language as well as for philosophy":[6]

In this sense, non-philosophical pragmatics can be defined by saying, for example, that *all language becomes performative in it but in the form of a performativity of description. . . . It is what it does, it does what it says by saying it.*[7]

Laruelle insists that we look at "that-which-I-do-in-saying and not just what I say"—for the latter is simply what happens when thought is "taken hold of again by philosophy."[8] Resisting this hold, non-philosophy performs redescriptions of philosophy that, *in doing so,* produce effects on how philosophical texts are seen.[9] Of course, whether these effects are always *desired* or are merely nominally considered *"effects"* such as *any* description might create (misunderstanding, disbelief, dismay, boredom) has been on ongoing issue for us. In accordance with this, it is notable that Laruelle objects to the focus on activity within the concept of a speech *act* and instead emphasizes the "descriptive passivity" that an immanent pragmatics obliges: statements that manifest "by their very existence what they must describe in the last instance—statements identically descriptive and performative."[10] In other words, the field of speech act philosophy remains decisionistic for Laruelle: philosophical decision is "implicit when it concerns the linguistic 'performative.'"[11]

In contrast to this, what Laruelle calls a "Performed-without-Performation" would be an action of the Real, or the "in-One"—philosophical language seen as a performed without *we* using this or any language to perform. This complex thought warrants the following extended quotation from *Principles of Non-Philosophy* to aid our grasp:

Non-philosophy thus frees up, by manifesting it on its behalf, the phenomenal core of performativity which was always despite everything somewhat divisible in the usage philosophy made of language. It particularly subtracts it from its verbal and active dimension and leaves it to-be-given as Real('s)-passivity, prior to the noun of beings and the verb of Being. . . . We will carefully distinguish the phenomenal given concerns, to which we designate the first axiomatic abstract name of Performed-Without-Performation. . . . If deconstructions and almost all philosophy since Freud (up to Badiou's work) are a "hetero-critique" of the proper identity of Being (of the *ontological* One, or the One attached

to Ontological Difference) as performativity, they have only destroyed
the ontological and transcendent forms of performativity, never the core
of the Performed that necessarily precedes every operation of performa-
tion.... The radical Performed signifies the definitive destruction of
hinter-worlds: there is no longer even any performation reconstituting a
world sketched out behind the One, and moreover none of these ultimate
hinter-worlds such as Phenomenological Givenness, Desiring Production
or the Will to Power, Writing and general Textuality, or even Language
Games. It is this Performed, stripped of its fetishes of "performativity"
and in general of activity and the *causa sui,* that transmits thought itself
as identity (in its relatively autonomous order of thought) of science and
philosophy, more generally of the "theoretical" and the "pragmatic." We
will not say too hastily—confusing the Real and thought once again—that
this is directly performed "in-One," but that *it is in-One in-the-last-instance
only through the One as the Performed itself.*[12]

It is the notion of the performative, *but without any philosophical adum-
bration,* and only in its own core, that we need to comprehend. Naturally,
this core cannot be a philosophical essence: this "Performed-without-
Performation" belongs to the Real or the in-One and so cannot be reduced
to any solitary method or concept. It requires numerous takes. In one
respect, this entire study has been an attempt to understand the maxim
of non-philosophy that "*it is what it does, it does what it says by saying it*"
through a multiplicity of performative takes (and so with an *undefined*
"core"). The attempt has for the most part been quasi-performative,
chapters 2–4 taking a literalist, naive, or avowedly "stupid" stance—seeing
non-philosophy as democratic to the point of paraconsistency ("performa-
tive contradiction"), as a behavioral posture, or as a nonhuman (animal)
philosophy. Each was an attempt to do what Laruelle does, namely, radi-
calize "the Marxist criterion of practice . . . against the transcendence of
ideology, indeed of philosophy" by *changing* the base of thought away from
(standard) notions of consistency, speculation, and anthropocentrism—
and doing so not only in word but also in deed (through words).[13] Here
"use" and "mention" merge whereby every mention (of philosophy) is also
a usage, such that citations within "ordinary language" (be it "constative,"
like an introduction, or "performative," like a rhetorical question) become

behavioral. The so-called representational dimension of "propositional content" is not rendered simply as the social practice of "giving and asking for reasons" (Robert Brandom) but is materialized in a host of different domains under categories such as "art," "science," or even nonhuman behavior (animality).[14]

If performative practice is not performativity as philosophy has understood it (as speech act, power, desire, and so on), what other non-standard and nonhuman models can we add to it, alongside paraconsistency, behavior, and animality? This chapter, consequently, brings our study to a close by introducing Laruelle as this "artist-without-art" by looking at non-philosophy as a model of performance art (rather than of the performative—or "philosophical"—speech act). Indeed, Laruelle is adamant that, "because of its Greco-spontaneous usage of thought, philosophy, which continues its desire to govern the real, man and science, finds itself lagging behind the arts and sciences."[15] It is time to address this "lag." The place of art has always been here, of course, as far back as chapter 2 and the notion of "philo-fiction," as well as in the film structure of *The Five Obstructions* that we have followed tangentially throughout. Moreover, Laruelle has described his work as a "rebellion-through-fiction" that can also be seen as an "invention of lived experience or of a life [that] takes . . . from thought's point of view, the form of a theory-practice."[16]

In this final introduction, then, we will look at the invention and practice of performed lives by turning to certain concepts and practices of performance (Allan Kaprow's, Richard Schechner's, and Michael Kirby's especially). Close to hand throughout these last pages will be the question whether Laruelle's non-philosophical practice can also be seen as a performed life, a "personal" or "'auto' nonphilosophy" that, without being reflexive, *enacts* the biography of a non-standard ("ordinary") human through reusing other (philosophical) lives. We will then conclude with a discussion of evaluation in terms of how performance per se might itself be valued as well as how this introduction might be assessed, be it as a (consistent) mutation of non-philosophy or as a species of nonhuman thought. In all of this, we will also be trying to explain what Laruelle might mean when he says that "Man is not an ancient lost paradigm which we must bring back . . . man is the 'performed' paradigm of the future-in-person."[17]

A PERFORMATIVE TANGENT: THIS IS HOW THE PERFECT HUMAN FALLS (THE RADICALLY PASSIVE OBSTRUCTION)

Obviously, we could subsume the idea of performance under the even more general category of "behavior" already tackled, but that would leave aside the *art* of performance too quickly and indeed the possibility that that art is already a form of philosophy *before* being taken up within other genera (that may or may not themselves be philosophical). Likewise, with respect to the active passivity of Laruelle's performance, we need to take care to examine how the category of "acting" (and nonacting) forms a continuum of behavior whose two vectors vary from types of performance that look wholly passive, to others that appear as full-blown acting for the theater stage or film. Alternatively—and going now in the direction of universal performance—one aesthetician, David Davies, has argued that *all* art can be seen as performance, claiming that individual artworks are snapshots of a performance toward a possible work.[18] Here, though, it is the specificity of art that is subsumed within a general concept of performance that is wholly philosophical, owing little or nothing to concepts of performance actually generated within performance studies by practitioners and performance theorists themselves. Though a number of philosophers have of late given more attention to performance art and theater in particular—Samuel Weber's *Theatricality as Medium*, Jacques Rancière's *The Emancipated Spectator*, or Alain Badiou's *Rhapsody for the Theatre*, for instance—this belies the ongoing "anti-theatrical prejudice" of even these more sympathetic positions inasmuch as they continue to *apply* philosophical concepts to theater and performance.[19] Performance is allowed to think only through (seemingly nonperformative) philosophy. As Laura Cull notes, "the extent to which performance might be considered a philosophical activity in its own right" remains closed for most philosophers.[20] Indeed, the idea of an autonomous "performance philosophy" (one that does not merely illustrate or apply extant philosophy) remains the holy grail—though she notes that *non-philosophy* might hold some potential for such a view:

> via the contemporary French thinker François Laruelle's notion of "non-standard philosophy" in particular, we find the seeds of hope that Perfor-

mance Philosophy might equally be embraced as an opportunity for the renewal of philosophy as much as of theatre and performance studies; or again, if this is not too grandiose, as an opportunity to reopen the very question of *what counts as philosophical thought*.[21]

Performance becomes a philosophy all its own, just as philosophy becomes something else. Indeed, the utopian hope for a (non-) philosophy that is regarded as an equal to art (qua thought) will be outlined in what follows through a film as well as that "pose" of the artist that Laruelle seemingly adopts in his work.

The Five Obstructions is neither a piece of theater nor performance art, of course, but in its fifth and final obstruction, the film produced is both performative and a performance, though not according to the norms of philosophy. The last obstacle set by von Trier renders Jørgen Leth *radically passive*: he will do virtually nothing for the final film. We also learn that von Trier has already made the fifth version of *The Perfect Human* but that, all the same, the film must still be credited as Leth's. Indeed, Leth must read this film's voice-over narration (in the form of a letter from Leth to von Trier) ostensibly from his own perspective, though it too in fact has been written by von Trier (Leth calls it a "fiction, really. A letter to him from me"). Moreover, the material that makes up this fifth film has already been shot, being composed of the documentary footage taken in their previous encounters (von Trier hopes, he says, that "we captured something human as we talked"). Doubtless, the form taken by this part of *The Five Obstructions* is ripe for a postmodernist, abyssal reading—an account of reflexivity that puts the identities of both Leth and von Trier (alongside *The Perfect Human*) into endless play, mirrors reflecting mirrors. As Murray Smith writes, "von Trier has imagined what and how Leth might imagine what von Trier had to say about Leth."[22] Yet, as Smith also remarks, there is a materiality to this final phase in the fact that "the record" (of their game) is now its "substance":

> Von Trier wrong foots Leth at the last by the most audacious interpreta-
> tion of the rules of their game of all, turning the *record* of the game (the
> documentary footage of Leth making the new films, and of Leth and von
> Trier in discussion at various stages of the project) into its *substance*. In

other words, various other strategies having failed, von Trier subjugates Leth by making Leth his (von Trier's) vehicle of expression, even as this final film is designed to appear to be the work of Leth.[23]

Leth appears as a "vehicle of expression," parroting von Trier's words (of him thinking about von Trier), and thereby producing what Smith describes as the "disorienting" affect of a "triple-embedding of levels."[24] Krista Geneviève Lynes goes further still, seeing this embedding at work not only within the fifth film but across the whole of *The Five Obstructions*. Indeed, she sees it as an extended act of ventriloquism beginning with the second obstruction set in the worst place in the world (Falkland Road) when Leth takes the role played by Claus Nissen in the original:

> In *Obstruction # 2* Leth repeats Nissen's words and actions. He is mimicking his own objects. Trier, on the other hand, is building new circuits of ventriloquism. In *Obstruction # 5*, Trier creates a dizzying relay: he offers to remake *The Perfect Human* and asks Leth to read a voiceover written by Trier. Trier is pulling all the strings. In the narrative, however, Leth's address (written by Trier) often cites Trier, a circling ventriloquism that has Trier speaking through the relay of Leth.[25]

Significantly, in the preparations before the final film is assembled, von Trier makes two admissions about his relationship with his mentor, Leth. The first concerns his own method, his "filmic upbringing" as he puts it, namely, that what Leth calls "the rules of the game" have always been central to von Trier's work. The second admission is the spur for making *The Five Obstructions* at all, inasmuch as von Trier argues that "Jørgen Leth" is one of the few areas in life on which he believes he is an expert. He knows "considerably more about him [Leth] than he does," and as such, "this entire project has been a 'Help Jørgen Leth' Project." The rest of this introduction to von Trier's image of Leth is provided in the letter written by von Trier to himself (though using Leth as his ventriloquist's dummy). It is performed in the film itself, part of which runs as follows:

> Dear Lars, thank you for your obstructions. They've shown me what I really am, an abject, human, human. I try to fool the world because I don't

want to be part of it. My trick is cheap and I repeat it endlessly. If I go on telling the viewer what I see, like a prisoner of war repeating his name and number, without adding anything... emotions are far too dangerous, the world and I will fall for it. I call it art.... Maybe you put words into other people's mouths to get out of saying them yourself.... You only saw what you wanted to see. The skepticism you felt about yourself must go for me, too. But you exposed yourself. You wanted to make me human, but that's what I am!... As we all know, it's the attacker who really exposes himself. The truth is, you got it wrong! I obstructed you, no matter how much you wanted the opposite. And you fell flat on your face. How does the perfect human fall? This is how the perfect human falls.

We will return to this commentary at various junctures in this chapter as the question of the imperfect, "abject" human arises, both in an objective "philosophical" vein and more personally and autobiographically. Questions of trickery, ventriloquism, the refusal of the world, reversal (who is really obstructing who?), and passive performance—"you wanted to make me human, but that's what I am"—need to be addressed anew, only now under the rubric of performance art (also known as "live art," "body art," or simply "performance"), the final tangent to non-philosophy that we will underline here.

THE SPECTRA OF PERFORMANCE: FROM NONART TO NOT-ACTING

What is it that permits us to see philosophy as a performance (or indeed performance as a philosophy)? Laruelle wants to broaden philosophy, but by mutation rather than mere extension. Yet he is not alone in trying to create a "new genre," as he so often puts it, nor in forming a more generic thought that can embrace art as well. Much of the last one hundred years of artistic innovation (that philosophy so far "lags" behind) has concerned the question of what counts as art, be it in music (Cage), theater (Artaud), or visual art (Duchamp). Such enquiries, however, are not pursued only in modernist terms in search of *theoretical* "essences" but through practices that discover new forms of art simply by inventing them. In this role, art takes on a philosophical hue by *performing* its research ("practice as research" or "artistic research," as it is sometimes called) and constructing

it out of the Real, rather than out of, or in conflict with, readymade theory or extant practice. As Allan Kaprow put it, as "art becomes less art" (i.e., less like official "Art"), "it takes on philosophy's early role as critique of life."[26] For Kaprow, the goal for practitioners was to invent "an art that was distinct from any known genre (or any combination of genres) . . . to develop something that was not another type of painting, literature, music, dance, theatre, opera."[27] In Kaprow's *Essays on the Blurring of Art and Life,* he describes this as the process of "un-arting," or the taking of "art out of art." Art is undefined in and through practice, or what he calls an "act or thought whose identity as art must forever remain unknown."[28] In his "Activities," for example, commonplace actions such as looking into a mirror or opening and closing a door were transformed into "art" through slight adjustments (viewing one's reflected breath and face, repeating the door opening over and over). This "nonart," Kaprow wrote, "exists only fleetingly. . . . Indeed, the moment any such example is offered publicly, it automatically becomes a type of art."[29] Calling it "Art" publicly is the product of a "conceptual decision" for him; but its capacity to become such "Art" was prefigured in the practices that created it out of the ordinary.[30] Indeed, there is a simultaneous two-way movement by which the ordinary is made into art and therewith "Art" is "unarted." Laura Cull writes of this as follows:

> Kaprow conceives of artistic conventions as a set of traits that allow us to recognize an event (as theatre, as dance) and trigger a conventional mode of relation to that event. In contrast, he sought to create unknown forms of event to which we must invent new ways of relating. . . . Representational implications are not denied then (how could they be with such a forcefully and, as such, problematically symbolic backdrop?), but it is important to note that Kaprow himself explicitly argues against any simple distinction between form and content in order to avoid producing works of art that will "remain only an illustration of a thought" rather than providing participants with what he calls an "experienced insight."[31]

The affinity between Kaprow's project of nonart and Laruelle's of non-philosophy is clearly evident, especially in terms of the former's cloning of the ordinary to render it into art, using it as a raw material that thereby

also destabilizes the decision of what counts as art. The difference is that, while creating the possibility that art practices (and so much else) can be forms of thought equal to that of philosophy, Laruelle concentrates his efforts on *using* philosophy as his own art-material, on unphilosophizing it. The second strategy lowers philosophy from its self-made pedestal just as the former elevates art, qua *thought,* from its merely illustrative or applied status. Both movements converge toward a "flat" thought. This parallel is even more striking when we consider that, for Kaprow, nonart must keep the "Art" establishment aware of the activity of unarting "to set in motion the uncertainties without which their [non-artists'] acts would have no meaning."[32] Similarly, the practice, or performance, of the non-philosopher is the constant reminder to philosophy that *not everything is philosophizable* and that there are other ways to think, or "philosophize," than that of philosophy.

Arriving at performance from the direction of theater rather than the visual arts, Richard Schechner offers us an alternative model of performance that has an especially crucial analogue for non-philosophy in its concept of "restored behavior." Since the 1970s, Schechner has promoted the "broad spectrum" theory of performance as that which involves a range of human activity: "performance must be construed as a 'broad spectrum' or 'continuum' of human actions ranging from ritual, play, sports, popular entertainments, the performing arts (theater, dance, music), and everyday life performances to the enactment of social, professional, gender, race, and class roles, and on to healing (from shamanism to surgery), the media, and the internet." From this perspective, "any action that is framed, presented, highlighted, or displayed is a performance."[33] Rather than basing this open definition on a semantic relativism, however, this is more of a "seeing as" activity that is itself based in practice. Central to the practice is this notion of restored behavior. In his 1985 text *Between Theater and Anthropology,* Schechner writes,

> Restored behavior is living behavior treated as a film director treats a strip of film. These strips of behavior can be rearranged or reconstructed; they are independent of the causal systems (social, psychological, technological) that brought them into existence. They have a life of their own. The original "truth" or "source" of the behavior may be lost, ignored, or

contradicted even while this truth or source is apparently being honored and observed. How the strip of behavior was made, found, or developed may be unknown or concealed; elaborated; distorted by myth and tradition. Originating as a process, used in the process of rehearsal to make a new process, a performance, the strips of behavior are not themselves process but things, items, "material." Restored behavior can be of long duration as in some dramas and rituals or of short duration as in some gestures, dances, and mantras. Restored behavior is used in all kinds of performances from shamanism and exorcism to trance, from poetic dance and theater, from initiation rites to social dramas, analysis to psychodrama and transactional analysis. In fact, restored behavior is the main characteristic of performance.[34]

Performance, the way Schechner sees it, reuses behaviors of all sorts as its "material," cuts or strips of behavior that, in being reused—or in what he also calls "twice-behaved behavior"—are simultaneously restored or "reactualised." As Peter Eckersall notes, however, this is not an act of conservation—restored behavior involves "mutation, transformation, agitation."[35] The cloning, so to speak, is not a mere copy but a mutilation, cutting up its material as might a film editor reusing found footage. In this regard, Rebecca Schneider remarks that "performance (re)gains complexity—grows haunted (and, surprisingly perhaps, filmic—as if he [Schechner] were *returning* us to a state of film after having returned us, previously, to theatre)."[36] There is also a dimension of ventriloquism in this concept, because it is not only behavior that is doubled or cloned but the performer too. As Schechner says,

> restored behavior is "me behaving as if I am someone else" or "as if I am 'beside myself,' or 'not myself,'" as when in trance. . . . The difference between performing myself—acting out a dream, reexperiencing a childhood trauma, showing you what I did yesterday—and more formal "presentations of self" . . . is a difference of degree, not kind.[37]

There are multiple *me*s in each person, so it is the performer who "channels" the behavior rather than he *who actively and decisively* performs it. This is a performed-without-performance. What Schechner calls a

"trance," Laruelle calls—as a description of non-philosophy—a passive performance and a "*waking dream*" (which we should contrast with Kant's dogmatic wakefulness).

However, such continuist thinking on the part of Kaprow and Schechner, its productive similarities with Laruelle's non-philosophy notwithstanding (unphilosophizing, cloning, performing-without-performance), brings with it the usual dangers that attend all-encompassing categorizations like this: for might not the very scope of "nonart" or "performance" render both concepts vacuous, making them mere synonyms for simple existence (and thereby trivial)? Stephen Bottoms is one performance theorist who has of late questioned whether seeing such a broad range of activities as performance gains us any explanatory power.[38] No less than the extension of Austin's concept of performativity by the likes of Derrida and Judith Butler left it both everywhere and so nowhere, might not a broadened concept of performance risk breaking it entirely? Is it not too weak to bear the weight of being such an *arché*-concept? Do we not need to create a minimal distinction, if only of tendency or direction, within these continua?

Michael Kirby's work may come to our aid here. As Eelka Lampe notes, Schechner's idea of the "restoration of behavior" is close to Kirby's own ideas of "acting" and "not-acting."[39] Indeed, Kirby forms an interesting triad with the other continuists, having documented Kaprow's earlier "Happenings," which were themselves an important influence on Schechner's "New Orleans Group" in the mid-1960s (as Kirby reminds us in his crucial 1972 essay "On Acting and Not-Acting"). The question of what is *not* acting and yet still a performance is vital for this essay's argument and may provide us with a new orientation within the performative spectrum. As Kirby notes, "the performers in Happenings generally tended to 'be' nobody or nothing other than themselves; nor did they represent, or pretend to be in a time or place different than that of the spectator."[40] They merely "behaved"—walking, running, speaking, singing, washing dishes, sweeping, and so on. Much as the "actors" in Leth's *The Perfect Human* do, they simply perform actions as themselves, as ordinary men and women, without impersonating anyone or anything else. This allows Kirby to propose the concept of a range of behavioral styles set along a continuum of actings:

In a performance, we usually know when a person is acting and when he is not. But there is a scale or continuum of behavior involved, and the differences between acting and not-acting may be quite small. In such cases categorization may not be easy. Perhaps some would say it is unimportant, but, in fact, it is precisely these borderline cases that can provide insights into acting theory and into the nature of the art.[41]

This continuum runs from not-acting (dubbed "nonmatrixed" performing) through "simple acting" and then all the way to full-blown "complex" acting (playing Hamlet, say, using the full range of actor's techniques). This is a quantitative scale, however, and does not involve any value judgment as to which is better and which is worse qua acting. It is only a matter of how *much* acting is being deployed, whereas, in value terms, sometimes what is appropriate is more acting and sometimes less (even when playing Hamlet).

Nonmatrixed acting comes in three types. The first is "nonmatrixed *performing*," such as is done by the stage attendants in Kabuki theater, who move props on- and off-stage, help with costume changes, or even serve tea to the actors—all on stage. Significantly (at least for Kirby), these performers "do *not do* anything to reinforce" their identification as nonactors. In other words, such an individual is not "imbedded, as it were, in matrices of pretended or represented character, situation, place and time, I refer to him as being 'non-matrixed.'"[42] The second type is a "nonmatrixed *representation*," as when "the performer does not act and yet his costume represents something or someone" (an example being when one encounters an off-duty Santa Claus having lunch in the shopping mall in early December).[43] Were we, instead, to have seen this actor on stage and in a suitably rustic setting (one aspect of a matrix), the fiction of having "Santa Claus" before us would be closer to hand, even though the actor had still *not* acted: "when the matrices are strong, persistent and reinforce each other, we see an actor, no matter how ordinary the behavior. This condition, the next step closer to 'true acting' on our continuum, we may refer to as 'received acting.'"[44] The behavior can be "seen as" acting, even though this Santa does nothing. This is the third of the non-matrixed performances.

The fourth stage on Kirby's continuum—"simple acting" (the last to

NOT-ACTING				ACTING
Non-Matrixed Performing	Non-Matrixed Representation	"Received" Acting	Simple Acting	Complex Acting

FIGURE 2. Michael Kirby's continuum of not-acting to acting.

come before full-blown acting)—is vital for us inasmuch as it also harks back to Schechner's restored behavior (see Figure 2). Here Kirby analyzes the work of the avant-garde group the Living Theatre:

> Acting also exists in emotional rather than strictly physical terms, however. Let us say, for example, that we are at a presentation by the Living Theatre of *Paradise Now*. It is that well-known section in which the performers, working individually, walk through the auditorium speaking directly to the spectators. "I'm not allowed to travel without a passport," they say. "I'm not allowed to smoke marijuana!" "I'm not allowed to take my clothes off!" They seem sincere, disturbed and angry.[45]

The question is, are they acting? Despite the fact that they are performers, they only "play" themselves and are not portraying characters. They are also in a theater, but even the theater building is being "itself," so to speak, rather than an "imaginary or represented place." And everything that the performers say is factual. This indefinite style of behavior—neither wholly nonmatrixed nor full-blown acting (fictioning), is named "simple acting" by Kirby. The acting here comes in the *use* of behavior, emotional behavior in particular, which is being "pushed" for the audience. It is this use and "projection" of behavior that distinguishes not-acting from acting, the first and minimal incursion of the matrix.[46] The similarity of simple acting with restored behavior (albeit now with the vector of acting/not-acting mapped onto the continuum of performance) goes further still. Describing the "mirror exercise" used in actor training (whereby two people face each other and one copies the movements of the other—an old Marx Brothers gag, by the way), Kirby argues that this "rudimentary acting" can actually be seen as either a purely mechanical reproduction of "abstract movements" *or* as acting:

Even "abstract" movements may be personified and made into a character of sorts through the performer's attitude. If he seems to indicate "I am this thing" rather than merely "I am doing these movements," we accept him as the "thing": He is acting. On the other hand, we do not accept the "mirror" as acting, even though he is a "representation" of the first person. He lacks the psychic energy that would turn the abstraction into a personification. If an attitude of "I'm imitating you" is projected, however—if purposeful distortion or "editorializing" appears rather than the neutral attitude of exact copying—the mirror becomes an actor even though the original movements were abstract.[47]

The "performer's attitude" (*attitudine*, "fitness, posture") involves a distortion, an "editorializing" of movement; or (in Schechner's terms) the restoring of behavior into cut strips; or (in Laruelle's terms) the cloning of behavior with mutation, a copying with "errors." As a form of performance art, we might now see non-philosophy as a type of simple acting and restored behavior (of philosophy) that also unphilosophizes its subject thereby.

Kirby even mentions the game of charades as one type of this simple acting, though it can become more complex or full-blown as the gestures become more detailed (merely "putting on a jacket" vs. putting on a jacket and acting out how the "resistance of the material, the degree of fit, the weight of the jacket," and so on, feels).[48] But there's the rub (once more). Despite his references to a "matrix" that cannot be determined by the actor, even Kirby defines the performer's acting in terms of *her volition*: "if . . . we define acting as something that is done by a performer rather than something that is done for or to him, we have not yet arrived at true acting on our scale."[49] Yet this begs the question and seems to reduce the orientation of the continuum ultimately to one pole only (complex acting being the actor's *active* performance, with all other forms being mere subtractions from this behavior). As Laura Cull notes,

> Kirby's continuum itself concerns the identification of degrees of acting, apparently based on the notion of performance as a non-continuous event of interpretation of an object by a subject. The difference between acting and not-acting is a matter of degree, and yet the process by which these

degrees are measured seems to separate the measurer and the measured as different in kind. At one point, Kirby does mention that "the exact point on the continuum" at which different observers might position a given performance "undoubtedly varies quite a bit from person to person," but the model itself is apparently still based on the principle of a transcendent subject.[50]

This would be a standard, heroic notion of full-blown acting, using the actor-subject's representational skills alongside those of the audience-subject (and their all-important power of imagination). Of course, there is no doubt that playing the role of Hamlet is normally a very different kind of performance from the "simple acting" used in a game of charades, but it is arguable nonetheless that what makes simple acting *different* is not the absence of the performer's *volition* to "act more" ("Desiring Production or the Will to Power," as Laruelle put it) but the performance "of" the matrix itself, as Real—a passive performance that is not mere lack. Elements of *Hamlet,* in other words, can appear on all points of the acting/not-acting continuum.

In *Anti-Badiou,* Laruelle writes of a "process of quasi-transfer" that sees the Real "as superposition," that is, as something that "should be a non-acting capable of 'acting' non-mechanically in the form of a simple under-potentialization or under-determination of transcendence." Whereas Badiou thinks in terms of lack and "the void," non-philosophy thinks in terms of the "*radically* passive (that is to say, non-contemplative) effect, generated or resumed by an occasional cause or a unilateral complementarity."[51] Passive performance or immanent pragmatics, therefore, if it can be thought of in terms of performance art (as we strive to here), is nonetheless *not* based around the voluntary human subject (that either acts, heroically, for Badiou, or lacks action, as an animal or victim, for Badiou). A nonhuman matrix creates a radical passivity in performance *vis-à-vis* the human and the Real, the former only "performing" the latter in its radical, immanent behavior, that is, in *not* representing the Real. *If* the matrix is a condition of representation (as it is for Kirby), it is not itself a representation and cannot be represented. And yet, Laruelle does not work in *conditions*: the matrix, the Real or in-One, performs through non-philosophy as it clones and unphilosophizes philosophy

(the charade or "absurd pretense" that is gestured in-One). This is not merely imagination at work, a fictioning (of philosophy) that is less real. The non-philosophical posture becomes a *fictionale* acting: less a "sincere lie" (to refer back to Laruelle's reference to the "artist, philosopher, or believer") than unconcealing the lie of authority; a welcome mockery of the absurd pretense of the (philosophical) *subject's* power. Power does not belong *to the subject's thought* but *is the philosophical position in thought*. In the final obstruction, Jørgen Leth is left passive, a victim of sorts, in the fifth remake of *The Perfect Human*. Yet his radical passivity belies a performance of simple acting and restored behavior (strips of found footage documenting the earlier remakes), only not one enacted by him but by the Real of the film itself. This is not a mere trick of editing (cutting strips of behavior) but the Real of a clone. What other nonhuman aspects there might be in this matrix of clones, both material and animal, remains to be seen.

THE SPECTER OF PERFORMANCE

The numerous arguments of philosophers against poetry are not without a sense of irony, given their most ardent manifestation in Plato (to whom all others are said to be footnotes), whose own work is so laden with theatrical and poetic devices. Despite what Martin Puchner calls the "theatrical turn" in philosophy—as "registered in the recurring use of such terms as 'performance,' 'performativity,' 'theatricality,' or 'dramatism' as well as in a fascination with theatrical topoi such as 'masks' and 'enactment' in the writings of Nietzsche, Benjamin, Deleuze and Butler"—the specific idea of an *immanent and actual* philosophical performance remains a thorn in the side of much philosophy.[52] As Laruelle writes, "Non-Philosophy is a practice and an immanent practice. This is what screens out a lot of philosophers, because philosophers always project something or desire it."[53] It is the *actual* performance *immanent in this* act of philosophy here and now (doing in saying and saying in doing)—as opposed to a theory *about* performativity or theatricality that occurs elsewhere or later—that poses a threat to the authority of philosophy. Non-philosophy is the "only theory," Laruelle claims, "that is 'all execution' . . . whereas philosophy left to its spontaneity is not execution without also being tradition and

memory."[54] It is not that theater, poetry, or any other "extraphilosophical" art *becomes* an "essence or a priori" *through* theory, as philosophy would have it, but that "the a priori cannot not manifest itself as such except on the condition of residing in the depths of experience and emerging theatrically."[55] Wherever the identity of theory and practice is cloven, we have "an absolutely sure sign of a return to the philosophical repressed."[56] Non-philosophy is therefore (according to *Philosophy and Non-Philosophy*)

> a practice that only exists in the immanence of its exercise. Whence the necessity of *inventing each time formulations* which are not satisfied with thematically describing what is in question—lest they again give rise, as this treatise risks doing at each moment, to the transcendent and fetishistic illusion of philosophy and of its discursivity—but which *de facto* reveal for the One-subject the new functions assigned to the material. The combination of the two styles, the ultra-descriptive style and the ultra-performative style, is here necessary so as to avoid the reconstitution of the philosophical disjunctions of the theoretical and the literary, of the scientific and the poetic, of the rational and the non-rational, of the philosophical and the extra-philosophical, etc.[57]

Philosophy is discursive, it discourses on X, with total authority (apportioning essences or a prioris *selectively*), even if it *says* that every philosophical statement (except *this* one) is performative or theatrical. What counts is its authority to say what art is and what it needs.[58] Hence, its fear of its own performativity, not in terms of speech act *philosophy* (which ultimately recuperates this "discursivity"), nor even theatricality (which can always be deferred or displaced), but in terms of its own *actual* form as art. The converse is also true for Laruelle, of course: art can think, and not only affectively (Deleuze) or therapeutically (Cavell) or poetically (Heidegger). Hence it is not the case (as more evenhanded philosophers might concede) that "without art, philosophy lacks sensitivity and without philosophy, art lacks thought."[59] There are forms of thought in art that are equal to philosophy, but not because they are the same (as philosophy's) but because *all thought is equally undefined or underdetermined*. And this is true of a multiplicity of non-philosophies in the making:

> *A field of new pragmatic possibilities, founded in the positivity of the De-*
> *termination in the last instance, is opened and frees a perhaps infinite*
> *multiplicity of new non-philosophical practices of philosophy.* These are not
> new philosophical varieties, new systems obtained by variation, grafts,
> intercessions, etc. on the invariants of decision.[60]

These are "new *usages* of philosophies, whether they exist yet or not."[61]
They are the arts of philosophy (non-philosophy as performances that *use*
philosophy) as well as "the arts" as forms of (non-philosophical) thought. If
anything, art-thoughts are less self-deluded than philosophy's inasmuch as
they do not hallucinate any capture of the Real: like non-philosophy, they
think alongside or according to the Real.[62] As Alexander Galloway says
of Laruelle's engagement with the work of American artist James Turrell,

> Laruelle assumes from the outset that Turrell and his art are performing
> theoretical work as such. Laruelle's is not a theoretical interpretation of
> a non-theoretical art work; the work itself is enacting the non-standard
> method. Turrell "has discovered a new aesthetic (and theoretical) object:
> light as such, the being-light of light." Thus in Laruelle's view, Turrell him-
> self discovered a non-phenomenological solution to the problem of light.[63]

Turrell's work makes its own discoveries, and, like non-philosophy, at-
tempts "not to think about perception, but to think *according to* per-
ception."[64]

Likewise, as we earlier heard from *The Concept of Non-Photography,*
Laruelle argues that he is *not* trying to "submit" photographic artists (or
their work) to philosophy so as finally "to 'explain' them but, on the basis
of *their* discovery taken up as a guiding thread . . . to mark its theoretical
effects in excess of all knowledge."[65] Fighting against the philosophical
aesthetics that overdetermines photography from without—"the *Principle
of Sufficient Photography* or photo-centrism," as he calls it—Laruelle ges-
tures toward a philosophy that is photography's own:[66]

> I call this gesture of creation non-aesthetics or non-standard aesthetics,
> its standard form being philosophical and photo-fiction being one of its
> non-standard objects. . . . This project seems absurd. It will no longer be

absurd if we accept changing our level of reference for defining the real. Instead of treating the photo and the concept of the photo as two given and describable physical, intellectual objects or representations, we treat them as completely different than given objects closed in on themselves.[67]

Photo-fiction is a philo-fiction of its own making, immanent to the Real and nothing else. In other terms, Laruelle's project involves the "'generic' extension of art to aesthetics; the moment when thought in its turn becomes a form of art." As we noted in chapter 2, this is "an art of thought rather than a thought about art"; it is not a "conceptual art, but a concept modeled by the art, a generic extension of art" that relays an attitude—an *aisthesis* rather than a *thesis*.[68] As such, it is not a new first position of philosophy nor a new system for the arts, as Laruelle's short essay on choreography explains:

> A system of fine arts arises from the comparison of arts to each other, if not from the comparison of finished works. It is a system of aesthetic *representations*, universals or abstract generalities in a state of survey [*survol*] in relation to experience. They give place to aesthetic categories that generalize experiences without relying on the essence of art as such, but by contenting themselves with postulating it, with postulating those experiences as "aesthetic." In opposition, we set out from a science of essences, but essences on the one hand determined in terms of the real or the aesthetic lived of the work and, on the other, overdetermined or co-determined by a particular material. There is no general essence of art, no universal first object of a philosophical aesthetics, but a science of *essences* each time *determined in the last instance* by real lived experiences, and codetermined by means and supports drawn from the World.... There is no universal or philosophical knowledge, no first knowledge of art, but a science that on one side is given as objects of supposedly "aesthetic" works through determined theories; and on the other, a real cause or a given-of-the-lived that prohibits this science from claiming to be "first" in the ontological sense of the word.[69]

Non-philosophy operates out of "the real or the aesthetic lived of the work" or "*essences* each time *determined in the last instance* by real lived

experiences"—that is, out of the work itself. The work generates its own philosophy.

It is doubtless arguable that a parallel has always existed between the artistic avant-garde (the anti-art of Duchamp, for instance) and the philosophical avant-garde (anti-philosophies and certain nihilisms). Art critic Boris Groys, for one, makes just such a comparison in his study *Introduction to Antiphilosophy*, arguing that the anti-philosophies of Marx, Kierkegaard, and Kojève can be connected to anti-art through the notion of the "readymade":

> I would like to draw some parallels between "anti-art" and what I call, by analogy, "antiphilosophy." The authors I treat in this book can be understood as ready-made philosophers, by analogy with the ready-made artists.... Antiphilosophy—in other words, [is] a ready-made philosophy that ascribes universal philosophical value to certain already existing ordinary practices, in the same way in which practices of the artistic readymade ascribe artistic value to ordinary objects.[70]

This parallel between art and philosophy is facilitated by the notion of a readymade *concept*: just as anything—even a urinal—can become the object of art given certain conditions of intention (by the artist and/or audience) and reception (by the art institution), so anything can become a worthy object for philosophy:

> A traditional philosopher is like a traditional artist: an artisan producing texts. An antiphilosopher is like a contemporary art curator: he contextualizes objects and texts instead of producing them. Production of philosophy can be interpreted as an extraordinary, mysterious, "poetic" process that is accessible only to a chosen few. Antiphilosophy does not abolish philosophical *metanoia*, but rather democratizes it.[71]

The ordinary becomes special, or rather, there is now nothing exceptional *about philosophy and its objects*. Kierkegaard's Christ, for example, is an ordinary man, and indeed *must be* an ordinary man (to be special in a new way). As such, He becomes a type of "proto-readymade." Likewise, Kojève treats Hegel's *Phenomenology of Spirit* as a readymade such that

Kojève's own role consists merely in "exhibiting this readymade in a new place—namely the Paris of his time."[72] The connection between non-philosophy and this leveling of art objects and disciplinary concepts is clear: in the readymade object and concept, both art and philosophy renounce their putative exceptionalism. In some of his work, Laruelle might even be regarded as a "curator"—recontextualizing philosophical texts as art objects. Where the difference remains with Laruelle's non-philosophy, however, is precisely in this role of the "anti-." In any simple *rejection* of philosophy, the power of the "anti-" remains in virtue of its act of mere reversal: it thereby perpetuates the authoritative position, albeit displaced (hence the continued valorization of Christ and Spirit as *exceptional* objects by Kierkegaard and Kojève, respectively). By expanding philosophy through non-philosophical mutation, however, *all* aspects of philosophy—*its objects, practices, and practitioners* alike (as actually performed)—are leveled or flattened. Thought is not merely displaced into a new *exemplary* domain (the anti-, the "nihil") with its objects nonetheless remaining intact but distributed according to a democratic code without any exemplariness or exceptionality.

The "without" *(sans)* structure endemic to non-philosophy ("lived-without-life," "subjects-without-predicates," "given-without-givenness," etc.) can also be detected in art practices in the twentieth century, of course. Kaprow's unarting is one instance—though it has its own roots in Dada and Situationism. The stripping away of any standard figurative determinations of the human, as found in "body art," is another example of such minimalism, one resulting in the body no longer being seen as the sign of the human subject "but also the material object of art."[73] Yves Klein's "New Anthropometric Period" of work in the 1960s gave us the stereotype of this kind of performance art, with naked bodies rolling around in blue paint. Such performers may be "simple" actors in Kirby's terms, inasmuch as they "are not acting, or playing a character in any way removed from themselves," especially if they "push" their emotions.[74] More generally, as Janelle Reinelt reminds us, the term *performance* is related to a "general history of the avant-garde or of anti-theater, taking its meanings from a rejection of aspects of traditional theater practice that emphasized plot, character, and referentiality."[75] Be it the "performance art" of Kaprow and Klein (as well as Joseph Beuys, Yoko Ono, Marina Abramović, and Chris

Burden), the subsequent "body art" of Klein (again), Carolee Schnee-mann, Vito Acconci, and Orlan, or the later "live art" scene with figures such as Franko B. and Ron Athey, it is *subtraction* and *elimination* that are among their most commonly shared strategies (though *what* is being removed may differ among them). Even the "post-dramatic theatre" of the Living Theatre, Forced Entertainment, and Goat Island tends to involve a sparseness that allows a focus on participation, duration, and movement; or, as in the case of Societas Raffaello Sanzio, the "bare presentation of performers" bodies marked by abjection and alterity."[76]

In her 1965 *No Manifesto* for dance, Yvonne Rainer goes even further in this puritanical ("without") trajectory:

No to spectacle.
No to virtuosity.
No to transformations and magic and make-believe.
No to the glamour and transcendency of the star image.
No to the heroic.
No to the anti-heroic.
No to trash imagery.
No to involvement of performer or spectator.
No to style.
No to camp.
No to seduction of spectator by the wiles of the performer.
No to eccentricity.
No to moving or being moved.[77]

As a result of this parsimony, Rainer's works focused on bodily move-ment alone, leaving emotion and drama aside. The Vow of Chastity in von Trier's and Thomas Vinterberg's Dogme 95 proclamation matches Rainer's subtractive process for cinema ("shooting must be done on location"; "the camera must be handheld"; "optical work and filters are forbidden"; "the director must not be credited," and so on), though it is phrased less negatively overall. The nihilism and eliminativism evident in all of these strategies have aspects in common that might help model non-philosophy, especially those (like Rainer's) emphasizing the absence of "spectacle," "virtuosity," and the "heroic." Nonetheless, it is not the sheer

removal of elements (be it the figurative, the dramatic, or the stylistic) so much as their mutation that counts for Laruelle. Such mutations still involve philosophy in all of its material specificity, and so *without its authority, without its positionality.* Philosophy's drama or theatricality must be nonstandardized (cloned) rather than denied.

Gustav Metzger's "Auto-Destructive Art" might offer us an even closer approximation (despite its title's connotations of annihilation). Here Metzger's artwork involves the mutation of the norms of standard art *as well as its own* destruction, a consistency that involves itself within the processes of self-transformation. As his 1959 *Manifesto for Auto-Destructive Art* declares,

> Auto-destructive art is primarily a form of public art for industrial societies.
>
> Self-destructive painting, sculpture and construction is a total unity of idea, site, form, colour, method, and timing of the disintegrative process.
>
> Auto-destructive art can be created with natural forces, traditional art techniques and technological techniques.
>
> The amplified sound of the auto-destructive process can be an element of the total conception.
>
> The artist may collaborate with scientists, engineers.
>
> Self-destructive art can be machine produced and factory assembled.
>
> Auto-destructive paintings, sculptures and constructions have a life time varying from a few moments to twenty years. When the disintegrative process is complete the work is to be removed from the site and scrapped.[78]

The materiality of art ("site, form, colour") is *conserved* to be destroyed. This is comparable, then, to what we heard Laruelle say at the Société française de philosophie: that his method involves *destroying* the "strictly philosophical part" of any mediation of the Real (or, elsewhere, how for him the "transcendental" must be "radicalised, i.e. destroyed").[79]

Indeed, in other forms of self-destructive art, this conservation acts even more perspicuously as a kind of "erasure." This is especially true of Robert Rauschenberg's idea of destroying (other) artists' work. Producing his artworks through "non-marking," Rauschenberg first erased some of his own drawings, leaving nothing behind except white paper. His *Erased de*

Kooning of 1953 advanced things even more, taking a piece by the abstract expressionist Willem de Kooning and slowly erasing its oil, pencil, and charcoal substance until only the paper with a few barely visible marks remained. Without a doubt, in this light, we can regard Lars von Trier's project to ruin Jørgen Leth's *The Perfect Human* through multiple remakes as following Rauschenberg's model: as Leth himself at one point remonstrates, a remake is "totally destructive." As a model of non-philosophy, however, what counts is not the remains as such (Rauschenberg's spartan work) but (again) the performance of its erasure, its mutation.[80]

HOPEFUL MONSTERS: EVALUATING PERFORMANCE

In *A Treatise of Human Nature,* David Hume bemoans his fate of exile from the philosophical mainstream:

> I am first affrighted and confounded with that forlorn solitude, in which I am placed in my philosophy, and fancy myself some strange uncouth monster, who not being able to mingle and unite in society, has been expelled all human commerce, and left utterly abandoned and disconsolate. . . . I have exposed myself to the enmity of all metaphysicians, logicians, mathematicians, and even theologians; and can I wonder at the insults I must suffer? I have declared my disapprobation of their systems; and can I be surprised, if they should express a hatred of mine and of my person.[81]

In the last chapter we described non-philosophy as partially alien, as a kind of monster. But is this perpetual "outsider" status of non-philosophy a *mere* posture (like some outsider art/*art brut*) that replicates the structures of philosophy in absentia? Is it a kind of *philosophie brute* that still gazes longingly into the Academy from without? And is its own distance (from philosophical distancing) itself a warning to others about such hubris—a true "monster" (from *monere,* "to warn")? As Hume wonders in his own case, perhaps the rejection of philosophy has transformed Laruelle into "some strange uncouth monster"—an outsider despite itself or even for the sake of it. If posture (chapter 3), animality (chapter 4), and now the performance of the body offer real alternatives to standard philosophy,

while also explaining its decisionistic structure *without* replicating it, then notions such as "bodying forth" (as we heard Coetzee describe Ted Hughes's jaguar poems perform) will have to be more than simply exotic forms of representation. Is the disavowal of philosophical decision (for Laruelle) or "rationalism" (for Coetzee), *even as performed* (saying equals doing), nonetheless thwarted by the representation of that performance, by its very thematization (as we are doing here too, we should add)? Perhaps it would be better if we kept silent and simply "acted" instead (by just "introducing" Laruelle). In other words, trying to overcome "X" may well only reinstall "X" at another level (deferred or displaced). Thematizing the postural embodiment of ideas as performance may reinstate standard, disembodied, and positional philosophy inasmuch as conscious representation is being privileged once more.

Or, might the representation of embodiment be *another type of embodiment*, another level of corporeality awaiting *demonstration* (a monstrous "showing" *and* "warning") in *this* place? Were this the case, the actual performance of a thesis, the enactment of a thought, would indeed be a deferral and displacement, but one that remains, *in-the-last-instance*, an immanent representation, an (animal) embodiment performed for another "here and now" (superposed with this one). Hence the corporeality at issue might still be behavioral, animal, and performative, only at other levels. Just as immanence can be seen as transcendent (by philosophy), transcendent representation can be seen as immanent. And position can be seen as posture, at another level. Indeed, this is just what non-philosophy does. The mutation or movement of ideas at such other "levels" (or "speeds," "tensions," "adequacies," "perspectives"—the vocabulary is itself mutating) would involve both the social practices of molar creatures and what we called "microbehaviors" (which are "performed in the brain," according to Bergson). This would not simply be representation as immaterial self-awareness but representation *as a bodily performance and practice* with both "external" ("psychocultural") and internal ("biophysical") components that are individuated spatially and temporally. There are different ways of saying and not-saying (doing), for not all so-called performative utterances (contradictory or not) are alike.

This approach would also help us to evaluate such performances without recourse to an elitism of "art" to provide norms of judgment (given

that we have nowhere attempted a definition of good art). Significantly, the question of evaluation is raised inadvertently by Ray Brassier in his following rumination on non-philosophy's immanent pragmatics:

> Philosophers, Laruelle insists, do not know what they are doing. They are never doing what they say or saying what they are doing—even and especially when they purport to be able to legitimate their philosophical decisions in terms of some ethical, political or juridical end. The theoreticist idealism inherent in decision is never so subtle and pernicious as when it invokes the putative materiality of some extra-philosophical instance in order to demonstrate its "pragmatic worth." To condemn Laruelle for excessive abstraction on the grounds that the worth of a philosophy can only be gauged in terms of its concrete, extra-philosophical (e.g. ethical, political or juridical) effects is to ignore the way in which extra-philosophical concretion invariably involves an idealized abstraction that has already been circumscribed by decision. It may be that Laruelle's crisp, sharply delineated mode of abstraction turns out to be far more concrete than those nebulous abstractions which philosophers try to pass off as instances of concretion. In other words, the criteria for evaluating the worth of non-philosophy's function for philosophy are not available to philosophers, who know not what they do. In non-philosophy, radical axiomatic abstraction gives rise, not to a system or doctrine inviting assent or dissent, but to an immanent methodology whose function for philosophy no one is in a position to evaluate as yet. Ultimately, then, non-philosophy can only be gauged in terms of what it can do. And no one yet knows what non-philosophy can or cannot do.[82]

Non-philosophy is an unknown quantity with an "an immanent methodology whose function for philosophy no one is in a position to evaluate as yet" (the irony of this use of "position" should not be lost). Laruelle himself expresses an allied point—there is no basis on which non-philosophy can be commended that is itself *philosophically necessary*:

> There is then no imperative fixing a transcendent, ontotheo-logical necessity to "do non-philosophy": this is a "posture" or a "force-(of)-thought" which has only the criterion of immanence as its real cause—which takes

itself performatively as force-(of)-thought—and the occasion of its *data*; which contents itself to posit axioms or hypotheses in the transcendental mode and to deduce or induce starting from them.[83]

Non-philosophy is a posture—a set of performed axioms. However, whereas Brassier is correct to see a radically immanent thought as its own obstruction to evaluation (or being "gauged"), the concepts of posture and performance may well lead us out of this labyrinth.

What is the "concrete" worth, and what is the mere "abstraction" referred to in the quotation from Brassier? If the concrete has inherent value (ethical, political, or juridical), how is it determined? In other words, how do abstract norms *follow* from (concrete) facts (without contravening Hume's "is–ought" fallacy)? These are standard dilemmas for philosophy, philosophically posed in terms of epistemic, representational norms (they "know not what they do," "no one yet knows," etc.). But what if "following" were understood behaviorally as *orientation*, which we saw even Kant deem to be an affect, a value? It could then *itself act as a norm* to be embraced or resisted *behaviorally*, that is, followed or not followed (according to other norms, themselves determined "in-the-last-instance" at another "level" of "concretion"). Movement through space can itself be a quality and not only a quantity. It can be (seen as) a performance, a demonstration, an axiomatic *and* axiological posture. *Kant's* orientation was the "self-preservation of reason," his own concrete standard set as abstract norm, a centrifugal "auto" and authority. What would be a genuine alternative to this movement (and not merely a reversal)? "Openness" in the abstract? But what or where is *that*?

As another option, we could forgo all positions, open or closed, and discover an evaluation, or "following," qua immanent performance. This would entail that *this evaluation itself* is rendered into a following, a performance, a behavior. And some followings follow more and are followed by more. Naturally, this "more" is quantitative, but it is also *affective*—being more democratic, more inclusive, and with that less abusive. On this understanding, therefore, a minimal condition for one performance to be preferred over another would be on account of its ever-increasing, broadening movement that incorporates and acknowledges the *non-* of others in widening circles ("levels"), in ever more attentive ethologies.

What such "centripetal" performances denote specifically (through the "body," through a kind of gesture, through ethology) must remain undefined, however, simply because their a prioris are local—they are both discovered and invented in the very practice of non-philosophy as immanent to the Real:

> It will be asked: is that real? We reply: *this* is precisely the real itself. *This* description is an immanent or transcendental auto-description and signifies that vision-in-One is an absolute thought.[84]

Of course, the indexicality of the demonstrative—the *when and where* of this "*this* description"—is crucial: was it spoken in a lecture, written (and rewritten) in a book, or read (and reread) later? Which was the performance? This is why Rocco Gangle describes the interpretations that non-philosophy makes of philosophy as a "*generalised indexicality*" and their clones as a "*radical that-ness.*"[85] In this respect, it is a continuation of Derrida's project, introduced in "Signature, Event, Context" and realized in works like *Glas* and *Dissemination,* to "open onto the concrete question of the *this, here-now* . . . they stage it or overflow this stage in the direction of that element of the scene which exceeds representation."[86] In the end, however, for non-philosophy, the seemingly fixed categories of discourse *or* performance, theory *or* practice, are unwieldy unless they too mutate. Hence Laruelle's critique of deconstruction as a petrified method and philosophical position held together "as a forced yoke, through the genius, that is, the violence of a single man."[87] Beyond everything, it is ultimately the Real that acts—this is Laruelle's ultrarealism that we only approximate *through* broad spectra (of performance, or art) in the *enactment* of their broadening in specific situations. Here is *The Five Obstructions* again:

> Why is he moving like *that*?
> Because women like it when he moves like *that.*
> *This* is how he moves.
> How does the perfect human fall?
> *This* is how the perfect human falls.

So, in parallel, when Laruelle says that *his* thought is determined by the Real, it must be that *this* thought, as now performed, is determined, now,

by the Real. *This* is the performed immanence over representation. A representational view of *this* thought (one pointing away—so that he is supposedly referring to *another* thought), would be, by contrast, a lie or the *non*-doing of saying. The nonrepresentational account would be the broadened view of performance that, being radically consistent, must incorporate every (non-) philosophical act. Which is what we do here.

Such broadening is not without its own dangers, though. In our earlier discussion of broad spectra, we encountered the problem of vacuity, the reduced usefulness for any term once its scope has been extended too far. Hence we should also ask ourselves here how far we can extend Laruelle's ideas before they become *logically* identical (and synonymous) with the Real in toto and therewith explain both everything and nothing. Perhaps non-philosophy's potential for all-encompassing scope borders on vacuity too? An explosion into triviality threatens us, only this time not as *real* triviality (of immanence) but the *representational* triviality of explanation (which, though immanent in-the-last-instance—nothing is left outside—must still pose as useful in any one time and place). In *En tant qu'un* Laruelle writes of a non-philosophy where the "field of *possibles* of thought is considerably enlarged," and in *Théorie des Identités* we hear that "it would be a question of being given the means of a conceptual and theoretical mutation likely to give a new *élan* to philosophy."[88] Yet is there *no* enlargement that can be deemed impossible, no mutation that is so monstrous that it becomes non-Laruellean, or a heresy *within* non-philosophy?[89]

Katerina Kolozova, for one, is happy to entertain "Monstrously Hybrid Concepts" and argues that radicalizing Laruelle's ideas leads to something like Julia Kristeva's notion of the "abject," which Kolozova glosses as "bordering a 'thérion,' a monstrosity" (or "wild beast").[90] This radicalism means, then, that who the self is, what human and Man-in-person means, must also mutate, become monstrous, and indeed a "thérion" or wild beast (for some, an abject human–animal hybrid). In chapter 4 we heard Laruelle speculate on whether we could "universalise non-philosophy even more." His own response was that "I don't believe that it would be possible. It has to pass through this mediation, this distorted mediation that is humankind."[91] Nevertheless, it might be that such a universal could be achieved should the "distorted mediation" (of) humankind distort or mutate even further. An actual demonstration is needed that would make

this possible (retroactively), however. And that is the wager or hypothesis of our reading of non-philosophy. Its vision-in-One offers a new structure of regard that attempts to recondition our "optical" and conceptual field toward the most faceless, strange, and alien others. It proposes "hopeful monsters"—philo-fictional inventions that also reinvent philosophy: they expand the human into the nonhuman, and vice versa. Part of this fictioning process, however, involves looking at things idiosyncratically, or seeing non-philosophy "in-person."

THINKING PERSONALLY: *NON-PHILOSOPHIA AD HOMINOS*

The description of Derridean deconstruction as an artifact of "the genius, that is, the violence of a single man" appears to come close to a personal attack, an openly *ad hominem* assertion from Laruelle. Obviously, were we to invoke again Arthur Danto's idea that (aesthetic) "style is the man," we might justify this personalized approach. As he says, "the language of immanence is made licit by the identity of the man himself and his style," for we are ourselves "systems of representations, ways of seeing the world, representations incarnate."[92] Or more "philosophically" perhaps, we could turn to J. G. Fichte's *The Science of Knowledge*, in which he personalizes philosophical decision: "what sort of philosophy one chooses depends . . . on what sort of man one is; for a philosophical system is not a dead piece of furniture that we can reject or accept as we wish; it is rather a thing animated by the soul of the person who holds it."[93] And yet the *hominem* here remains too determinate to fit non-philosophy. It is not Derrida's person or soul that is being addressed but—as always—the *philosophy-in-person* of "Derrida," or "Badiou," or "Deleuze." It is the philosophical *position* that counts, for, as we heard in the introduction, Laruelle means to "blame the 'philosopher' for nothing." It is his or her "philosopher-sufficient essence" that is the target.[94] Consequently, rather than being *ad hominem*, non-philosophy is precisely

> *ad hominos*—it is an act of defense, not of intolerance; the defense of a certain human universality against an individual spokesperson of a tradition that is believed to place it in danger. This combining of the address and that to which it is addressed is the first aspect of an ultimatum of defense.[95]

Non-philosophy defends the (undefined) human-in-person against phi-losophy. Moreover, when it happens that Laruelle actually addresses the *person* of the philosopher, it is most often quite *auto*-biographical:

> People may ask me, but how then did you in fact arrive at non-philosophy? Then I must say that I have made my "auto" nonphilosophy. It is contin-gent, arbitrary, it depends on lots of things which are mine.[96]

In a recent interview, this place of contingency becomes even more central:

> my non-standard philosophy has its own contingency, in a certain sense. The contingency of any production of non-standard thought comes from the philosophical model one chooses—in my case, from the utilisation of the quantum mechanical reference. In a sense, nothing especially authorises it, but nothing prohibits me from doing it either! . . . So I can speak of contingency, contingency in the rather banal sense that it is my decision. . . . And there you have it, now I am ready to know that it will all disappear.[97]

Yet these empirical facts are not wholly incidental either. As Rocco Gan-gle confirms, for non-philosophy, "any critique must be understood (at least potentially) as a *self*-critique, an auto-inhibition."[98] It is also auto-destructive, a self-harm ("*it will all disappear*" could prove to be a self-fulfilling prophecy). Here we have another indexical, the *author* as deictic subject: the identity of the subject that performs non-philosophy is not constituted though *the subject's* performativity (à la Judith Butler) but by the wholly contingent performance (of the Real).

Leaving aside the matter of contingency—and disappearance (self-destruction)—for a moment, such a Real identity between the self and the Real might amount to a passive *egoism* were it not also a performative realism. Other commentators, like Alexander Galloway, describe Laruelle's stance as *positively* autistic, and yet, despite such appearances of egoism or autism, non-philosophy claims to be neither idealist nor solipsist.[99] It is certainly not Cartesian: for Laruelle, Descartes's supposedly "radical" beginning within the cogitative ego was an "all-too weak radicality, which understands radicality as primacy *and* priority of a principle, a principle as hierarchy, domination, power over . . . , and its realization as thinking

substance."[100] If there is an "ego" in non-philosophy, it is not an authorita-
tive one, and to think that it may be so is to confuse radicality, as starting
at the root of the self in consistent doing and saying, with radicality as
power or philosophical privilege. The radical must also be self-oriented.
All the same, some might still like to think that all of Laruelle's idiosyn-
crasies and neologisms are merely his own autism being acted out within
a public monologue. The very writing of Laruelle's *Anti-Badiou*, after all,
is described by him as "above all, finally—and one must take it as such—a
book in which non-philosophy explains itself to itself, but with the aid of
a counter-model that it falls to us to transform."[101]

So what are we to make of this "auto"? First, it should be distinguished
from the "autos" of philosophy, *auto*-position and *auto*-sufficiency. Philo-
sophical decision is all about the "*Auto,* that is to say the idea of an ab-
solute autonomy of *Philosophy* under the form of a circle, of a return to
itself," whereas non-philosophy concerns the "*non-auto* (-positioning and
giving)" and "will lose this 'superior' identity first."[102] But there is also a
personal dimension to the "auto":

> Each philosopher claims to possess the universal language of thought
> and of the Real but only carves out a sphere of private usage over a vaster
> domain that escapes him and that he believes himself to exhaust here
> where he renders it adequate to *his* real. The non-philosopher proceeds
> otherwise and draws from all possible languages, philosophical or not,
> and, in this case, finally philosophizable. He is forced to return here and to
> find materials here. First, to form a language-without-speech, a language-
> without-discourse, words-without-language, which is to say the primitive
> language, or language given-without-givenness of the transcendental
> axiomatic, a language *according to* the Real and in-One.[103]

In this description we have a list of "withouts" again, only now linked to
the person. This alternative procedure of non-philosophy, as we know,
goes from the human to philosophy ("philosophy is made for man, not
man for philosophy"), and so "according to the Real."[104] Non-philosophy
is *for* the human: "*if non-philosophy must be made 'by' and thus 'for' all
men, and not solely 'by' the philosopher for other men, then the 'human'
reception of non-philosophy is the* a priori *that governs its production*

rather than the other way around."[105] But note how the human is left in scare quotes here, undefined. As *Anti-Badiou* already stated for us, "Man-in-person... prohibits me from recognizing him in himself or from identifying him through given predicates."[106] Galloway echoes this point nicely—we do not "'increase the resolution' of the subject by adding more definitional predicates—I am militant, I am freedom fighter, I am subject to truth," and so on, but rather we "de-individuate the subject... toward a condition of generic being."[107]

Which brings us back to contingency: what makes *Laruelle's* non-philosophy arbitrary is the fact that "it"—its content, its style—is *not* authorized or necessary at all. Because Laruelle "starts from the Real," that is, in a posture that sees all thoughts as equal before the Real (equally foreclosed, but not thereby *mis*-representational), then, of course, non-philosophy could have been otherwise.[108] Indeed, it has been constantly otherwise (hence its versions, one to five) and will continue to mutate in his and others' hands.

REFLECTION AS MUTATION: UNCONDITIONAL REFLEXES (A FINAL TANGENT)

In a recent discussion of the relevance of animal studies for performance theory, Laura Cull has exposed various forms of speciesism at work in the domain of performance studies. Referring to Richard Schechner's collaborator, Victor Turner, she describes his concept of *homo performans* as the notion that performance itself offers us a new definition of the human. Turner himself writes of it as follows:

> If man is a sapient animal, a tool making animal, a self-making animal, a symbolizing animal, he is, no less, a performing animal, *Homo performans,* not in the sense, perhaps, that a circus animal may be a performing animal, but in the sense that man is a self-performing animal—his performances are, in a way, reflexive, in performing he reveals himself to himself. This can be in two ways: the actor may come to know himself better through acting or enactment; or one set of human beings may come to know themselves better through observing and/or participating in performances generated and presented by another set of human beings.[109]

Once again, it is *reflexivity*—that which "reveals himself to himself"—that forms the basis to the exception (be it performance or anything else). We will leave aside the fact that there is much evidence that animals do perform as well, and not merely as "circus" entertainments but in truly creative yet nonreflective ways.[110] Moreover, we might ask, what would follow were reflection *not* understood as self-representation (either directly or vicariously) but *behaviorally*, as a form of unconditioned *reflex*? For Laruelle, remember, reflection is not the holy of holies; indeed, it is philosophy that curses the human with reflection: "Philosophy has never been 'human' in the rigorous sense of the absolutely subjective or of the unreflected affect."[111] Non-philosophy is this "unreflected" human, and as such it is also a bodily, affective reflex, although one that is both *unconditional* (outside of Kantian representational conditions) and *unconditioned* (indefinitely mutable rather than Pavlovian). And it is in *this* sense that non-philosophy is genuinely (non-) human. So here we come to the next question: how does this notion of reflex sit with the performances in von Trier and Leth's fifth remake of *The Perfect Human*?

For a start, we know that the author is deauthorized: "the director must not be credited" is a Dogme 95 vow that Leth must practice in the final film. As Mette Hjort writes, this disavowal is crucial to the last experiment: "it is precisely some form of imperfection that von Trier seeks as a kind of 'gift' or 'sacrifice' from Leth.... What the game requires is a willingness to be exposed, to be vulnerable, to fail."[112] And yet, as von Trier himself admits in his script for the final film, "it's the attacker who really exposes himself," and then later: "nothing was revealed, and nothing helped." Hector Rodriguez remarks on this nonrecognition and nonrevelation at the heart of both *The Five Obstructions* as a whole as well as in this fifth remake in particular:

> This difficulty is not a matter of some contingent cognitive limitation on the part of either filmmaker; it is in the nature of an interpersonal situation that these determinations should remain essentially elusive. There are no precise or definite facts of the matter. The point of this indefiniteness is not, as another cliché would have it, to encourage viewers to "think for themselves." Rather, the point is to express an image of thought, a paradigm of what it means to think. More specifically, the film tackles

the possibility of thinking thoughts that defy clear-cut categorisation. Thinking is not (at least not only) the application of a predefined image or schema that enables recognition and identification. Rather, thought is an opening to the new. Ambiguity is thus not an end in itself; it is an aspect of a mode of thinking as radical openness, without a predefined image.[113]

The Five Obstructions, Rodriguez continues, "is about the origin of thinking as an open adventure, beyond mere recognition, out of a conflict-ridden encounter with a loved one."[114] The film is not about self-knowledge *or* awareness; it is not a performance that reflects and reveals (the notions with which Victor Turner defines the human) but a performance of "indefiniteness." The fifth remake uses strips of film, or "restored behaviors," to allow Leth and von Trier each to play himself (simple acting) in a nonreflective manner. A new film, the last remake, clone, or mutation of the *The Perfect Human* is the result.

But this last film is no longer Lars von Trier telling Jørgen Leth what to do either, but a review of what Leth has done as *already* actions that are beyond success or failure. We no longer have the theoretical command of the Real but the Real (of) theoretical command. Any radical (i.e., self-rooted) movement must always finally meet its own performative self and, with that, mutate. This final chapter of our study, which takes elements from the previous chapters and reproduces them, stripped down, is another instance of this. It amplifies the mutation further, not in an attempt to capture (through reflection) the Real of Laruelle but to think according to the Real through a quasi-cinematic practice. If we pose as another philosopher, it is a performance, a ventriloquist act, an imposture, but one no more dishonest than that von Tier strikes as Leth, when he makes him describe (back to von Trier) how he "put words into other people's mouths to get out of saying them yourself." As a mere introduction, it is always a "twice-behaved behavior."

This is no "big reveal," however. Nor is it the tragic self-awareness of another failed introduction to non-philosophy. There is neither *Anagnorisis* (recognition) nor *Peripeteia* (reversal) in the Greek tragic style here but only the perpetuation of an act—another remake or review that confects what is happening as an action, as part of the Real rather than a representation or "introduction" to the Real, both *ad hominem* and *ad hominos.*

No final flourish or *crescendo,* then, but at least a level of self-consistency *(diminuendo).* After all, Laruelle had always said that non-philosophy is not "a 'model' or 'system' closed in on itself," it is "a practice of—and in—thought." And it is thereby open to all the mutations and corruptions that come with such practice. As *Anti-Badiou* declares, "this structure of NP [non-philosophy] necessitates its being practiced in such a way that one invents NP itself with the aid of its object, since it is from this object (an interfering object) that is extracted the lived-without-subject."[115] And *this* is (one version) of what happens when non-philosophy takes *itself* as its object (in a consistent introduction). Non-philosophy needs to be reinvented, to mutate anew with each practitioner. As a consequence, one cannot say that there is a clear, transferable method in non-philosophy that must be adhered to unbendingly. There is only a set of suggestions, or a recipe that, if followed, invites a revision of what we see thinking and philosophy to be: "it is the opening of thought beyond philosophy."[116]

Yet non-philosophy is not only a (heretical and foolish) usage of philosophy but opens out onto a host of other fields of enquiry. If it were otherwise, non-philosophy would indeed be led (as has been charged) into the endless narcissism of philosophical autocommentary, instead of being the liberating force it claims to be that generates new ways of thinking.[117] Indeed, it is precisely by extracting any philosophy *out* of our thinking about photography, for example (as in an aesthetics of photography), that photography's own discoveries come into view. Not *more* "philosophy" (of a certain kind) but comparatively *less.* As a thinking according to the Real, therefore, non-photography is non-philosophy in another name, and its discoveries can be mapped onto those of the other sciences—quantum mechanics and fractal geometry, for instance—in such a way as to show that there are no distinctions of regional-versus-fundamental science for Laruelle. Non-photography is already a non-philosophy without any provincial substatus. As we heard him state, from the preface to the English translation of *The Concept of Non-Photography,*

> these essays aim to disencumber the theory of photography of a whole set of ontological distinctions and aesthetic notions imposed on it by the Humanities, with the help of philosophy, and which celebrate photography as a double of the world. Written around 1992, they contain the entirety of

non-philosophy as exposited in *Theorie des identités*... and make the link with the quantum themes of *Philosophie non-standard*. ... It is enough to understand that the term "identity"—perhaps not the happiest of terms, given its logical associations—assures the passage between the One (the perennial object of our research) and that of quantum "superposition" our key concept at present. Just a minor change of vocabulary would suffice.[118]

"Just a minor change of vocabulary would suffice": only a small mutation then, a disfigured clone, would be sufficient.

CONCLUSION

MAKING A MONSTER OF LARUELLE

On Actualism and Anthropomorphism

> Heard about the guy who fell off a skyscraper?
> On his way down past each floor, he kept saying to reassure
> himself:
> "So far so good... so far so good..."
> How you fall doesn't matter. It's how you land.
>
> *La Haine,* Mathieu Kassovitz, 1995

Throughout this work, we have said that Laruelle's use of "man" or "human" called for its *own* non-philosophical treatment, for an extension of his method. And yet, as we already heard, in *En tant qu'un,* Laruelle writes that "man is a man for man," as opposed to (some) philosophy's proclamation that "man is a wolf, an eagle, or a sheep, etc. for man."[1] By nonstandardizing what an animal is (and so what sheep and wolves, or bees and lizards, are), however, we are arguing that now the first clause "man is a wolf," like the statement "cinema is a philosophy," for that matter, is no longer a reduction or an inflation of the one to the other as if both were *already* fixed in their separate identities. It is not a *logical* identification. To be sure, in saying that not only "X equals X" but *also* "X equals Y" or even "X equals X plus Y" (idempotency), the retort may come that, of all these identifications, it is *still the self-identical ones that are exceptional* (the Xs that equal Xs rather than the Xs that equal Ys).

In other words, if everything *really* is animal, or really is human, or really is philosophy, or even really is already dead (as some argue), we still have to account for the appearance of *those* animals, humans, philosophies, or already dead that also actually look like an animal, a human, a philosophy, or dead and *those* others that *do not*. They do have a self-identity after all, even if only an *apparent* one, and the appearance of a (self-) identity counts for something, a something that can then be used as the basis of an exceptionality (were one so inclined). Anything less,

such as to say that the self-identity itself is merely an illusion (even if "well founded" or "useful"), still leaves the basis for *illusion as such* unaccounted for, while also dismissing entire worlds far too easily. There are *these* and *those*; there is *this* and *that*—its completely demonstrable. As Alan Read records when writing about Agamben's "Anthropological Machine" in conjunction with the work of the performance group *Shunt*, "*you need to know the difference between this and this. And that is an elephant.*"[2]

Alternatively, to say that wolves are humans *too* (or film or performance is philosophical *too*) in a non-philosophical manner is not another logical equation but a *remodeling*, a hypothesis to be explored, a new comparative that must be only one among many. Saying that "X equals Y" in this Real identification is also to say that "X *could* equal Z *or* Q *or* R," and so on. Of course, this multiplication of Real identities *could* "explode" into triviality or, if you prefer, idiocy, but only in a theory-position separated from practice. In practice, that is, performatively, the identifications have each to be executed in actual spaces and times, in Real momentary postures (and not in the philosophical position of everywhere and always). *Any* thing looked at closely enough *can* be anything else ("in-One"), so long as their equation *makes any* sense at all, even in *paraconsistency*.[3] So a wolf can be human. And a man can be a (thinking) reed. This "can be" is the leap, and benefit, of doubt, the posture in-the-last-instance. The phrase "making sense" is too semantic, no doubt—no one vocabulary should be fetishized. What counts is the invention, the philo-fiction that discovers and performs a convergent or integrative movement—a vector that mutates both man and wolf, eagle and sheep, or cinema and philosophy, together in a *full* (consistent and reciprocal) anthropomorphism or a *full* philosomorphism. It is always the mutation that counts.

Of course, the call upon Laruelle to justify his usage of various philosophically saturated terms such as *a priori, ordinary, empirical, immanence,* and *transcendental* is usually rebuffed by him as no more than a typical philosopher's stratagem, either in *tu quoque* mode or in the name of a disingenuous consistency, being "more Laruellean than Laruelle." Nonetheless, if we invoke the need for consistency here in extending his use of the (non-) human, it is on account of a non-philosophical *paraconsistent* consistency that aims to radicalize such words so that, at its root, in its own performance, it too is equally implicated in an autofictioning. (This

is something that Graham Priest, for one, does not perform—for he does not do as he says—being careful to immunize his approach, as "coherent," from paraconsistent explosion.) Hence, the normative call for a consistent treatment of terms actually entails nothing other than the extant fact that non-philosophy *always practices what it preaches by mutation*: it transforms itself through its own operations.[4]

Vision-in-One, cloning, DLI, and so on, in their articulation through the various vocabularies we have employed here, only provide a glimpse rather than a permanent account *(logos)* and transferable methodology. As a *permanent* account, this introduction quickly falls into performative self-contradiction (immanence), but this *fall* is itself what allows it to mutate. This, perhaps, is why Laruelle's non-philosophy, *at least as understood as a lived body of practices, or postures,* exists mostly between philosophy and the Real, between transcendent philosophies (*of* the Real) and the pure immanence (which *is* the Real). In that it transcends (and resists) those transcendencies, it has no place or position. Utopia. The *Principles of Non-Philosophy* put it as follows: "non-philosophy *has not taken place.*"[5] Doubtless, "betweenness" too has a lineage in philosophical terminology (Merleau-Pontian and phenomenological in its transcendence), so its usage (here) must mutate too—for *this* is how the imperfect always falls. As the *Anti-Badiou* proposes, "it is not necessarily a matter of new 'great philosophies' with a hegemonic vision, but at least of texts that could be called, globally, 'non-standard.' By definition, we do not entirely know what to expect of ourselves."[6]

And yet, we still do not wish to romanticize failure. So let us review our positive argument concerning the nonhuman with one final take. Ray Brassier, as we earlier heard, has pointed out that non-philosophy's identification of the Real with the human would seem to reontologize it (as an idealism or even a solipsism). He continues as follows:

> The slide from "I think according to my ultimate identity with a real that is already given" to "this real of the last-instance is the human that I am" is as precipitate as the more familiar leap from "I think" to "I am." This slide envelops what by Laruelle's own lights amounts to a decision: "I am human." But what can "being-human" mean given that the radically

in-consistent real is not? What I think I am can have no privilege vis-à-vis the identity of a real already given independently of anything I may happen to think about it. To claim that I harbour some sort of pre-ontological understanding of my own being-human is to plunge straight back into Heidegger's hermeneutics of *Dasein*. ... The privileging of the nomenclature "man" to designate the real cannot but re-phenomenologize and re-substantialize its radical in-consistency and invest it with a minimal degree of ontological consistency.[7]

Brassier's point as regards humanizing the Real is valid at face value. But the validity weakens as soon as we understand that what is being hypothesized is not a definite logical essence but an indefinite Real identity. The fact is that Laruelle's descriptions always involve Real identities, and it is this that gives his account the ability to practice a *non-standard* humanism. Hence, the human is *never* given.

Indeed, it is arguably Brassier who has an overtly *anthropic* standard of knowing given his own faith in the objectivity of the "scientific image." Brassier practices *epistemology*—rather than a Laruellean science—and so knows what knowing is: he quantifies it, captures it as a true philosopher should in a philosophy or *logos* of knowledge (all of whose history as a scientism from the Vienna Circle onward has, ironically, been completely ignored by actual practicing scientists). Brassier is less Laruellean than Badiouian (as channeled through Wilfred Sellars): it is the matheme that ultimately counts. His own notion of "intelligence" is thereby anthropocentric and quantitative. Its scientific status is based on experimental *repeatability* and *universality* with a wholly known notion of who repeats (the social practices of human technology) within a quantified space and time (where and how often). Intelligence may be rendered in synthetic and inhuman terms, yet it remains a model of *human* intelligence that has only been extended by degrees.

This must be opposed to not-knowing who this public is, what this society is, or what the human is, according to the non-philosophical posture. This not-knowing is no mere ignorance, nor even the romantic notion of a negative capability. It is an active "degrowth" (unknowing) of epistemology by the Real—a de-philosophizing of the philosophy of knowledge. The "public," *dēmos,* or man, is undefined, so what is an *experiment* is not reduced to one kind of quality—the one deemed

"quantity." Quantity is the quality of and under control, or authority: it is the *logos* of instrumental science and reason (versus the nonstandard *scientificity* of science). Quality asks the question of "*qualis,*" "what kind are you?" Quantity, having already made up its mind as to kinds, is only interested in numbers and so asks, "*quantus*"—"how many of you are there?"

This thought of quality is not the thought of *qualia,* of qualitative essences: rather, it is the thought that leaves open the question of kinds, of what kind of people are "people." We have described Laruelle as an "actualist": on one hand, he depotentializes ontology and all philosophy, and on the other, his practice is entirely performative—it is "all execution" and "criminally performative."[8] As the quotation from *Principles of Non-Philosophy* near the start of chapter 5 stated, there are no "hinterworlds" or anything else "behind the One." For such an actualism, things are always visible in and to themselves and only invisible to certain perspectives. Indeed, "we" *make* things invisible simply because we must occupy a certain position (if only momentarily), a certain structure of regard (as opposed to the vision-in-One). Wittgenstein's behaviorism is often summed up in the phrase "nothing is hidden." This is usually taken to relate to epistemology.[9] However, in terms of a nonrepresentational perspectivism, it means that everything has its own perspective (on it), and so what *is* hidden must be due to the position of that perspective, and what is revealed must be due to a qualitative movement beyond that point of view—a postural mutation. Everything is public, but there are different forms of public, and not all of them are human. Some of these publics are hidden from each other, blinded to each other, screened off from each other. Being public does not entail being democratic (the idea that every public enjoys the same visibility). But being radically democratic, in actualist terms, means that there are always multiple publics, multiple perspectives, and multiple spaces and times that we can move among to varying extents (if we try). There are not only anthropological "people." Jaguars are people too (X = Y). It is a similar case with behaviorism: here, the body is the picture of the soul, but in a genuinely radical behaviorism (one that is consistent with itself), there is neither a best picture nor one type of soul (or body). There are multiple visibilities, certain of which render others invisible: this, again, would be a genealogy of absolutes, as immanental appearance, within a radical approach.

In performance also, the urge for a democracy of the visible and the human is evident in a number of new interventions within the field. In his "A Manifesto for Generalized Anthropomorphism," for example, Esa Kirkkopelto has set out a model of nonhuman performance that takes the concept of anthropomorphic theater and generalizes it (beyond its own "black box") in a fashion redolent of non-philosophy on a number of fronts:

> The problem of theatre, as it is thematized here, is a problem of the whole western way of experience. It concerns both, being limited to the human figure and the limitations of the human figure.... Since our experience is so strongly tied to a predefined human figure, we are unable to encounter the phenomenon of human.... *The phenomenon of human must be liberated from the human figure.* This aim cannot be reached in any individual theatre performance. There is no one expressive solution to this. This is about a process of transformation to which this manifesto calls all those, equally and without distinction, who work with performing arts. Abandoning the model of human means that we really first turn our gaze to each other in this situation where there is no authority, ideology or ideal to supervise us anymore.[10]

The aim of such a project, he goes on to say, is to "distance theatre from that *restrained* 'anthropomorphism' which has conventionally given a negative connotation to all 'anthropomorphism,' and to do so time and again through using different means and methods." This is clearly a model oriented toward a democratic equality of methods (with no "authority ... to supervise us anymore"). Moreover, it is also focused on *expanding* the human through its own nonstandard, "*generalised*" anthropomorphism: "as its means it has the ability to extend the human phenomenon to all existence." All the same, this is not to "turn the world into our own image" (in idealism or solipsism) but actually to allow other beings their own visibility beyond the perfect image some have created of man. As such, it hopes

> to dismantle that too perfect a picture which we have built so that beings could from now on come to encounter and address us more on their own terms, in all their unfamiliarity, in all their uniqueness which

does not trace back to our definitions and our way of being.... This reaching outside of the human figure is neither progress, nor a project. It is encountering something unfamiliar and non-human and opening up to it.... Human hope lies behind all restricted anthropomorphism, behind everything that calls itself "humanism." It lies in the decidedly non-human. What we encounter at its most beautiful in other humans is something that always goes beyond us.[11]

Like non-philosophy, Kirkkopelto's generalized anthropomorphism has no more time for that "too perfect a picture" of the human. What is "most beautiful in other humans" is other forms of human being discovered in new pictures. Likewise, in Amerindian perspectivism, as we heard it described by Viveiros de Castro, the human is discovered existing on all sides, not just "ours." What he calls "the invisible of the invisible" is the "visible," while

the other side of the other side is this side. If the body hides the soul, then the soul hides the body as well: the "soul" of the soul is the body, just like the "body" of the body is the soul. Nothing is hidden, in the end... because there is no ontological dualism.[12]

Nothing is ever hidden. How can we evaluate a performance, and so, at long last, a non-philosophy? By not answering but continually reiterating the questions, who are you? who is human? in words as deeds.[13] *Not answering* leads to effects in knowledge and practice rather than simply quietism. The *perfect* human falls this way: but the imperfect human, the nonhuman, is allowed to stand this way too ("you wanted to make me human, but that's what I am!"). Philosophical perfection falls, and with it also the perfect man. Yet it may well be ultimately immaterial whether humans or nonhumans fall: what counts is how they land.

CODA

PARADISE NOW; OR, THE BRIGHTEST THING IN THE WORLD

On Nonhuman Utopia

Laruelle writes, "One of the things that motivate non-philosophy is the eternal question 'what is to be done?'"[1] This study has looked at the dystopias of philosophy—its "worst places" or "positions"—in one response to Laruelle's question. In this regard, Alexander Galloway notes that Laruelle does not follow received opinion when it comes to seeing utopia as a "non-place apart from this world":

> Laruelle's utopia is a non-world, yet it is a non-world that is entirely rooted in the present. Laruelle's non-world is, in fact, entirely real. Revealing his gnostic tendencies, Laruelle's non-standard real is rooted *in* matter, even if the standard world already lays claim to that same space. The non-standard method simply asserts the real in parallel with the world.[2]

Such a coexistent utopia is not a liberal conformism but the hope and hypothesis of a world that can be *superposed* on this one as both invention and discovery. As Laruelle puts it in *Struggle and Utopia at the End Times of Philosophy*, "even hatred of the World has its limits; it is still about saving the World from the World."[3] Indeed, Galloway further points out that the non-philosophical utopia is not concerned with constructing "bigger and better castles in the sky, transcendental and sufficient for all. Rather, utopia is always finite, generic, immanent, and real." Moreover, Laruelle's utopianism is not a state but a method, a practice:

> If indeed utopia perished as narrative or world or image, it was reborn as method.... To refuse the philosophical decision is to refuse the world, and thus to discover the non-standard universe is to discover the non-place of utopia.[4]

So what, finally, is in that "non-standard universe," and how might it assist our utopian-method—the "what is to be done?" or (waking) "dream of Eden"—that is peculiar to non-philosophy? Matthew Goulish, cofounder of the performance group Goat Island, has recently written of *The Brightest Thing in the World*. As he tells us toward the end of this work, the question of what precisely is "the brightest thing in the world" was answered in 1919 by the diarist and naturalist W. N. P. Barbellion (aka Bruce Frederick Cummings). Goulish discusses Barbellion's argument (made soon before his death in his own book, *Enjoying Life and Other Literary Remains*) as follows:

> He prefaced that book with an epigram from Amiel: *I love everything, and detest one thing only—the hopeless imprisonment of my being within a single arbitrary form.* . . . Now he devotes what he knows to be his final breath to setting the natural history record straight. The brightest thing in the world is not, as Rupert Brooke has claimed, a leaf in sunlight. It is a ctenophore, a ribbed or combed jellyfish. Barbellion fixes his gaze on this obscure miniscule creature, whose name derives from the Greek for "comb bearer," and we see his naturalism achieve quiet transfiguration. What exhalation escapes the suffering human form? What angel of the light at last ascends? Only this: the jellyfish.[5]

The perfect human falls as the animal ctenophore ascends. The brightest thing in the world is a jellyfish, a *méduse,* a mutating animal (rather than a "single arbitrary form"—or Kant's unchanging animal shape). Laruelle's philo-fictional *poisson-eau,* the fish that is both immanent in and transcendent to water, serves the same transfigurative role. But note that Barbellion's brightest thing in the world, a ctenophore, is a very special jellyfish, being *bioluminescent*: it is a deep-sea creature that invents its own light within the darkest place in the world. It does not reflect the light of the sun but generates light immanently within its black universe (which is aptly named the "Midnight Zone" by marine biologists).

Beyond such seemingly allegorical animals, we know that in this world, too, what counts as human is itself somewhat *"arbitrary"* and that our ability to empathize with the suffering and struggles of other humans, those called "animal" or "nonhuman," is sometimes a mark of

our "humaneness." According to J. M. Coetzee's Elizabeth Costello, "there are people who have the capacity to imagine themselves as someone else, there are people who have no such capacity . . . and there are people who have the capacity but choose not to exercise it."[6] The philo-fiction of a *poisson-eau* or the Real of ctenophora is a call or advocacy for a nonhuman utopia of immanent light, a light that the philosophical sun cannot claim to be its own. Non-philosophy is oriented in this same direction. It sees the enlightened norms and authority of philosophy as precisely the means by which the world is made unequal and uninhabitable for humans and nonhumans alike.[7] Non-philosophy consequently constructs a black world of radical equality that can coexist alongside this standard one:

> Stop sending your vessels through the narrow cosmological corridor. . . .
> Cease having them compete with light, for your rockets too can realise the
> more-than-psychic, postural mutation, and shift from light to universe
> black, which is no longer a colour; from cosmic colour to postural and
> subjective black.[8]

In the standard position, light creates the perfect, absolute exception: be it in *thought,* where (some) *others'* thoughts come to be seen as parochial, nonessential, or even idiotic and unthinking (leaving Philosophical Thought to stand absolute and alone); or in *logic,* where some coexisting, plural truths come to be seen as only contradictions (conflicting truths) or even trivial (leaving absolute Truth to stand alone); or in *behavior,* where some expressive bodies come to be seen as simple mechanical events or even mindless movements (leaving absolute Mind alone); or in *animality,* where some humans come to be seen as only animals or even objects (leaving *Homo sapiens* standing alone); or in *performance,* where some actions come to be seen as merely transparent acts or even artless functions (leaving Art alone absolute). Light creates the inequality, the withdrawn perfection. In the nonstandard posture, "universe black" removes that absolute exception and allows all to stand *and* fall together as imperfect equals.[9]

ACKNOWLEDGMENTS

The last five years of this book's development bring with them a debt of gratitude to many people, but I would particularly like to thank Stella Baraklianou (for her photographic promenades), James Burton (for his metafictional advice), Laura Cull Ó Maoilearca (for teaching me everything I know about performance philosophy), and Hannah Still (for introducing me to the wonders of *The Five Obstructions*). Those who have hosted presentations of my often rough work in progress deserve my appreciation too: Pamela Sue Anderson (at Oxford University), Amanda Beech (at the California Institute of the Arts in Pasadena), Brian Fay (at the Dublin Institute of Technology), Matthew Goulish and Lin Hixson (at the School of the Art Institute of Chicago, via Prague), Kristóf Nyíri (at the Budapest University of Technology and Economics), Yve Lomax (at the Royal College of Art, London), and Craig Smith (at the University of Florida). For sharing their recent translations of Laruelle and interpretations of non-philosophy, I must acknowledge Alyosha Edlebi, Rocco Gangle, Marjorie Gracieuse, Katerina Kolozova, Sven Läwen, Alice Rekab, Anne-Françoise Schmid, and (especially) Anthony Paul Smith. A special mention goes to Deac Rossell at Goldsmiths, London, for generously helping me track down an elusive reference. My colleagues at the London Graduate School and in Film-Philosophy helped to keep this project afloat early on, both spiritually and financially. Later, Cary Wolfe and Doug Amato at the University of Minnesota Press were amazingly supportive throughout the publication process, while the comments on the manuscript by Ian James were also a huge help. The copy editor, Holly Monteith, improved upon the work in great measure. And, of course, without the ongoing and fierce intellectual experimentation of Professor François Laruelle, there would be no project at all—so I am also extremely thankful to him for his invention of non-philosophy.

Nothing real can ever happen without a family's support, however

(be it a standard or a non-standard one): so—for watching a lot of horror films with me (James), for only arriving two weeks prematurely (Eoin), for being patient with humans (Bob and Nina), and, finally, for constantly supplying me with love, companionship, and coffee (Laura)—I dedicate this book to them.

NOTES

INTRODUCTION

1 Laruelle, *Struggle and Utopia*, 238.
2 Heller, *Radical Philosophy*, 137.
3 Ibid., 136.
4 Laruelle, *Anti-Badiou*, 110.
5 Laruelle, *Principles of Non-Philosophy*, 43.
6 Laruelle, *Philosophy and Non-Philosophy*, 120.
7 Laruelle, *Une biographie de l'homme ordinaire*, 105, 110.
8 Laruelle, *Principles of Non-Philosophy*, 49; Laruelle, *Anti-Badiou*, 14.
9 See Laruelle, *Anti-Badiou*, 13: "Thought [is] defetishized as the force-(of)-thought [*force (de) pensée*] (cf. 'labor-power' [*force de travail*])."
10 Ibid., xxxiii.
11 Laruelle, *Struggle and Utopia*, 214.
12 Kolozova, *Cut of the Real*, 13, my italics.
13 Mackay and Laruelle, "Introduction," 20–21.
14 Laruelle, *Principles of Non-Philosophy*, 301.
15 Ibid., 14.
16 Mackay and Laruelle, "Introduction," 27.
17 Laruelle, *Anti-Badiou*, 148; Laruelle, *Principles of Non-Philosophy*, 100.
18 Laruelle, *Principles of Non-Philosophy*, xxi.
19 Laruelle, *Anti-Badiou*, 211, 212, my italics.
20 Laruelle, *Intellectuals and Power*, 38. See also Laruelle, *Principles of Non-Philosophy*, 70: "we are going to have to 'construct' non-philosophical thought by using science and philosophy without purporting to say what they are in themselves."
21 Laruelle, *Anti-Badiou*, xix.
22 Laruelle, "Toward a Science of Philosophical Decision," 89.
23 We should note that, in his *Le Philosophie du non*, Bachelard utilizes "non" as Laruelle does, that is, to indicate a broader paradigm à la non-Euclidean geometry (though whether it is not also a negation is another matter).
24 Laruelle, *Anti-Badiou*, 141. See also "NP [non-philosophy] does not maintain, as certain appearances might suggest, a relation of negation to philosophy, but a *positive relation of generic usage*." Ibid., 15, my italics.

25 See Laruelle, *Principles of Non-Philosophy*, 10: "non-philosophy is in effect not only descriptive but equally (in its intrinsic identity) theoretical; capable, through an original reduction and deduction, of explaining philosophical-and-scientific efficacy and not only of understanding it."

26 This includes the anti-philosophies like Lacan, certain analytic thought, and Marxism, simply because they are "anti": any rejection of philosophy in the name of a higher-order thought (representation of the Real) is still philosophical for Laruelle.

27 Laruelle, "Transcendental Method," 150.

28 Bacon, *Philosophical Works*, 264.

29 Laruelle, *Principles of Non-Philosophy*, 136, translation altered.

30 Ibid., 118. This equation of the Real and "Ego" will be discussed in chapter 5.

31 Ibid., 163.

32 Ibid., 63.

33 Laruelle, "I, the Philosopher, Am Lying," 67.

34 Laruelle, *Principles of Non-Philosophy*, 100; Laruelle, "A Rigorous Science of Man," 45. See also Laruelle, *Principles of Non-Philosophy*, 163: "philosophy evidently does not exhaust thought."

35 Laruelle, *Intellectuals and Power*, 32.

36 Laruelle, *Anti-Badiou*, 71.

37 Ibid., 45.

38 Gangle, *François Laruelle's Philosophies of Difference*, 6; Mackay and Laruelle, "Introduction," 2.

39 Laruelle, *Philosophy and Non-Philosophy*, 116.

40 Laruelle, "Non-Philosophy as Heresy," 259. See also Laruelle, "Non-Philosophy, Weapon of Last Defence," 244: "A style of thought. It's necessary to add that this is a practice and a performance. This practice and performance can't be immediately understood starting from a linguistic model, or an artistic model, or a practical one, because these practices are 'in-the-last-instance.' And this is the big obstacle for philosophy, this thing I call 'in-the-last-instance.'" The notion of (determination-) "in-the-last-instance" will be clarified through the course of this study, starting in chapter 1.

41 Laruelle, *Principles of Non-Philosophy*, 285.

42 Laruelle, *Intellectuals and Power*, 149, my italics.

43 Deleuze, for example, appears to avoid the bifurcation of philosophical theory and practice. As Badiou has noted, Deleuze wanted a "philosophy 'of' nature" understood as a "*description in thought of the life of the world,* such that the life thus described might include, as one of its living gestures, the description" itself. Badiou, "Review of Gilles Deleuze, *The*

Fold," 63. Whether he succeeded, and what would count as success, remains moot.

44 Laruelle, *Principles of Non-Philosophy,* 142.

45 Laruelle, "I, the Philosopher, Am Lying," 41.

46 Laruelle, *Principles of Non-Philosophy,* 175.

47 See Hintikka, "Cogito, Ergo Sum: Inference or Performance?"

48 Laruelle, "Is Thinking Democratic?," 230. See also Laruelle, *Principles of Non-Philosophy,* 142: "But we know through the philosophers themselves, in an undoubtedly still limited manner, that they do not say what they are doing, and do not do what they are saying."

49 Laruelle, *Principles of Non-Philosophy,* 157 (my translation of "to do what" in place of "from doing what": original French in *Principes de la Non-Philosophie,* 191: "la non-philosophie est contrainte—au matériau près—de faire ce qu'elle dit et de dire ce qu'elle fait").

50 Ibid., 175–76; see also 158.

51 Laruelle, *Anti-Badiou,* 81; Laruelle, *Principles,* 340. See also Laruelle, "From the First to the Second Non-Philosophy", 309 "the science of philosophy is a *quasi*-quantum physics of concepts"; and Laruelle, *Philosophie Non-Standard,* 490.

52 Laruelle, *Anti-Badiou,* 153.

53 Laruelle, *The Concept of Non-Photography,* 53, my italics.

54 Laruelle, *Principe de minorité,* 108 (this section on "Le réel contre le materialism et l'idéalisme" was translated as "The Decline of Materialism in the Name of Matter" in the journal *Pli*).

55 Laruelle, *Philosophy and Non-Philosophy,* 56.

56 See Mullarkey, *Post-Continental Philosophy,* chapter 5, for an attempt to materialize metaphilosophy through a use of the diagram that would move metaphilosophy away from being a higher-order reflection and come closer to a non-philosophical material fractal.

57 The idea that *only philosophy can understand philosophy* is a corollary to the view that *all* metaphilosophy is merely more philosophy. See, e.g., Hylton, "Nature of the Proposition," 394: "Philosophy is a subject for which the meaningfulness of its terms and the correctness of its procedures is always an issue; the distinction between philosophy and metaphilosophy is therefore not a useful one, because metalevel issues constantly arise, within the practice of the subject." In fact, Laruelle agrees with the idea that any philosophy of philosophy can only be more philosophy and so cannot actually do what it purports to do—that is, *raise* itself above philosophy: given that philosophy *is* that which creates a hierarchy of height, it will always be out of reach. Laruelle, *Intellectuals and Power,* 13: philosophy "functions above the intelligible." Only a

non-philosophy can see philosophy for what it is, but not by trying to outreach it so much as materialize, or mutate, its "height," the "meta-" or abstraction as such. For an alternative view of metaphilosophy whereby the "meta-" is not understood either as representation or material (à la non-philosophy) but as process or movement (of) thought, see the section on "Metaphilosophical Dualisation" in Mullarkey, *Bergson and Philosophy*, 177–81.

58 Laruelle, *Philosophy and Non-Philosophy*, 80.

59 The stakes of this implausibility for the Anglophone reception of Laruelle's work are well articulated by Ian James in his review of the English translation of *Philosophy and Non-Philosophy*.

60 Laruelle, *Anti-Badiou*, xx; Laruelle, *Philosophy and Non-Philosophy*, 123; Laruelle, *Principles of Non-Philosophy*, 235, 239. See also Laruelle, *Intellectuals and Power*, 12–13: "What we call philosophy is an extremely vague term, hazily maintained. Philosophy is first of all a verbal generality—one does philosophy. We don't really know what it means except that it designates academic study. We therefore have to look for some criterion, if there is one. And yet there is a criterion but it's very complicated since it is precisely like a criterion for decriterialization; it auto-affects itself. Let's imagine an invariant, but one that is identical or co-extensive to its variations and which, furthermore, is not formal but claims to be of the real, whatever the name of the real. Of course the definitions of philosophy are programmed failures. If philosophy speaks of the intelligible, it itself is not, it functions above the intelligible."

61 Smith, *A Non-Philosophical Theory of Nature*, 66.

62 Laruelle, "Is Thinking Democratic?," 229.

63 Laruelle, "Biography of the Eye."

64 Laruelle, *Une biographie de l'homme ordinaire*, 105, 112. See also 103: "*The place of unitary illusion and of its critique is the 'dual,' that is, the order of successive donation of the One and of the World.*"

65 Laruelle, *En tant qu'un*, 246.

66 Laruelle, *Principles of Non-Philosophy*, 256–57; Laruelle, *Philosophy and Non-Philosophy*, 50–51.

67 Mackay and Laruelle, "Introduction," 23.

68 See, e.g., Laruelle, *Struggle and Utopia*, 7: "Non-philosophy aims overall to operate through radicality and inversion (uni-version) of this order and not a reversal, and to put philosophy in exclusive dependence on man." Also 114: "One must certainly understand the inequality of this equality via non-philosophy, not as a reversal of philosophy but as its *radical inversion.*"

69 As Hughes Choplin writes when explaining Laruelle's antipathy to

linguocentric approaches (the hallmark of structuralist and poststructuralist theory), "suggesting a movement taking its source in language and turned towards this uni-verse, the idea of description, like that of reference, goes against the non-philosophical posture or look [*regard*], oriented in the inverse direction to that centered—exclusively—on philosophy and its language." Choplin, *La Non-Philosophie de François Laruelle*, 73.

70 Laruelle, *Anti-Badiou*, 232, translation altered.

71 Laruelle, *Philosophy and Non-Philosophy*, 42.

72 Laruelle, *En tant qu'un*, 34.

73 Schumacher, *Human Posture*, 18.

74 Ibid., 26.

75 Baier, *Postures of the Mind*, ix.

76 Laruelle, *Intellectuals and Power*, 89. Anne-Françoise Schmid explains the difference between an axiom and a hypothesis as follows in "Quelque chose rouge dans la philosophie," 128: "what is the difference between an axiom and an hypothesis? The first is related more to the theory, the second is nearer to the model and modelisation."

77 Laruelle, *Principles of Non-Philosophy*, 11.

78 Laruelle, *Concept of Non-Photography*, 30.

79 See Laruelle, "Universe Black in the Human Foundations of Colour" (pace Hegel's concern for empirical, nonblack cows).

80 Cited in Adkins, "Death of the Translator," vi.

81 Laruelle, *Philosophy and Non-Philosophy*, 2. See also Laruelle, *Philosophies of Difference*, 106–14. From Laruelle's perspective, the "Judaic turn" in philosophy implicates more than those historically Jewish thinkers but every philosophy of difference that opposes the Greek metaphysics of identity.

82 Laruelle, *Philosophy and Non-Philosophy*, 4.

83 Laruelle, *Principles of Non-Philosophy*, 289–90.

84 Laruelle, "Non-Philosophy, Weapon of Last Defence," 249.

85 Laruelle, *Philosophy and Non-Philosophy*, 142. See also Laruelle, *Intellectuals and Power*, 29: "As a non-philosopher I accept that there is some irreducible and definitive presupposed in thought, and this is necessary in order to defeat idealism and to think according to the Real." See also Laruelle, "Transvaluation of the Transcendental Method," 473–74, or Laruelle, *Principles of Non-Philosophy*, 3, 56, 69.

86 Not being a numeral, the One is not opposed to a plural: as Kolozova puts it in *Cut of the Real*, 30, this One involves "the possibility that there might be a 'good one,' a 'good unity,' namely, one that does not necessarily have to exclude the multiplicity."

87 Smith and Rubczak, "Cloning the Untranslatable," xvii.

88 Laruelle et al., *Dictionary*, 30; Laruelle, *Intellectuals and Power*, 50.

89 Brassier, *Nihil Unbound*, 137.

90 James, *New French Philosophy*, 179.

91 Laruelle, *Principles of Non-Philosophy*, xv.

92 Laruelle, "A Rigorous Science of Man," 46.

93 Daston and Mitman, "How and Why of Thinking with Animals," 2.

94 Gangle, *François Laruelle's Philosophies of Difference*, 13.

95 Laruelle, "Is Thinking Democratic?," 233–34. Laruelle's preference for "individual" is partly a matter of language, given the less opposed sense of the term's component—"dual"—the human being therein understood as an undivided duality (of the One Real).

96 Laruelle, "A Rigorous Science of Man," 40.

97 Laruelle, *Anti-Badiou*, 3.

98 Laruelle, *Intellectuals and Power*, 40. The reference to "learned ignorance" is an allusion to Nicholas of Cusa's work. David Hume famously wrote that "the most perfect philosophy of the natural kind only staves off our ignorance a little longer" (*An Enquiry Concerning Human Understanding*, 28), whereas Bergson spoke of the élan vital as only "a label for our ignorance"—"a sort of label affixed to our ignorance [as to the true cause of evolution], so as to remind us of this occasionally" (*Creative Evolution*, 45). What if these motors of ignorance were ontological rather than epistemological, or even if the epistemological become real, as realized? Staving, élan, the non-philosophical—would each be a kind of practice as well as the *materialization* and *action* of unknowing?

99 Nonetheless, the recent literature on the (philosophical) importance of forms of not knowing is extensive, a small portion of which includes Unger, *Ignorance*; Bromberger, *On What We Know We Don't Know*; Rescher, *Ignorance*; and the essays in the collection edited by Proctor and Schiebinger, *Agnotology*.

100 Laruelle, "I, the Philosopher, Am Lying," 61.

101 Laruelle, "Degrowth of Philosophy," 340, translation altered.

102 Laruelle, *Principles of Non-Philosophy*, 98.

103 Laruelle, *Philosophy and Non-Philosophy*, 135.

104 Gangle, *François Laruelle's Philosophies of Difference*, 7; he goes on: "Laruelle's style is part and parcel of the strangeness, power and truth of what non-philosophy aims to instantiate."

105 Adkins, "Death of the Translator," ii.

106 Reszitnyk, "Wonder without Domination," 51.

107 Laruelle and Ó Maoilearca, "Artistic Experiments with Philosophy," 178.

108 Ibid., 179.

109 Mackay and Laruelle, "Introduction," 29.

110 See Laruelle, *Photo-Fiction*; Laruelle, *Concept of Non-Photography*.
111 Laruelle, *Anti-Badiou*, 125.
112 Laruelle, *Philosophy and Non-Philosophy*, 135. The importance of these fictions will be examined in chapter 2.
113 Laruelle, "Generic Orientation of Non-Standard Aesthetics."
114 Laruelle and Ó Maoilearca, "Artistic Experiments with Philosophy," 177.
115 Ibid., 182.
116 See Mullarkey, *Philosophy and the Moving Image*.
117 We pursue this course despite Laruelle's personal penchant for music, poetry, and painting over cinema, which, one suspects, he regards as overdetermined by Deleuzian interventions, as seen here in this passage from *Philosophy and Non-Philosophy*, 41, that distances non-philosophy from a (Deleuzian) film ontology: "the One is an Identity which is conflated with its depth, its consistency, its flesh, its immediate (auto-)impression, and which therefore is not requisitioned as . . . *film* infinitely developing, etc.—here one recognizes the externalized avatars of the old universal substance or of philosophical decision put to the test of the Other. The One is not a film or an ultra-flat surface without thickness devoted to the sub-altern functions of a tearproof envelope."
118 Reszitnyk, "Wonder without Domination," 26.
119 I am indebted to Ian James for making the importance of this point clear.
120 Hjort, "*The Five Obstructions*," 631–32.
121 Ibid., 636; see also 632.
122 Rodriguez, "Constraint, Cruelty, and Conversation," 50, 55.
123 Though turning to an art house favorite like this is not totally contingent either, given the attraction of von Trier's films to many "philosophical" minds (his art is often deemed a great "metacinematic work"). See Bainbridge, *Cinema of Lars Von Trier*, 158.
124 Lynes, "Perversions of Modesty," 599–600.
125 Bainbridge, *Cinema of Lars Von Trier*, 159.
126 Bainbridge points out, ibid., 158, that "rules have played a central role in the formation of von Trier's *oeuvre*"—such as the "vows of chastity" of the Dogme 95 movement in film realism.
127 Ibid., 160.
128 Cited in Lynes, "Perversions of Modesty," 599.
129 From the promotional copy on the back cover of Bainbridge's *Cinema of Lars Von Trier*.
130 Lynes, "Perversions of Modesty," 609.
131 Leth himself thinks that it is von Trier who is (foolishly) romantic in

respect to valorizing failure: "Lars has this crazy theory that truth comes out if you are broken. And I don't agree with that. It is a romantic and sentimental notion." Cited in Dwyer, "Romancing the Dane," 12. And in the film he declares how von Trier believes that he will be "affected by being placed in a situation where social drama is going on beside you. . . . There is no physical law that states that you can witness so much that you can reach the limit where you break down."

132 See Bollert, "Plato and Wonder", on how *thaumazein* relates to the Greek *deinon*, which can mean "that which brings about a sense of wonder, but it also can connote that which is strange or uncanny, terrible, fearful, or dreadful; it can pertain at once to that which evokes an affirming wonder with respect to a human being and to that which is monstrous in humanity" (4–5).

133 Dufour, *Le cinéma d'horreur et ses figures*, 11.

134 Laruelle, *Philosophy and Non-Philosophy*, 92.

135 Ibid., 124.

136 See, for example, Badmington, *Alien Chic*; Braidotti, *The Posthuman*; MacCormack, *Cinesexuality*; Weil, *Thinking Animals*; Wolfe, *What is Posthumanism?*; Fuller, *Humanity 2.0*.

137 Laruelle, *Principles of Non-Philosophy*, 58. See also 284: "Neither synthesis nor resolution of this antinomy; it is indeed the identity, but in-the-last-instance, of the pragmatic of philosophical extraction and the theory of scientific extraction."

138 Ibid., 300–301.

139 Wolfe, *What Is Posthumanism?*, 99; see also Wolfe, "Human, All Too Human," 568.

140 I came across this biographical anecdote *after* having decided to use a film structure to inform this introduction to Laruelle.

141 Laruelle, *Philosophy and Non-Philosophy*, 107.

142 Laruelle, *Struggle and Utopia*, 135.

143 See Nietzsche, *On the Genealogy of Morals and Ecce Homo*, 119.

144 Laruelle, *Intellectuals and Power*, 149, my italics.

145 Laruelle, *Philosophy and Non-Philosophy*, 45.

146 Ibid. See also 47, 219.

147 Later, we will note the significance of "orientation" for Kant's philosophy, which ultimately has an ethical import for thought—the question of how thinking is aligned to the moral law (which, in Laruelle, one might reconfigure as the question of how *this* thought *too* is not unethical).

148 Laruelle, "Is Thinking Democratic?," 236–37.

149 Cited in Phillips, "What If Freud Didn't Care?," 19.

150 Laruelle, "From the First to the Second Non-Philosophy," 321: "One of

the things that motivate non-philosophy is the eternal question 'what is to be done?' In the face of what?"

151 See Mulvey, "Death Twenty-Four Times a Second," 101, 93.
152 Laruelle, *Anti-Badiou*, xxii.

1. PHILOSOPHY, THE PATH OF MOST RESISTANCE

1 Laruelle, *Principles of Non-Philosophy*, 4.
2 Ibid., 13.
3 Deleuze and Guattari, *What Is Philosophy?*, 28.
4 Laruelle, *Principles of Non-Philosophy*, 228.
5 Laruelle, *Philosophy and Non-Philosophy*, 104.
6 Gangle, *François Laruelle's Philosophies of Difference*, 13.
7 Laruelle, "I, the Philosopher, Am Lying," 67. Laruelle actually makes this remark when writing specifically about Deleuze, observing that philosophers, because they "already know what thinking and Being are . . . assume the validity of philosophy itself."
8 Laruelle, *Philosophy and Non-Philosophy*, 6.
9 Laruelle, *Philosophies of Difference*, 16.
10 Laruelle, "La concept d'analyse generalisée ou de 'non-analyse.'"
11 Laruelle, *Principles of Non-Philosophy*, 136.
12 Ibid., 243; Laruelle, *Anti-Badiou*, 202.
13 Laruelle, *Principles of Non-Philosophy*, 243.
14 Ibid., 44. See also 241: "it is the perpetual motor of philosophy or its 'black box': postulating an impossible identification, assumed but not given, of opposites, consequently being only a 'technologically' sprung amphibology rather than a real identity."
15 Laruelle, *Principles of Non-Philosophy*, 210.
16 Laruelle, *Future Christ*, 17.
17 Laruelle, *Intellectuals and Power*, 24.
18 Ibid., 75.
19 Ibid., 86.
20 Badiou, *Ethics*, 11.
21 Laruelle, *Intellectuals and Power*, 93.
22 Ibid., 12.
23 Ibid., 87.
24 Ibid., 81.
25 Ibid., 25.
26 Ibid., 114, my italics.
27 Ibid., 80, my italics.
28 Ibid., 91–2.

29 Laruelle, *Philosophy and Non-Philosophy*, 248, my italics. See also 31
 on "the supercilious guardian of a tradition of which it would like to
 make us believe that it has 'decided' once and for all upon the essence
 of thought and of man: an exploitation—in every sense of the word—of
 thought."

30 Laruelle, *Principles of Non-Philosophy*, 292. Likewise, "'The World,' 'His-
 tory,' 'Language,' 'Sexuality,' 'Power,' etc.—what we designate in general
 as *Authorities*." Laruelle, "A Rigorous Science of Man," 34.

31 Galloway, "Review of François Laruelle, *Théorie générale des victimes*,"
 105.

32 See Laruelle, "Toward a Science of Philosophical Decision," 94.

33 Laruelle, *Philosophy and Non-Philosophy*, 11.

34 Laruelle, *Anti-Badiou*, 230. The "philosophical loss of philosophy"
 would refer to a Lévinasian depiction of epistemology and ontology as
 forms of oppression, *but only so seen in the light of another philosophy.*
 Non-philosophy is the attempt to step outside that circle, or rather, to
 render it material. Significantly, Laruelle does recuperate the term *force*
 through his more recent work on quantum mechanics: "But we have
 learnt to distinguish, on the model of physics (albeit in a very different
 way) between a 'strong force' (that which Badiou intends to introduce
 into thought) and a 'weak force' that we also call 'generic'—that is to say,
 a force proper to humans rather than to Being. In reality, this generic
 force is not so much itself weak as it is a weakening of the strong force"
 xvi).

35 Ibid., 131.

36 Ibid., 230–31, my italics.

37 Lynes, "Perversions of Modesty," 610.

38 Smith, "Funny Games," 132.

39 Lynes, "Perversions of Modesty," 602–3. Lynes actually records Leth's
 last line erroneously as "And he can't have it."

40 Ibid., 606–7.

41 Which barely seen victim of this experimental film, and meal, is the
 more miserable, the ones in the background or the one on the plate
 (the salmon), will be a matter to touch on later.

42 Laruelle, *Anti-Badiou*, xxvi; Laruelle, *Struggle and Utopia*, 100; see also
 Laruelle, *Principles of Non-Philosophy*, 23.

43 Laruelle, *Philosophy and Non-Philosophy*, 128.

44 Laruelle, *Principles of Non-Philosophy*, 17. See also Laruelle, *En tant
 qu'un*, 172–74.

45 Laruelle, *Struggle and Utopia*, 176.

46 See Mullarkey, *Post-Continental Philosophy*, chapter 2.

47 Laruelle, *Principles of Non-Philosophy*, 116, 117, translation altered.
48 Laruelle, *Anti-Badiou*, xxvii.
49 Laruelle, *Machines textuelles*.
50 Gangle, *François Laruelle's Philosophies of Difference*, 123.
51 Laruelle, *Philosophy and Non-Philosophy*, 177; see Leroy, "Derrida et le 'non-philosophique' restreint," 82.
52 Brassier, "Axiomatic Heresy," 33.
53 Laruelle, *Principles of Non-Philosophy*, 201. Laruelle also says that non-philosophy "is sometimes interpreted by its adversaries as a new species of 'deconstruction' and by deconstruction itself as a form thereof but an ungrateful one, devoid of its spirit of appreciation" (168).
54 Ibid., 205.
55 Laruelle, *Anti-Badiou*, 36.
56 Laruelle, *Struggle and Utopia*, 80.
57 Laruelle, *Principles of Non-Philosophy*, 224.
58 We will return to Derrida in chapter 2, under the auspices of deconstruction and paraconsistent logic.
59 Laruelle, "I, the Philosopher, Am Lying," 55.
60 Deleuze and Guattari, *What Is Philosophy?*, 220n.
61 Laruelle, "I, the Philosopher, Am Lying," 41.
62 Ibid., 57.
63 Laruelle, "From the First to the Second Non-Philosophy," 320; Laruelle, *Anti-Badiou,* xxvii–iii.
64 Laruelle, "I, the Philosopher, Am Lying," 44.
65 Laruelle, *Anti-Badiou*, vii, x.
66 In his preface to the English translation of *Being and Event,* for example, Badiou reflects on being quite aware, when it first appeared in 1988, "of having written a 'great' book of philosophy. I felt that I had actually achieved what I had set out to do. Not without pride, I thought that I had inscribed my name in the history of philosophy" (xi).

 Of course, Badiou's great book of philosophy might also be a humorous reference to Galileo and his view of nature's "great book," which is "written in mathematical language."
67 Badiou, *Ethics*, 37.
68 Laruelle, *Anti-Badiou*, 12.
69 See chapter 3 of Mullarkey, *Post-Continental Philosophy,* for further analysis of this role of philosophy in Badiou's system.
70 Badiou and Woodard, "Interview," 20.
71 Laruelle, *Anti-Badiou*, xiv.
72 Ibid., 28, 62.
73 Stern, *Dead and Alive*, 8.

74 Morton, *Realist Magic*, 19–20.

75 Latour, *We Have Never Been Modern*, 12.

76 Harman, *Prince of Networks*, 14, 15, 34.

77 Whitehead, *Process and Reality*, 3.

78 Laruelle, *En tant qu'une*, 29.

79 Laruelle, *Philosophy and Non-Philosophy*, 240–41.

80 Ibid., 138. He continues: "Non-philosophy is no more 'anti-speculative' than it is 'anti-philosophical,' it presents itself as the very identity of speculation insofar as it has renounced the sufficiency of auto-position and is thought as commanded by the Real."

81 This is especially true of the work of Quentin Meillassoux and Graham Harman; see Meillassoux, *After Finitude,* and Harman, *Prince of Networks.*

82 See Harman, "Review of *Philosophies of Difference.*" In this review of the translation of *Philosophies of Difference,* Harman refers to "the remarkable arrogance with which Laruelle's theory is presented" on account of it reducing all philosophy to one decisional form. Much could be said here in reply, but the crucial point to be made is that this "arrogance" only appears to the philosopher who either *cannot* accept that aspect of Laruelle's approach that attempts to integrate the philosophical form of thinking within a consistent theory of immanence (such that its opening axiom obviously makes no sense) *or will not* accept other aspects of it, such as the fact that, contra Harman's faith in the transparent singularity and worthiness of notions such as "clarity" and "proof" (deemed absent in Laruelle), a non-philosophical approach would contest whether their meaning is singular at all. Do we have a clear and universal concept of "clarity," for example, which would avoid the obvious circularity of the question in its answer? (For more on this, see Hart, "Clarity.") Harman remains insensitive to the force of such questions. A more helpful inference one can make from Harman's review, though, is that it shows the general tendency of philosophies to take representationalist form despite their best, or worst, intentions—to mediate everything through themselves, and so to be blind to the mystery of how they, or anyone, should be able to have *complete* "insight" into reality.

83 Laruelle, "Transcendental Method," 138.

84 Laruelle, *Principles of Non-Philosophy,* 22.

85 Laruelle, "Transcendental Method," 142.

86 Ibid., 181.

87 Laruelle, *Introduction au Non-Marxism,* my italics.

88 Laruelle, "Generic Orientation of Non-Standard Aesthetics."

89 Laruelle, *Anti-Badiou,* 215.

90 Laruelle, *Introduction au Non-Marxism.*

91 Of course, there are also those, like Dan Smith, who see Deleuze as a (post-) Kantian thinker of sorts, and with that recanonize his counterphilosophy.

92 Brassier, "Axiomatic Heresy," 33.

93 Laruelle, "Controversy over the Possibility of a Science of Philosophy," 88.

94 Laruelle, "What Is Non-Philosophy?," 239.

95 Laruelle, *Principles of Non-Philosophy,* 265, my italics.

96 Laruelle, "Transcendental Method," 171, 164.

97 Ibid., 436–37.

98 Laruelle, *Anti-Badiou,* xxix–xxx.

99 Ibid., 74.

100 Smith, *A Non-Philosophical Theory of Nature,* 116.

101 Laruelle, *Philosophy and Non-Philosophy,* 11.

102 Laruelle, *Principles of Non-Philosophy,* 295.

103 Schmid, "Science-Thought of Laruelle and Its Effects on Epistemology," 138; and see also Schmid et al., "Une nouvelle logique de l'interdisciplinarité."

104 Laruelle, "Transcendental Method," 147. Laruelle is alluding to Dufrenne's later book, *L'inventaire des a priori,* rather than to the more renowned *La Notion d'a priori* from 1959.

105 Casey, introduction to Dufrenne, *Notion of the A Priori,* x.

106 Dufrenne, *Notion of the A Priori,* 65.

107 Ibid., 81–82.

108 Kant, *Critique of Pure Reason,* A270–B326, 371.

109 Likewise, where it might then be said that these real a prioris must be closer to Aristotle's sensuous particulars, this would again presuppose the hylomorphic duality operative in his Greek philosophy, which Laruelle cannot endorse.

110 Laruelle, "Transvaluation of the Transcendental Method," 467.

111 Kant, *Critique of Pure Reason,* A101, 229.

112 Laruelle, "Transvaluation of the Transcendental Method," 441.

113 Ibid., 468–69.

114 Ibid., 469.

115 Kripke, *Naming and Necessity,* 116.

116 See, on the question of "imaginability" in Kripke's argument, Tye, "Subjective Qualities of Experience," 2–6.

117 Kripke, *Naming and Necessity,* 39.

118 Laruelle, "Le concept d'une éthique ordinaire ou fondée dans l'homme," my italics.

119 Alternatively, for a direct analysis of *rigidity* (and hardness) itself as a form of evolving "conceptual behavior," see Wilson, *Wandering Significance.*

120 See, e.g., Bernasconi, introduction to *Race and Racism in Continental Philosophy.*

121 Laruelle and Ó Maoilearca, "Artistic Experiments with Philosophy," 182.

122 Laruelle, *Anti-Badiou,* 232.

2. PARACONSISTENT FICTIONS AND DISCONTINUOUS LOGIC

1 Laruelle, "Le concept d'une éthique ordinaire," my italics. Laruelle calls the human "ordinary man" in this study and elsewhere to highlight once more a nonrelation with philosophy. The Bergsonian aspect of this primacy of the possible over the real is evident here. The *locus classicus* for Bergson's discussion is "The Possible and the Real" in Bergson, *The Creative Mind.*

2 Laruelle, *Concept of Non-Photography,* 41–42.

3 Laruelle, *Philosophie non-standard,* 500, 502.

4 Laruelle, *Non-Philosophy Project,* 220.

5 Laruelle, *Photo-Fiction,* 2, 5; Laruelle, *Théorie des Identités,* 302.

6 Laruelle, *Philosophy and Non-Philosophy,* 231.

7 Ibid.

8 Ibid., 234. The idea of "fictionale" will be discussed later in this chapter.

9 Ibid., 230.

10 Ibid.

11 Laruelle, *Anti-Badiou,* 223.

12 Priest, *In Contradiction,* 162.

13 Laruelle, *Philosophy and Non-Philosophy,* 244.

14 Laruelle, *Philosophie non-standard,* 489.

15 Laruelle, "What Can Non-Philosophy Do?," 207.

16 Laruelle, *Philosophy and Non-Philosophy,* 170.

17 Ibid., 177ff. For an even more succinct view of their differences, see Laruelle, "Deconstruction and Non-Philosophy," 54–63.

18 Laruelle, *Philosophie non-standard,* 489; Laruelle, *Anti-Badiou,* 224.

19 See Derrida, "Structure, Sign, and Play."

20 Laruelle, "Controversy over the Possibility of a Science of Philosophy," 75–76.

21 Ibid., 87.

22 Ibid., 91; Laruelle, *Principles of Non-Philosophy,* 285.

23 Laruelle, *Philosophy and Non-Philosophy,* 213. The reference to "duali-

tary" here invokes the unilateral duality that always takes philosophical dyads and realizes them on one, same side, according to the Real/One.

24 Laruelle, "Controversy over the Possibility of a Science of Philosophy," 78.

25 Ibid., 87–88.

26 Ibid., 88.

27 Ibid., 82.

28 Laruelle, *Philosophies of Difference*, xv.

29 Laruelle, *En tant qu'un*, 68.

30 Laruelle, *Concept of Non-Photography*, 17.

31 Ibid., 102.

32 Ibid., 4; see also 13, 28, 36, 43, 42.

33 Ibid., 27.

34 Ibid., 11, 36, 38, 94.

35 See, e.g., Flusser, *Towards a Philosophy of Photography*, 36: "In choosing their categories, photographers may think they are bringing their own aesthetic, epistemological or political criteria to bear. They may set out to take artistic, scientific or political images for which the camera is only a means to an end. But what appear to be their criteria for going beyond the camera nevertheless remain subordinate to the camera's program. In order to be able to choose camera-categories, as they are programmed on the camera's exterior, photographers have to 'set' the camera, and that is a technical act, more precisely a conceptual act.... In order to be able to set the camera for artistic, scientific and political images, photographers have to have some concepts of art, science and politics: How else are they supposed to be able to translate them into an image? There is no such thing as naïve, non-conceptual photography. A photograph is an image of concepts. In this sense, all photographers' criteria are contained within the camera's program." And yet, despite the "camera's program" being able to generate its own philosophy, Flusser can still say that "photographers only provide such answers when called to account by philosophical analysis" (80), as though "philosophical analysis" was a standardized approach for all to apply.

36 Laruelle, *Concept of Non-Photography*, 43, 46. Laruelle continues: "one does not photograph the object or the 'subject' that one sees—but rather, on condition of suspending (as we have said) the intentionality of photography, one photographs Identity—which one does not see—through the medium of the 'subject'" (47). And also: "It is the congenital automatism of the photo itself, of semblance, that creates the impression of an 'objective' resemblance and subsequently of a magical causality of the object over its representation that 'emanates' from *it*" (115).

37 Ibid., 57, my italics.

38 Ibid., 112–13.

39 Interstitial frames of black between each image are also necessary to avoid blurring.

40 Smith, "Funny Games," 119.

41 Cited in Hjort, preface to *Dekalog 01*, xvii.

42 Hjort, "Style and Creativity in *The Five Obstructions*," 28.

43 Smith, "Funny Games," 129. Calling the movement "smooth" is a little too generous—it is still rather jumpy, though in a manner suited to the film score and overall pacing.

44 See ibid., 128.

45 Livingston, "Artistic Nesting in *The Five Obstructions*," 64.

46 Leth, "*Dekalog* Interview," 141.

47 Bazin, *What Is Cinema?*, 2:81.

48 Laruelle, *Philosophy and Non-Philosophy*, 233.

49 Smith, "Funny Games," 122.

50 For a critique of Bordwell's essentialism, see Mullarkey, *Philosophy and the Moving Image*, 29–57, which instead looks at filmic properties as processual (though at different speeds, to be sure).

51 Bordwell, *Narrative in Fiction Film*, 76. The *syuzhet* is the way that the story is organized, logically and chronologically, whereas the *fabula* is the raw material of the story.

52 Ibid., 31.

53 Ibid., 164.

54 Ibid., 249. Bordwell has subsequently amended his view to a degree: "I think that *NiFF (Narrative in Fiction Film)* made the valid point that our understanding of narrative is often inferential, and we do flesh out what we're given. But I now think that the inference-making takes place in a very narrow window of time, and it leaves few tangible traces. What is built up in our memory as we move through a film is something more approximate, more idiosyncratic, more distorted by strong moments, and more subject to error than the *fabula* that the analyst can draw up." See http://www.davidbordwell.net/essays/commonsense.php#_ednref11.

55 Is it the thought's expression in sentential form, its underlying logical or propositional form? These questions and answers—along with their nonlinguistic/nonlogical variants no doubt—rest on a host of assumptions.

56 Ryle, *Concept of Mind*, 284.

57 See Deleuze and Guattari, *What Is Philosophy?*, 21: "The concept is defined by *the inseparability of a finite number of heterogeneous components traversed by a point of absolute survey at infinite speed.* Con-

cepts are 'absolute surfaces or volumes,' forms whose only object is the inseparability of distinct variations. The 'survey' [survol] is the state of the concept or its specific infinity, although the infinities may be larger or smaller according to the number of components, thresholds and bridges. In this sense the concept is act of thought, it is thought operating at infinite (although greater or lesser) speed." See also ibid., 36, 48.

58 See Connolly, *Neuropolitics*.

59 Stiegler, *Technics and Time*, 1:146.

60 Drawing on cognitive science especially, psychologists like Daniel Kahneman have popularized the idea of thought having *speed* in other fields such as behavioral economics and (more generally) decision theory: see Kahneman's *Thinking, Fast and Slow*.

61 This was the basic thesis of Mullarkey, *Philosophy and the Moving Image*.

62 See Leth, "*Dekalog* Interview," 143: "Camilla and Morten are 'my' people. Camilla has edited all my films since 1985, and she knows what I like; she has an intuitive grasp of the direction in which I want the film to go. This is absolutely crucial, as I never work with a script that arranges scenes in a certain sequence."

63 The linkage between inference system and logic is basic: "A *logic* is a set of well-formed formulae, along with an inference relation ⊢. The inference relation, also called logical *consequence*, may be specified syntactically or semantically, and tells us which formulae (conclusions) follow from which formulae (premises)." Weber, "Paraconsistent Logic."

64 Čapek, *Bergson and Modern Physics*, 182.

65 See, e.g., Wittgenstein, *Tractatus*, 1.13, 2.11, 2.202, 3.4, 3.42, and 4.463.

66 Čapek, *Bergson and Modern Physics*, 76.

67 Laruelle, *Concept of Non-Photography*, 52, translation amended.

68 Ibid., 119, 120.

69 Laruelle, *Principles of Non-Philosophy*, 282.

70 Ibid., 219.

71 Beall, "Introduction: At the Intersection of Truth and Falsity," 2–3.

72 Priest, *In Contradiction*, 208.

73 Simons, "Bolzano, Brentano and Meinong," 125, 123.

74 Meinong, "Theory of Objects," 83.

75 Ibid., 82.

76 Chisholm, "Meinong, Alexius," 261.

77 Miró Quesada, "Does Metaphysics Need a Non-Classical Logic?," 35.

78 Routley and Routley, "Re-habilitating Meinong's Theory of Objects," 224, cited in Azzouni, *Talking about Nothing*, 56n15.

79 Quine, "On What There Is," 2. Priest, in *Towards Non-Being*, 108, points

out that "On What There Is?" starts with "two philosophical caricatures, McX and Wyman. It is not clear who McX is supposed to be; Wyman is usually taken to be Meinong. He is not. According to Wyman, all terms denote; the objects that are denoted all have being; but some of these exist (are actual) and the rest merely subsist. As is clear, this is not Meinong, even less noneism; it is Russell of the *Principles of Mathematics*."

80 Priest, *Towards Non-Being*, vi. Such philosophical distaste notwithstanding, Meinong's ideas have refused to die (despite Gilbert Ryle's infamous judgment that they were "dead, buried and not going to be resurrected"). A recent issue of *Humana.Mente*, vol. 25 (2013), edited by Laura Mari and Michele Paolini Paoletti, is devoted to discussions of both Meinongian and Neo-Meinongian views (of Héctor-Neri Castañeda, Terence Parsons, Richard Sylvan, Edward N. Zalta, and others) and is indicative of a strong renaissance in Meinong studies. (Ryle's premature verdict is cited in the foreword to the issue.)

81 Routley, *Exploring Meinong's Jungle and Beyond*, reverse of frontispiece. Routley changed his name after he married Louise Sylvan (née Merlin), adopting the surname "Sylvan" (which means "of the forest") partly in reflection of his ecological commitments.

82 Priest, *Towards Non-Being*, vii, ix.

83 These references to a *chôra* or chaos are not the same as the "chaotic" that Laruelle rejects as a description of non-philosophy in, e.g., *Philosophy and Non-Philosophy*, 244.

84 Laruelle, *Principles of Non-Philosophy*, 48.

85 Laruelle, *Philosophy and Non-Philosophy*, 172.

86 Priest, *Towards Non-Being*, 5, 25, notes, on one hand, that "intentionality is a fundamental feature—perhaps the fundamental feature—of cognition" and, on the other hand, that "intentional notions *are* pretty anarchic logically. That is just the nature of the beasts." Priest also points out that some have even argued (e.g., Horcutt, "Is Epistemic Logic Possible?") that there can be no logic for epistemic states because acts of knowing are simply too unquantifiable.

87 Laruelle, *Introduction au Non-Marxism*.

88 Laruelle, *Principles of Non-Philosophy*, 141.

89 Priest, *Towards Non-Being*, 32–33.

90 Laruelle, "I, the Philosopher, Am Lying," 71–73. In the original French, the essay is titled simply "Réponse à Deleuze." Priest refers to the Megarian philosopher Eubulides's version of the Liar paradox. The strange reference to "Epimetheus" (brother of Prometheus) by Laruelle is presumably meant as a reference to "Epimenides," the lying Cretan.

91 Hegel, *Lesser Logic*, section 48, cited in Priest, *In Contradiction*, 1.

92 Priest, *In Contradiction*, 299.

93 Ibid., 102.

94 Ibid., 107.

95 See Weber, "Paraconsistent Logic."

96 Laruelle et al., *Dictionary*, 43.

97 See Weber, "Paraconsistent Logic."

98 Ibid.

99 Laruelle, *Non-Philosophy Project*, 30–31.

100 Ibid., 199.

101 Laruelle, *Principles of Non-Philosophy*, 143. See also Laruelle, *Anti-Badiou*, 223: "the Real of immanence, by virtue of the particle that it configures, is the non-dialectical solution to contradiction and to antinomies."

102 Laruelle, *Concept of Non-Photography*, viii.

103 Laruelle, *Principles of Non-Philosophy*, 143.

104 As Zach Weber puts it, "a paraconsistent logician can say that a theory is *inconsistent* without meaning that the theory is *incoherent*, or *absurd*." Weber, "Paraconsistent Logic."

105 Priest, *In Contradiction*, 5.

106 Laruelle, *Struggle and Utopia*, 135.

107 See Kabay, *A Defense of Trivialism*.

108 Laruelle, *Philosophy and Non-Philosophy*, 138.

109 Priest, *In Contradiction*, 117.

110 Laruelle, *Concept of Non-Photography*, 75.

111 Laruelle, *Introduction aux sciences générique*, 119.

112 Priest, *In Contradiction*, 162.

113 Ibid. He also admits that "my discussion so far has been predicated upon the assumption that there are instants of time. If there are no instants, there are no instants of change, and the problem of the instant of change, and the conclusions I have drawn from it, are no longer available. This has led some people to suggest that time is composed of intervals rather than instants" (162). Quite so.

114 Ibid., 170, 161.

115 Ibid., 175, 170.

116 Jaki, "The Physicist and the Metaphysician," 189. Jaki attributes this view to Réginald Garrigou-Lagrange.

117 Laruelle, *Philosophy and Non-Philosophy*, 85.

118 See Laruelle, *Introduction aux sciences générique*, 73, 76.

119 Laruelle, *En tant qu'un*, 40.

120 Laruelle, *Philosophy and Non-Philosophy*, 63–64, 74. See also 65: "This is not an *activity* of idealization or of ideation, this is an *extraction* by

the One." Also 68: "The radical 'interruption' of all circularity . . . is the same thing as the transcendental extraction of the *a prioris* by the One."

121 Deleuze, *Nietzsche and Philosophy*, 30.

122 See, e.g., Jarry, *Exploits and Opinions of Dr. Faustroll, Pataphysician*; Bök, '*Pataphysics*.

123 Laruelle, *Philosophy and Non-Philosophy*, 230, 234.

124 Cited in Hjort, "*The Five Obstructions*," 632. Livingston, "Artistic Nesting," 73, states that "we will probably never know how much genuine competition was in play in Leth's and von Trier's interactions in the making of *The Five Obstructions*. Whether the film can be resolutely classified as fiction or non-fiction is far from obvious, but even if one tends to think that it was on the whole framed by its makers as targeting belief rather than make-believe or imaginings, it has to be recognised that fictionalizing was a means along the way, if not the ultimate end."

125 See Lambert-Beatty, "Make-Believe," 54: "Fiction or fictiveness has emerged as an important category in recent art. But, like a paramedic as opposed to a medical doctor, a parafiction is related to but not quite a member of the category of fiction as established in literary and dramatic art. It remains a bit outside. It does not perform its procedures in the hygienic clinics of literature, but has one foot in the field of the real. Unlike historical fiction's fact-based but imagined worlds, in parafiction real and/or imaginary personages and stories intersect with the world as it is being lived."

126 Mackay and Laruelle, "Introduction," 31.

127 Laruelle, *Anti-Badiou*, 211, 212, my italics.

128 Laruelle, *Philosophie non-standard*, 489, 593; Schmid, "Quelque chose rouge dans la philosophie," 127.

129 Laruelle, *Philosophy and Non-Philosophy*, 239.

130 Laruelle, *Philosophie non-standard*, 492, 489.

131 See ibid., 181–84, for a formulation of the Copenhagen interpretation of quantum mechanics according to a "non-Schrödingerian cat."

132 Laruelle, *Philosophy and Non-Philosophy*, 234.

133 Laruelle, *Anti-Badiou*, 223.

134 Ibid., 224.

135 Laruelle, *Philosophy and Non-Philosophy*, 227–28, 229.

136 Ibid., 229.

137 Ibid., 211. Even where Laruelle in his later work does valorize the imaginary in relation to the fictionale, it is via the Real of "imaginary numbers" in mathematics (such as the square root of −1: imaginary numbers were once called "impossible numbers").

138 Priest, *Towards Non-Being*, 128.

139 Ibid., 131.

140 Laruelle, *Principles of Non-Philosophy*, 44.

141 Priest, *Towards Non-Being*, 121.

142 Nolan, "A Consistent Reading of Sylvan's Box," 669.

143 See ibid., 670. The question of lying—is Priest lying about whether it did happen or it did not happen—has been notable in the subsequent secondary literature. See, e.g., Chris Mortensen's work on "Inconsistent Images" and Priest/Sylvan. Mortensen here also claims to have seen the box, but then adds, "Needless to say, I must reassure readers, who may be discomfited by the thought that there are true contradictions, that I am lying." Mortensen, "Inconsistent Images."

144 Priest, "Sylvan's Box: A Short Story and Ten Morals," 579, 581. He goes on, "In reality I found no such box. This is a truth that has been deleted to construct the story: it is not the case that I both did and did not find a box." Of course, Priest tantalizes us here by denying *both* that he found an impossible object *and* that he both did and did not find one. Yet he still confines this intentional *ambiguation* to a coda discussing metafictional issues.

145 Laruelle, *Anti-Badiou*, 212.

146 Laruelle, *Concept of Non-Photography*, 30.

147 Laruelle, *Principles of Non-Philosophy*, 144.

148 Laruelle, *Philosophy and Non-Philosophy*, 18.

3. HOW TO ACT LIKE A NON-PHILOSOPHER

1 Apart from artifacts (both visual and auditory) stemming from the new contemporary setting of the story and its recasting, the most startling intentional differences come in the two murder scenes, which have surreal/subjective inserts.

2 See Cheshire, "Review: *Psycho*—'Psycho' Analysis," and Lien, "Review of *Psycho*."

3 In DeLillo's *Point Omega*, two characters, facing the installation from different vantage points, debate whether the product of Gordon's manipulation is meant to be an elevation of the horror of the original or the introduction of humor.

4 Laruelle, *Principles of Non-Philosophy*, 232.

5 Priest, *In Contradiction*, 99.

6 An alternative example would be the work of theater director Jetzy Grotowski, whose actor training exercises were "designed to develop the ability of the actor to express different, and even contradictory, things with different parts of his body at the same time." Kirby, "On

Acting and Not-Acting," 7. A posture (behavior) can be both itself and a "negative" for Grotowski (or "double negative"). Though he himself understood such contradictions ("*conjunctio-oppositorum*") dialectically on account of his prior education in Marxism and Hegelianism (see Slowiak and Cuesta, *Jetzy Grotowski,* 44, 68–69), one can retain the notion of contradictory bodily behavior and render it immanently as the movement of the body itself—that only becomes "realized contradiction" laterally through philosophical mediation.

7 Brassier, *Nihil Unbound,* 133.

8 Ibid., 134.

9 Laruelle, *Principles of Non-Philosophy,* 98, 100.

10 Laruelle, *Anti-Badiou,* 14–15.

11 Pepper, *World Hypotheses,* 232.

12 See Hallward, *Badiou,* 348.

13 Badiou, *Being and Event,* 178. For a general critique of Badiou on this arbitrariness of the event, see Mullarkey, *Post-Continental Philosophy,* chapter 3.

14 See Sartre, *Being and Nothingness,* 561: "But to be, for Flaubert, as for every subject of 'biography,' means to be unified in the world. The irreducible unification which we ought to find, which is Flaubert, and which we require biographers to reveal to us—this is the unification of an original project, a unification which should reveal itself to us as a non-substantial absolute."

15 Ibid., 573, 565.

16 Ibid., 563.

17 Bergson, *Creative Mind,* 112.

18 Ibid.

19 Alas, there are no philosophical events for Badiou, and so the philosophical decision is not eventful.

20 Cited in Hjort, "Style and Creativity in *The Five Obstructions,*" 21.

21 Ibid.

22 Smith, "Funny Games," 135.

23 Livingston, "Artistic Nesting in *The Five Obstructions,*" 65.

24 Dwyer, "Romancing the Dane," 6.

25 Hjort, "Style and Creativity in *The Five Obstructions,*" 33.

26 Of course, we must be open to the possibility that it might also be that the "crap" results from the animated material *failing* to behave as decided, but that does not appear to be the issue for either von Trier or Leth here.

27 Schepelern, "To Calculate the Moment," 98.

28 Laruelle, *Introduction aux sciences générique,* 119.

29 Laruelle, "Concept of 'First Technology'"; Laruelle, *Anti-Badiou*, 4.

30 Smith, "Funny Games," 130.

31 Ibid., 118.

32 Hjort, "Style and Creativity in *The Five Obstructions*," 22, 23.

33 Danto, *Transfiguration of the Commonplace*, 204.

34 Laruelle, *Principles of Non-Philosophy*, 35; Laruelle, *Philosophy and Non-Philosophy*, 232.

35 Laruelle, *En tant qu'un*, 33–40, 34–35. Choplin, *De la Phénoménologie à la Non-Philosophie*, 166–69, also has a section titled "Changer de Posture," which he relates to the "discovery of the One." In Laruelle's *En tant qu'un*, posture is described as "global change," with "less restricted universals that those of philosophy" (37, 39).

36 Laruelle, *Théorie des identités*, 58; Laruelle, *Philosophy and Non-Philosophy*, 243, 74. See also Laruelle, "Concept of 'First Technology'": "We give ourselves a space, a posture rather or a scientific but transcendental interiority (which adds nothing to the concept of science) in which we will project these meta-technical discourses. A posture, that is to say here the minimal conditions for having a science, a *reality* of this latter." Adopting, and mutating, a more Badiouian language, Laruelle, in *Anti-Badiou*, 85, refers to the phrase "'stances of truth [*postures de vérités*],' which is less technical, more human and perhaps broader, and which, above all, can also encompass philosophy, since the problem is that of their all arriving at the generic, a trait that is not given them from the start."

37 Laruelle, *Philosophy and Non-Philosophy*, 54.

38 Laruelle, *Principles of Non-Philosophy*, 179. Gangle, *François Laruelle's Philosophies of Difference*, 153, confirms this: "position" (whose etymology is linked to that of *thesis*) belongs to a "decisional stance with respect to the Real: *the Real may/must be decided by thought.*"

39 Laruelle, "Toward a Science of Philosophical Decision," 85–86.

40 Laruelle, *Philosophy and Non-Philosophy*, 42.

41 Laruelle, *Introduction aux sciences génériques*, 117–20.

42 Laruelle, *Philosophy and Non-Philosophy*, 25.

43 Ibid., 149.

44 Laruelle, *Concept of Non-Photography*, 6, translation altered.

45 Ibid., 19, translation altered.

46 Ibid., 12, translation altered.

47 Laruelle, *Photo-Fiction*, 57.

48 Ibid., 19.

49 Goodwin, "Pointing as Situated Practice," 225.

50 For example, Schumacher, *Human Posture*, 18, notes, "Merleau-Ponty

spoke of a person's body as the system of all that person's holds on the world. Not surprisingly, the root of the term 'system' is to-place-or-set-together."

51 Baraklianou, "*Pasearse*," 131–32. See also Agamben, "Absolute Immanence," 234: "In Ladino (that is, in the archaic Spanish spoken by Sephardim at the time of their expulsion from Spain), 'to stroll' or 'to take a walk' is expressed by the verb *pasearse* ('to walk-oneself' . . .). As an equivalent for an immanent cause, which is to say, an action that is referred to the agent himself, the Ladino term is particularly felicitous."

52 Baraklianou, "*Pasearse*," 143.

53 Laruelle, *Introduction aux sciences génériques*, 119.

54 Heller, *Radical Philosophy*, 136–37.

55 Laruelle, *Concept of Non-Photography*, 48.

56 See Laruelle, *Théorie des Étrangers*, 57, 68, 166; Laruelle, *Future Christ*, 25; Laruelle, *Philosophy and Non-Philosophy*, 230; Laruelle, "Controversy over the Possibility of a Science of Philosophy," 91; Laruelle, *Théorie des Identités*, 76.

57 Laruelle et al., *Dictionary*, 61. See also Kolozova, *Cut of the Real*, 13–14: "By 'radicalization' I mean getting to the roots of the discourse that has become one's theoretical inertia. Therefore, the use of the word 'radical' is etymological."

58 Laruelle, *Principles of Non-Philosophy*, 190.

59 Laruelle, *Anti-Badiou*, 6.

60 Torneke, *Learning RFT*, 11–12.

61 Laruelle, *Principles*, 7, 73.

62 Cited in "The Five Obstructions," in Stjernfelt, *Film: Special Issue: Jørgen Leth*, 32.

63 That said, in films such as Leth's own *Notater om kærligheden* (Notes on love) from 1989, Leth apparently likes to be in front of the camera too: "I'm fascinated with this idea of performing an action while at the same time observing myself doing it. There's a kind of 'schizophrenia,' if you will—which is perhaps part of life too—in both my poetry and my films." Cited in Hjort, "Style and Creativity in *The Five Obstructions*," 31.

64 Examples of some recent scientific (and neobehaviorist) studies of posture as an affective–communicative element include Coulson, "Attributing Emotion to Static Body Postures"; Bernhardt, "Posture, Gesture, and Motion Quality"; Bianchi-Berthouze et al., "On Posture as a Modality for Expressing and Recognizing Emotions"; Riskind and Gotay, "Physical Posture"; and the earlier Bull, *Posture and Gesture*.

65 Wittgenstein, *Philosophical Investigations*, 178.

66 Laruelle, *Anti-Badiou*, 61–62.
67 Ibid., xxi, 212–13. In Annette Baier's list of "postures of the mind" (Baier, *Postures of the Mind*, 39), she includes "wondering, revising, correcting, rejecting, ignoring, welcoming, repenting, forgiving, redeeming."
68 Ryle, *Concept of Mind*, 279–80.
69 Evans, "Behaviourism as Existentialism," 66. What is just as interesting in this account, however, is when Ryle translates what seem like irredeemably inner states, for they also become forms of power. "Thinking things out," for instance, is reviewed as "saying things to oneself, or to one's other companions, with an instructive intent. The assertion of each proposition is intended to equip or prepare the recipient to turn what he is told to further accounts, to use it, for example, as a premise, or as a procedure maxim." Ryle, *Concept of Mind*, 294–95. This form of "thinking" becomes instructing, a form of educational authority, though one reposing in public behavior rather than private states of mind.
70 Cappuccio, "Introduction: Pointing," xxxi. See also Valiaho, *Mapping the Moving Image*, 17, on this expanded notion of the gesture: "Generally speaking, the gesture is not simply bodily movement but 'a manner of carrying the body,' as the Oxford English Dictionary defines it. It is a corporeal rhythm that has become expressive, a rhythm of quality. . . . The gesture can thus be seen as a very basic mode of distantiation and separation. Instead of being merely a means of communication, it imparts a sense or 'feeling' of demarcation, which is a vital process of psychogenesis at the source of life." The use of the body in creating distance and re-creating immanence will be explored later.
71 Laruelle, *Philosophy and Non-Philosophy*, 141.
72 Ibid., 149.
73 Wittgenstein, *Philosophical Investigations*, 49.
74 See Roy, "What's So Bad with Infinite Regress?," draft article at http://cal.csusb.edu/Faculty/Philosophy/roy/regress-pap.pdf.
75 See Dennett, *Brainstorms*, 3–22. See also Dennett's *Intentional Stance*. Dennett himself is ambivalent as regards his own status as a behaviorist. In Dennett's *Consciousness Explained*, he reports how he has met with the following kind of questioning: "But you are, *really*, a sort of behaviorist, aren't you? This question has been asked before, and I am happy to endorse the answer that Wittgenstein (1953) gave to it: 'Are you not really a behaviourist in disguise? Aren't you at bottom really saying that everything except human behaviour is a fiction?—If I do speak of a fiction, then it is of a grammatical fiction.' Several philosophers have seen what I am doing as a kind of redoing of Wittgenstein's attack on the 'objects' of conscious experience. Indeed it is" (462).

76 Laruelle, "Transcendental Method," 136, 137; Laruelle, *Anti-Badiou*, 32.

77 Laruelle, "What Is Non-Philosophy?," 236; Laruelle, "Is Thinking Democratic?," 229; Laruelle, *Principles of Non-Philosophy*, 133.

78 Gangle, *François Laruelle's Philosophies of Difference*, 16.

79 See ibid., 180.

80 Cappuccio, "Introduction: Pointing," xxx.

81 Laruelle, *Anti-Badiou*, 144.

82 Laruelle, *Philosophy and Non-Philosophy*, 240.

83 Laruelle, *Anti-Badiou*, 67. This rejection of Kantian transcendental illusions in *Anti-Badiou* is a recent development in Laruelle's thought; for his earlier positive use, see, e.g., *Philosophy and Non-Philosophy*, 131, 163, 241, and *Principles of Non-Philosophy*, 152, 216.

84 Laruelle, *Anti-Badiou*, 66–67.

85 Laruelle, *Philosophy and Non-Philosophy*, 94, 110.

86 Laruelle, "Degrowth of Philosophy," 340, 343.

87 Dufrenne, *Notion of the A Priori*, 159, my italics; Lefebvre, *Production of Space*, 289, 288; Stiegler, *Technics and Time*, 2:2, 3, 6, 11; Ahmed, *Queer Phenomenology*.

88 Kant, "What Is Orientation in Thinking?," 237.

89 Ibid., 239.

90 Ibid., 245.

91 Ibid., 249n, italics original.

92 Laruelle, *Philosophy and Non-Philosophy*, 84.

93 Ibid., 53.

94 For another version of this contrast, see Laruelle, *Intellectuals and Power*, 145–46: "Reversing and inversing are not the same gesture. To reverse is to rectify an erected idol, history—this is what every philosopher does, especially the most recent ones like Deleuze and Foucault, and even Derrida. But to uni-lateralize is to invert the World, to make history fall from the height of its pretensions to meaning or to some 'end.' To invert is a radical gesture that can only come from nowhere, meaning from Man-in-person, and which uni-lateralizes history and other forms of domination."

95 Laruelle, *Philosophy and Non-Philosophy*, 50–51.

96 Laruelle, *Principles of Non-Philosophy*, 217; see also Brassier, *Nihil Unbound*, 134.

97 Laruelle, *Intellectuals and Power*, 52.

98 Laruelle, *Principles of Non-Philosophy*, 125.

99 Laruelle, *Intellectuals and Power*, 50; see also Laruelle, *Principles of Non-Philosophy*, 72.

100 Laruelle, *Introduction au Non-Marxism.*

101 Laruelle, *Principles of Non-Philosophy,* 102.

102 See Cull, *Theatres of Immanence,* 122–26.

103 Baraklianou, "Moiré Effect," 90.

104 Ibid., 93.

105 Ibid., 94. One can see the *moiré* effect as a macrophenomenal version of the quantum phenomena favored by Laruelle in his most recent work. As Baraklianou puts it, "moire patterning and monochromatic light diffraction were noted by the inventor of photography, Henry Fox Talbot, as early as 1836. Talbot's 'fractal carpets' are observed when a light beam is diffracted through measured out slates or gratings, creating patterned sequences of the same image at varying distances. The 'Talbot effect,' as it is otherwise known, is one of the optical phenomena that involve the extreme coherent interference of waves. In theory, quantum carpets can produce the same image in a discontinuous patterning array. Belonging to the limits of physics and number theory, these phenomena have only recently been revisited, not least because of their importance in quantum physics" (81).

106 Laruelle, *Photo-Fiction,* 55.

107 Laruelle, *En tant qu'un,* 50. As Smith and Rubczak point out in "Cloning the Untranslatable," xvi, "Laruelle will often playfully ape the style of some other philosopher."

108 In Book III of *The Republic* (Jowett translation), Plato promises that "pantomimic gentlemen, who are so clever that they can imitate anything," will not be "permitted to exist."

109 Jürs-Munby, "*Hanswurst* and *Herr Ich,*" 129, 130.

110 See Agamben, "Notes on Gesture," 49–60.

111 Mayer, "Acting in Silent Film," 13. See also Naremore, *Acting in the Cinema,* 50: "From the late Renaissance until the eighteenth century, leading actors worked from what was known as the 'teapot' stance—a position influenced by Greco-Roman statuary, in which the male figure is posed with one foot forward, one hand on the hip, and the other lifted in gesture."

112 For a grounding in the theory of communicative and philosophical gesture (both human and nonhuman), see McNeill, *Gesture and Thought*; Agamben, "Notes on Gesture"; Valiaho, *Mapping the Moving Image*; Châtelet, *Figuring Space*; Guérin, *Philosophie du geste*; Schmitt, *La Raison des gestes*; Kita, *Pointing*; Cappuccio, *Pointing*; Roy, *Trouer la membrane*; Stiegler, *Technics and Time,* vol. 1. See also Lefebvre, *Production of Space,* 174, 215.

113 Naremore, *Acting in the Cinema,* 51, 52. Naremore adds: "'Pantomime'

in this sense has something in common with the techniques of silent performance, but it is a much broader concept, indicating a whole attitude toward the mechanics of gesture. As Benjamin McArthur has pointed out, for most actors in the nineteenth century, 'each emotion had its appropriate gesture and facial expression, which were passed down from one generation to the next.... Books were written analyzing, classifying, and breaking down gestures and expressions into their component parts.' Until fairly recently, the old 'cookbook' tradition seemed almost to define acting. 'The fundamental concept of codified pantomime,' John Delman has remarked, 'is several thousand years old, while the modem tendency to laugh off all codes and conventions is younger than the memory of living men'" (51).

114 Schmitt, *La Raison des gestes,* 41, 177ff. My thanks to Sven Läwen for this reference.

115 Engberg-Pedersen, "From Pointing to Reference and Predication," 287.

116 Bergson, *Matter and Memory,* 100.

117 Bergson, *Mind-Energy,* 56, 58.

118 Laruelle, *Introduction aux sciences générique,* 118.

119 Ibid., 119.

120 Ibid., 120.

121 Stiegler, *Technics and Time,* 1:145.

122 Leroi-Gourhan, *Gesture and Speech,* 19.

123 Laruelle, *Anti-Badiou,* 32.

4. THE PERFECT NONHUMAN

1 Bergson, *Matter and Memory,* 71.

2 See Mullarkey, *Philosophy and the Moving Image.*

3 See Williams, "Film Bodies: Gender, Genre, and Excess."

4 German media theorist Dieter Mersch writes of a "plurality of showing" that "refers to a practice which cannot alone be reserved for the iconic." Mersch continues to discuss a "visual or pictorial thought ... [that] has to also be non-discursive or non-dichotomous or non-oppositional ways of differentiating, whereby the 'logic' of showing can be identified as an example of such differentiation." Mersch, "Aspects of Visual Epistemology," 177, 181–82.

5 Bazin, "Les films d'animaux nous révèlent le cinéma," 126, my translation.

6 Laruelle, *Philosophy and Non-Philosophy,* 200.

7 See Mullarkey, "Animal Spirits," 11–29.

8 Sartre, *Critique of Dialectical Reason,* 1:111.

9 Galloway, "Review of François Laruelle, *Théorie générale des victimes*," 105.

10 Laruelle can use "animal" with scare quotes one moment—as in *Future Christ*, 7 ("it is still an 'animal' essence there [of aggression]")—to mark his distance from a philosophical abuse but then muddy things by identifying the animal as a true philosophical entity (rather than victim of abuse): "heresy is the innocence of Man, undoubtedly because it is not completely a metaphysical animal, which is to say an animal" (70). Or see also Laruelle, "Le Tsunami et le Mythe du Poisson-eau," 14: "In the history of the 'evolution' of the philosophising species, the properly human stage, of which the model would be the fish-water, has been preceded by the stage of the actual philosopher. The philosopher has features of the ancient animal, but not of the most archaic, that was forced out of its first element, water."

11 Cited in Viveiros de Castro, "Cosmologies: Perspectivism," 101.

12 Ibid.

13 Laruelle, *Philosophie Non-Standard*, 320.

14 See Kolozova, "Theories of the Immanent Rebellion," and Kolozova, *Lived Revolution*.

15 This, of course, reorients the Hegelian view, as articulated by Adorno, in *Negative Dialectics*, that "not even as an idea can we conceive a subject that is not an object; but we can conceive an object that is not a subject. To be an object also is part of the meaning of subjectivity; but it is not equally a part of the meaning of objectivity to be a subject" (183). It is *this* latter conceptual possibility that needs to be reexamined.

16 Admittedly, Laruelle can also refer to the "lived" *(le vécu)* as a conceptual standard, yet there is no reliance on a *vitalistic* concept of "Life" here (hence his term "lived-without-life" in *Anti-Badiou*, 232). We must note that, no less than the human or "Man-in-person," none of these concepts are actually defined by Laruelle or deemed given and are only hypothesized (and *used*) as identical with the Real, "in-the-last-instance." And it becomes consequently evident that they too call for non-philosophical treatment. In other words, we should think of the "non-lived," say, as an amplification of the normal set of definitions for the lived (or, indeed, the human).

17 Laruelle, *En tant qu'un*, 32, 33.

18 Laruelle, *Intellectuals and Power*, 37.

19 See Laruelle, "Le Tsunami," 10; Laruelle, *Philosophy and Non-Philosophy*, 89. See also ibid., 90–91.

20 Laruelle, *En tant qu'un*, 250: "The One, The Real, Man" ("it's all the same to me" [*même combat*]). We say that Laruelle's gendered use of

"man" is *mostly* an artifact of the French language because there may also be a para-religious use of Man that alludes to the gnostic Christ—a restricted area we must leave aside for a future analysis.

21 Ibid., 207. See also 59, 185, 210–11. Laruelle's use of the term *individual* is somewhat nuanced, as Anthony Paul Smith points out: "it is difficult to express in a single word the meaning of *individual* in English as Laruelle differentiates *individual* from *individuel*. The first is a neologism of his own construction playing on the sense of 'dual' to express the fundamental duality of individuals, and the second is the term that is usually translated into English as individual, but he plays with the 'duel,' which means the same in English as it does in French, to signify that it is a fundamentally antagonistic concept." Smith, *A Non-Philosophical Theory of Nature*, 241n18.

22 Laruelle, *En tant qu'un*, 216.

23 See Laruelle, *Future Christ*, 2: "'The-man' of the philosophers and of common sense is a generality that levels out a special duality, an *individuality* through which it is a cause or determinate identity of the subject in-struggle with the World, Christianity, gnosis and Judaism included."

24 Laruelle, *Théorie des Etrangers*, 162, 166. When Laruelle says that "man only exists as absolutely relational," he means as "the phenomenal identity of all relation" (rather than as in a relational philosophy, which is only as a "semi-rapport" or "semi-term").

25 Laruelle, *Intellectuals and Power*, 83. See also Laruelle, "I, the Philosopher, Am Lying," 69: "That thought could be conceived as an 'ethology' albeit of the 'superior' or 'transcendental' type, can only inspire disgust: man is neither plant nor animal, whether terrestrial or celestial, nor even a becoming-plant or a becoming-animal—yet it is still necessary to feel *(sentir)* this rather than to resent *(ressentir)* it and let it be lost in resentment and repression."

26 Laruelle, "Degrowth of Philosophy," 349.

27 Wolfe, *What Is Posthumanism?*, 99.

28 Clarke, *Paradox of the Posthuman*, 1.

29 Wolfe, *What Is Posthumanism?*, xiii.

30 Fuller, *Humanity 2.0*, 2.

31 Hook, "Transhumanism and Posthumanism," 2517–20.

32 Laruelle, "Degrowth of Philosophy," 328.

33 Stiegler, *Technics and Time*, 1:150.

34 Laruelle, *Philosophy and Non-Philosophy*, 130. This is described by Laruelle as "Rule 1" of a "list of the rules of procedures." It is "the most important because it describes the pivot of the whole operation" (132).

35 Laruelle, *Théorie des Etrangers*, 24.

36 Mackay and Laruelle, "Introduction," 11–12.

37 Laruelle, *Anti-Badiou*, 231, my italics.

38 This is particularly true of Cavell's work, such that the second edition of *The World Viewed* goes out of its way to show how cartoons can be realist because they install a series of "animated world projections." See Cavell, *World Viewed*, 167–73. There is still a world in a cartoon—the crucial criterion for Cavell's realism—only it is an animated one.

39 Perhaps it is notable at this point that von Trier's film *The Idiots* (1998) concerned the pretense of mental retardation in public, a quite Cynical form of public behavior.

40 Ponech, "Work and Play," 85. In the film, it is clearly a tortoise.

41 Smith, "Funny Games," 134.

42 Ibid., 139n12.

43 Ironically, when Leth sees Sabiston's first drafts of his work, he likes almost everything—"they're all good"—and is unsure of what *not* to use in the final version: "I don't know what to do there," he says.

44 Smith, "Funny Games," 132.

45 Laruelle, *Philosophy and Non-Philosophy*, 247.

46 It is interesting on this score that the "type specimen" of *Homo sapiens* was and remains the biologist Carl Linnaeus (1707–78). In other words, the man who laid the foundations for our modern biological naming scheme used himself as the model for his own species. Narcissism indeed.

47 Laruelle, *Théorie des Etrangers*, 40.

48 Laruelle et al., *Dictionary*, 30.

49 Laruelle, *Théorie des Etrangers*, 22, 41.

50 Laruelle, *En tant qu'un*, 37. Used by Hobbes, but originally attributed to Plautus (circa 254–184 BC), *Homo homini lupus est* (man is a wolf to man) is usually taken to refer to the cruelty some men are capable of in their treatment of their fellow man.

51 Laruelle, *Théorie des Etrangers*, 40.

52 Badiou, "Review of Gilles Deleuze: *The Fold*," 55.

53 Deleuze and Guattari, *What Is Philosophy?*, 109.

54 Derrida, *Animal That Therefore I Am*, 29.

55 Derrida, "Eating Well," 112.

56 *Animaux* (French for "animals") is a French homophone with Derrida's neologism *animot*. This phonic identity, subtended by written difference, allows him to play upon the written French plural for animals and the French for "word" *(mot)*, thereby revealing once more (as he did with "*différance*") how writing determines linguistic meaning through difference. See Derrida, *Animal That Therefore I Am*, 41, 47–48, 55.

57 Haraway, *When Species Meet,* 20.

58 This is something that Derrida himself avows—"I who always feel turned toward death" (Derrida, *H.C. for Life,* 36).

59 Burt, "Morbidity and Vitalism," 158–59.

60 See Midgley, *Beast and Man,* 349, 349n21.

61 Latour, *We Have Never Been Modern,* 137.

62 Derrida, *Animal That Therefore I Am,* 48.

63 Deleuze and Guattari, *What Is Philosophy?,* 109.

64 Deleuze and Guattari, *Anti-Oedipus,* 107.

65 See Irigaray, *This Sex Which Is Not One,* 141.

66 Deleuze and Guattari, *A Thousand Plateaus,* 238. Deleuze continues that this is true of the becoming of the animal as well, in its "becoming something else." But his oblique reference to "something else" is in clear contrast with the order of human becomings (from woman through animal to imperceptible): animal becoming does not interest him inasmuch as it might participate in anything affirmative *for it.*

67 Ibid., 11.

68 This is also to leave aside the paradox of a philosophy that *commends* what everyone and everything already *is* (in an ontology of absolute immanence): see Mullarkey, *Post-Continental Philosophy,* 36–41, for more on this.

69 Deleuze and Guattari, *A Thousand Plateaus,* 239.

70 Ibid., 399, 260.

71 The reference to the dying rat cited in the preceding quotation stems from the use of rat poison by the character of Lord Chandos in Hugo von Hofmannsthal's epistolary fable. See Lawlor, "Following the Rats."

72 Deleuze and Guattari, *A Thousand Plateaus,* 293. In *A Thousand Plateaus,* 316, there is the example of the stagemaker bird as a kind of artist ("the stagemaker practices *art brut.* Artists are stagemakers, even when they tear up their own posters"), but this is on account of the transversal and inhuman nature of art rather than the becoming-human of the bird per se.

73 And this despite the fact that, as John Protevi has argued, "Deleuze's most basic philosophical instinct is against anthropomorphism." Protevi, *A Dictionary of Continental Philosophy,* 132.

74 For the full critique of Badiou's illegitimate exclusion of animal advocacy from his concept of the political event, at least as described in *Being and Event,* see Mullarkey, *Post-Continental Philosophy,* 117–21.

75 Badiou, *Logics of Worlds,* 2.

76 Badiou's philosomorphism is openly Platonic on this front, for when he does engage with animals explicitly, he prefers their Forms over their

specific instances. And, as with Deleuze, it is horses that loom large in this mediation. Badiou's *Logic of Worlds* opens with the Platonic idea of the Horse as it runs from prehistoric cave painting through to Picasso. Contra Antisthenes's remark to Plato—"I do see some horses, but I see no Horseness"—Badiou contends that it is *nothing but Horseness* that we see: "Nevertheless, I contend that it is indeed an invariant theme, an eternal truth, which is at work between the Master of the Chauvet cave and Picasso. Of course, this theme does not envelop its own variation, and everything we have just said about the meaning of the horses remains correct: they belong to essentially distinct worlds. In fact, because it is subtracted from variation, the theme of the horse renders it perceivable.... We simultaneously think the multiplicity of worlds and the invariance of the truths that appear at distinct points in this multiplicity" (18).

77 Agamben, *The Open*, 77.

78 Oliver, *Animal Lessons*, 232.

79 Agamben, *The Open*, 58.

80 Ibid., 37–38, penultimate italics mine.

81 Ibid., 92.

82 Lippit, "Death of the Animal," 18.

83 Burt, "Morbidity and Vitalism," 165.

84 For further readings on anthropomorphism, see Daston and Mitman, *Thinking with Animals*; see also Guthrie, *Faces in the Clouds*.

85 Hume, *Natural History of Religion*, section 3.

86 Laruelle et al., *Dictionary*, 8.

87 We must recognize that such a "leap" is a retroactive construction. See Laruelle, "Controversy over the Possibility of a Science of Philosophy," 92.

88 See also Kolozova, *Cut of the Real*, 108, 123: "I see it as my 'non-philosophical duty' to persevere in this posture of thought and secure a radical openness of thought.... I am arguing for the possibility of establishing a relation of empathy—or of the 'compassion' Laruelle writes about in his *Théorie generale des victimes* from 2012—with such a transcendental rendition of the other's otherness, one based on the inceptive gesture of reaching out to the other by means of enacting solidarity with her or his (or its) imagined radical solitude and insurmountable singularity."

89 Smith, *A Non-Philosophical Theory of Nature*, 220.

90 O'Sullivan, *Animals, Equality, and Democracy*, 5.

91 Wolfe, *Animal Rites*, 101.

92 Laruelle, *Théorie des Etrangers*, 162.

93 Latour, *We Have Never Been Modern*, 136.

94 Laruelle, *Philosophie Non-Standard*, 507.

95 See Dennett, *Brainstorms*, 3–22. Wolfe, *What Is Posthumanism?*, 34, 36ff., mounts a significant critique of Dennett's hermeneutics. His "functionalist approach" to what it is to have a mind, he argues, "is unable to escape the spell of the very philosophical tradition (whose most extreme expression is Cartesian idealism) that he supposedly rejects. . . . The primary problem with Dennett . . . is not just that he overlooks how the prosthetic nature of the human permanently destabilizes the boundaries between 'our' thinking and anyone—or more radically, any*thing*—else's. It is that he then—in a subsidiary move—uses a fundamentally representationalist concept of language that reinstalls the disembodied Cartesian subject at the very heart of his supposedly embodied, materialist functionalism." See also Wolfe, *Animal Rites*, 89.

96 Laruelle, *Anti-Badiou*, 31. "OV/NP" equates to Badiou's "Ontology of the Void"/Laruelle's Non-Philosophy.

97 Mackay and Laruelle, "Introduction," 11.

98 Laruelle, *Théorie des Etrangers*, 110.

99 Laruelle, *General Theory of Victims*, 89. There are also some backhanded compliments to animality here (89, 88): "as there is no creation, neither is Man-in-person a kingdom within that kingdom; Man-in-person has no priority over the animal" (yet Man does have a "prior priority"); or Man is not exceptional, "the whole world is victimisable," and the "simple animal" too can be "protected that is, defended" (and yet "it cannot be treated better than man").

100 Ibid., 89.

101 Laruelle, "Is Thinking Democratic?," 236.

102 Laruelle, *Future Christ*, 23, my italics.

103 Cited in Badiou, *Infinite Thought*, 127.

104 Agamben, *The Open*, 79.

105 Thacker, "Thought Creatures," 328.

106 Kolozova, *Lived Revolution*, 113, my italics. What Kolozova refers to here as the "behind" is analyzed in cinematic and philosophical terms as the "background" in Mullarkey, "Animal Spirits," and Mullarkey, "Tragedy of the Object."

107 Kolozova, *Lived Revolution*, 138, italics mine.

108 Ibid., 144. For Kolozova, "suffering" or "pain" is a radical concept "in the Laruellean sense of the word."

109 Berger, *Why Look at Animals?*, 261.

110 See Lippit, *Electric Animal*; Burt, *Animals in Film*.

111 Burt, *Animals in Film*, 22, 43.

112 See Mullarkey, *Philosophy and the Moving Image*, 202–4, for an analysis of the double-edged nature of this specific attempt at a reality effect created through manipulating real death.

113 Agamben, "Difference and Repetition," 314. For more on this animality of cinematic perception—especially in connection with autism and Temple Grandin's work on picture-thinking, see Mullarkey, "Temple Grandin's Animal Thoughts."

114 Thacker, *In the Dust of This Planet*, 9.

115 See Rowlands, *Philosopher at the End of the Universe*, 3.

116 See the journal *Collapse*, vol. 4, for the special issue collecting essays on "concept-horror."

117 Cholodenko, "Animation of Cinema," 1.

118 See Rossell, "Double Think," 31: "it is on the basis of this negotiation that the first cinema audiences were so startled, as Vaughn and many contemporary reporters noted, by the gentle fluttering of background leaves on trees, and other non-central 'inessential' details of the first films." See, e.g., the following report in the *Post-Express* from February 6, 1897 (cited in Pratt, *Spellbound in Darkness*, 17, 18): "The Lumiere Cinematographe will begin its fifteenth consecutive week at the Wonderland [theatre] next week, continuing what was long ago the longest run ever made by any one attraction in this city. People go to see it again and again, for even the familiar views reveal some new feature with each successive exhibition. Take, for example, *Baby's Breakfast*, shown last week and this. It represents Papa and Mamma fondly feeding the junior member of the household. So intent is the spectator usually in watching the proceedings of the happy trio at table that he fails to notice the pretty background of trees and shrubbery, whose waving branches indicate that a stiff breeze is blowing. So it is in each of the pictures shown; they are full of interesting little details that come out one by one when the same views are seen several times." Many thanks to Deac Rossell for this remarkable reference.

119 Fudge, *Animal*, 21. This was the story's second screen adaption, there having been a silent French version in 1913.

120 Coats is cited in Cohen, *Monster Theory*, 24n39; Badley, *Film, Horror, and the Body Fantastic*, 39.

121 Schefer, *Enigmatic Body*, 120.

122 Shukin, *Animal Capital*, 92, 20.

123 Ibid., 91. See also 109: "In 1925, Dr. Samuel Sheppard, at the time an emulsion scientist working for Kodak, traced organic impurities in photographic gelatin back to the particularities of a cow's diet." "Twenty

years ago we found out that if cows didn't like mustard there wouldn't be any movies at all."

124 Ibid., 100.

125 Ibid., 92, 100, 101.

126 Even with respect to nonhumans like the *sea*, Laruelle posits that "Man can finally see his fixed and moving image, his intimate openness as the greatest secret in the ocean" as well as "*the sea . . . which is also human in the way that every Last Instance is.*" Laruelle, "L'Impossible foundation d'une écologie de l'océan." See also Smith, *A Non-Philosophical Theory of Nature*, 120–21, on this.

127 *Bêtise*, meaning "stupidity, folly" (from French, *bête*, "beast, fool, foolish"; from Old French *beste*, "beast").

128 Laruelle, *Théorie des Etrangers*, 78, 110, 96, 160.

129 Laruelle, "A Rigorous Science of Man," 54.

130 Deleuze, *Difference and Repetition*, 150.

131 Ibid., 151.

132 Stiegler, "Doing and Saying Stupid Things in the Twentieth Century," 161–62.

133 Ibid., 172n11.

134 Ibid., 163.

135 Deleuze, *Difference and Repetition*, 150. See also Derrida, *The Beast and the Sovereign*, 1:180–81, on this separation of the animal and the stupid.

136 Deleuze, *Difference and Repetition*, 152.

137 Laruelle, "I, the Philosopher, Am Lying," 61.

138 *Ibid.*

139 Merleau-Ponty, *Phenomenology of Perception*, 298–99.

140 *Ibid.*, 302–3.

141 *Ibid.*, 304, 310–11.

142 The episode titled "Hell" of the TV comedy *Father Ted* (series 2, episode 1) shows the perfect example of absolute, transcendental idiocy when Father Dougall cannot see why a faraway thing is not also really a smaller thing.

143 Plato, *The Republic*, 523–24.

144 Deleuze, *Difference and Repetition*, 141.

145 Reproduced from Hudson, "Pictorial Depth Perception in Subcultural Groups in Africa."

146 Bordwell, *Narrative in Feature Film*, 114.

147 Bazin, *What Is Cinema?*, 1:35.

148 Ibid., 1:86, 2:64.

149 See Mullarkey, "Tragedy of the Object."

150 Cited in Mitry, *Aesthetics and Psychology of the Cinema*, 195.

151 Bazin, *What Is Cinema?*, 2:56. Likewise, Fellini's characters are no longer seen merely "*among* the objects but, as if these had become transparent, *through* them" (2:88).

152 Ibid., 2:64, 92.

153 Film reveals the spatio-optical intersection of lives, and this is shown through their "simultaneous [equal] presence." Ibid., 2:50.

154 Laruelle, *Concept of Non-Photography*, 51.

155 Bazin, *What Is Cinema?*, 2:89.

156 Jeong, "Animals," 177. See also Jeong and Andrew, "Grizzly Ghost"; Fay, "Seeing/Loving Animals"; Daney, "Screen of Fantasy (Bazin and Animals)."

157 Jeong and Andrew, "Grizzly Ghost," 3.

158 See Mullarkey, *Philosophy and the Moving Image*, 201–4.

159 Heidegger, *Fundamental Concepts of Metaphysics*, 282; for an analysis of this, see Agamben, *The Open*, 61.

160 Lynes, "Perversions of Modesty," 610.

161 Bazin writes that "there is no such thing as pure neorealism. The neorealist attitude is an ideal that one can approach to a greater or lesser degree." Bazin, *What Is Cinema?*, 2:100.

162 Deleuze, *Difference and Repetition*, 159.

163 ten Bos, "Touched by Madness," 438–39.

164 Laruelle, "Life in-the-Last-Humanity."

165 Ibid.

166 Agamben, *Homo Sacer*, 1.

167 Garcia, *Forme et objet*, 240.

168 Viveiros de Castro, *Cosmologies*, 97.

169 Ibid., 106.

170 Ibid., 56, 83.

171 Viveiros de Castro, "Cosmological Deixis and Ameridian Perspectivism," 470.

172 Viveiros de Castro himself has a more sympathetic reading of Deleuze's (and Guattari's) animal becomings than we do, one which he attempts to integrate into the reverse anthropology of Amerindian perspectivism (and "cannibalism") in his *Métaphysiques cannibals*.

173 Viveiros de Castro, "Cosmological Deixis and Amerindian Perspectivism," 478.

174 See Laruelle, *Principles of Non-Philosophy*, 184: "And finally it is not the practical or even quasi-poetic realization that we substitute for its [metaphysics's] old theoretical ambition but its performation without qualities which alone can transform it (really and not effectively) by making this happen in another order."

175 Viveiros de Castro, *Cosmologies*, 56.

176 Latour, *We Have Never Been Modern*, 138.

177 Montaigne, *Complete Essays*, 505.

178 Torneke, *Learning RFT*, 11–12, my italics.

179 Žižek, *Less Than Nothing*, 306. Chesterton called this type of reversal "thinking backwards" (which was also Bergson's description of intuition—see Moore, *Bergson, Thinking Backwards*.

180 Wittgenstien, *Tractatus*, 6.43.

181 Coetzee, *Lives of Animals*, 45. For more prolonged engagements with Coetzee's work on animals, see Cavell et al., *Philosophy and Animal Life*.

182 Coetzee, *Lives of Animals*, 53.

183 Ibid., 22.

184 Ibid., 35.

185 Mill, *Utilitarianism*, 281.

186 Sloterdijk, *Critique of Cynical Reason*, 103. See also Huyssen, foreword to Sloterdijk, *Critique of Cynical Reason*, xvii. In Plato's *Republic*, II 376b, Socrates likens "a well-bred dog" with a philosopher, but merely because the dog "distinguishes the face of a friend and of an enemy only by the criterion of knowing and not knowing," that is, by being just as authoritarian as the human philosopher.

187 Sloterdijk, *Critique of Cynical Reason*, 151, 168.

188 Ibid., 165.

189 Ibid., 253. In *A Philosophy of Walking*, 133–34, Frederic Gros refers to how the Cynics' attachment to earth and immanence "should serve to shatter the derisory grand postures of the stoop-shouldered philosopher, hunched over his internal wealth."

190 Laruelle, "Obscénité de la philosophie," 123. For more on vomit in philosophy, see also Laruelle, "La Scène du Vomi."

191 Laruelle, *En tant qu'un*, 224.

192 Flusser, *Vampyroteuthis Infernalis*, 74. See also 82, "to wish to intuit vampyroteuthian existence implies a wish to decipher his philosophy," or a letter written during his preparation of the book: "For us the world is splendid (reflects sunlight). For him the world is made to shine by his bioluminescent organs. For us the 'truth' is the discovery of the reality behind appearances. For him, it is the feat of making appear what the eternal night hides. For us 'to think' is to organise concepts, that is: the outlines of objects felt by the fingers *(begreifen des vorhandenen)*. For him 'to think' is to discriminate between the influences of the world, all of them experienced sexually, since Vampyroteuthis grasps, smells and absorbs by means of sex. Our thought is mechanical, his is cybernetic" (138).

193 Ibid., 27–28 ("the tale is told of you").

194　On one hand, Flusser can be quite flexible and nonanthropocentric about what, say, thought means qua "reflection" (see ibid., 81ff.), while, on the other hand, remaining quite rigid in his biological identifications (of the human, the animal, and the vampire squid as a human analogue). This duality reflects the different orientations of the text, some of them directed toward putative biological facts, others more toward myth and fable, a "'fictitious science' . . . the overcoming of scientific objectivity in the service of a concretely human knowledge" (123). Whether the text is able to combine the two in one remains in doubt.

195　Ibid., 31, 38.

196　Ibid., 46.

197　Cited in Finger et al., *Vilém Flusser*, 120.

198　Flusser, *Vampyroteuthis Infernalis*, 54.

199　To be precise, Flusser thinks of the amorous posture of *Vampyroteuthis Infernalis* as a synthesis of love and war, but this is only due to a "double repression" without which its posture would express love all the more clearly. Ibid., 54–55.

200　See Rancière, *Ignorant Schoolmaster*, 101: "One can teach what one doesn't know. A poor and ignorant father can thus begin educating his children: *something must be learned and all the rest related to it, on this principle: everyone is of equal intelligence.*" This is from the opening of the final chapter of *Ignorant Schoolmaster*, whose unfortunate, but unexplained, title is "The Emancipator and His Monkey."

201　Laruelle, *En tant qu'un*, 250.

202　Laruelle, "A Summary of Non-Philosophy," 299.

5. PERFORMING THE IMPERFECT HUMAN

1　Laruelle, *Théorie des Identités*, 92.

2　Laruelle, *Principles of Non-Philosophy*, 197.

3　Laruelle, *Struggle and Utopia*, 148–49.

4　Laruelle, *Principles of Non-Philosophy*, 3; Gangle, *François Laruelle's Philosophies of Difference*, 135.

5　Laruelle, *What is Non-Philosophy?*, 233.

6　Laruelle, *Struggle and Utopia*, 148; Laruelle, *Philosophy and Non-Philosophy*, 4, 172.

7　Laruelle, *Philosophy and Non-Philosophy*, 168, my italics.

8　Laruelle, *Intellectuals and Power*, 38. See also Laruelle, "I, the Philosopher, Am Lying," 42: "Because if it is a question of doing what the authors have done rather than of saying what they have said, perhaps there still remains one last situation they have not foreseen: that of really

doing what they said they did or what they have only done by saying, mixing doing and saying once more under the name of 'creation,' as all philosophers have. It remains to do or to practice, solely to practice, the immanence that they say and which is perhaps still only that of philosophical saying: it remains to practice immanence with regard to their saying-of-immanence."

9 See Laruelle, *En tant qu'un*, 40.

10 Laruelle, *Philosophy and Non-Philosophy*, 167.

11 Laruelle, *Principles of Non-Philosophy*, 178. See also ibid., 175: "Vision-in-One or the Real can thus be understood starting from 'performativity.' This term is at least a datum given by ordinary language philosophy; it must be transposed and generalized here outside of the linguistic sphere under certain conditions of work proper to non-philosophy in order to characterize the radical kind of immanence, compared to the efficacy of language or to the action of Being in a regime of logos."

12 Ibid., 176, 177.

13 Laruelle et al., *Dictionary*, 55.

14 See Brandom, *Between Saying and Doing*, and Brandom, *Making It Explicit*, 496: "The thesis is that the *representational* dimension of propositional content is conferred on thought and talk by the *social* dimension of the practice of giving and asking for reasons."

15 Laruelle, *Philosophy and Non-Philosophy*, 31.

16 Laruelle, "Non-Philosophy as Heresy," 280–81.

17 Laruelle, *Struggle and Utopia*, 5.

18 See Davies, *Art as Performance*, x: "Artworks in the different arts, I argue, must be conceived not as the products (decontextualized or contextualized) of generative performances, but as the performances themselves. Vermeer's *Art of Painting*, then, represents not a possible performance productive of a work, but a moment in the unfolding of a possible work."

19 See Weber, *Theatricality as Medium*; Rancière, *Emancipated Spectator*; Badiou, *Rhapsody for the Theatre*.

20 Cull, "Performance Philosophy," 1. See also 4–5.

21 Ibid., 15. She continues: "according to a non-philosophical perspective, philosophy and theatre would be realigned as equal yet different forms of thought—embedded in the whole of the Real, with neither being granted any special powers to exhaust the nature of the other, nor indeed the nature of the whole in which they take part" (18).

22 Smith, "Funny Games," 137.

23 Ibid., 121.

24 Ibid., 137.

25 Lynes, "Perversions of Modesty," 609.

26 Kaprow, "Manifesto," 292.

27 Kaprow, *Essays on the Blurring of Art and Life*, 195. Kaprow makes this statement in respect to his earlier work on "Happenings."

28 Ibid., xxix.

29 Ibid., 98.

30 See Cull, *Theatres*, 174–75: "Rather than being a conceptual decision, 'Performing Life' is an aspect of the process of what Kaprow calls 'un-arting': a new mode of research and development in the preparation of works, distinct from the conventional idea of the artist at work in her studio—especially if the studio is a place detached from daily routines of eating and sleeping and so forth. Kaprow's concept of 'performing everyday life' names a research process in which the un-artist engages before creating an Activity."

31 Ibid., 154, 157. Cull goes on as follows: "What matters most to Kaprow are the experiential products of the interference of the processual in the symbolic, the immanent in the transcendent, in the event of participation itself, not what the Activity looks like from a position outside of it" (157).

32 Kaprow, *Essays on the Blurring of Art and Life*, 98.

33 Schechner, *Performance Studies*, 1–2.

34 Schechner, *Between Theater and Anthropology*, 35.

35 Eckersall, "Australian Performance Studies Marginally Off Centre," 119.

36 Schneider, "Reactuals," 140–41.

37 Schechner, *Between Theater and Anthropology*, 37.

38 See Bottoms, "In Defense of the String Quartet."

39 See Lampe, "Rachel Rosenthal Creating Her Selves," 299.

40 Kirby, "On Acting and Not-Acting," 3.

41 Ibid.

42 Ibid., 4.

43 Ibid.

44 Ibid.

45 Ibid., 6.

46 Ibid., 7.

47 Ibid.

48 See ibid., 8–9.

49 Ibid., 6.

50 Cull, *Theatres*, 235.

51 Laruelle, *Anti-Badiou*, 220–21.

52 Puchner, "Theater in Modernist Thought," 524.

53 Laruelle, *Intellectuals and Power*, 38–39. See also Laruelle, *Principles of Non-Philosophy*, 191: "It is precisely this trait of radical actuality or Performed-without-Performation, of being-given identically without

excess or reserve, which renders the real-One absolutely invisible for philosophy."

54 Laruelle, *Principles of Non-Philosophy*, 180.

55 Ibid., 241.

56 Laruelle, *Struggle and Utopia*, 235.

57 Laruelle, *Philosophy and Non-Philosophy*, 168, first italics mine.

58 A case in point is Andrew McGettigan's review of *Philosophy and the Moving Image: Refractions of Reality*—which attempted a Laruellean study of film and film-philosophy (as the philosophy *immanent* to cinema). Here it is clear that only German idealist philosophy, as read by McGettigan, can say what art is and what it requires from philosophy. McGettigan's disquiet with the non-philosophical approach rests entirely on his own clear intolerance for such a democratization of philosophy—for anything outside of the Hegel–Adorno axis of thought is simply not relevant, either to film or to art in general (however that is defined). The irony here is striking: McGettigan writes as a philosopher on behalf of art (not just cinema)—he announces that "those already engaging with the arts have no need of this book" even though he has neither any art practice of his own nor any knowledge of film studies. Without an understanding of the generic concepts of art arising out of "the richer strain drawing from German Idealism," and without understanding "mediation," such work cannot offer anything of value. However, it is not just this book but *any* work of film-philosophy that is at fault on this score, according to McGettigan. Film-philosophy cannot be said to be a proper "subdiscipline" and so must be subsumed within what has been said about art in general by those in the German idealist tradition, that is, *philosophy—his own philosophy is particular*. McGettigan's resort to art in general is especially ignorant of his chosen tradition, however, in that he accuses *Philosophy and the Moving Image* of having occluded film with theory, even though Adorno can hardly be said to have ever done otherwise.

59 Laruelle, *Photo-Fiction*, 14.

60 Laruelle, *Philosophy and Non-Philosophy*, 122.

61 Ibid.

62 This is in contrast to the artist or idiot, as Laruelle writes in *Philosophies of Difference*, 179: "They [philosophers] seek the One precisely because they have not found it, and *they will never find anything but their own hallucination. They neither find nor become anything other than what they already are: them-'selves'*" (my italics).

63 Galloway, "Laruelle and Art," 231.

64 Ibid., 232.

65 Laruelle, *Concept of Non-Photography*, 71, my italics. See also ibid., 86: "One should not think, however, that the work of artists is for us a mere occasional cause, that it is secondary. It is rather that it is the symptom or the indication of a theoretical discovery that has not yet produced all its effects in art itself and above all in its theory." Hence it is very much an overstatement when John Roberts says (in his review of *Concept of Non-Photography*) that Laruelle hopes to "introduce some of the categories and terms of non-philosophy into the theory of photography and representation" (134). Quite the opposite, in fact. See Roberts, "Flat-Lining of Metaphysics," and my reply, Mullarkey, "A + A = A."

66 Laruelle, *Photo-Fiction*, 19.

67 Ibid., 13.

68 Ibid., 2, 5.

69 Laruelle, "First Choreography," 147.

70 Groys, *Introduction to Antiphilosophy*, viii, xi.

71 Ibid., xiii. By "metanoia," Groys means "the radical 'change of mind' through which a subject rejects everything that connected this subject to the 'old,' ordinary, limited life perspective and opens itself up to a new, universal, infinite perspective of philosophical evidence" (ix).

72 Ibid., 100, 162.

73 Heathfield, *Live*, 11.

74 Forte, "Women's Performance Art: Feminism and Postmodernism," 224.

75 Reinelt, "Politics of Discourse," 202.

76 Heathfield, *Live*, 13.

77 Rainer, *No Manifesto*.

78 Metzger, *Manifesto for Auto-Destructive Art*.

79 Laruelle, "Transvaluation of the Transcendental Method," 468–69.

80 One might contrast this with Derrida's method of putting under erasure, which still emphasizes absence over presence in a reversal.

81 Hume, *A Treatise of Human Nature*, I, 4, 7.

82 Brassier, "Axiomatic Heresy," 34.

83 Laruelle, *Principles of Non-Philosophy*, 198–99.

84 Laruelle, *Philosophy and Non-Philosophy*, 75, my italics.

85 Gangle, *François Laruelle's Philosophies of Difference*, 177, 206. Gangle refers this *"radical that-ness"* to "Non-Thetic-Transcendence," which Laruelle would later reinterpret as cloning.

86 Derrida, *Points . . . Interviews 1974–1994*, 11, cited in Gangle, *François Laruelle's Philosophies of Difference*, 128.

87 Laruelle, *Philosophies of Difference*, 108.

88 Laruelle, *Théorie des Identités,* 312–13; Laruelle, *En tant qu'un,* 242.
89 Laruelle, *En tant qu'un,* 225: "My project . . . [is] to introduce philosophy
 to heretical experience."
90 Kolozova, *Lived Revolution,* 27, 33.
91 Laruelle, "Non-Philosophy, Weapon of Last Defence," 251.
92 Danto, *Transfiguration of the Commonplace,* 204.
93 Fichte, *Science of Knowledge,* 16.
94 Laruelle, *Anti-Badiou,* xxxiii.
95 Ibid., xxxii.
96 Laruelle, "Non-Philosophy, Weapon of Last Defence," 251.
97 Mackay and Laruelle, "Introduction," 28.
98 Gangle, *François Laruelle's Philosophies of Difference,* 172. So, when
 Gangle elsewhere writes ("Laruelle and Ordinary Life," 61–62) that
 "the philosophical organisation and legitimisation of the world as a
 mixture of immanence and transcendence (or as a correlation of reality
 and thought) would thus involve, in particular, an *ad hominem* attack
 against what such a world cannot encompass," it is still not a personal-
 ized attack but a generic one (against a world).
99 See Galloway, "Laruelle, Anti-Capitalist," 202. McGettigan, character-
 istically negative, describes it as tending to "solipsism." McGettigan,
 "Fabrication Defect," 41.
100 Laruelle, *Principles of Non-Philosophy,* 93. See also 95: "To this divided
 and thus split Ego, Ego-of-Ego or Self-of-Self, at once under- and over-
 determined by the onto-cogitative plane, we therefore oppose the Ego
 absolutely *given* without reference, even of 'immediate negation,' to
 a universal horizon; we call it Ego-in-Ego, Self-in-Self, the *in* being
 charged with signifying its already reduced state or with annulling the
 philosophical splitting."
101 Laruelle, *Anti-Badiou,* xxxix.
102 Laruelle, *Principles of Non-Philosophy,* 234, 273.
103 Ibid., 223.
104 Laruelle, *Philosophy and Non-Philosophy,* 247.
105 Ibid., 30.
106 Laruelle, *Anti-Badiou,* 232.
107 Galloway, "Review of *Théorie générale des victimes,*" 104.
108 Given this lack of necessity to do non-philosophy, and that it could have
 been otherwise, one might thereby arrive at answers to such questions
 as, Why haven't the "obvious" dilemmas of representational philosophy
 led everyone to Laruelle? Or, Does non-philosophy need standard
 philosophy? Questions of implication and inference, of leading and
 following, are contingently (unconditionally) behavioral and not of

logical necessity. Indeed, "what follows," even as logical consequence, is never necessary. It was not necessary, for instance, that, when writing this study, the language of the author's name reverted from the English "Mullarkey"—a homophone for "nonsense" in its bastardized form—to the original Irish, "Ó Maoilearca," which was discovered to translate ultimately as "follower of the animal." But it was a happy coincidence.

109 Turner, *Anthropology of Performance*, 81.

110 As Marvin Carlson writes, "animals are not simply negotiating social situations, but are knowingly repeating certain actions for physical or emotional rewards, a process that, to me at least, seems to have important features in common with human performance." Carlson, *Performance*, 200. Even Richard Schechner has argued that "performance is an inclusive term. Theater is only one node on a continuum that reaches from the ritualizations of animals (including humans) through performance in everyday life." Schechner, *Performance Theory*, xvii.

111 Laruelle, *Philosophy and Non-Philosophy*, 227.

112 Hjort, "Style and Creativity in *The Five Obstructions*," 25.

113 Rodriguez, "Constraint, Cruelty, and Conversation," 54.

114 Ibid., 55.

115 Laruelle, *Future Christ*, 122.

116 Laruelle, *Principles of Philosophy*, 291.

117 See Harman, "Review of *Philosophies of Difference*."

118 Laruelle, *Concept of Non-Photography*, viii.

CONCLUSION

1 Laruelle, *En Tant qu'un*, 37.

2 Read, *Theatre, Intimacy, and Engagement*, 81.

3 What we were concerned about in the introduction as a "threat" (an explosion "whereby all things become performative") can now be seen as an opportunity.

4 In an earlier essay, I argued that Laruelle's transcendentalism was intrinsically spatial and so opposed to the temporality of mutation. My amended reading is that, in the spirit of his transvaluation of the transcendental *as autodestructive,* it already has mutation built into it. The duration of this temporality, of its mutation, is not fixed objectively but set locally by each practice. Before something mutates, it must appear as an identity long enough for some to register "it" as a mutation, at least momentarily. Mullarkey, "1 + 1 = 1."

5 Laruelle, *Principles of Non-Philosophy*, 266.

6 Laruelle, *Anti-Badiou*, 61.

7 Brassier, *Nihil Unbound*, 137. See also Brassier, "Liquider l'homme une fois pour toutes."

8 Laruelle, *Principles of Non-Philosophy*, 180; Laruelle, *Intellectuals and Power*, 149. See Mullarkey, *Post-Continental Philosophy*, chapter 4.

9 Wittgenstein, *Philosophical Investigations*, 128.

10 Kirkkopelto, "A Manifesto for Generalized Anthropomorphism."

11 Ibid.

12 Viveiros de Castro, *Cosmologies*, 143.

13 Finally, this leads us to the question, which we can only mention here, of how to orient oneself toward objects *as* subjects as well as those subjects that appear to us *as* objects—to the problems of panpsychism, and to the purported anthropomorphism attendant to that stance. If there really is a "flat" thought of objects—a "democracy of things"—how is it that only *some* objects appear to other objects as subjects? What use is there for this chauvinism (both as a material chauvinism contra some objects and as a "spiritual" chauvinism pro some others)? How can we create, immanently, a "genealogy of the absolute," of absolutism, of hierarchy, a structure of *disregard*? One could simply discount such hierarchies as *mere* chauvinism, that is, as only prejudicial error or illusion. However, I hope to show in a later work that, for a nonstandard approach to philosophy, this option is not available: everything is included within Laruelle's "radical immanence" and nobody is left behind, including the idiots (indeed, especially the idiots). So, if nothing is outside of the Real (a kind of monism of flat *thought* rather than a flat *ontology* that begs the question), this includes these dualities (chauvinisms) as moments within immanence itself—the "immanental," as Laruelle also calls it. This is not merely to *tolerate* intolerance in some kind of Latour-meets-Lévinas thought experiment, nor is it to *deconstruct* tolerance (as one might deconstruct "hospitality," say, through aporetic reasoning): it is the attempt to explain or realize intolerance within the Real as a kind or behavior or orientation.

CODA

1 Laruelle, "From the First to the Second Non-Philosophy," 321.

2 Galloway, "Laruelle and Art," 235.

3 Laruelle, *Struggle and Utopia*, 250.

4 Galloway, "Laruelle and Art," 236.

5 Goulish, *Brightest Thing in the World*, 64.

6 Coetzee, *Lives of Animals*, 35.

7 By contrast, according to Novalis, philosophy is homesickness—but

only for humans. Agnes Heller glosses this adage as "the longing for a world in which philosophy is at home." But she then continues to say that, so long as philosophy wants to "give a norm to the world, it finds itself at home in morality and in comprehension." Such normativity is, for Novalis and Heller at least, to make "*the world to be a home for humanity.*" See Heller, *Radical Philosophy,* 134.

8 Laruelle, "Universe Black in the Human Foundations of Colour," 407.

9 We have only glimpsed the genealogy of such absolute inequalities and their radical inversion here, offering a mere outline of these structures of regard and disregard (with all the deflations of "only," "merely," and "simple" attaching to the latter): rendering that outline with other images must remain the goal of a future work in non-philosophy.

BIBLIOGRAPHY

Adkins, Taylor. "Death of the Translator, a Uni-lateral Odyssey." In Laruelle, *Philosophy and Non-Philosophy*, i–viii.

Adorno, Theodore. *Negative Dialectics*. Translated by E. B. Ashton. London: Routledge, 2004.

Agamben, Giorgio. "Absolute Immanence." In *Potentialities: Collected Essays in Philosophy*, edited and translated by Daniel Heller-Roazen, 220–39. Palo Alto, Calif.: Stanford University Press, 1999.

———. "Difference and Repetition: On Guy Debord's Films," translated by Brain Holmes. In *Guy Debord and the Situationist International: Texts and Documents*, edited by T. McDonough, 314–19. Cambridge, Mass.: MIT Press, 2002.

———. *Homo Sacer: Sovereign Power and Bare Life*. Translated by Daniel Heller-Roazen. Palo Alto, Calif.: Stanford University Press, 1998.

———. "Notes on Gesture." In *Means without End: Notes on Politics*, translated by Vincenzo Binetti and Cesare Casarino, 49–60. Minneapolis: University of Minnesota Press, 2000.

———. *The Open: Man and Animal*. Translated by Kevin Attell. Palo Alto, Calif.: Stanford University Press, 2004.

Ahmed, Sara. *Queer Phenomenology: Orientations, Objects, Others*. Durham, N.C.: Duke University Press, 2006.

Azzouni, Jodi. *Talking about Nothing: Numbers, Hallucinations, and Fiction*. Oxford: Oxford University Press, 2012.

Bachelard, Gaston. *Le Philosophie du non*. Paris: Presses Universitaires de France, 2012.

Bacon, Francis. *The Philosophical Works of Francis Bacon*. Edited by John M. Robertson, translated by Robert Leslie Ellis and James Spedding. London: Routledge, 2011.

Badiou, Alain. *Being and Event*. Translated by Oliver Feltham. London: Continuum, 2006.

———. *Ethics: An Essay on the Understanding of Evil*. Translated by Peter Hallward. London: Verso, 2001.

———. *Infinite Thought: Truth and the Return to Philosophy*. Translated and edited by Oliver Feltham and Justin Clemens. London: Continuum, 2003.

———. *Logics of Worlds*. Translated by Alberto Toscano. London: Continuum, 2009.

———. "Review of Gilles Deleuze, *The Fold: Leibniz and the Baroque.*" In *Gilles Deleuze and the Theatre of Philosophy,* edited by Constantin V. Boundas and Dorothea Olkowski, 51–69. London: Routledge, 1994.

———. *Rhapsody for the Theatre.* Translated by Bruno Bosteels. London: Verso, 2013.

Badiou, Alain, and Ben Woodard. "Interview." In *The Speculative Turn,* edited by Levi Bryant, Nick Srnicek, and Graham Harman, 19–20. Melbourne: re-press, 2011.

Badley, Linda. *Film, Horror, and the Body Fantastic.* Westport, Conn.: Greenwood, 1995.

Badmington, Neil. *Alien Chic: Posthumanism and the Other Within.* London: Routledge, 2004.

Baier, Annette. *Postures of the Mind: Essays on Mind and Morals.* Minneapolis: University of Minnesota Press, 1985.

Bainbridge, Caroline. *The Cinema of Lars Von Trier: Authenticity and Artifice.* New York: Columbia University Press, 2008.

Baraklianou, Stella. "*Moiré* Effect: Index and the Digital Image." *Footprint,* no. 14 (2014): 81–96.

———. "*Pasearse*: Duration and the Act of Photographing." In *Bergson and the Art of Immanence: Painting, Photography, Film,* edited by John Mullarkey and Charlotte de Mille, 131–47. Edinburgh: Edinburgh University Press, 2013.

Bazin, André. "Les films d'animaux nous révèlent le cinéma." In *Radio-Cinéma-Télévision* 285 (July 1955).

———. *What Is Cinema?* 2 vols. Translated by Hugh Gray. Berkeley: University of California Press, 2004.

Beall, J. C. "Introduction: At the Intersection of Truth and Falsity." In *The Law of Non-Contradiction: New Philosophical Essays,* edited by Graham Priest, J. C. Beall, and Armour-Garb Bradley, 1–19. Oxford: Clarendon, 2004.

Berger, John. "Why Look at Animals?" In *Selected Essays,* edited by Geoff Dyer, 259–73. London: Bloomsbury, 2001.

Bergson, Henri. *Creative Evolution.* Translated by Arthur Mitchell. London: Macmillan, 1911.

———. *The Creative Mind: An Introduction to Metaphysics.* Translated by Mabelle L. Andison. New York: Philosophical Library, 1946.

———. *Matter and Memory.* Translated by N. M. Paul and W. S. Palmer. New York: Zone Books, 1988.

———. *Mind-Energy: Lectures and Essays.* Translated by H. Wilson Carr. Westport, Conn.: Greenwood Press, 1975.

Bernasconi, Robert. Introduction to *Race and Racism in Continental Philosophy,* edited by Robert Bernasconi, with Sybol Cook, 1–6. Bloomington: Indiana University Press, 2003.

Bernhardt, Daniel. "Posture, Gesture, and Motion Quality: Multilateral Approach to Affect Recognition from Human Body Motion." http://www.di.uniba.it/intint/DC-ACII07/Bernhardt.pdf.

Bianchi-Berthouze, Nadia, Paul Cairns, Anna Cox, Charlene Jennett, and Whan Woong Kim. "On Posture as a Modality for Expressing and Recognizing Emotions." Paper presented at Emotion and HCI Workshop at BCI HCS, London, 2006. http://web4.cs.ucl.ac.uk/uclic/people/c.jennett/BerthouzeHCI06.pdf.

Bök, Christian. 'Pataphysics: The Poetics of an Imaginary Science. Evanston, Ill.: Northwestern University Press, 2002.

Bollert, David. "Plato and Wonder." In Extraordinary Times, IWM Junior Visiting Conferences 11. 2001.

Bordwell, David. Narrative in Fiction Film. London: Methuen, 1985.

Bottoms, Stephen. "In Defense of the String Quartet: An Open Letter to Richard Schechner." In Harding and Rosenthal, Rise of Performance Studies, 23–38.

Braidotti, Rosi. The Posthuman. Cambridge: Polity, 2013.

Brandom, Robert. Between Saying and Doing: Towards an Analytic Pragmatism. Oxford: Oxford University Press, 2010.

———. Making It Explicit: Reasoning, Representing, and Discursive Commitment. Cambridge, Mass.: Harvard University Press, 1998.

Brassier, Ray. "Axiomatic Heresy: The Non-Philosophy of François Laruelle." Radical Philosophy 121 (September/October 2003): 24–35.

———. "Liquider l'homme une fois pour toutes." In Grelet, Théorie-Rébellion, 77–80.

———. Nihil Unbound: Enlightenment and Extinction. Basingstoke, U.K.: Palgrave-Macmillan, 2007.

Bromberger, Sylvain. On What We Know We Don't Know: Explanation, Theory, Linguistics, and How Questions Shape Them. Chicago: University of Chicago Press, 1992.

Bull, E. P. Posture and Gesture. Oxford: Pergamon, 1987.

Burt, Jonathan. Animals in Film. London: Reaktion, 2002.

———. "Morbidity and Vitalism: Derrida, Bergson, Deleuze, and Animal Film Imagery." Configurations 14 (2006): 157–79.

Čapek, Milič. Bergson and Modern Physics: A Reinterpretation and Reevaluation. Dordrecht, Netherlands: D. Reidel, 1971.

Cappuccio, Massimiliano L. "Introduction: Pointing: A Gesture That Makes Us Special?" Humana.Mente 24 (July 2013): xi–xl.

Carlson, Marvin. Performance: A Critical Introduction. New York: Routledge, 1996.

Casey, Edward S. Introduction to Dufrenne, The Notion of the A Priori, xviii–xxviii.

Cavell, Stanley. *The World Viewed*. Enlarged ed. Cambridge, Mass.: Harvard University Press, 1979.

Cavell, Stanley, Cora Diamond, John McDowell, Ian Hacking, and Cary Wolfe. *Philosophy and Animal Life*. New York: Columbia University Press, 2010.

Châtelet, Gilles. *Figuring Space: Philosophy, Mathematics, and Physics*. Translated by Robert Shore and Muriel Zagha. Dordrecht, Netherlands: Kluwer, 2000.

Cheshire, Godfrey. "Review: *Psycho*—'Psycho' Analysis: Van Sant's Remake Slavish but Sluggish." December 6, 1998. http://variety.com/1998/film/reviews/psycho-psycho-analysis-van-sant-s-remake-slavish-but-sluggish-1200456298.

Chisholm, Roderick M. "Meinong, Alexius." In *Encyclopedia of Philosophy*, vol. 5, edited by Paul Edwards, 261–63. New York: Macmillan, 1967.

Cholodenko, Alan. "The Animation of Cinema." *Semiotic Review of Books* 18, no. 2 (2008): 1–10.

Choplin, Hughes. *De la Phénoménologie à la Non-Philosophie: Lévinas et Laruelle*. Paris: Kimé, 1997.

———. *La Non-Philosophie de François Laruelle*. Paris: Kimé, 2000.

Clarke, Julie. *Paradox of the Posthuman: Science Fiction/Techno-Horror Films and Visual Media*. Saarbrücken, Germany: VDM, 2009.

Coetzee, J. M. *The Lives of Animals*. Princeton, N.J.: Princeton University Press, 1999.

Cohen, Jerome J. *Monster Theory*. Minneapolis: University of Minnesota Press, 1996.

Connolly, William E. *Neuropolitics: Thinking, Culture, Speed*. Minneapolis: University of Minnesota Press, 2002.

Coulson, Mark. "Attributing Emotion to Static Body Postures: Recognition Accuracy, Confusions, and Viewpoint Dependence." *Journal of Nonverbal Behavior* 28, no. 2 (2004): 117–39.

Cull, Laura. "Performance Philosophy: Staging a New Field." In *Encounters in Performance Philosophy*, edited by Laura Cull and Alice Lagaay, 1–19. Basingstoke, U.K.: Palgrave-Macmillan, 2014.

———. *Theatres of Immanence: Deleuze and the Ethics of Performance*. Basingstoke, U.K.: Palgrave-Macmillan, 2012.

Daney, Serge. "The Screen of Fantasy (Bazin and Animals)," translated by Mark A. Cohen. In *Rites of Realism: Essays on Corporeal Cinema*, edited by Ivone Margulies, 32–41. Durham, N.C.: Duke University Press, 2003.

Danto, Arthur. *The Transfiguration of the Commonplace: A Philosophy of Art*. Cambridge, Mass.: Harvard University Press, 1981.

Daston, Lorraine, and Gregg Mitman. "The How and Why of Thinking with Animals." In Daston and Mitman, *Thinking with Animals*, 1–14.

——, eds. *Thinking with Animals: New Perspectives on Anthropomorphism.* New York: Columbia University Press, 2005.

Davies, David. *Art as Performance.* Oxford: Blackwell, 2004.

Deleuze, Gilles. *Difference and Repetition.* Translated by Paul Patton. London: Athlone Press, 1994.

——. *Nietzsche and Philosophy.* Translated by Hugh Tomlinson. London: Athlone Press, 1983.

Deleuze, Gilles, and Félix Guattari. *Anti-Oedipus.* Translated by Robert Hurley, Mark Seem, and Helen R. Lane. London: Athlone Press, 1984.

——. *A Thousand Plateaus.* Translated by Brian Massumi. London: Athlone Press, 1988.

——. *What Is Philosophy?* Translated by Hugh Tomlinson and Graham Burchill. London: Verso, 1994.

DeLillo, Don. *Point Omega.* New York: Scribner, 2010.

de Montaigne, Michel. *The Complete Essays.* Translated by M. A. Screech. Harmondsworth, U.K.: Penguin, 1987.

Dennett, Daniel. *Brainstorms: Philosophical Essays on Mind and Psychology.* Sussex, U.K.: Harvester Press, 1978.

——. *Consciousness Explained.* London: Little, Brown, 1991.

——. *The Intentional Stance.* Cambridge, Mass.: MIT Press, 1987.

Derrida, Jacques. *The Animal That Therefore I Am.* Translated by David Wills. New York: Fordham University Press, 2008.

——. *The Beast and the Sovereign.* Vol. 1. Translated by Geoff Bennington. Chicago: University of Chicago Press, 2011.

——. "'Eating Well,' or the Calculation of the Subject: An Interview with Jacques Derrida," translated by Peter Connor and Avital Ronnell. In *Who Comes after the Subject?,* edited by Eduardo Cadava, Peter Connor, and Jean Luc-Nancy, 96–119. London: Routledge, 1991.

——. *H.C. for Life, That Is to Say.* Translated by Laurent Milesi and Stefan Herbrechter. Palo Alto, Calif.: Stanford University Press, 2006.

——. "Structure, Sign, and Play in the Discourse of the Human Sciences." In *Writing and Difference,* translated with an introduction and notes by Alan Bass, 351–70. London: Routledge, 1978.

Dufour, Eric. *Le cinéma d'horreur et ses figures.* Paris: Presses Universitaires de France, 2006.

Dufrenne, Mikel. *L'inventaire des a priori: Recherche de l'originaire.* Paris: C. Bourgois, 1981.

——. *The Notion of the A Priori.* Translated by Edward S. Casey. Evanston, Ill.: Northwestern University Press, 2009.

Dwyer, Susan. "Romancing the Dane: Ethics and Observation." In Hjort, *Dekalog 01,* 1–14.

Eckersall, Peter. "Australian Performance Studies Marginally Off Centre." In Harding and Rosenthal, *Rise of Performance Studies*, 118–32.

Engberg-Pedersen, Elisabeth. "From Pointing to Reference and Predication: Pointing Signs, Eyegaze, and Head and Body Orientation in Danish Sign Language." In Kita, *Pointing*, 269–92.

Evans, C.-Stephen. "Behaviourism as Existentialism: Ryle and Merleau-Ponty on the Mind." *Journal of the British Society for Phenomenology* 14 (1983): 65–78.

Fay, Jennifer. "Seeing/Loving Animals: André Bazin's Posthumanism." *Journal of Visual Culture* 7, no. 1 (2008): 41–64.

Fichte, J. G. *The Science of Knowledge*. Translated and edited by Peter Heath and John Lachs. Cambridge: Cambridge University Press, 1982.

Finger, Anke, Rainer Guldin, and Gustavo Bernardo. *Vilém Flusser: An Introduction*. Minneapolis: University of Minnesota Press, 2011.

Flusser, Vilém. *Towards a Philosophy of Photography*. Translated by Anthony Mathews. London: Reaktion Books, 2000.

———. *Vampyroteuthis Infernalis*. Edited and translated by Rodrigo Maltez Novaes. New York: Anthropos Press, 2011.

Forte, Jeanie. "Women's Performance Art: Feminism and Postmodernism." *Theatre Journal* 40, no. 2 (1988): 217–35.

Fudge, Erica. *Animal*. London: Reaktion Books, 2004.

Fuller, Steve. *Humanity 2.0: What It Means to Be Human, Past, Present and Future*. London: Palgrave-Macmillan, 2011.

Galloway, Alexander. "Laruelle, Anti-Capitalist." In Mullarkey and Smith, *Laruelle and Non-Philosophy*, 191–208.

———. "Laruelle and Art." *Continent* 2, no. 4 (2013): 230–36.

———. "Review of François Laruelle, *Théorie générale des victimes*." *Parrhesia*, no. 16 (2013): 102–5.

Gangle, Rocco. *François Laruelle's Philosophies of Difference: A Critical Introduction and Guide*. Edinburgh: Edinburgh University Press, 2013.

———. "Laruelle and Ordinary Life." In Mullarkey and Smith, *Laruelle and Non-Philosophy*, 60–79.

Garcia, Tristan. *Forme et objet: Un traité des choses*. Paris: Presses Universitaires de France, 2011.

Goodwin, Charles. "Pointing as Situated Practice." In Kita, *Pointing*, 217–41.

Goulish, Matthew. *The Brightest Thing in the World: 3 Lectures from the Institute of Failure*. Chicago: Green Lantern Press, 2012.

Grelet, Gilles, ed. *Théorie-rébellion: Un ultimatum*. Paris: L'Harmattan, 2005.

Gros, Frederic. *A Philosophy of Walking*. Translated by John Howe. London: Verso, 2014.

Groys, Boris. *Introduction to Antiphilosophy.* London: Verso, 2012.

Guérin, Michel. *Philosophie du geste.* Paris: Actes Sud, 2011.

Guthrie, Stewart. *Faces in the Clouds: A New Theory of Religion.* Oxford: Oxford University Press, 1995.

Hallward, Peter. *Badiou: A Subject to Truth.* Minneapolis: University of Minnesota Press, 2003.

Haraway, Donna. *When Species Meet.* Minneapolis: University of Minnesota Press, 2007.

Harding, James, and Cindy Rosenthal, eds. *The Rise of Performance Studies: Rethinking Richard Schechner's Broad Spectrum.* Basingstoke, U.K.: Palgrave Macmillan, 2011.

Harman, Graham. *Prince of Networks: Bruno Latour and Metaphysics.* Melbourne: re.press, 2009.

———. "Review of *Philosophies of Difference.*" *Notre Dame Philosophical Reviews.* http://ndpr.nd.edu/news/25437-philosophies-of-difference-a-critical-introduction-to-non-philosophy.

Hart, W. D. "Clarity." In *The Analytic Tradition: Meaning, Thought, and Knowledge,* edited by David Bell and Neil Cooper, 197–222. Oxford: Blackwell, 1990.

Heathfield, Adrian. *Live: Art and Performance.* London: Tate, 2004.

Heidegger, Martin. *The Fundamental Concepts of Metaphysics.* Translated by William McNeill and Nicholas Walker. Bloomington: Indiana University Press, 1995.

Heller, Agnes. *Radical Philosophy.* Oxford: Blackwell, 1986.

Hintikka, Jaakko. "Cogito, Ergo Sum: Inference or Performance?" *Philosophical Review* 71 (1962): 3–32.

Hjort, Mette, ed. *Dekalog 01: The Five Obstructions Notes.* London: Wallflower Press, 2008.

———. "*The Five Obstructions.*" In *The Routledge Companion to Philosophy and Film,* edited by Paisley Livingston and Carl Plantinga, 631–40. London: Routledge, 2008.

———. Preface to Hjort, *Dekalog 01,* xliii–xxviii.

———. "Style and Creativity in *The Five Obstructions.*" In Hjort, *Dekalog 01,* 15–37.

Hook, C. Christopher. "Transhumanism and Posthumanism." In *Encyclopedia of Bioethics,* 3rd ed., 2517–20. London: Macmillan Reference, 2003.

Horcutt, M. O. "Is Epistemic Logic Possible?" *Notre Dame Journal of Formal Logic* 13 (1972): 433–53.

Hudson, William. "Pictorial Depth Perception in Subcultural Groups in Africa." *Journal of Social Psychology* 52 (1960). http://www.davidbordwell.net/essays/commonsense.php#_edn16.

Hume, David. *A Treatise of Human Nature: Being an Attempt to Introduce the Experimental Method of Reasoning into Moral Subjects.* Edited by P. H. Nidditch and L. A. Selby-Bigge. Oxford: Oxford University Press, 1978.

———. *An Enquiry Concerning Human Understanding.* Edited by Tom L. Beauchamp. Oxford: Oxford University Press, 2000.

———. *The Natural History of Religion.* London: A. and H. Bradlaugh Bonner, 1889.

Huyssen, Andreas. Foreword to Sloterdijk, *Critique of Cynical Reason,* ix–xxv.

Hylton, Peter. "The Nature of the Proposition and the Revolt against Idealism." In *Philosophy in History: Essays on the Historiography of Philosophy,* edited by J. B. Schneewind and Quentin Skinner, 375–97. Cambridge: Cambridge University Press, 1984.

Irigaray, Luce. *This Sex Which Is Not One.* Translated by Catherine Porter, with Carolyn Burke. Ithaca, N.Y.: Cornell University Press, 1985.

Jaki, Stanley L. "The Physicist and the Metaphysician." *The New Scholasticism* 63, no. 2 (1989): 183–205.

James, Ian. *The New French Philosophy.* Cambridge: Polity, 2012.

———. "Review of the English translation of *Philosophy and Non-Philosophy.*" http://ndpr.nd.edu/news/45165-philosophy-and-non-philosophy.

Jarry, Alfred. *Exploits and Opinions of Dr. Faustroll, Pataphysician.* Translated and with annotation by Simon Watson Taylor. Boston: Exact Change, 1996.

Jeong, Seung-hoon. "Animals: An Adventure in Bazin's Ontology." In *Opening Bazin: Postwar Film Theory and Its Afterlife,* edited by Dudley Andrew, with Hervé Joubert-Laurencin, 177–85. Oxford: Oxford University Press, 2011.

Jeong, Seung-Hoon, and Dudley Andrew. "Grizzly Ghost: Herzog, Bazin and the Cinematic Animal." *Screen* 49, no. 1 (2008): 1–12.

Jürs-Munby, Karen. "*Hanswurst* and *Herr Ich*: Subjection and Abjection in Enlightenment Censorship of the Comic Figure." *New Theatre Quarterly* 23, no. 2 (2007): 124–35.

Kabay, P. D. "A Defense of Trivialism." PhD diss., School of Philosophy, Anthropology, and Social Inquiry, University of Melbourne, 2008.

Kahneman, Daniel. *Thinking, Fast and Slow.* London: Penguin, 2011.

Kant, Immanuel. *Critique of Pure Reason.* Edited and translated by Paul Guyer and Allen W. Wood. Cambridge: Cambridge University Press, 1998.

———. "What Is Orientation in Thinking?" In *Kant: Political Writings,* translated by H. B. Nisbet, edited by H. S. Reiss, 237–49. Cambridge: Cambridge University Press, 1991.

Kaprow, Allan. *Essays on the Blurring of Art and Life.* Expanded ed. Berkeley: University of California Press, 2003.

———. "Manifesto." In *The Discontinuous Universe,* edited by Sallie Sears and Georgianna W. Lord, 291–92. New York: Basic Books, 1972.

Kirby, Michael. "On Acting and Not-Acting." *The Drama Review* 16, no. 1 (1972): 3–15.

Kirkkopelto, Esa. "A Manifesto for Generalized Anthropomorphism." http://www.eurozine.com/pdf/2004-09-07-kirkkopelto-en.pdf.

Kita, Sotaro, ed. *Pointing: Where Language, Culture, and Cognition Meet.* Mahwah, N.J.: Lawrence Erlbaum, 2003.

Kolozova, Katerina. *Cut of the Real: Subjectivity in Poststructuralist Philosophy.* New York: Columbia University Press, 2014.

———. *The Lived Revolution: Solidarity with the Body in Pain as the New Political Universal.* Skopje, Macedonia: Evro-Balkan Press, 2010.

———. "Theories of the Immanent Rebellion: Non-Marxism and Non-Christianity." In Mullarkey and Smith, *Laruelle and Non-Philosophy*, 209–26.

Kripke, Saul. *Naming and Necessity.* Cambridge, Mass.: Harvard University Press, 1980.

Lambert-Beatty, Carrie. "Make-Believe: Parafiction and Plausibility." *October* 12 (Summer 2009): 51–84.

Lampe, Eelka. "Rachel Rosenthal Creating Her Selves." In *Acting (Re)Considered: A Theoretical and Practical Guide*, 2nd ed., edited by Phillip B. Zarrilli, 291–304. London: Routledge, 2002.

Laruelle, François. *Anti-Badiou.* Translated by Robin Mackay. London: Bloomsbury Academic, 2013.

———. "A Rigorous Science of Man." In Laruelle, *From Decision to Heresy*, 33–73.

———. "A Summary of Non-Philosophy." In Laruelle, *From Decision to Heresy*, 285–304.

———. "Biographie de l'oeil." *La Decision philosophique* 9 (1989): 93–104. Translated as "Biography of the Eye" by Taylor Adkins, http://fractalontology.wordpress.com/2009/11/21/new-translation-of-laruelles-biography-of-the-eye.

———. "The Concept of 'First Technology': A 'Unified Theory' of Technics and Technology." In *Sur Simondon: Une Pensée de L'Individuation et de La Technique*, edited by Gilles Châtelet, 206–19. Paris: Albin Michel, 1994. Translated by Taylor Adkins, http://speculativeheresy.wordpress.com/2008/08/03/laruelles-essay-on-simondon-the-concept-of-a-first-technology.

———. "Controversy over the Possibility of a Science of Philosophy." In Laruelle, *Non-Philosophy Project*, 74–92.

———. "The Decline of Materialism in the Name of Matter." *Pli* 12 (2001): 33–40.

———. "Deconstruction and Non-Philosophy," translated by Nicholas Hauck. *Chiasma: A Site for Thought* 1, no. 1 (2014): 54–63.

———. "The Degrowth of Philosophy: Towards a Generic Ecology." Translated by Robin Mackay. In Laruelle, *From Decision to Heresy,* 327–49.

———, et al. *Dictionary of Non-Philosophy.* 1995. Translated by Taylor Adkins et al., https://sites.google.com/site/nsrnicek/DictionaryNonPhilosophy.pdf?attredirects=0.

———. *En tant qu'un.* Paris: Aubier, 1991.

———. "First Choreography," translated by Alyosha Edlebi. *Qui Parle: Critical Humanities and Social Sciences* 21, no. 2 (2013): 143–55.

———. *From Decision to Heresy: Experiments in Non-Standard Thought.* Edited by Robin Mackay. Falmouth, U.K.: Urbanomic/Sequence Press, 2012.

———. "From the First to the Second Non-Philosophy." In Laruelle, *From Decision to Heresy,* 305–25.

———. *Future Christ: A Lesson in Heresy.* Translated by Anthony Paul Smith. London: Continuum, 2010.

———. *General Theory of Victims.* Translated by Jessie Hock and Alex Dubilet. Cambridge: Polity, 2015.

———. "The Generic Orientation of Non-Standard Aesthetics." Paper presented at the Weisman Art Museum, University of Minneapolis, November 17, 2012. http://univocalpublishing.com/blog/111-lecture-on-the-orientation-of-non-standard-aesthetics.

———. "'I, the Philosopher, Am Lying': Reply to Deleuze." In Laruelle, *Non-Philosophy Project,* 40–73.

———. *Intellectuals and Power: The Insurrection of the Victim. François Laruelle in Conversation with Philippe Petit.* Translated by Anthony Paul Smith. Cambridge: Polity, 2014.

———. *Introduction au Non-Marxism.* Paris: Presses Universitaries de France, 2000. Chapter 3 translated by Taylor Adkins, http://speculativeheresy.wordpress.com/2008/07/20/chapter-3-of-laruelles-introduction-to-non-marxism-determination-in-the-last-instance-dli.

———. *Introduction aux sciences générique.* Paris: Petra, 2008.

———. Introduction to *Machines textuelles.* Paris: Seuil, 1976. Translated by Taylor Adkins, http://speculativeheresy.wordpress.com/2013/09/01/translation-of-f-laruelles-introduction-to-textual-machines.

———. "Is Thinking Democratic? Or, How to Introduce Theory into Democracy." In Mullarkey and Smith, *Laruelle and Non-Philosophy,* 227–37.

———. "La concept d'analyse generalisée ou de 'non-analyse.'" *Revue internationale de philosophie* 43, no. 171 (1989): 506–24. Translated by Taylor Adkins, http://speculativeheresy.wordpress.com/2013/06/15/translation-of-laruelles-the-concept-of-generalized-analysis-or-of-non-analysis.

———. "La Scène du Vomi ou comment ça se détraque dans la théorie." *Critique* 347 (1976): 418–43.

———. *Le Concept de non-photographie/The Concept of Non-Photography.* Bilingual ed. Translated by Robin Mackay. Falmouth, U.K.: Urbanomic, 2011.

———. "Le concept d'une éthique ordinaire ou fondée dans l'homme." *Rue Descartes* 7 (1993). Translated by Taylor Adkins, http://univocalpublishing.com/blog/108-the-concept-of-an-ordinary-ethics-or-ethics-founded-in-man.

———. "Le Tsunami et le Mythe du Poisson-eau." *Philo-Fictions, No. 2: Fiction, une nouvelle rigueur* (2009): 7–15.

———. "Life in-the-Last-Humanity: On 'Speculative' Ecology of Man, Animal, and Plant." Paper presented at London Graduate School, June 13, 2014.

———. "L'Impossible foundation d'une écologie de l'océan." 2008. http://www.onphi.net/lettre-laruelle-l-impossible-fondation-d-une-ecologie-de-l-ocean-27.html.

———. "Non-Philosophy as Heresy." In Laruelle, *From Decision to Heresy,* 257–84.

———. *The Non-Philosophy Project: Essays by François Laruelle.* Edited by Gabriel Alkon and Boris Gunjevic. New York: Telos, 2012.

———. "Non-Philosophy, Weapon of Last Defence: An Interview with François Laruelle." In Mullarkey and Smith, *Laruelle and Non-Philosophy,* 238–58.

———. "Obscénité de la philosophie (pour non-philosophes avertis)." In Grelet, *Théorie-rébellion,* 123–25.

———. *Philosophie non-standard: Générique, quantique, philo-fiction.* Paris: Kimé, 2010.

———. *Philosophies of Difference.* Translated by Rocco Gangle. London: Continuum, 2010.

———. *Philosophy and Non-Philosophy.* Translated by Taylor Adkins. Minneapolis, Minn.: Univocal, 2013.

———. *Photo-Fiction, a Non-Standard Aesthetics.* Translated by Drew S. Burke and Anthony Paul Smith. Minneapolis, Minn.: Univocal, 2012.

———. *Principe de minorité.* Paris: Aubier, 1981.

———. *Principes de la Non-Philosophie.* Paris: Presses Universitaires de France, 1996.

———. *Principles of Non-Philosophy.* Translated by Nicola Rubczak and Anthony Paul Smith. London: Bloomsbury Academic, 2013.

———. *Struggle and Utopia at the End Times of Philosophy.* Translated by Drew S. Burke and Anthony Paul Smith. Minneapolis, Minn.: Univocal, 2012.

———. *Théorie des Étrangers: Science des hommes, démocratie, non-psychanalyse.* Paris: Kimé, 1995.

———. *Théorie des Identités: Fractalité généralisée et philosophie artificielle.* Paris: Presses Universitaires de France, 1992.

———. "Toward a Science of Philosophical Decision." In Laruelle, *From Decision to Heresy,* 75–105.

———. "The Transcendental Method." In Laruelle, *From Decision to Heresy,* 135–71.

———. "Transvaluation of the Transcendental Method." In Laruelle, *From Decision to Heresy,* 425–96.

———. *Une biographie de l'homme ordinaire: Des Autorités et des Minorités.* Paris: Aubier, 1985.

———. "Universe Black in the Human Foundations of Colour." In Laruelle, *From Decision to Heresy,* 401–8.

———. "What Can Non-Philosophy Do?" In Laruelle, *Non-Philosophy Project,* 196–231.

———. "What Is Non-Philosophy?" In Laruelle, *From Decision to Heresy,* 185–244.

Laruelle, François, and John Ó Maoilearca. "Artistic Experiments with Philosophy: François Laruelle in Conversation with John Ó Maoilearca." In *Realism Materialism Art,* edited by Christoph Cox, Jenny Jaskey, and Suhail Malik, 177–83. Berlin: Sternberg/CCS Bard, 2014.

Latour, Bruno. *We Have Never Been Modern.* Translated by Catherine Porter. Cambridge, Mass.: Harvard University Press, 1993.

Lawlor, Leonard. "Following the Rats: Becoming Animal in Deleuze and Guattari." *SubStance* 37, no. 3 (2008): 169–87.

Lefebvre, Henri. *The Production of Space.* Translated by Donald Nicholson-Smith. Oxford: Blackwell, 1991.

Leroi-Gourhan, André. *Gesture and Speech.* Translated by Anna Bostock Berger. Cambridge, Mass.: MIT Press.

Leroy, Laurent. "Derrida et le 'non-philosophique' restreint." In *La Non-philosophie des contemporains,* edited by Collectif, 81–105. Paris: Kimé, 1995.

Leth, Jørgen. "The *Dekalog* Interview: Jørgen Leth." In Hjort, *Dekalog 01,* 141–47.

Lien, Fontaine. "Review of *Psycho.*" *IMDB Reviews* (1998). http://www.imdb.com/reviews/188/18868.html.

Lippit, Akira. "The Death of the Animal." *Film Quarterly* 56 (2002): 9–22.

———. *Electric Animal.* Minneapolis: University of Minnesota Press, 2000.

Livingston, Paisley. "Artistic Nesting in *The Five Obstructions.*" In Hjort, *Dekalog 01,* 57–77.

Lynes, Krista Geneviève. "Perversions of Modesty: Lars von Trier's *The Five Obstructions* and 'The Most Miserable Place on Earth.'" *Third Text* 24, no. 5 (2010): 597–610.

MacCormack, Patricia. *Cinesexuality.* Aldershot, U.K.: Ashgate, 2008.

Mackay, Robin, ed. *Collapse: Concept-Horror.* Vol. 4. December 2012.

Mackay, Robin, and François Laruelle. "Introduction: Laruelle Undivided." In Laruelle, *From Decision to Heresy,* 1–32.

Mari, Laura, and Michele Paolini Paoletti, eds. "Meinong Strikes Again: Return to Impossible Objects 100 Years Later." Special issue, *Humana. Mente* 25 (2013).

Mayer, David. "Acting in Silent Film: Which Legacy of the Theatre?" In *Screen Acting,* edited by Alan Lovell and Peter Krämer, 10–30. London: Routledge, 1999.

McGettigan, Andrew. "Fabrication Defect: François Laruelle's philosophical materials." *Radical Philosophy* 175 (September/October 2012): 33–42.

———. "Review of *Refractions of Reality: Philosophy and the Moving Image.*" *Radical Philosophy* 158 (November/December 2009): 66–67.

McNeill, David. *Gesture and Thought.* Chicago: University of Chicago Press, 2005.

Meillassoux, Quentin. *After Finitude.* London: Continuum Press, 2008.

Meinong, Alexius. "The Theory of Objects," translated by Isaac Levi, D. B. Terrell, and Roderick M. Chisholm. In *Realism and the Background of Phenomenology,* edited by Roderick Chisholm, 76–117. New York: Free Press, 1960.

Merleau-Ponty, Maurice. *Phenomenology of Perception.* Translated by Colin Smith. London: Routledge and Kegan Paul, 1962.

Mersch, Dieter. "Aspects of Visual Epistemology: On the 'Logic' of Showing." In Nyíri and Benedek, *Images in Language,* 169–94.

Metzger, Gustav. *Manifesto for Auto-Destructive Art.* 1959. http://radicalart .info/destruction/metzger.html.

Midgley, Mary. *Beast and Man: The Roots of Human Nature.* London: Routledge, 1978.

Mill, J. S. "Utilitarianism." In *Utilitarianism and Other Essays,* by J. S. Mill and Jeremy Bentham, 272–338. London: Penguin, 2000.

Miró Quesada, Francisco. "Does Metaphysics Need a Non-Classical Logic?" In *Alternative Logics: Do Sciences Need Them?,* edited by Paul Weingartner, 27–39. Berlin: Springer, 2004.

Mitry, Jean. *The Aesthetics and Psychology of the Cinema.* Translated by Christopher King. London: Athlone Press, 1998.

Moore, F. C. T. *Bergson, Thinking Backwards.* Cambridge: Cambridge University Press, 1996.

Mortensen, Chris. "Inconsistent Images." http://www.hss.adelaide.edu.au/ philosophy/inconsistent-images/sylvans.

Morton, Timothy. *Realist Magic: Objects, Ontology, Causality.* Ann Arbor, Mich.: Open Humanities Press, 2013.

Mullarkey, John. "1 + 1 = 1: The Non-Consistency of Non-Philosophical Practice (Photo: Quantum: Fractal)." In Mullarkey and Smith, *Laruelle and Non-Philosophy*, 143–68.

———. "A + A = A: A Response to John Roberts on François Laruelle." *Philosophy of Photography* 2, no. 2 (2011): 311–14.

———. "Animal Spirits: Philosomorphism and the Background Revolts of Cinema." In "We Have Never Been Human: From Techne to Animality," edited by Ron Broglio and Frederick Young, special issue, *Angelaki* 18, no. 1 (2013): 11–29.

———. *Bergson and Philosophy*. Notre Dame, Ind.: University of Notre Dame Press, 2000.

———. *Philosophy and the Moving Image: Refractions of Reality*. Basingstoke, U.K.: Palgrave-Macmillan, 2010.

———. *Post-Continental Philosophy: An Outline*. London: Continuum, 2006.

———. "Temple Grandin's Animal Thoughts: On Non-Human Thinking in Pictures, Films, and Diagrams." In Nyíri and Benedek, *Images in Language*, 155–68.

———. "The Tragedy of the Object: Democracy of Vision and the Terrorism of Things in Bazin's Cinematic Realism." In "The Promise of Cinema: Revisiting Themes from Bazin," edited by Lisabeth During and Lisa Trahair, special issue, *Angelaki* 17, no. 4 (2013): 39–59.

Mullarkey, John, and Anthony Paul Smith, eds. *Laruelle and Non-Philosophy*. Edinburgh: Edinburgh University Press, 2012.

Mulvey, Laura. "Death Twenty-Four Times a Second: The Inorganic Body and the Cinema." In *Becoming Human: New Perspectives on the Inhuman Condition*, edited by Paul Sheehan, 93–102. Westport, Conn.: Praeger, 2003.

Naremore, James. *Acting in the Cinema*. Berkeley: University of California Press, 1988.

Nietzsche, Friedrich. *On the Genealogy of Morals and Ecce Homo*. Translated by Walter Kaufmann and R. J. Hollingdale. New York: Vintage, 1989.

Nolan, Daniel. "A Consistent Reading of Sylvan's Box." *The Philosophical Quarterly* 57, no. 229 (2007): 667–73.

Nyíri, Kristóf, and András Benedek, eds. *Images in Language: Metaphors and Metamorphoses*. Frankfurt am Main, Germany: Peter Lang, 2011.

Oliver, Kelly. *Animal Lessons: How They Teach Us to Be Human*. New York: Columbia University Press, 2009.

O'Sullivan, Siobhan. *Animals, Equality, and Democracy*. Basingstoke, U.K.: Palgrave Macmillan, 2011.

Pepper, Stephen. *World Hypotheses: A Study in Evidence*. Berkeley: University of California Press, 1942.

Phillips, Adam. "What If Freud Didn't Care? Review of Phyllis Grosskurth,

The Secret Ring: Freud's Inner Circle and the Politics of Psychoanalysis." *London Review of Books* 14, no. 9 (1992): 19.

Pick, Anat. *Creaturely Poetics: Animality and Vulnerability in Literature and Film.* New York: Columbia University Press, 2011.

Plato. *The Republic.* Translated by B. Jowett. London: Penguin, 1984.

Ponech, Trevor. "Work and Play: The 5–0 Game." In Hjort, *Dekalog 01,* 76–94.

Pratt, George. *Spellbound in Darkness.* Greenwich, Conn.: New York Graphic Society, 1966.

Priest, Graham. *In Contradiction: A Study of the Transconsistent.* 2nd ed. Oxford: Clarendon Press, 2006.

———. "Sylvan's Box: A Short Story and Ten Morals." *Notre Dame Journal of Formal Logic* 38, no. 4 (1997): 573–82.

———. *Towards Non-Being: The Logic and Metaphysics of Intentionality.* Oxford: Clarendon, 2005.

Proctor, Robert, and Londa Schiebinger, eds. *Agnotology: The Making and Unmaking of Ignorance.* Palo Alto, Calif.: Stanford University Press, 2008.

Protevi, John. *A Dictionary of Continental Philosophy.* Edinburgh: Edinburgh University Press, 2005.

Puchner, Martin. "The Theater in Modernist Thought." *New Literary History* 33, no. 3 (2002): 521–32.

Quine, W. V. O. "On What There Is." In *From a Logical Point of View,* 1–19. Cambridge, Mass.: Harvard University Press, 1953.

Rainer, Yvonne. *No Manifesto.* 1965. http://www.1000manifestos.com/yvonne-rainer-no-manifesto.

Rancière, Jacques. *The Emancipated Spectator.* Translated by Gregory Elliott. London: Verso, 2011.

———. *The Ignorant Schoolmaster: Five Lessons in Intellectual Emancipation.* Translated by Kristin Ross. Stanford, Calif.: Stanford University Press, 1991.

Read, Alan. *Theatre, Intimacy, and Engagement: The Last Human Venue.* Basingstoke, U.K.: Palgrave Macmillan, 2009.

Reinelt, Janelle. "The Politics of Discourse: Performativity Meets Theatricality." *SubStance* 31, nos. 2–3 (2002): 201–15.

Rescher, Nicholas. *Ignorance: On the Wider Implications of Deficient Knowledge.* Pittsburgh, Pa.: University of Pittsburgh Press, 2009.

Reszitnyk, Andrew. "Wonder without Domination." *Chiasma: A Site for Thought* 1, no. 1 (2014): 24–53.

Riskind, J. H., and C. C. Gotay. "Physical Posture: Could It Have Regulatory or Feedback Effects on Motivation and Emotion?" *Motivation and Emotion* 6, no. 3 (1982): 273–98.

Roberts, John. "The Flat-Lining of Metaphysics: François Laruelle's 'Science-

Fictive' Theory of Non-Photography." *Philosophy of Photography* 2, no. 1 (2011): 169–73.

Rodriguez, Hector. "Constraint, Cruelty and Conversation." In Hjort, *Dekalog 01*, 38–56.

Rossell, Deac. "Double Think: The Cinema and Magic Lantern Culture." In *Celebrating 1895: The Centenary of Cinema*, edited by John Fullerton, 27–36. New Barnet, U.K.: John Libbey Cinema and Animation, 1998.

Routley, Richard. *Exploring Meinong's Jungle and Beyond: An Investigation of Noneism and the Theory of Items*. Canberra: RSSS, Australian National University, 1980.

Rowlands, Mark. *The Philosopher at the End of the Universe*. London: Ebury Press, 2003.

Roy, Philippe. *Trouer la membrane: Penser et vivre la politique par des gestes*. Paris: L'Harmattan, 2012.

Roy, Tony. "What's So Bad with Infinite Regress?" http://rocket.csusb.edu/~troy/regress-pap.pdf.

Ryle, Gilbert. *The Concept of Mind*. London: Penguin, 1970.

Sartre, Jean-Paul. *Being and Nothingness: An Essay on Phenomenological Ontology*. Translated by Hazel Barnes. London: Routledge, 1959.

———. *Critique of Dialectical Reason*. Vol. 1. Translated by Alan Sheridan-Smith. London: Verso, 2004.

Schechner, Richard. *Between Theater and Anthropology*. Philadelphia: University of Pennsylvania Press, 1985.

———. *Performance Studies: An Introduction*. London: Routledge, 2002.

———. *Performance Theory*. London: Routledge, 1988.

Schefer, Jean-Louis. *The Enigmatic Body: Essays on the Arts*. Cambridge: Cambridge University Press, 1995.

Schepelern, Peter. "To Calculate the Moment: Leth's Life as Art." In Hjort, *Dekalog 01*, 95–116.

Schmid, Anne-Françoise. "Quelque chose rouge dans la philosophie." *Philo-Fictions* 2 (2009): 117–28.

———. "The Science-Thought of Laruelle and Its Effects on Epistemology." In Mullarkey and Smith, *Laruelle and Non-Philosophy*, 122–42.

Schmid, Anne-Françoise, Muriel Mambrini-Doudet, and Armand Hatchuel. "Une nouvelle logique de l'interdisciplinarité." *Nouvelles Perspectives en Sciences Sociales* 7, no. 1 (2011): 105–36.

Schmitt, Jean-Claude. *La Raison des gestes dans l'Occident medieval*. Paris: Gallimard, 1990.

Schneider, Rebecca. "Reactuals: From Personal to Critical and Back." In Harding and Rosenthal, *Rise of Performance Studies*, 135–51.

Schumacher, John A. *Human Posture: The Nature of Inquiry*. Albany: State University of New York Press, 1989.

Shukin, Nicole. *Animal Capital: Rendering Life in Biopolitical Times*. Minneapolis: University of Minnesota Press, 2009.

Simons, Peter. "Bolzano, Brentano, and Meinong: Three Austrian Realists." In *German Philosophy since Kant*, edited by Anthony O'Hear, 109–36. Cambridge: Cambridge University Press, 1999.

Sloterdijk, Peter. *Critique of Cynical Reason*. Translated by Michael Eldred. Minneapolis: University of Minnesota Press, 1987.

Slowiak, James, and Jairo Cuesta. *Jetzy Grotowski*. London: Routledge, 2007.

Smith, Anthony Paul. *A Non-Philosophical Theory of Nature: Ecologies of Thought*. Basingstoke, U.K.: Palgrave-Macmillan, 2013.

Smith, Anthony Paul, and Nicola Rubczak. "Cloning the Untranslatable: Translators' Introduction." In Laruelle, *Principles of Non-Philosophy*, xi–xix.

Smith, Murray. "Funny Games." In Hjort, *Dekalog 01*, 117–40.

Stern, Lesley. *Dead and Alive: The Body as Cinematic Thing*. Montreal: Caboose, 2012.

Stiegler, Bernard. "'Doing and Saying Stupid Things in the Twentieth Century': *Bêtise* and Animality in Deleuze and Derrida," translated by Daniel Ross. *Angelaki* 18, no. 1 (2013): 159–74.

———. *Technics and Time: Vol. 1. The Fault of Epimetheus*. Translated by Richard Beardsworth and George Collins. Palo Alto, Calif.: Stanford University Press, 1998.

———. *Technics and Time: Vol. 2. Disorientation*. Translated by Stephen Barker. Palo Alto, Calif.: Stanford University Press, 2009.

Stjernfelt, Agnete Dorph, ed. *Film: Special Issue: Jørgen Leth*. Copenhagen: Danish Film Institute, 2002.

ten Bos, René. "Touched by Madness: On Animals and Madmen." *South African Journal of Philosophy* 28, no. 4 (2009): 433–46.

Thacker, Eugene. *In the Dust of This Planet: Horror of Philosophy*. Vol. 1. Ropley, U.K.: Zero, 2011.

———. "Thought Creatures." *Theory, Culture, and Society* 24 (2007): 327–29.

Turner, Victor. *The Anthropology of Performance*. New York: PAJ, 1986.

Tye, Michael. "The Subjective Qualities of Experience." *Mind* 95 (1986): 1–17.

Unger, Peter. *Ignorance: A Case for Scepticism*. Oxford: Clarendon Press, 1975.

Valiaho, Pasi. *Mapping the Moving Image: Gesture, Thought, and Cinema circa 1900*. Amsterdam: University of Amsterdam Press, 2010.

Viveiros de Castro, Eduardo. "Cosmological Deixis and Ameridian Perspectivism." *Journal of the Royal Anthropological Institute* 4, no. 3 (1998): 469–88.

———. "Cosmologies: Perspectivism." In *Cosmological Perspectivism in Amazonia and Elsewhere*, Vol. 1, 45–168. Manchester: HAU Network of Ethnographic Theory, 2012.

———. *Métaphysiques cannibals: Lignes d'anthropologie post-structurale*. Paris: Presses Universitaires de France, 2009.

Weber, Samuel. *Theatricality as Medium*. New York: Fordham University Press, 2004.

Weber, Zach. "Paraconsistent Logic." In *Internet Encyclopedia of Philosophy*, http://www.iep.utm.edu/para-log.

Weil, Kari. *Thinking Animals: Why Animal Studies Now?* New York: Columbia University Press, 2012.

Whitehead, Alfred North. *Process and Reality*. Revised ed. New York: Free Press, 1978.

Williams, Linda. "Film Bodies: Gender, Genre, and Excess." *Film Quarterly* 44, no. 4 (1991): 2–13.

Wilson, Mark. *Wandering Significance: An Essay on Conceptual Behavior*. Oxford: Clarendon Press, 2006.

Wittgenstein, Ludwig. *Philosophical Investigations*. Translated by G. E. M. Anscombe. Oxford: Blackwell, 1967.

———. *Tractatus Logico-Philosophicus*. Translated by C. K. Ogden. New York: Cosimo Classics, 2007.

Wolfe, Cary. *Animal Rites: American Culture, the Discourse of Species, and Posthumanist Theory*. Chicago: University Of Chicago Press, 2003.

———. "Human, All Too Human: 'Animal Studies' and the Humanities." *MLA* 124, no. 2 (2009): 564–75.

———. *What Is Posthumanism?* Minneapolis: University of Minnesota Press, 2010.

Žižek, Slavoj. *Less Than Nothing: Hegel and the Shadow of Dialectical Materialism*. London: Verso, 2012.

INDEX

Abramović, Marina, 265

absolute, 28, 37, 46, 51, 54, 60, 65, 125, 128, 131, 132, 138, 161, 177, 209, 233, 276, 287, 293, 342n13, 343n9. *See also* radical

abstraction, 4, 58, 60, 98, 117, 131, 132, 187, 258, 270, 271, 300n57. *See also* extraction

Acconci, Vito, 266

acting, 16, 33, 38, 142, 152, 158, 162, 169, 176, 177, 182, 248, 252, 253, 254, 255–60, 265, 277, 317–18n6, 323n111, 323–24n113. *See also* behavior, continuum of acting and not-acting

actualism, 287

ad hominem, 274, 279, 340n98

Adams, Douglas, 233

Adkins, Taylor, 35, 301n80, 302n105

Adorno, Theodor, 325n15, 338n58

Agamben, Giorgio, 44, 177, 182, 197, 198, 205, 206–8, 213, 215, 227, 230, 240, 284, 320n51, 323n110, 329n77, 329n79, 330n104, 331n113, 333n159, 333n166; on animals, 198, 205–8, 215, 217, 227, 230; on bare life, 206, 207, 217, 227, 230, 266. *See also* anthropological machine

Ahmed, Sara, 171, 322n87

Alien (film), 238

Althusser, Louis, 44, 81, 196

Andrew, Dudley, 227, 333n156, 333n157

animals, 4, 15, 22, 26, 31–33, 43, 45, 49, 57, 167, 182, 183, 184–88, 190, 195, 196, 196–218, 220–21, 224–25, 227–41, 246, 259, 260, 269, 277, 278, 283, 292–93, 325n10, 326n25, 327n56, 328n66, 328nn71–72, 328n74, 328–29n76, 330n99, 331n113, 331–32n123, 332n135, 333n172, 334n186, 334n192, 335n199, 335n200, 341n110; Agamben on, 198, 205–8, 215, 217, 227, 230; animal becomings, 198, 202, 213, 328, 333n172; animal-in-person, 184, 187, 210, 212; animality, 26, 34, 38, 39, 42, 43, 48, 180–81, 205, 207, 210, 221, 229, 231, 233, 247, 268, 293, 330n99, 331n113; animalization, 43, 182, 204, 205, 208; animal life, 206, 207, 218, 219, 230; animal philosophy, 4, 43, 176, 180, 182, 188, 202, 204, 233, 235, 238; animal posture, 239; Badiou on, 204–6, 213; cinematic, 214, 217; Deleuze on, 196, 200–204, 230, 232; Derrida on, 198–201; disappearance of, 215, 218; humanized, 207, 210; nonhuman, 46, 189, 195, 210, 214. *See also* nonhuman

363

(continued from page ii)

JOHN Ó MAOILEARCA is professor of film and television studies at Kingston University, London. He has also taught philosophy and film theory at the University of Sunderland, England, and the University of Dundee, Scotland. He has published ten books, including, as author, *Bergson and Philosophy* (2000), *Post-Continental Philosophy: An Outline* (2006), and *Refractions of Reality: Philosophy and the Moving Image* (2010), and, as editor, *Laruelle and Non-Philosophy* (2012) and *The Bloomsbury Companion to Continental Philosophy* (2013). In 2014 his name reverted from the English "Mullarkey" to the original Irish "Ó Maoilearca," which ultimately translates as "follower of the animal."

Printed and bound by CPI Group (UK) Ltd, Croydon, CR0 4YY

13/04/2025

14656504-0002